BLACK BEAUTIES

ICONIC CARS

PHOTOGRAPHED BY RENÉ STAUD

TEXTS BY JÜRGEN LEWANDOWSKI

teNeues

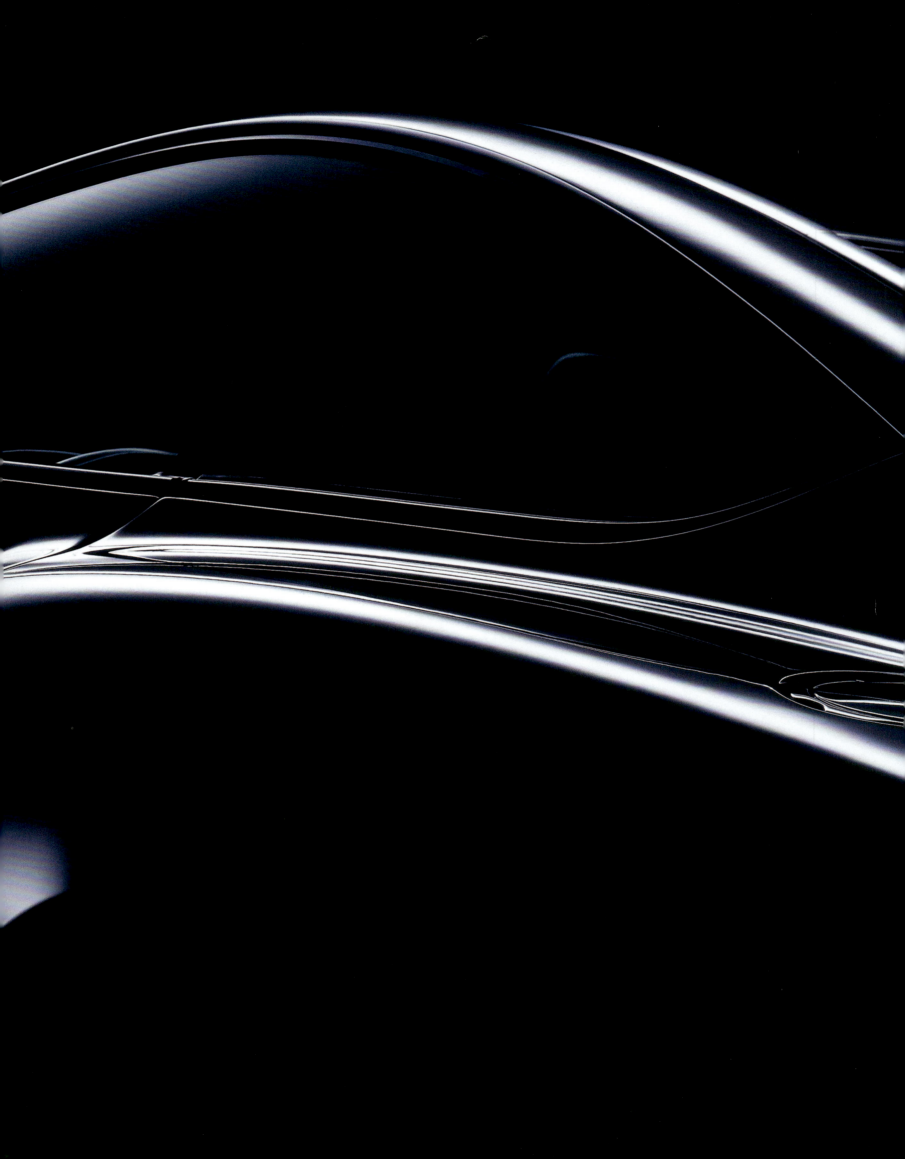

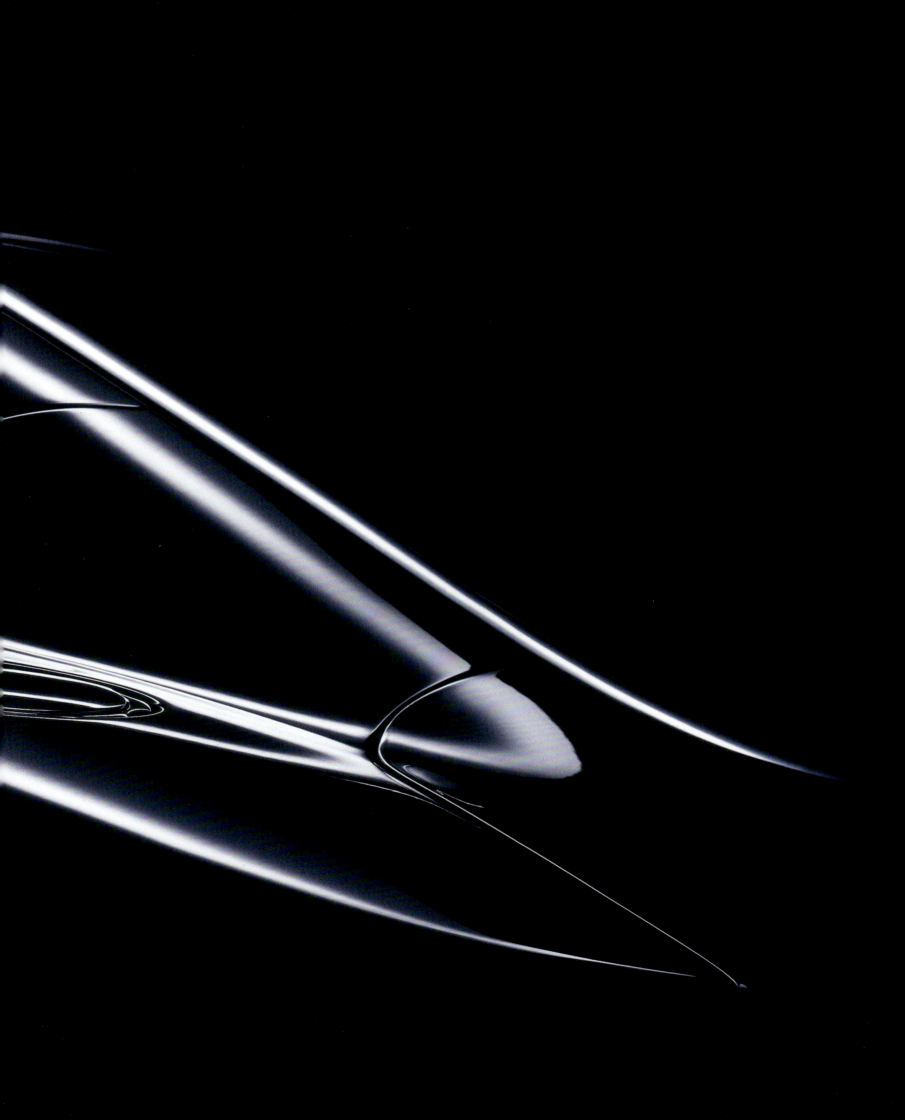

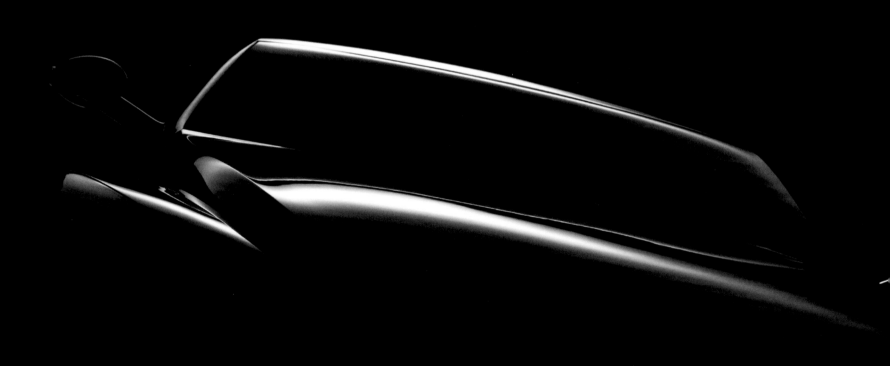

Contents / Inhalt

8 Foreword / Vorwort
Dr. Andreas Kaufmann

10 Introduction / Einleitung
Jürgen Lewandowski

14 BLACK HERITAGE

64 BLACK ELEGANCE

102 BLACK POWER

158 BLACK LEGENDS

216 BLACK ETERNITY

286 BLACK UNIVERSE

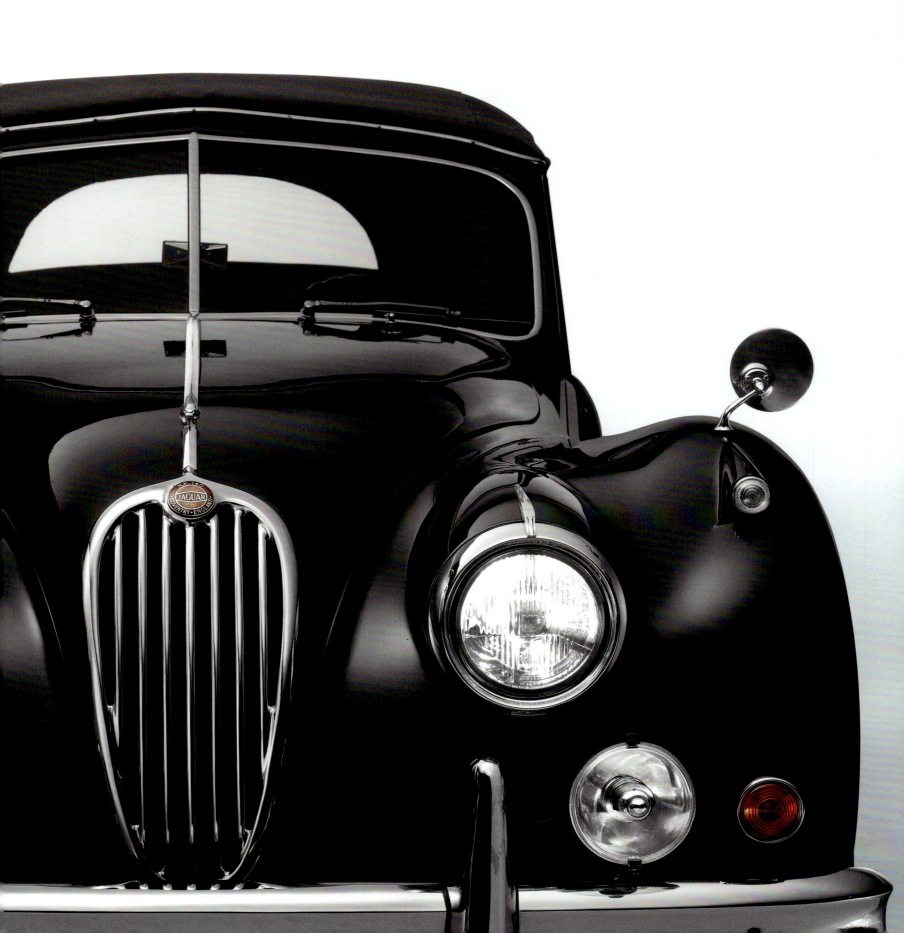

List of Essays / Verzeichnis der Essays

36 **BLACK IS A GREAT COLOR! / SCHWARZ IST EINE TOLLE FARBE!**
Mark Gutjahr

62 **PAINT IT BLACK! / PAINT IT BLACK!**
Konstantin Jacoby

100 **BLACK IS A NON-COLOR! / SCHWARZ IST EINE UNFARBE!**
Stefan Sielaff

130 **BLACK: THE COLOR FOR ARCHITECTS? / SCHWARZ: FARBE DER ARCHITEKTEN?**
Prof. Werner Sobek

154 **DARK COLORFUL NIGHT THOUGHT / DUNKEL BUNTES NACHT GEDACHT**
David Staretz

186 **THE "COLOR" BLACK / DIE „FARBE" SCHWARZ**
Prof. Michael Ulbig

214 **BLACK IS AN INSPIRATION / SCHWARZ IST EINE INSPIRATION**
Interview with / Interview mit Prof. Gorden Wagener

246 **THE SYNTHESIS OF POWER / KRAFT PUR**
Dr. Andrea Michele Zagato

289 **BLACK: THE ULTIMATE COLOR / SCHWARZ: DIE ENDGÜLTIGE FARBE**
Lukas-Pierre Bessis

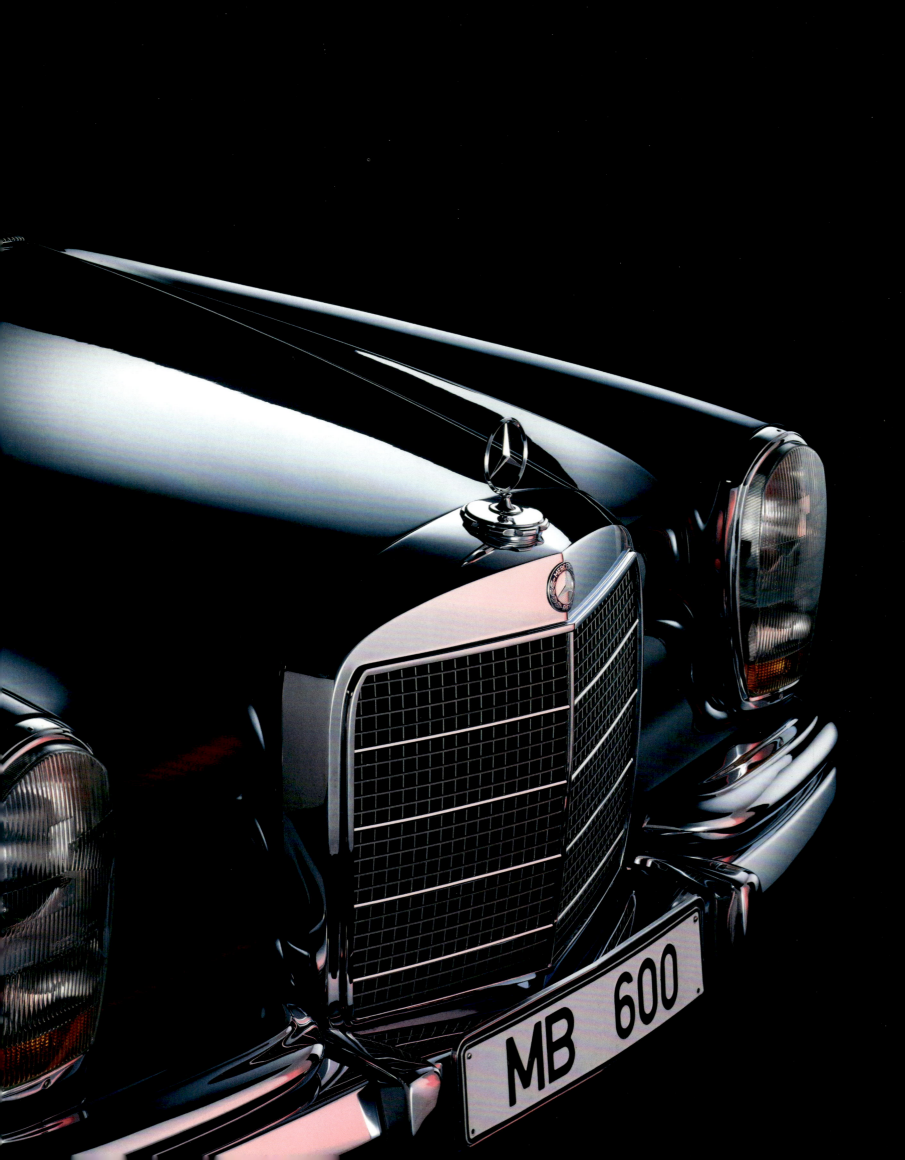

Foreword

Dr. Andreas Kaufmann,
Chair of the Supervisory Board, Leica Camera AG

Black is ... depending on the culture, there are differing ideas about the effect of the color black. In a European context, people frequently say white is the color of joy and innocence, while black is the color of death, grief, and guilt. People also say that individualists, egocentric people, and deceivers prefer black; black shows individuality, coolness, and a flair for secrecy and mysticism, but also gives your counterpart the feeling that you are unapproachable.

Whatever the case may be, we cannot and will not provide the definitive solutions to the puzzles surrounding the color black. But we know one thing right away when we look at René Staud's pictures in this book: black cars are sexy! They exude coolness! They have a big emotional impact—and what is better than a car that has an emotional effect on the viewer?

And I think that René, with his signature photographic style, has definitely captured this coolness and sexiness!

Vorwort

Dr. Andreas Kaufmann,
Vorsitzender des Aufsichtsrats, Leica Camera AG

Black is ... Je nach Kultur gibt es unterschiedliche Auffassungen über die Wirkung der Farbe Schwarz. Im europäischen Kontext sagt man häufig: Weiß ist die Farbe der Freude und Unschuld, Schwarz die Farbe des Todes, der Trauer und Schuld. Man sagt auch, dass Individualisten, Egozentriker und Täuscher Schwarz bevorzugten; Schwarz zeige Individualität, Coolness, Flair von Geheimnis und Mystik, gebe aber auch dem Gegenüber das Gefühl, dass die Person, die Schwarz trägt, unnahbar sei.

Sei es, wie es sei, wir werden und wollen hier nicht final die letzten Rätsel der schwarzen Farbe lösen. Eins aber wissen wir sofort, wenn wir die Bilder von René Staud in diesem Band betrachten: schwarze Autos sind sexy! Sie strahlen Coolness aus! Sie wirken sehr emotional – was gibt es Schöneres, als wenn ein Auto emotional wirkt?

Und ich denke, René hat mit seiner fotografischen Handschrift diese Coolness, diese Sexyness adäquat eingefangen!

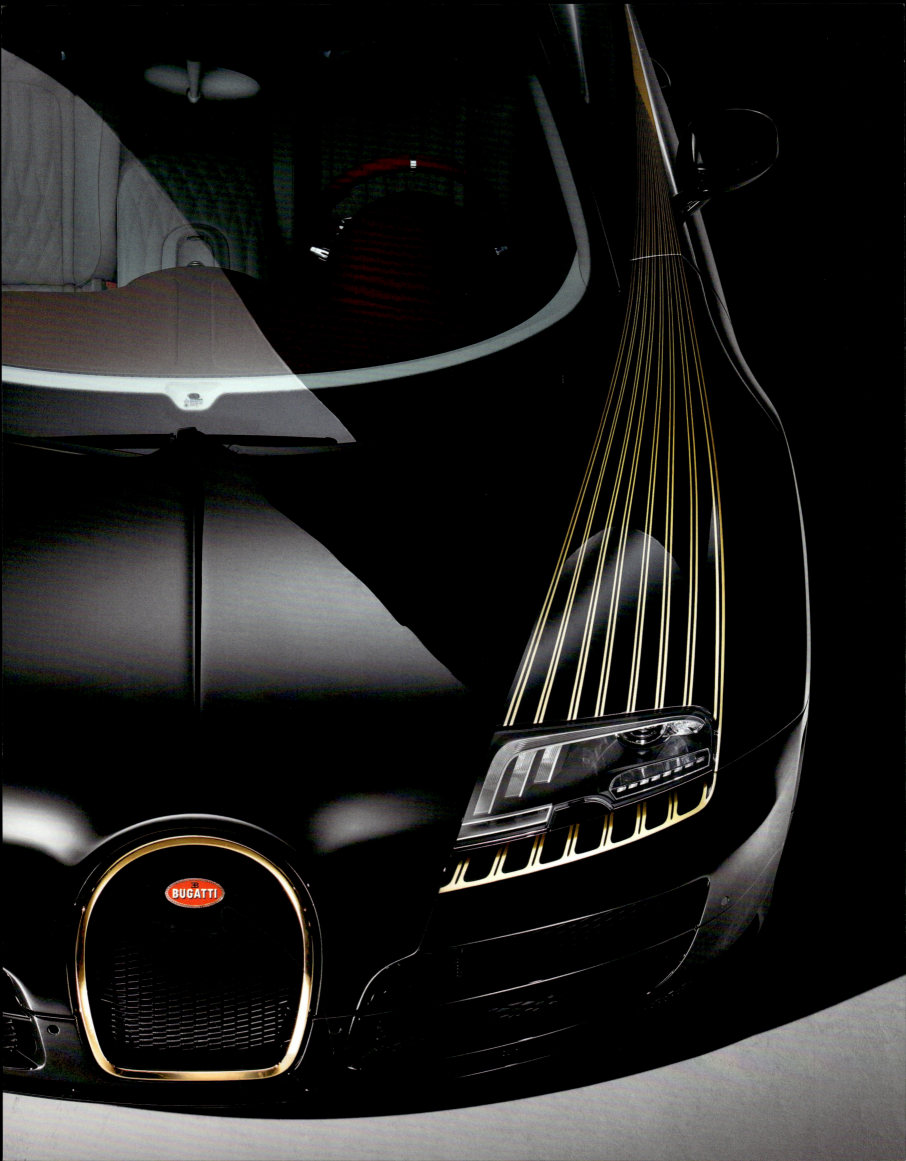

Is black beautiful?

Jürgen Lewandowski

"At some point, all events will cease. And our current understanding of the end of the universe is of a sea of remnant stable particles that expands and thins out more and more slowly." *In his book* Zeit *(Time), this is how Rüdiger Safranski describes not only the end of all time, but also the ideal form of the "color" black. Then the darkness that embodies perfect blackness will reign—but no eye will see it.*

Over the years, as I have been able to look over René Staud's shoulder while he created many of his projects, it became increasingly clear to me that the art of making a black car look great is equal parts *easy* and *complicated*. The *easy* part is because black cars have a natural elegance, because black stands "for both luxury and sportiness," as Mercedes head designer Gorden Wagener put it. But it's also *complicated* because black is not a color, but merely a surface that absorbs all wavelengths of light. Professor Michael W. Ulbig, one of the world's leading experts on the human eye, describes the phenomenon like this: "Black only reflects when it shines—via the smooth surface, the clearcoat or the polish. Matte black, on the other hand, reflects almost nothing at all—which is why the old Rally version of the Opel Kadett had a matte black hood." So you have to work with light to make the aesthetic qualities of the car visible.

It sounds complicated because it is—and once you've seen for yourself how many hours it takes to stage a black car so that the light reflects perfectly on the edges and curves that reveal the car's form, it gives you a new respect for the sheer effort that went into the photographs collected in this book. But let's get back to our fascination with black: this non-color—after all, black is the complete absence of color—is imbued with a wide range of emotions and meaning unlike any other.

Black embodies elegance—the little black dress, the tuxedo, the Hermès Kelly Bag, the Eileen Gray daybed, the black-as-night iPhone. But black also stands for power, self-confidence, and the authority to lead: priests have black robes, as do judges and barristers. Dictators like to wear black—the most evil force in the universe, Darth Vader, wears black from head to toe, providing an optical demonstration of the dark side of power. And there is a fascinating ambivalence: on the one hand, evil chooses, of all things, the non-color black as an identifier, but on the other hand, that choice ensures that it always makes a splashy entrance. If you wear black, you have to step into the light to be seen—in other words, you yourself determine the light, and thus the context in which you wish to be recognized. And last but not least, at least in the Western world, black is the "color" of death and mourning.

Black also offers many projection surfaces—or as Austrian artist Dieter Huber says, "You can find everything in absolute blackness—the complexity of the world and a mirror of your own existence."

And so we come to the art of enveloping this complex "color" in light so that the viewer's eye can recognize and evaluate the beauty, elegance, and sophistication of the automobile hidden underneath. If you look at the *Black Beauties* on the following pages, you will see that René Staud is a master of light, and that his art grants the vehicles their shape, and thus, their very existence.

From the dawn of his career, René Staud emphasized light as a medium—that is what propelled him to fame and why he is so highly regarded. Staud kept working and tinkering with his lighting until he found adequate solutions, and then kept nudging them ever closer to perfection. Lighting something so that people can recognize it for what the designers and engineers wanted it to be—that is his mission. And as a perfectionist, he chose the most difficult and complicated of all colors, the non-color black, to be the standard by which his work is measured.

Looking at the vehicles in this book, you'll see that each one has its own charms—on every model, on every view, your eye will linger on lines, on details. Even the most yawn-inducing car that we would give only a passing glance if it were painted red or yellow, develops a special presence in black with the right lighting, a presence that demands that we pause and look closer. This book is more than another Staud book with excellent photographs—it is a statement about the importance of light in any photographic work. It shows that you can render even a non-existent color perfectly.

selbst bestimmt damit den Kontext, in dem er erkannt werden möchte. Und last, but not least, ist Schwarz auch – zumindest in der westlichen Tradition – die „Farbe" des Todes und der Trauer.

Schwarz bietet also viele Projektionsflächen – oder wie der österreichische Künstler Dieter Huber sagt: „Im absoluten Schwarz findet sich alles – die Komplexität der Welt und ein Spiegel der eigenen Existenz".

Und nun also die Kunst, diese komplexe „Farbe" so in Licht zu hüllen, dass das Auge des Betrachters die Schönheit, die Eleganz und Raffinesse des darunter verborgenen Fahrzeugs erkennen und bewerten kann. Wer die folgenden Seiten mit den *Black Beauties* betrachtet, wird erkennen, dass René Staud ein Meister des Lichts ist, der durch seine Kunst den Fahrzeugen die Form und damit eine Existenz gibt.

Von Beginn seiner Karriere an hat René Staud auf das Medium Licht gesetzt – damit ist er berühmt geworden, deshalb wird er geschätzt. An diesem Thema hat Staud solange getüftelt und gefeilt, bis er adäquate Lösungen gefunden und weiter perfektioniert hatte. Etwas ins Licht setzen, damit es als das erkannt werden kann, was die Designer und Techniker erschaffen wollten – das ist seine Mission. Und als Perfektionist hat er die komplizierteste und schwierigste aller Farben, die Nicht-Farbe Schwarz, als Maßstab seiner Arbeit ausgewählt.

Der Blick über die ausgewählten Fahrzeuge zeigt, dass jedes seine eigenen Reize besitzt – bei jedem Modell, bei jeder Ansicht bleibt das Auge an Linien, an Details hängen. Selbst banale Gefährte, über die unser Auge, wenn sie rot oder gelb lackiert wären, hinweggleiten würde, entwickeln in Schwarz und mit der richtigen Ausleuchtung eine besondere Präsenz, die das Auge zum Innehalten auffordert und zu näherer Betrachtung zwingt. Dieses Buch ist mehr als nur ein weiteres Staud-Buch mit exzellenten Fotografien – es ist ein Statement für die Bedeutung des Lichts bei jeder fotografischen Inszenierung. Es zeigt, dass man auch eine unbunte Farbe perfekt in Szene setzen kann.

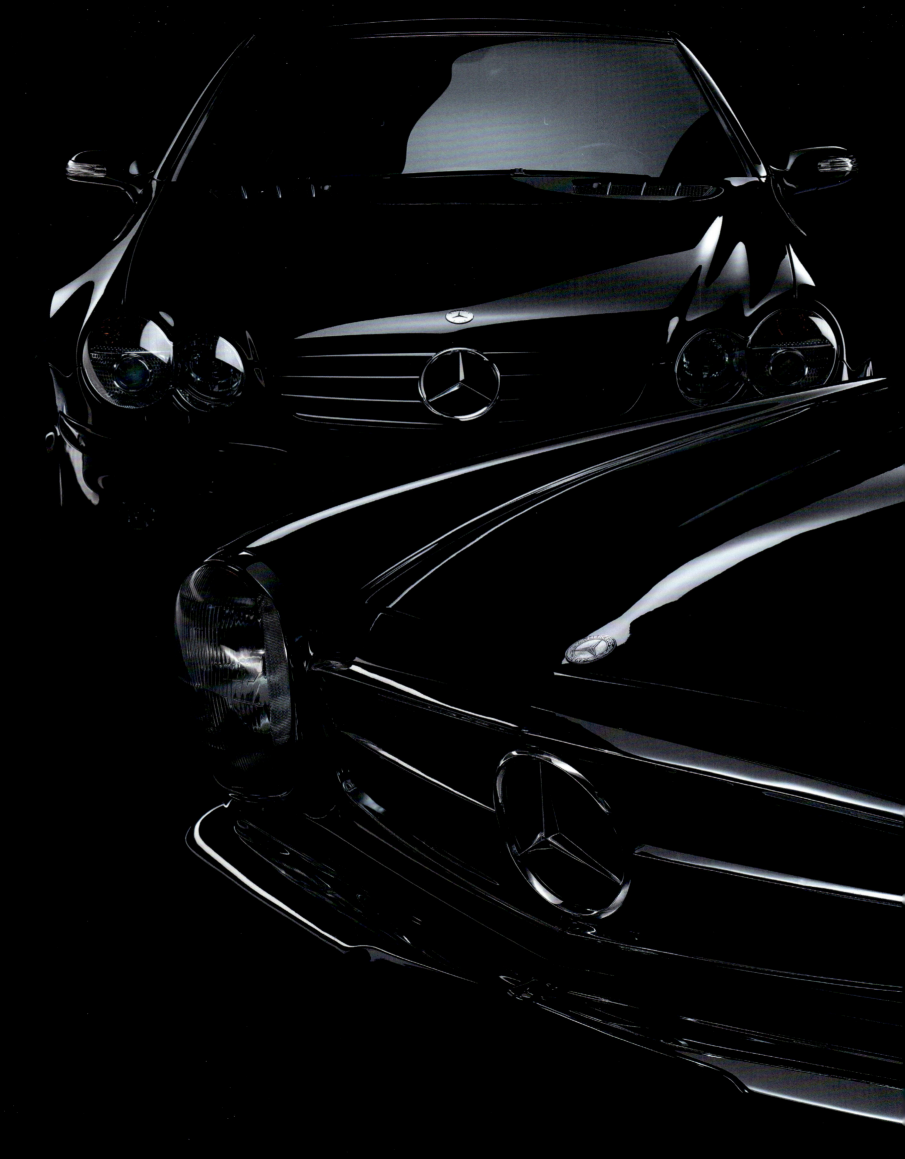

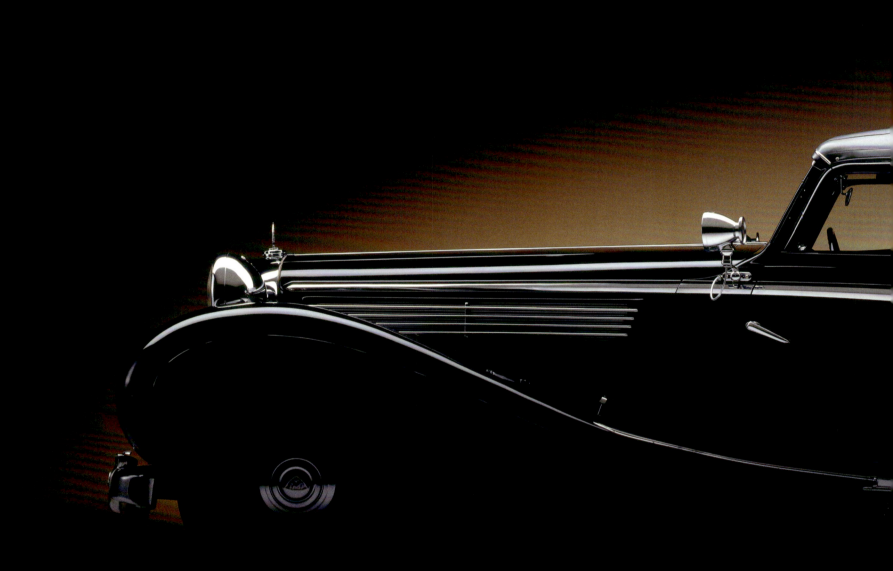

BLACK
HERITAGE

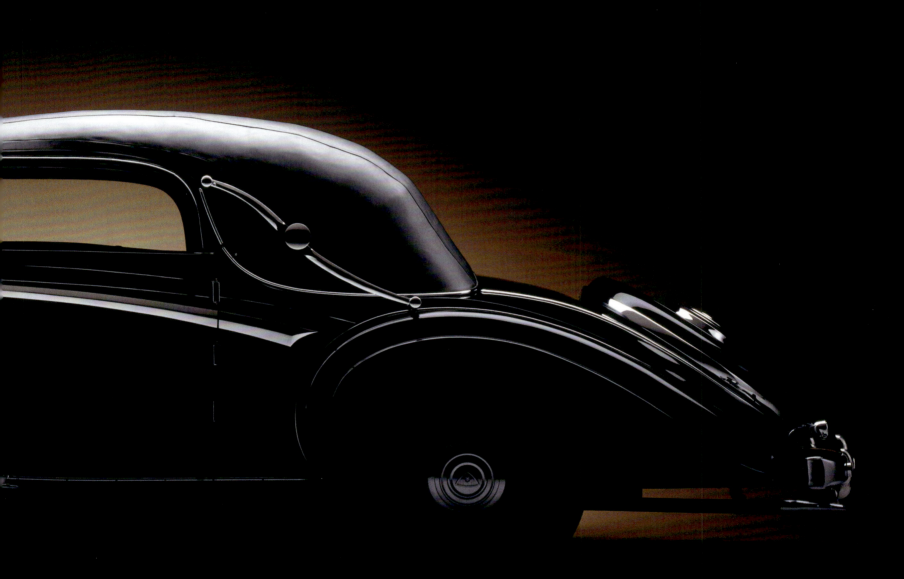

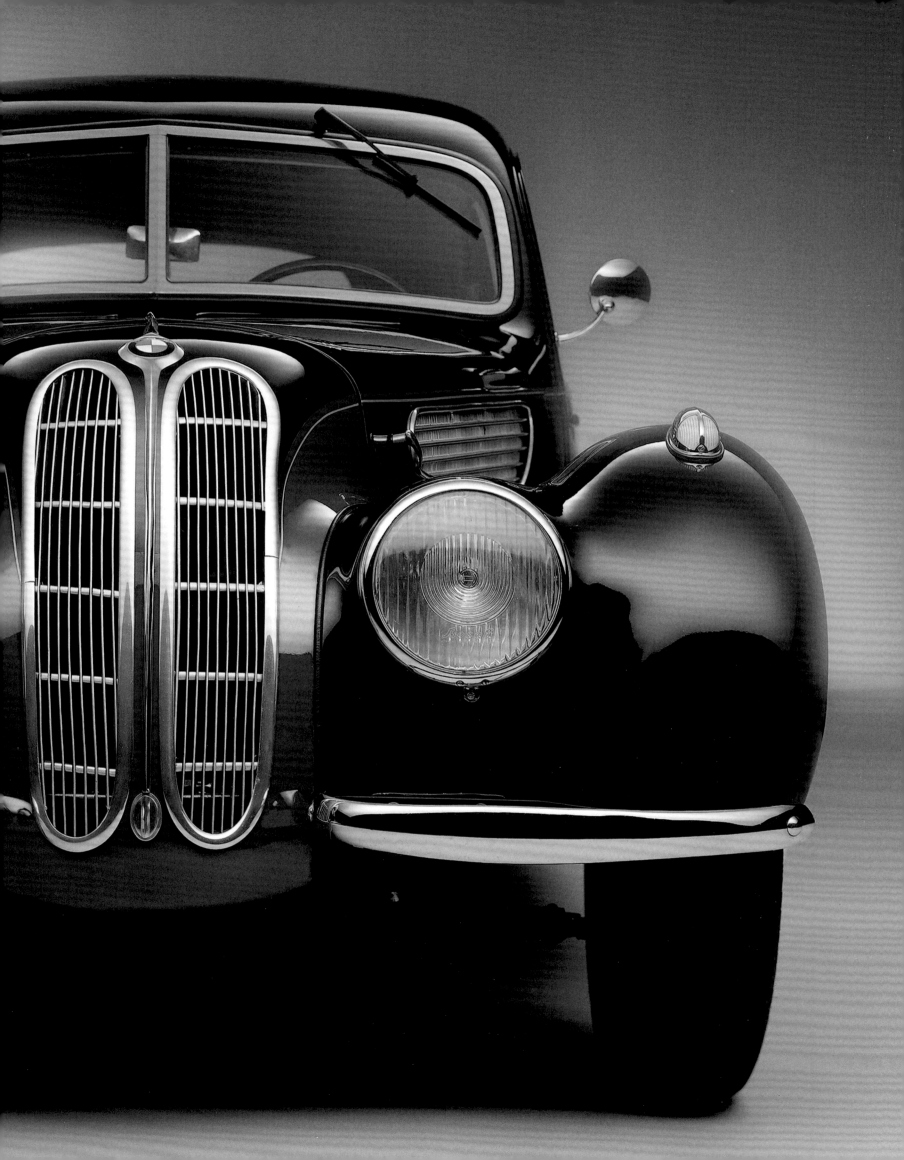

Black has always been the color of authority and power—so it is no wonder that it took until the early 1950s for cars to start appearing in brighter, happier colors. The USA was at the forefront of this trend, where a pink Cadillac even hit the top of the music charts. Of course, white or beige cars were also available until the late 1930s, but black was the dominant color. The prestigious sedans of the day had an almost statesmanlike presence, classics like the Maybach Zeppelin DS 8 or the legendary Mercedes-Benz Kompressor line, whose buyers only occasionally opted for silver or red on even the sportiest models. The rest were painted black.

A look at the following pages will prove that the sportier automotive gems—whether made by Alfa-Romeo, Bugatti, or Bentley—simply look fabulous in the darkest of all available colors. They exude an elegance and dignity that would be wiped out by a brighter hue.

For the 1934 Deutschland-Fahrt (a long race conducted on public roads), Prince Max zu Schaumburg-Lippe ordered a very special 380 Spezial Roadster from Mercedes-Benz with a 144 hp engine and had renowned Berlin coachbuilders Erdmann & Rossi build an extra-light barebones roadster chassis. Max drove this car to a resounding victory—and what color was this one-of-a-kind machine? Black, of course. And even the 1920s experimental Opel RAK 2 rocket-propelled car was black, perhaps to better highlight the blinding light from the igniting rockets?

Heritage is all about remembering history—and the vehicles from this long-ago era do a wonderful job of telling us about the aesthetics and design of that period. And doesn't the inherent aesthetic of these cars come through especially well in black? Bright colors would allow only a fraction of these classic automobiles' elegance to shine through—can you imagine a Maybach SW 38 or Daimler Consort in bright red? That would be an act of sacrilege that would destroy the art and the efforts of the original designers. These creations must be presented discreetly. This is the only way they can speak clearly about their heritage, a gift from a fascinating past.

Schwarz war stets die Farbe der Mächtigen – und so wundert es auch nicht, dass es bis in die frühen 1950er Jahre dauern sollte, bis die Automobile helle, fröhliche Farben erhielten. Allen voran in den USA, wo es der Pink Cadillac sogar bis in die Hitparaden schaffte. Natürlich gab es bis in die späten 1930er Jahre auch weiße oder beige Angebote, doch Schwarz war die dominierende Farbe. Die repräsentativen Limousinen mussten geradezu staatsmännisch auftreten, wie der Maybach Zeppelin DS 8 oder die legendären Mercedes-Benz Kompressor-Modelle, deren Käufer sich auch bei den sportlichsten Varianten nur hin und wieder für Silber oder Rot entscheiden konnten. Der Rest wurde schwarz lackiert.

Der Blick über die folgenden Seiten beweist aber auch, dass die eher sportlichen Preziosen – egal ob aus dem Hause Alfa-Romeo, Bugatti oder Bentley – in der dunkelsten aller verfügbaren Farben einfach gut aussehen. Sie strahlen so eine Eleganz und Würde aus, die von jedem bunten Ton hinweggewischt werden würden.

Für die Deutschland-Fahrt 1934 bestellte sich Prinz Max zu Schaumburg-Lippe bei Mercedes-Benz einen ganz besonderen Typ 380 Spezial Roadster mit einem speziellen Motor mit 144 PS Leistung und brachte das Chassis zu der renommierten Firma Erdmann & Rossi in Berlin, die für den Prinzen eine extra leichte und auf das nötigste reduzierte Roadster-Karosserie schuf. Das Ergebnis war ein überragender Klassensieg – und welche Farbe hatte dieses Unikat? Natürlich schwarz. Und selbst der Opel RAK 2 präsentierte sich in Schwarz. Damit das gleißende Licht der gezündeten Raketen besser zum Tragen kam?

Nun steht der Begriff „Heritage" ja für „Erbe" – und tatsächlich vermitteln die Fahrzeuge aus einer längst dahingegangenen Vergangenheit einen wunderbaren Einblick in die Ästhetik und Formgebung dieser Jahre. Und kommt die eigene Ästhetik nicht gerade bei schwarz lackierten Fahrzeugen besonders gut zur Entfaltung? In bunten Tönen würden diese Gefährte nur Bruchteile ihrer Eleganz preisgeben – oder möchte man sich einen Maybach SW 38 oder einen Daimler Consort in Knallrot ansehen? Das wäre ein Sakrileg, das die Kunst und die Anstrengungen der damaligen Formgestalter fraglos zerstören würde. Diese Schöpfungen müssen diskret präsentiert werden. Nur so können sie formvollendet von der Heritage, dem Erbe einer faszinierenden Zeit erzählen.

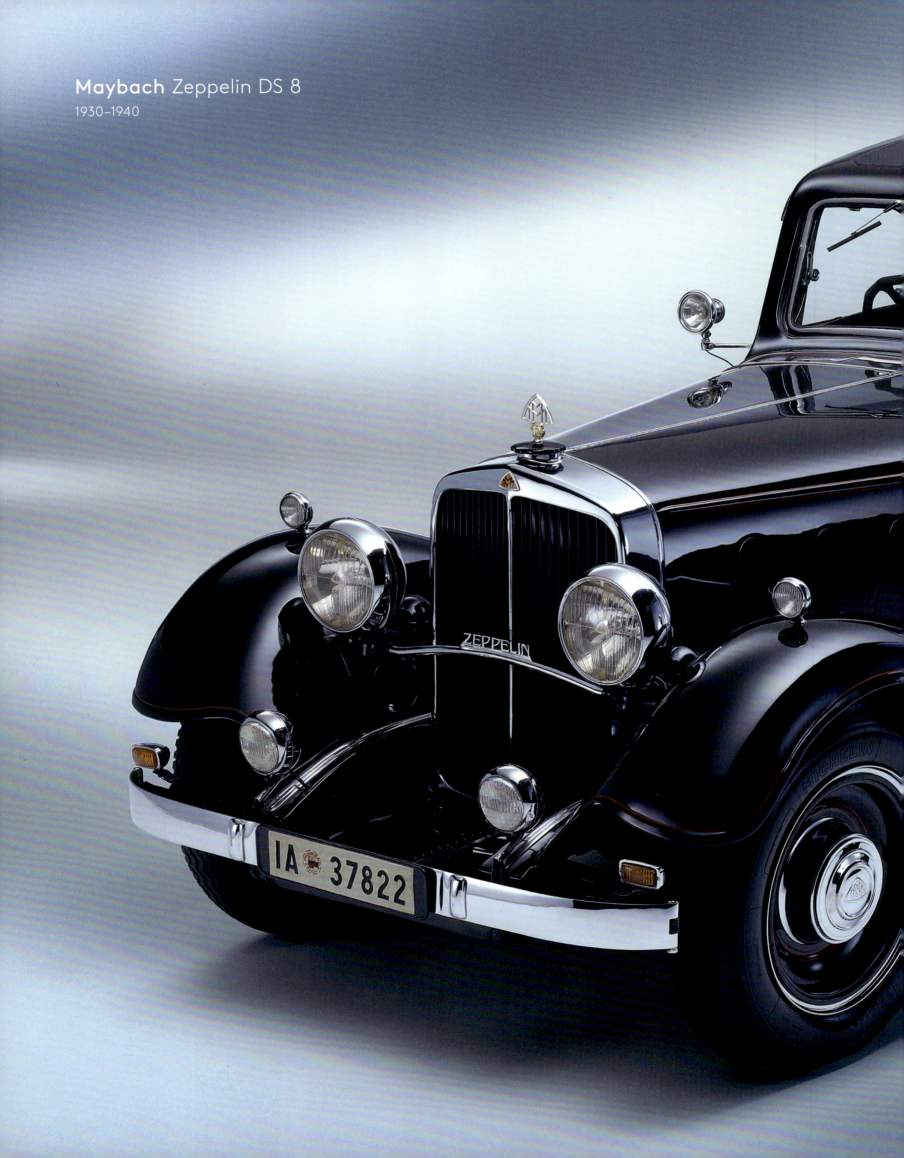

Maybach Zeppelin DS 8
1930–1940

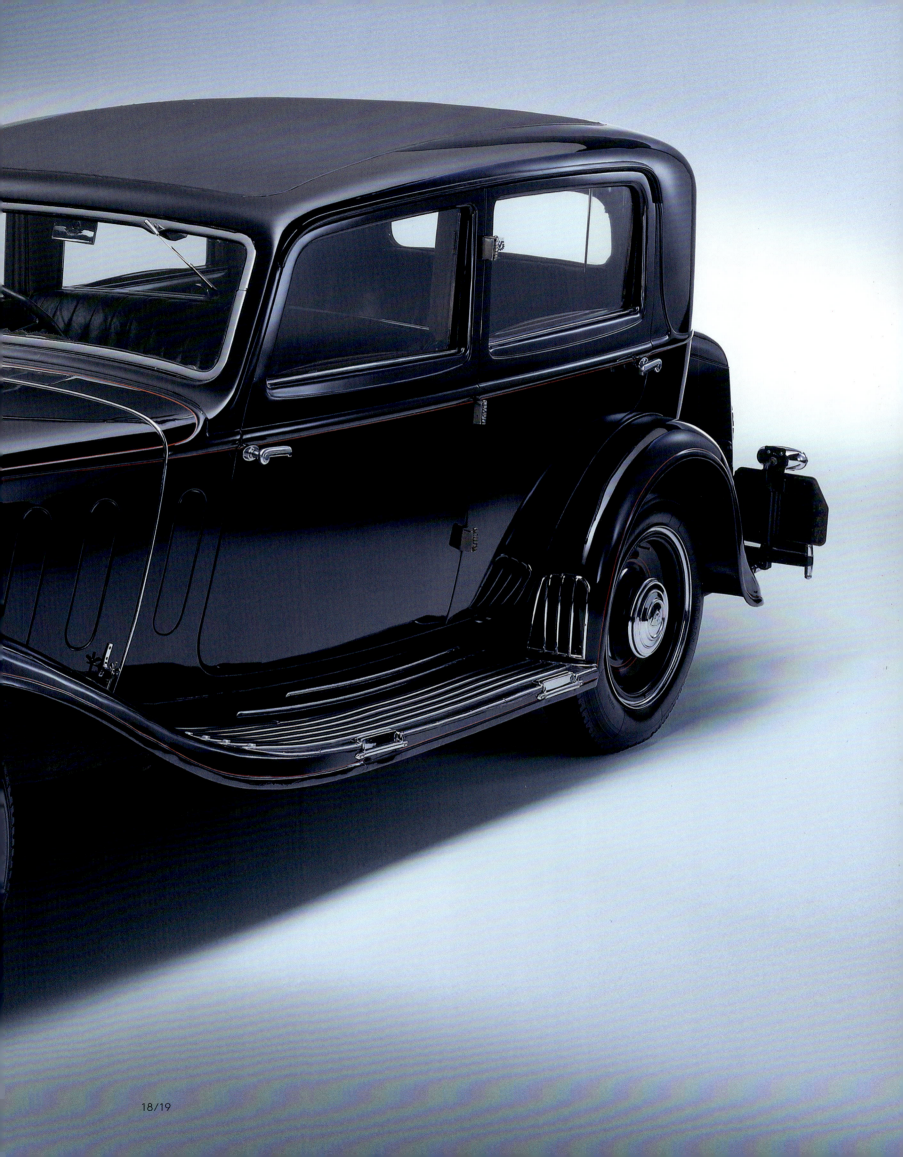

Adler Trumpf
1932–1938

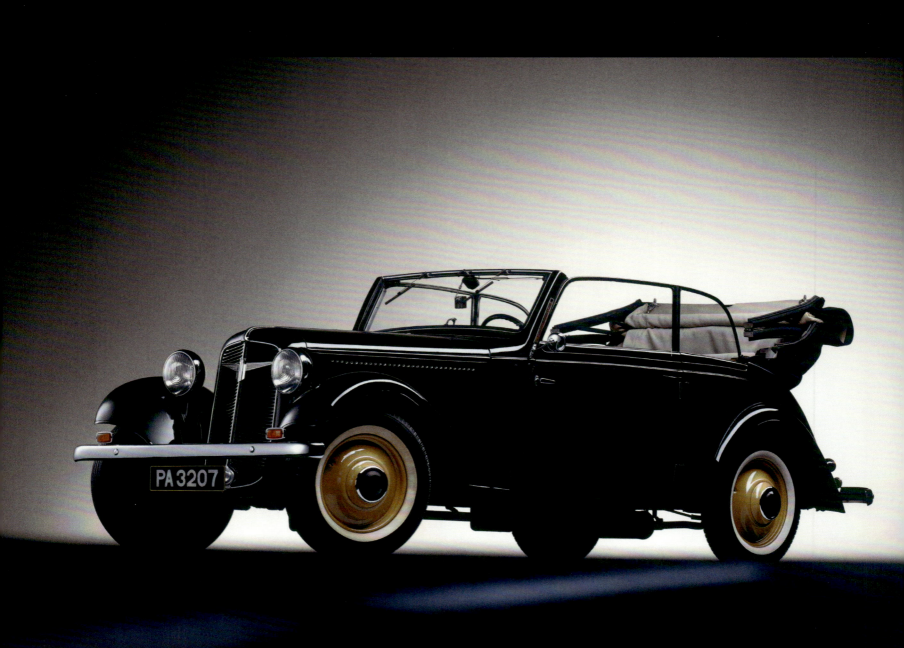

Bugatti Type 50
1931–1933

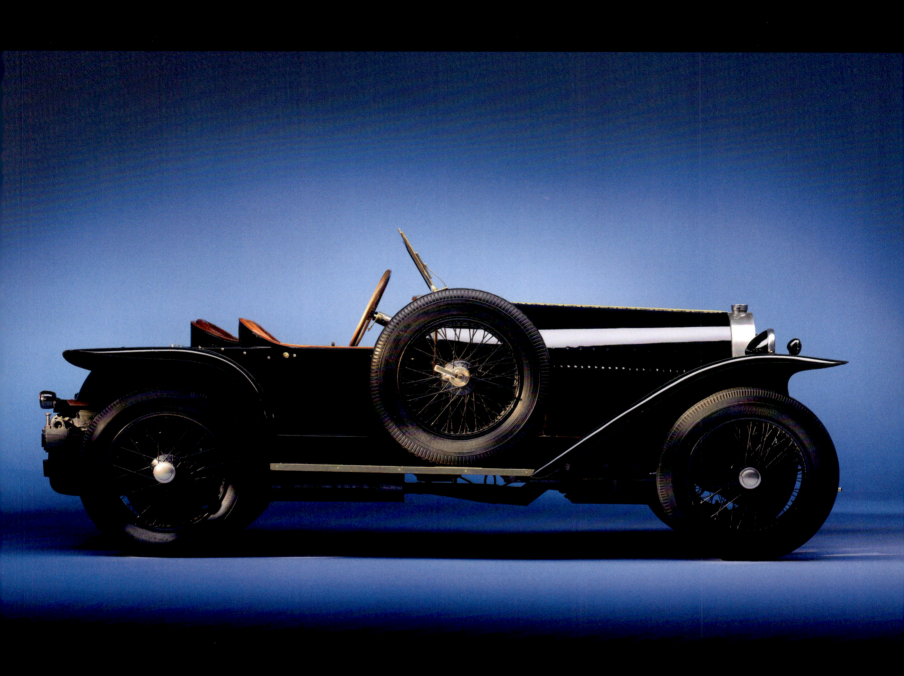

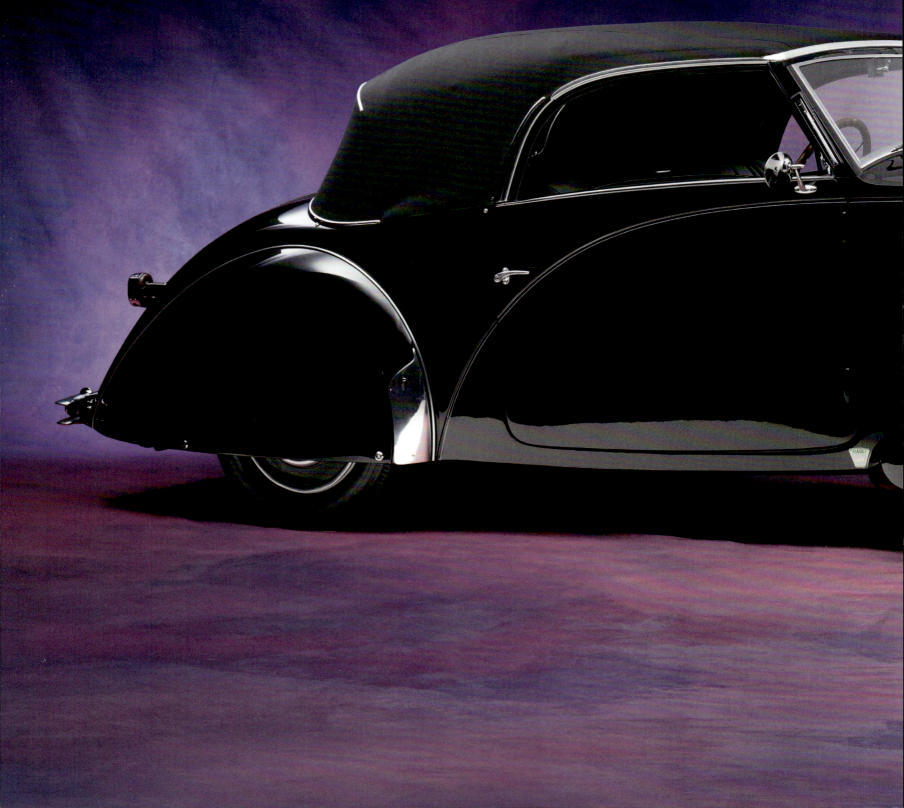

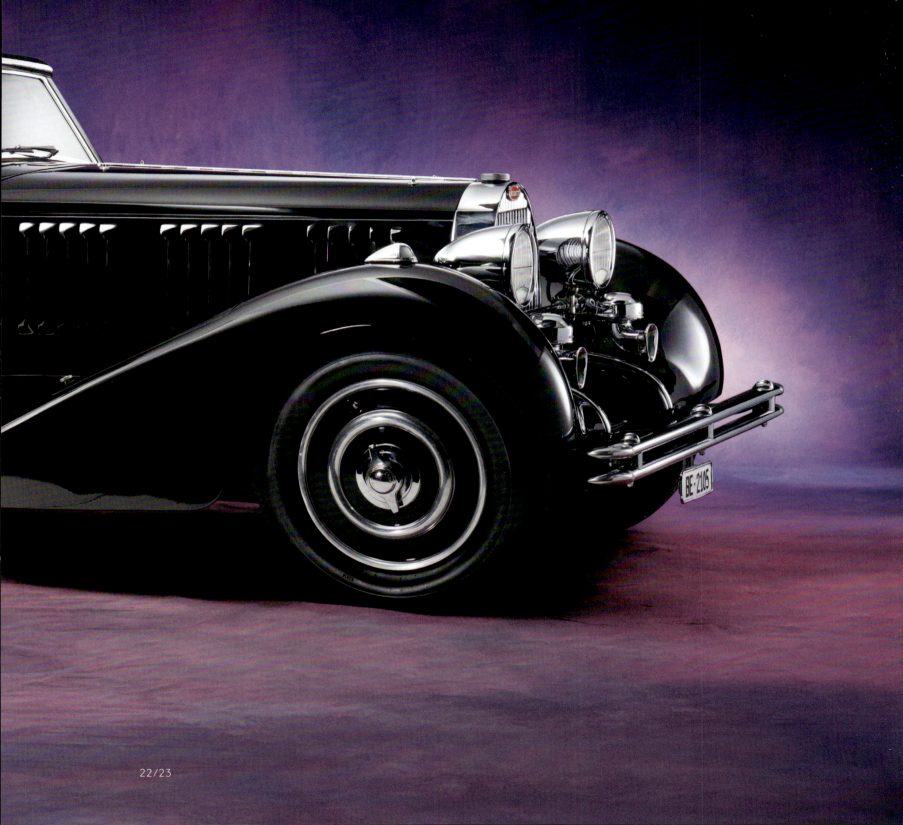

BMW 309
1934–1936

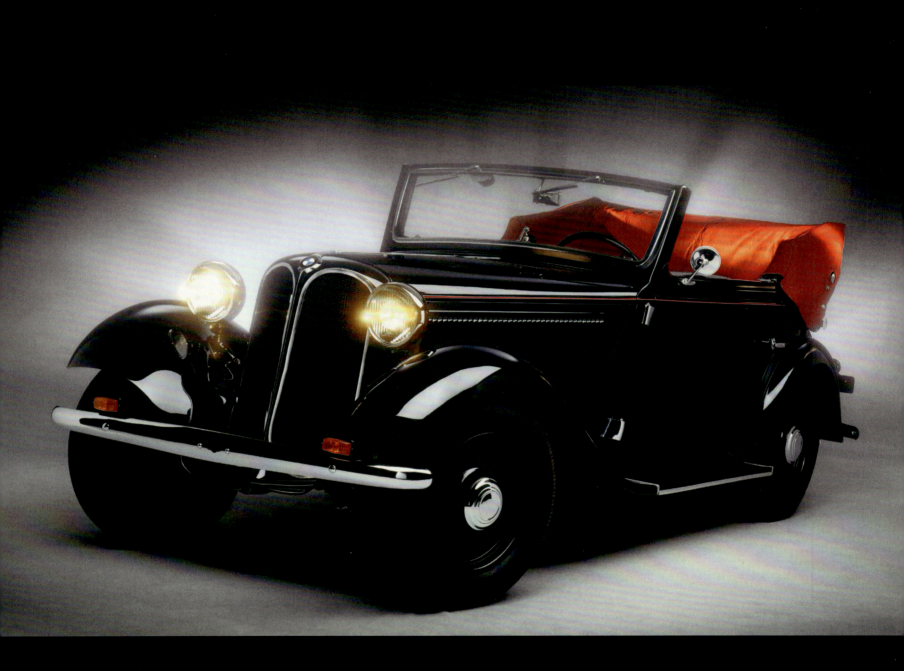

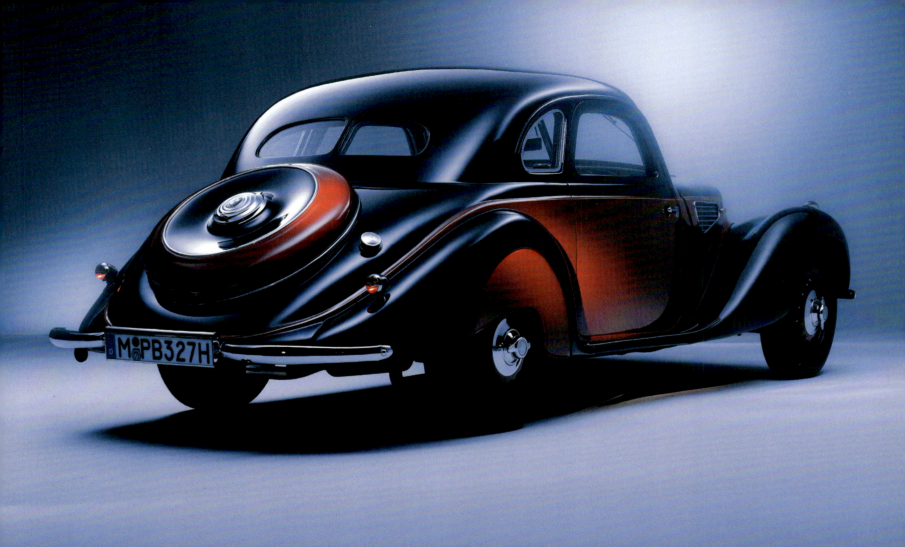

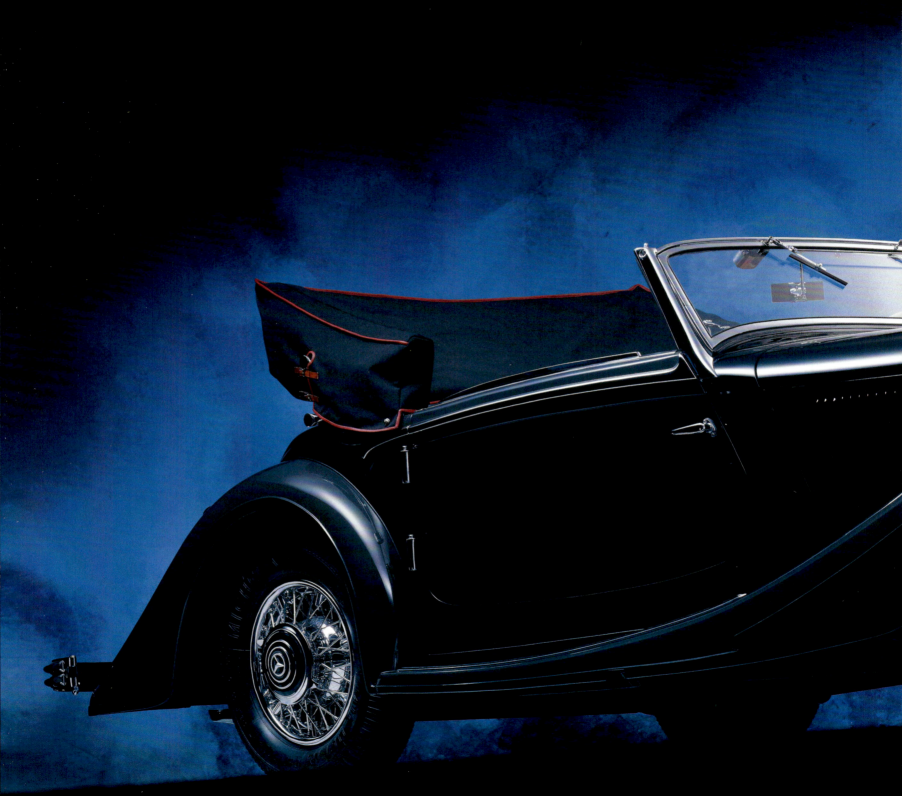

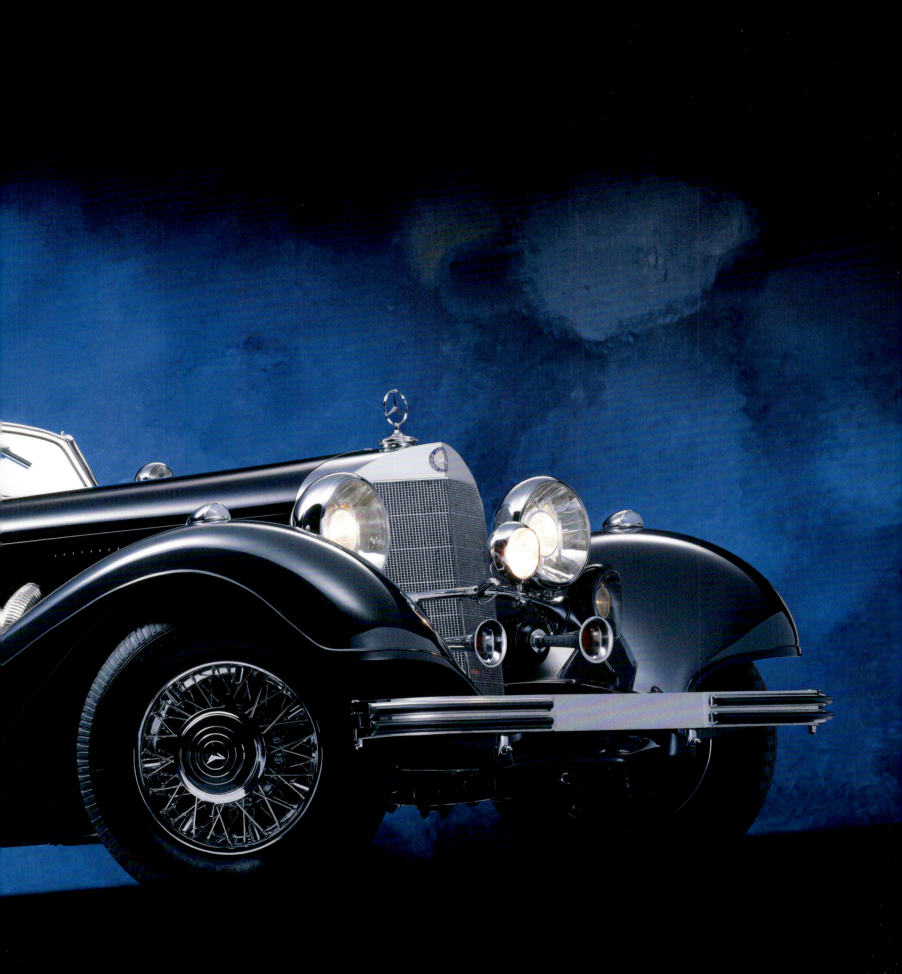

Mercedes-Benz 540 K
1936–1939

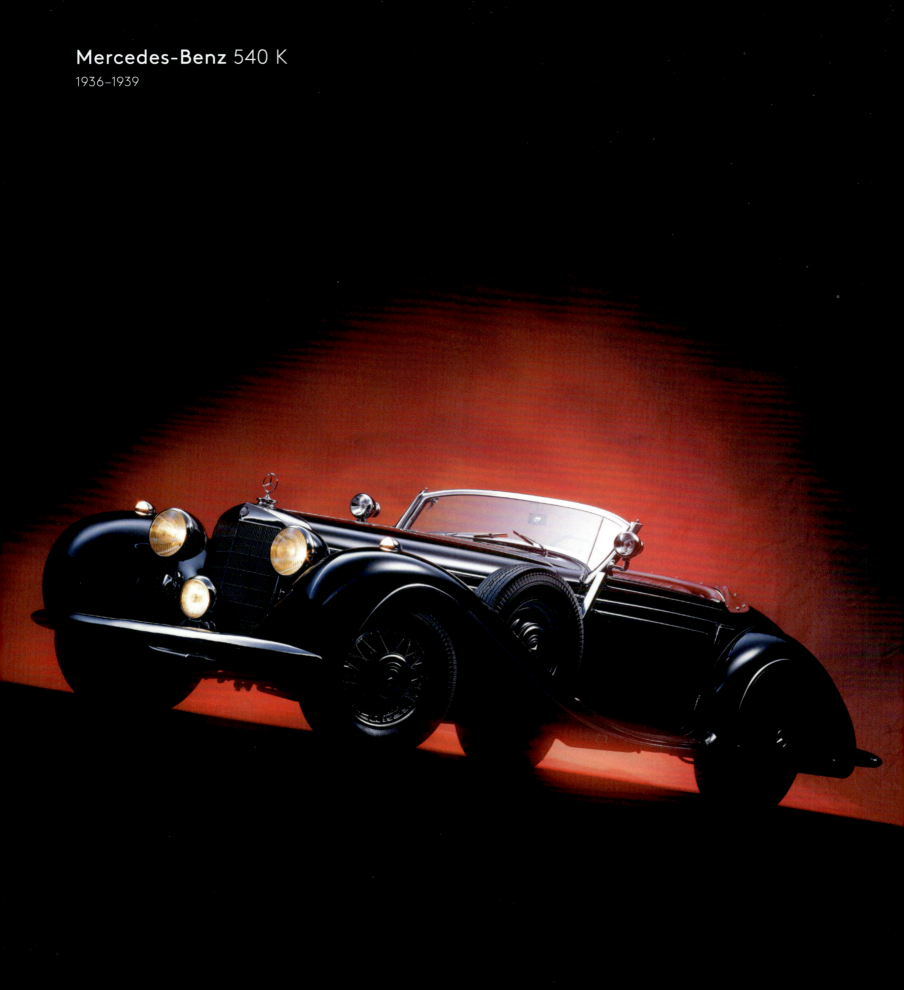

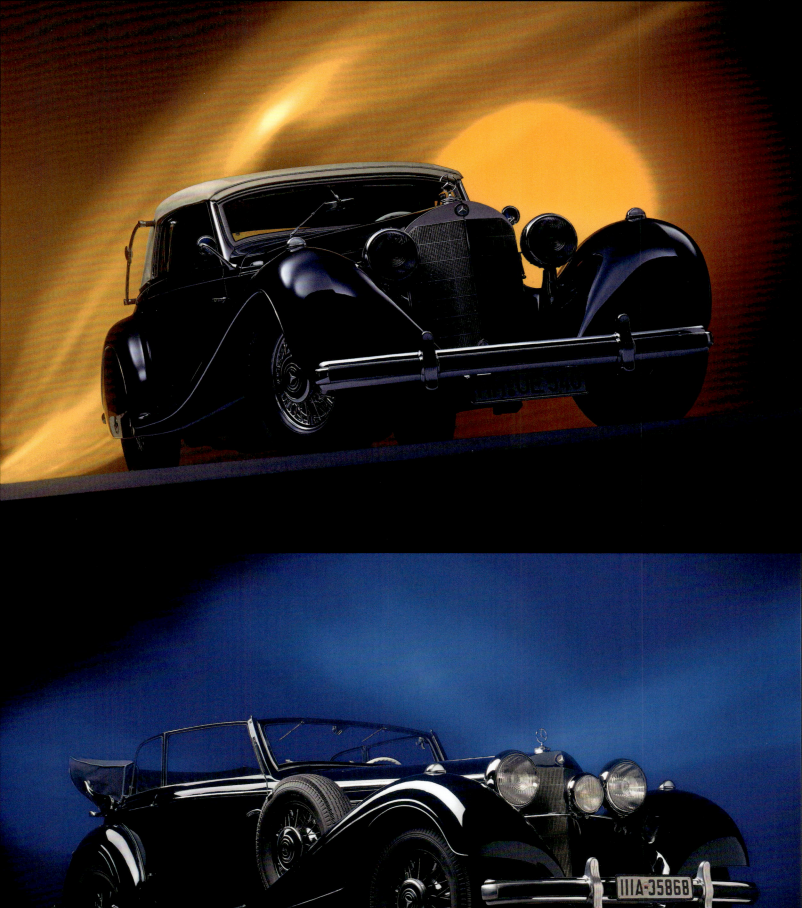

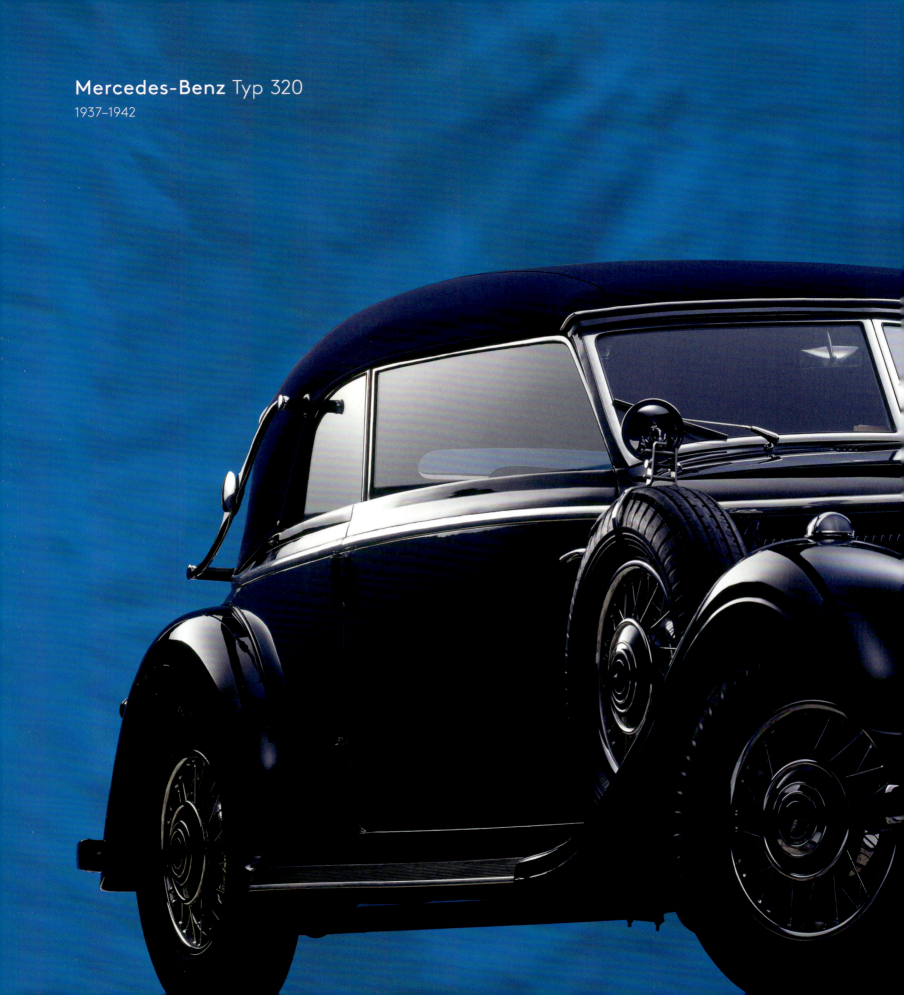

Mercedes-Benz Typ 320
1937–1942

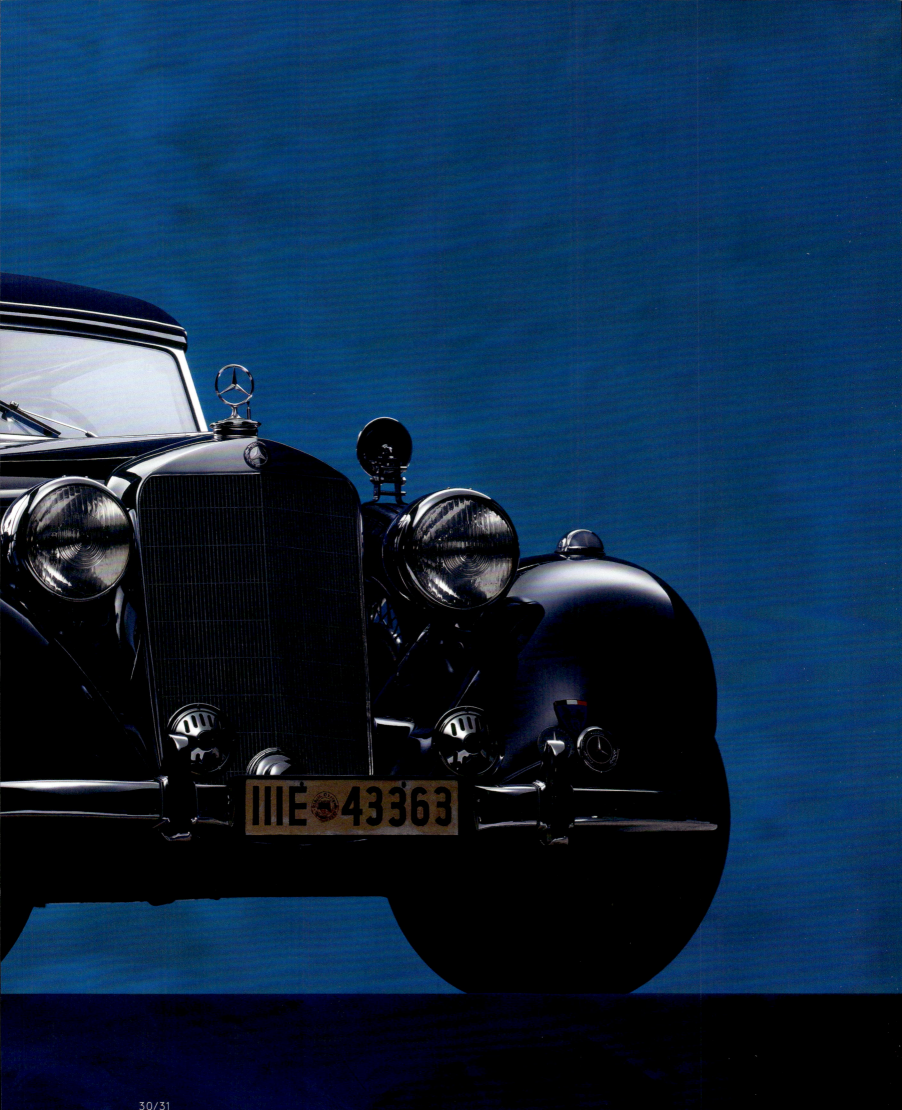

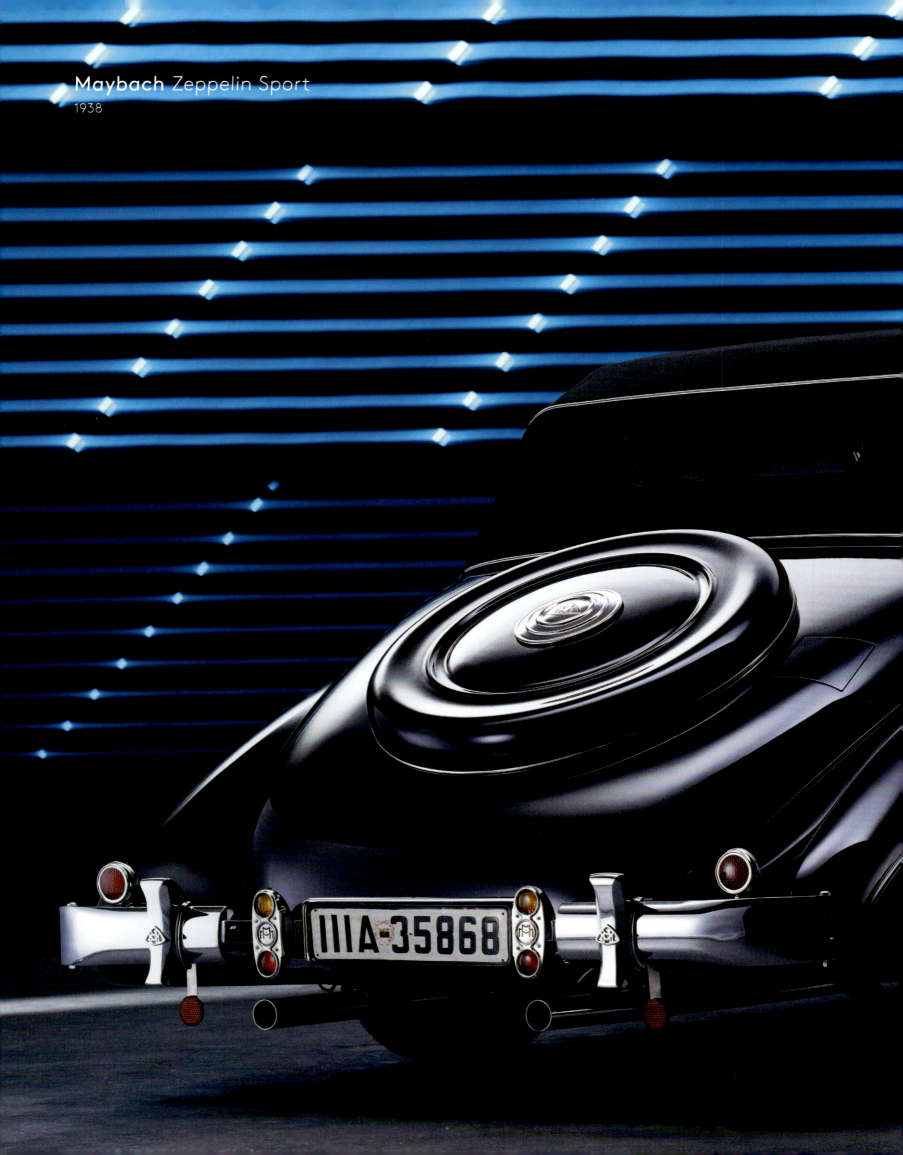

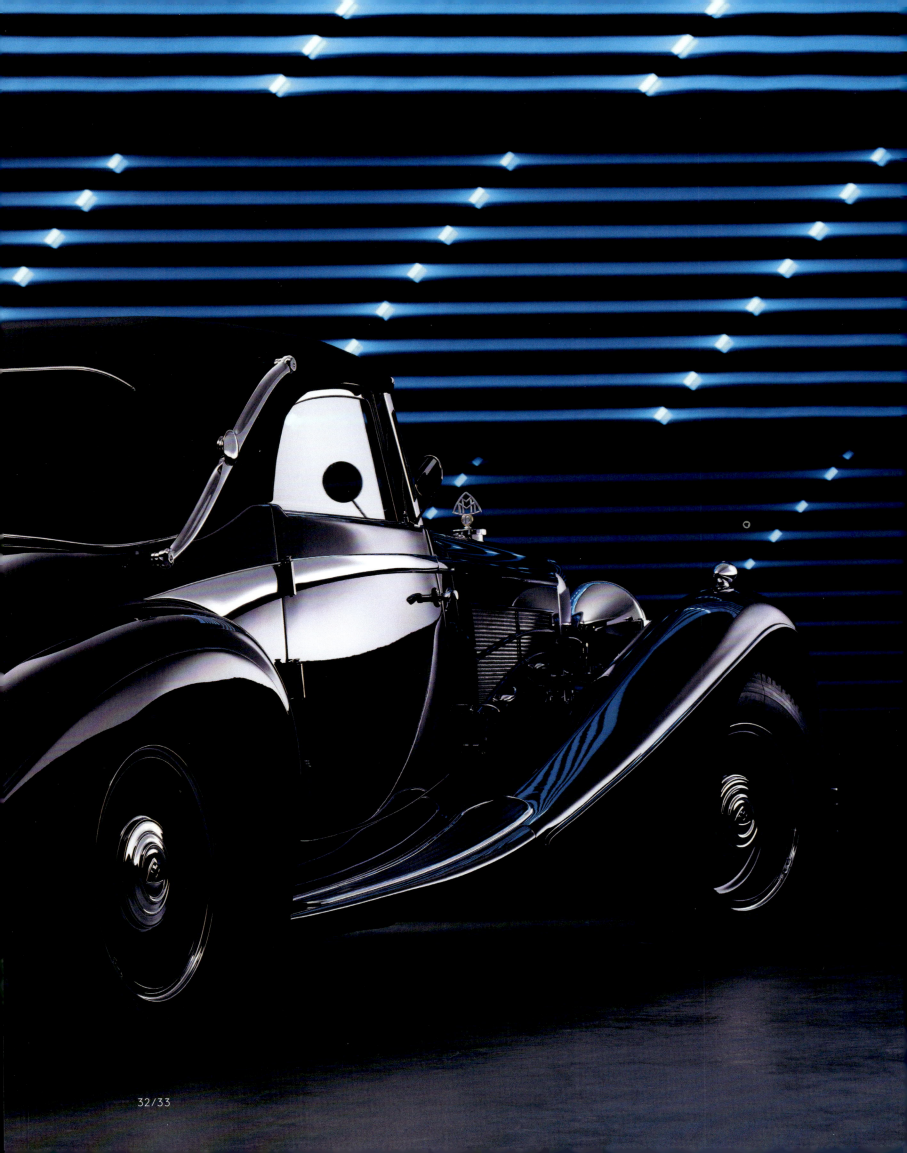

Bugatti Type 50
1931–1935

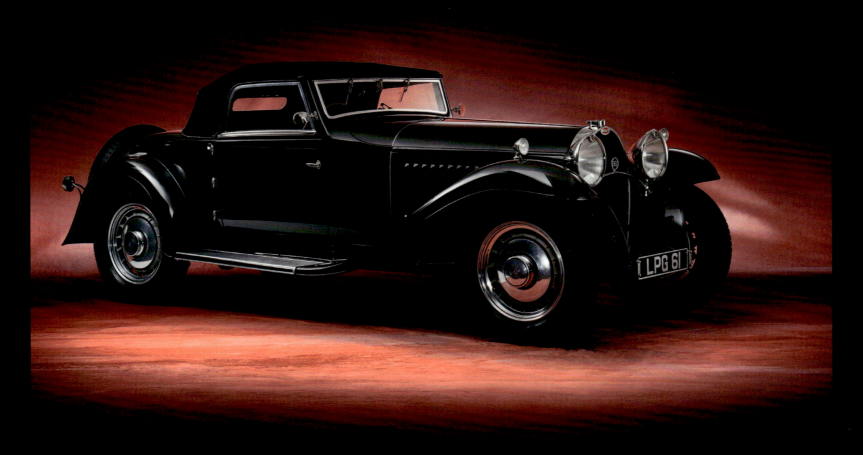

Alfa Romeo 8C 2300
1931–1939

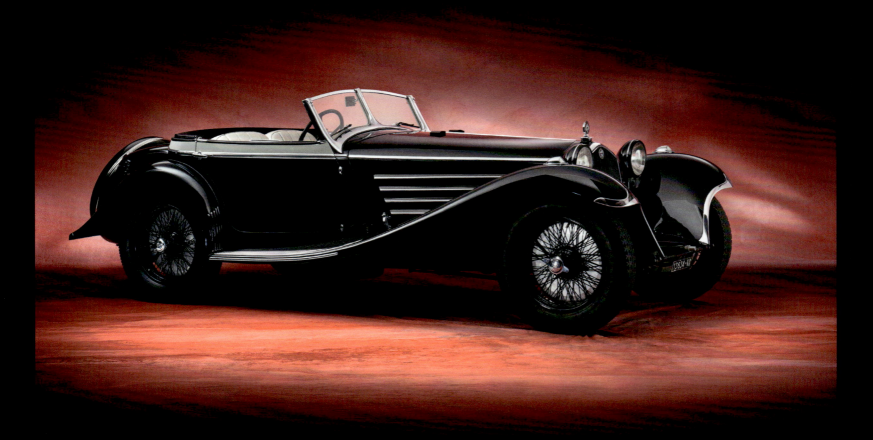

Mercedes-Benz 380 Spezial Roadster
1933

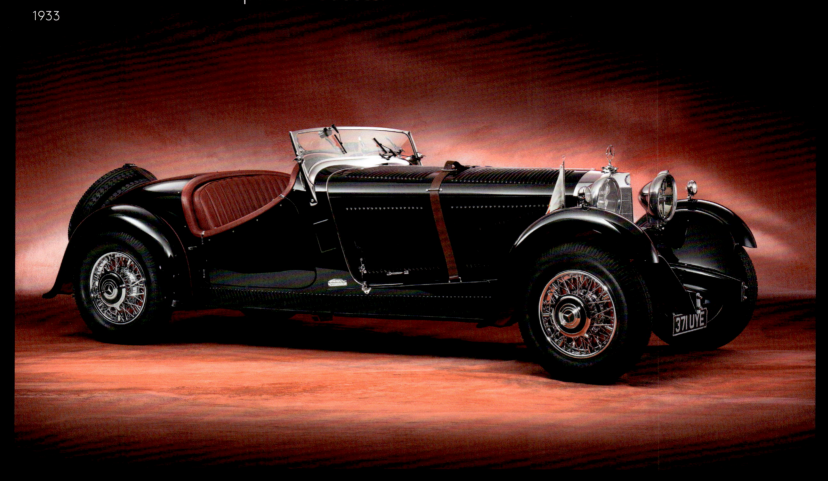

Skoda Popular Sport Monte Carlo
1935

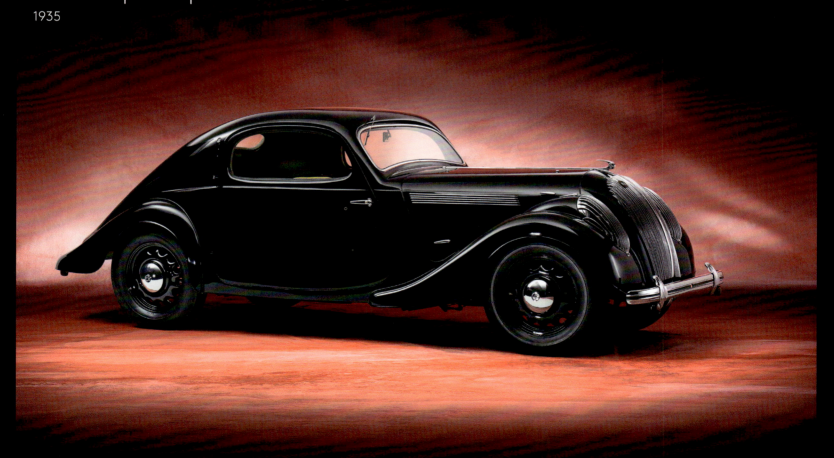

BLACK IS A GREAT COLOR!

Mark Gutjahr, Head of Design, BASF Coatings Europe

Currently, every fifth new car registered in Europe is black [BASF European Color Report for Automotive OEM Coatings 2015]. And black isn't even considered one of the traditional "favorite" colors (Really, would *you* say black is your favorite color?). In many cultures, black is the color of mourning, of evil, of power. And black is the absence of light—dark, enigmatic, scary. So why have so many car buyers, for so long, kept picking a color that is associated primarily with negative things?

What is it about a black car that people find so fascinating? First, black is a very traditional automotive color (hello, Henry Ford!). It makes cars look bigger, adds visual weight, makes them blocky and massive. The contours are blurred, and the outline disappears. But black also has an amazing shine to it that reflects the light in a mysterious way, like the coat of Black Beauty: spirited, yet classy—a successful, timeless combination in automotive history!

Other reasons seem terribly banal by comparison: black paint is cheaper (so there's money left over for a killer stereo system), automotive black is surprisingly unemotional (you don't really see much of the design), black cars are supposedly a snap to resell (fleet and aftermarket)—especially when the dealer specifically recommends it. And cars for official use are almost always black.

On the other hand, black is generally unmatched as a tip-off for luxury: black is endlessly sophisticated, elegant, and expensive. Black diamonds are rare, deep black silk is the archetype of ultimate luxury—and black, polished urushi lacquer represents the earliest painting techniques from thousands of years ago. Black is also the ultimate companion: any bright color can be combined with black—which only highlights it and makes it look even more refined!

But the fact that this color has been so popular for so long means that it is undergoing constant change. State cars are becoming a thing of the past: today's parliamentary representatives would rather bike to work. In other countries, under other systems, almost no one wants to openly admit a connection to the state apparatus. And a lot of mass almost always means terrible gas mileage.

No other automotive color is subjected to this level of tension and back-and-forth—so black must constantly reinvent and transform itself, opening up a whole new field of design and development. Will new surfaces completely absorb the light? Can we play with light to create effects that make the car look light and dainty? How will new black production colors look from maker to maker and model to model? There's a lot of change afoot—and black is a great color!

SCHWARZ IST EINE TOLLE FARBE!

Mark Gutjahr, Leiter Design, BASF Coatings Europe

Aktuell wird jedes fünfte in Europa neu zugelassene Auto in Schwarz ausgeliefert [BASF European Color Report for Automotive OEM Coatings 2015]. Und dabei zählt Schwarz nicht zu den klassischen Lieblingsfarben (oder würden Sie Schwarz als Ihre Lieblingsfarbe bezeichnen?). Schwarz steht in vielen Kulturen für Trauer, für das Böse, für Macht. Und Schwarz ist die Abwesenheit von Licht – dunkel, geheimnisvoll, beängstigend. Warum entscheiden sich dennoch seit Jahrzehnten so viele Autokäufer für eine Farbe, die vor allem mit negativen Adjektiven belegt ist?

Was macht die Faszination schwarzer Farbe auf einem Automobil aus? Zuerst ist die Farbe eine sehr klassische automobile Farbe, Herr Ford lässt grüßen. Sie lässt Autos größer erscheinen, macht sie visuell schwerer, massig und massiv. Die Konturen verwischen, die Zeichnung wird gelöscht. Schwarz hat aber auch den besonderen Glanz, der Klarlack reflektiert das Licht geheimnisvoll wie das Fell von Black Beauty: rassig mit Klasse – eine erfolgreiche, zeitlose Kombination in der Automobilgeschichte!

Mancher Grund scheint dagegen sehr banal: Schwarz wird günstig angeboten (da bleibt noch Platz im Budget für eine gute Soundanlage), automobiles Schwarz ist erstaunlich unemotional (man sieht ja auch wenig von der gestalteten Form), schwarze Autos lassen sich angeblich super wiederverkaufen (Flotten- und Second Market) – vor allem wenn der Händler dies ausdrücklich empfiehlt. Und offiziell genutzte Autos sind fast immer schwarz.

Gegenteilig steht Schwarz generell ganz oben im Konzert des Luxus: Schwarz ist unendlich edel, elegant und teuer. Schwarze Diamanten sind selten, tiefdunkle schwarze Seide ist der Inbegriff eines ultimativen Luxus – und schwarzer, polierter Urushi-Lack ist der Beginn der Lacktechnik vor tausenden Jahren. Schwarz ist zudem der ultimative Begleiter: Jeder Buntton kann mit Schwarz kombiniert werden – und wird somit unterstützt und veredelt!

Doch gerade eine Farbe, die so sehr im Gebrauch verankert ist, durchlebt einen kontinuierlichen Wandel: Staatskarossen haben immer mehr ausgedient; wenn möglich, fahren Abgeordnete mit dem Fahrrad zur Arbeit. In anderen Ländern und Systemen möchte kaum noch jemand mit dem Staatsapparat in Verbindung gebracht werden. Eine große Masse wird fast automatisch mit hohem Verbrauch gleichgesetzt.

In diesem Spannungsfeld befindet sich keine andere automobile Farbe – und so muss sich Schwarz immer neu erfinden und wandeln: Ein wunderbares Feld der Gestaltung und Entwicklung öffnet sich – werden die neuen Oberflächen künftig das Licht komplett absorbieren? Heben Effekte im Spiel mit Licht die Massigkeit auf? Wie sehen neue schwarze Serienfarben je Marke und Modell aus?

Es ist viel im Wandel – und: Schwarz ist eine tolle Farbe!

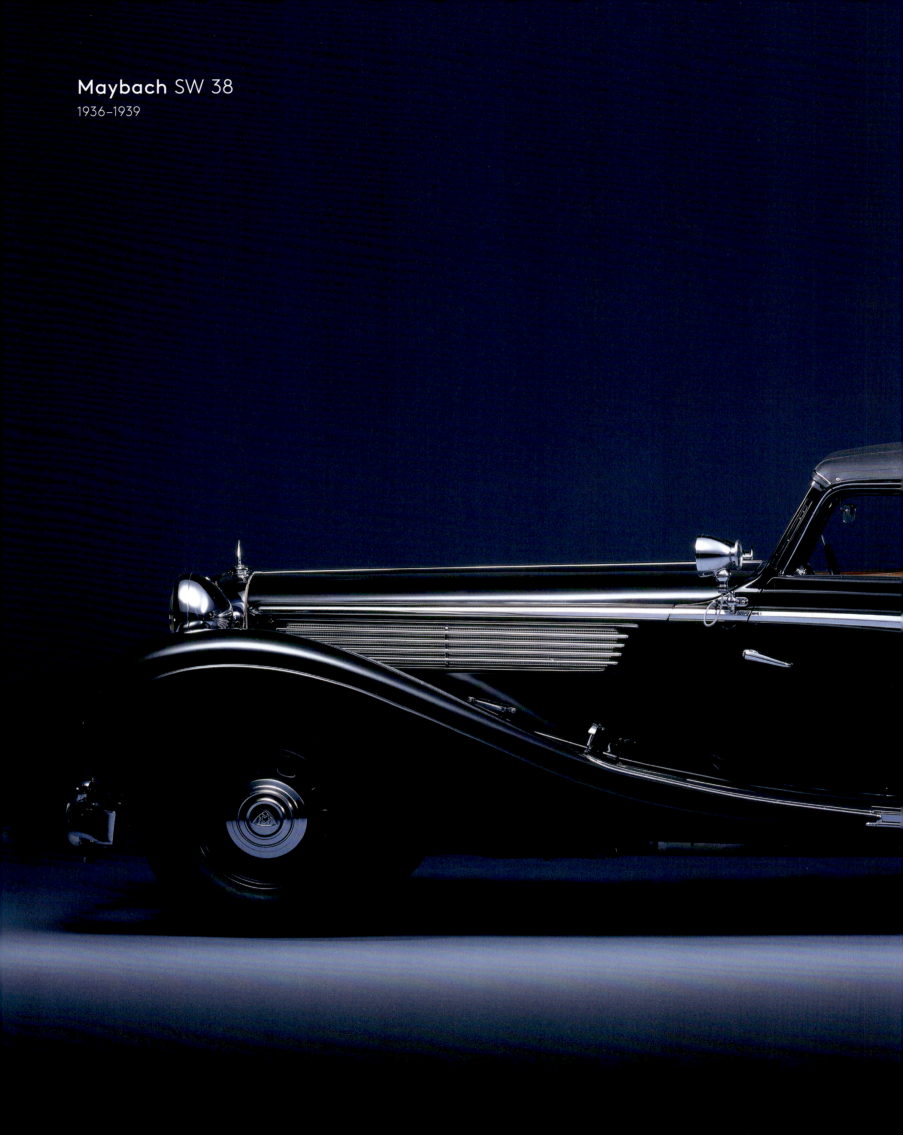

Maybach SW 38
1936–1939

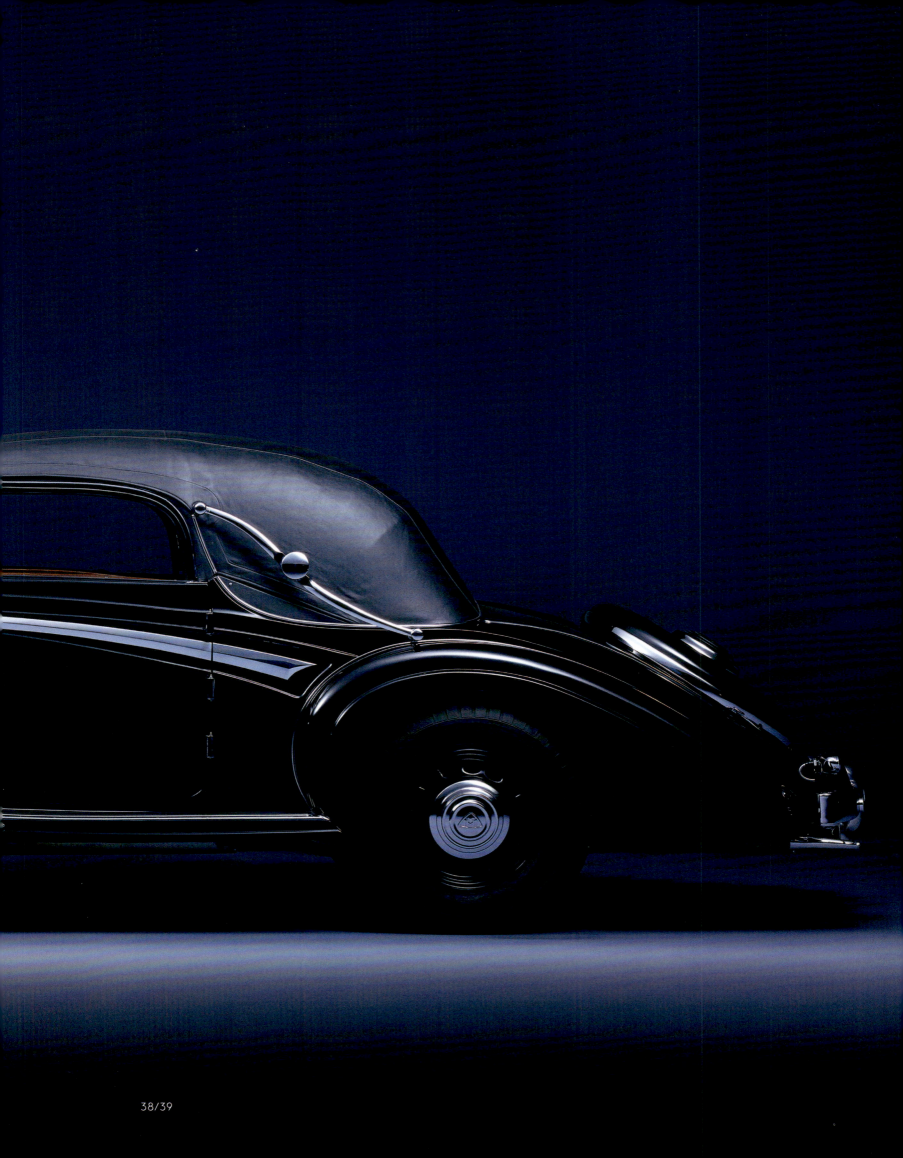

Alfa Romeo 8C 2300
1931–1939

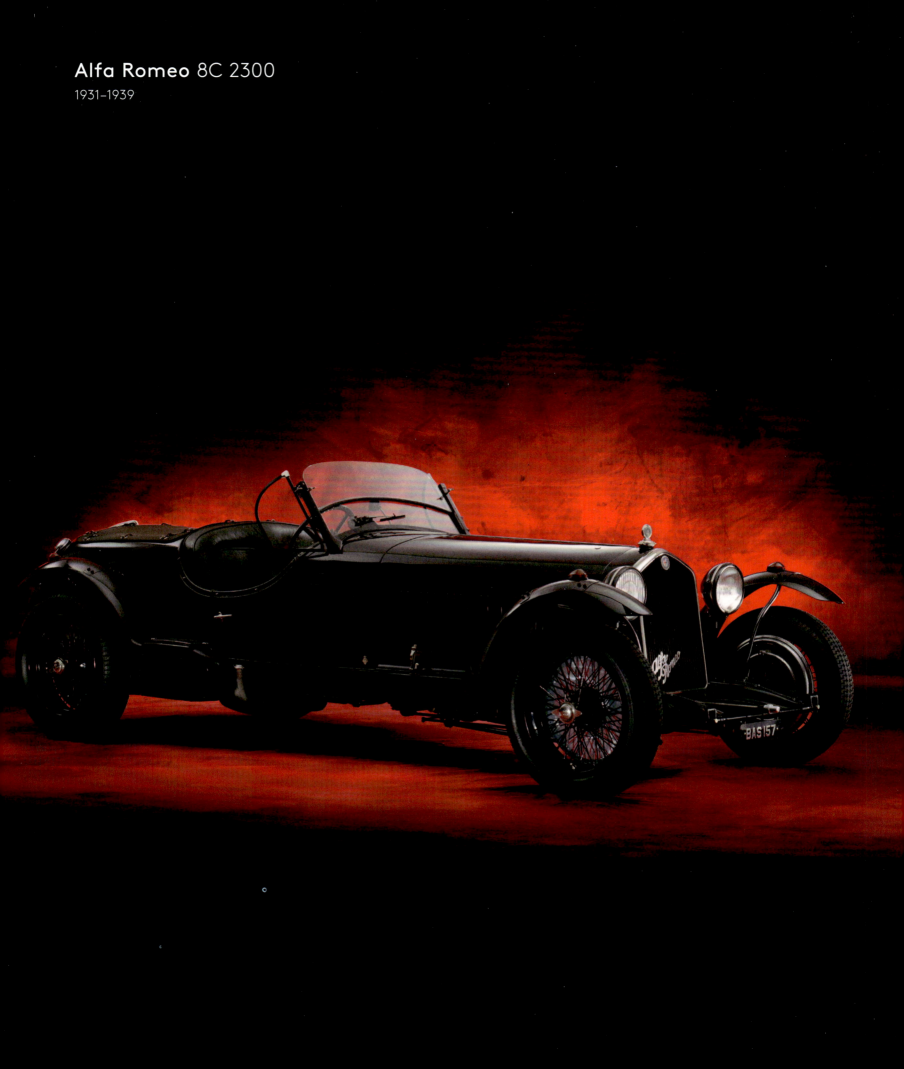

Alfa Romeo 8C Competizione
2007–2010

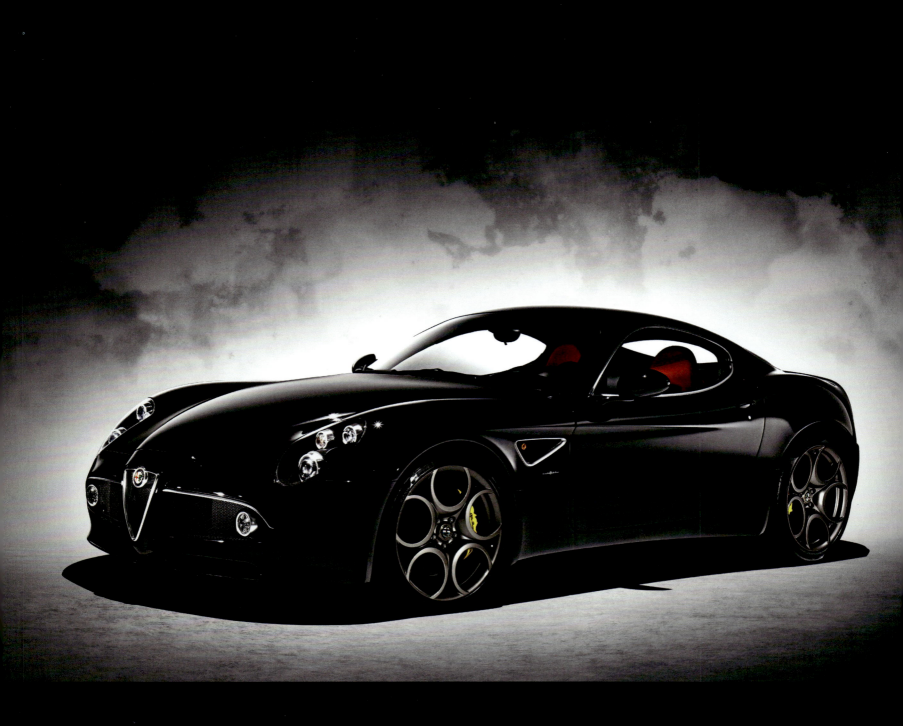

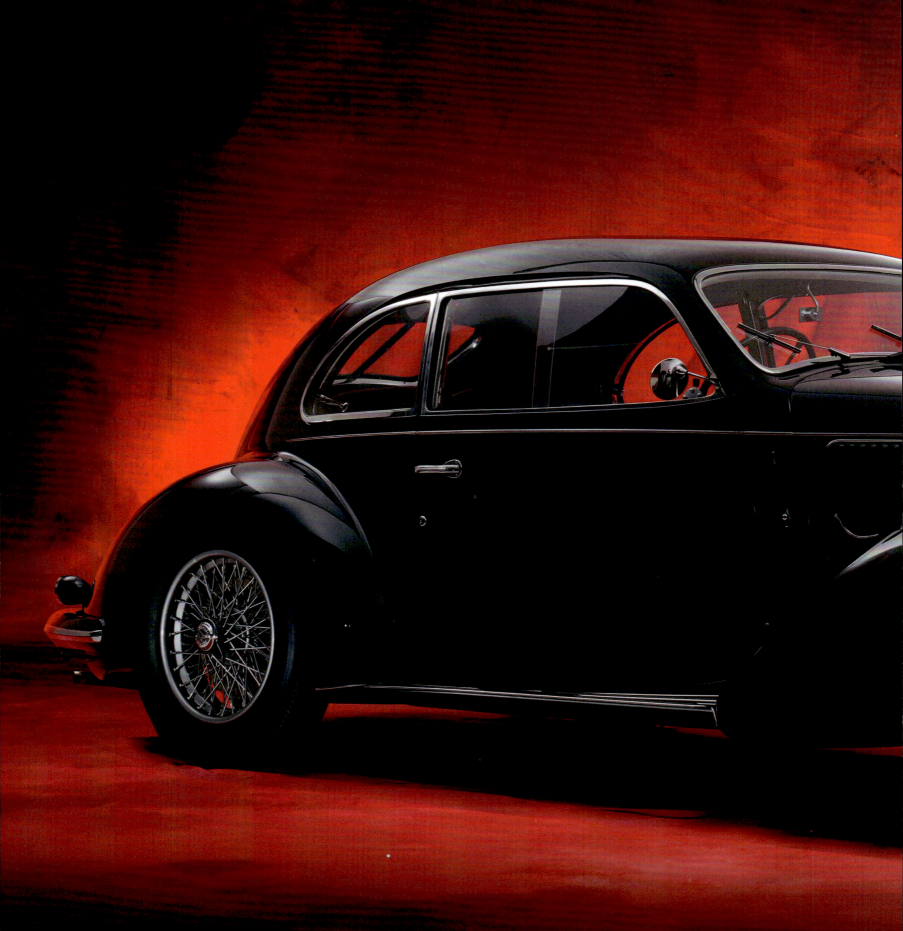

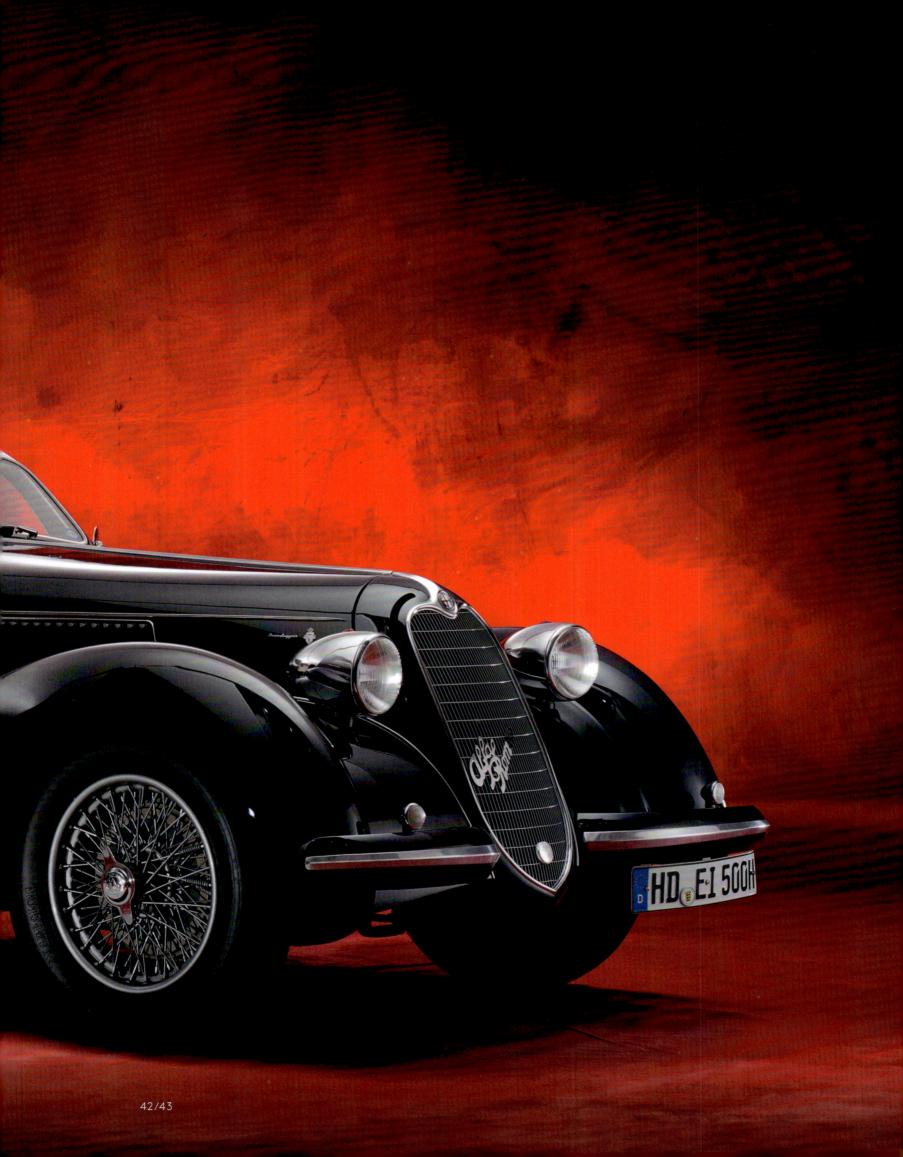

Daimler Consort

1939–1953

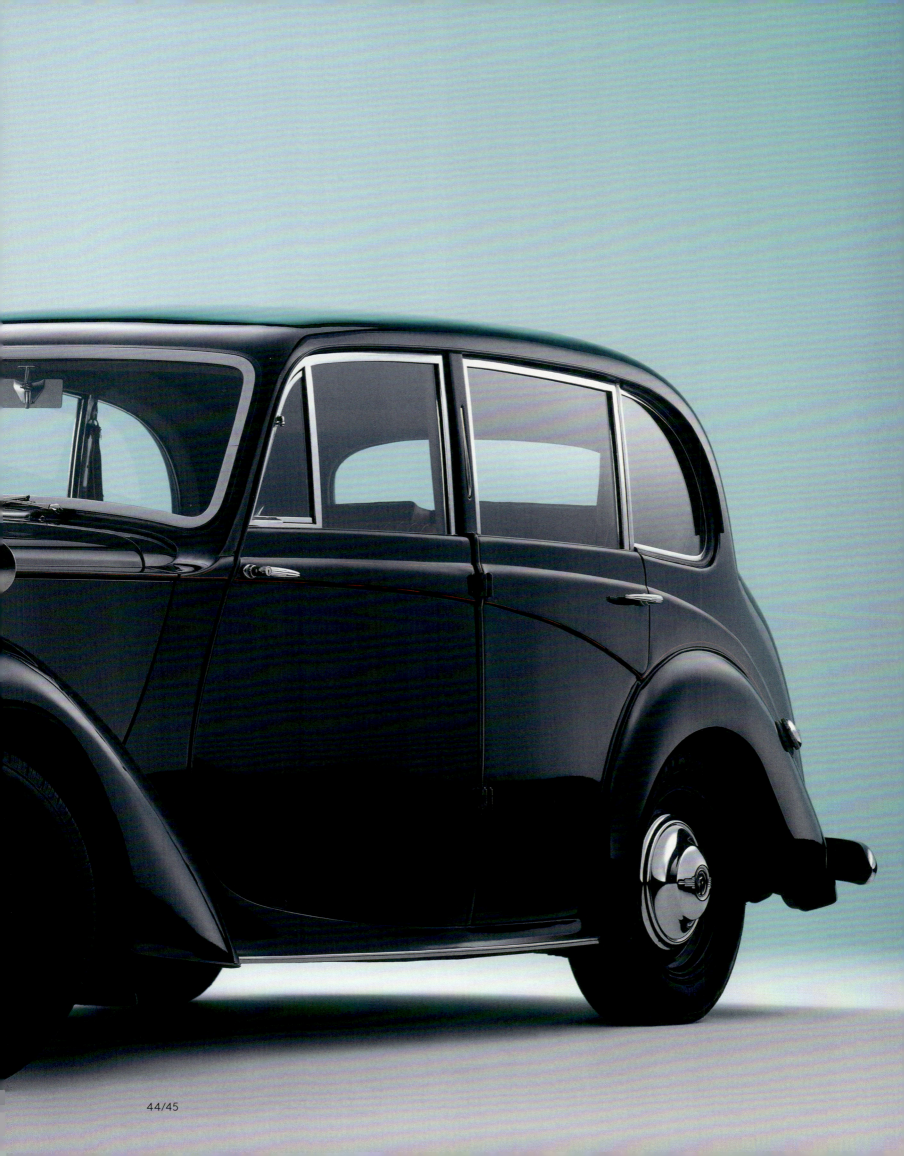

Bentley 4 ¼ Litre
1927–1937

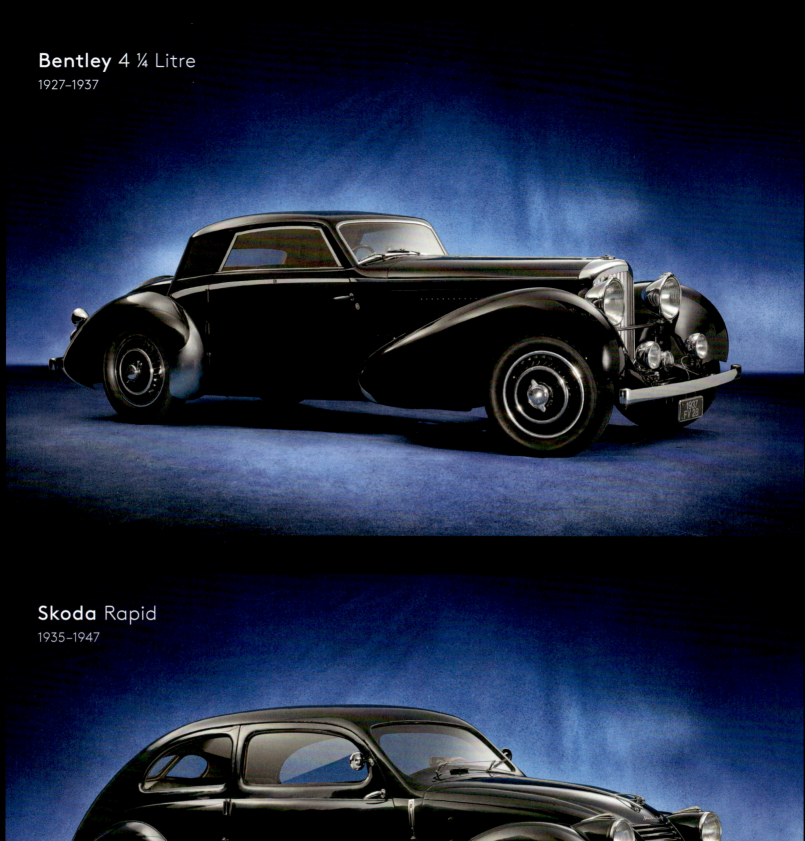

Skoda Rapid
1935–1947

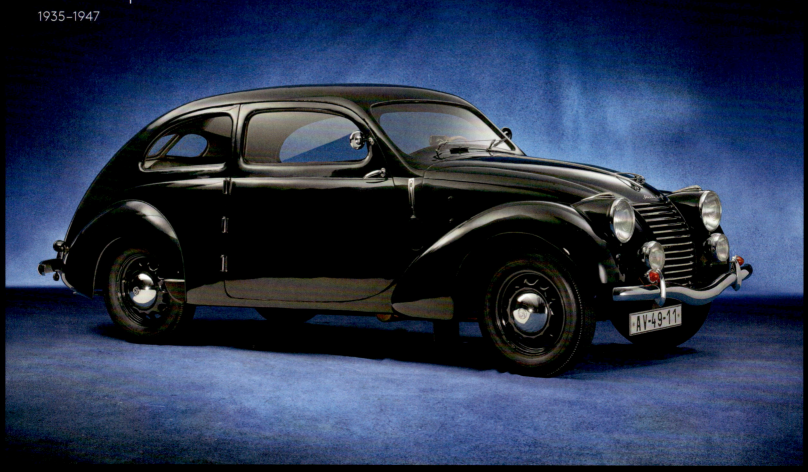

Bugatti Type 30
1922–1926

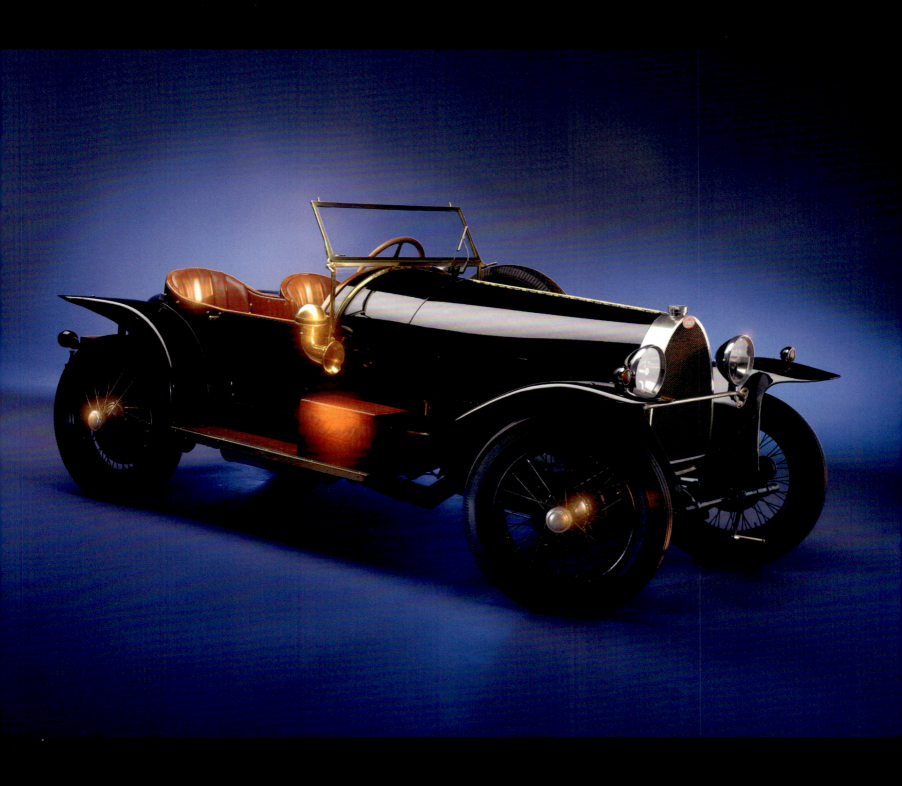

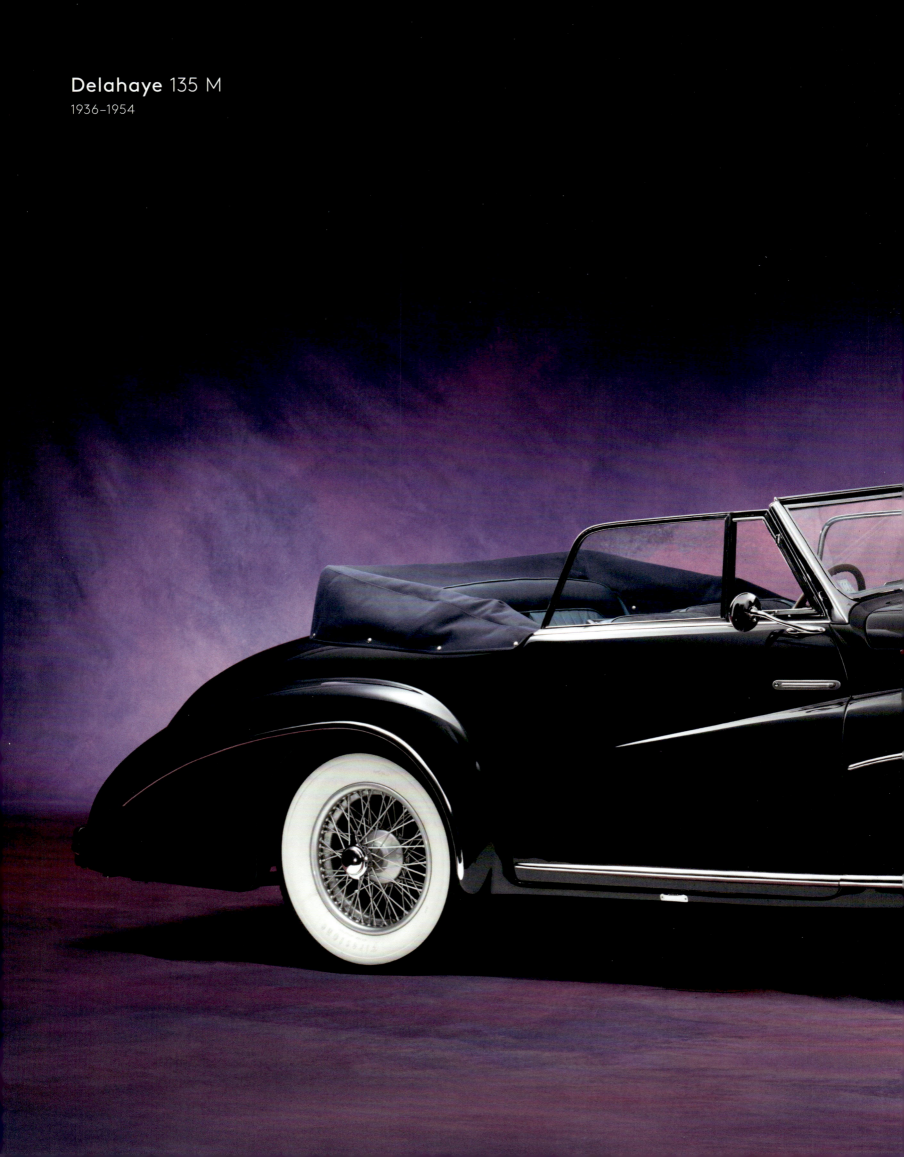

Delahaye 135 M
1936–1954

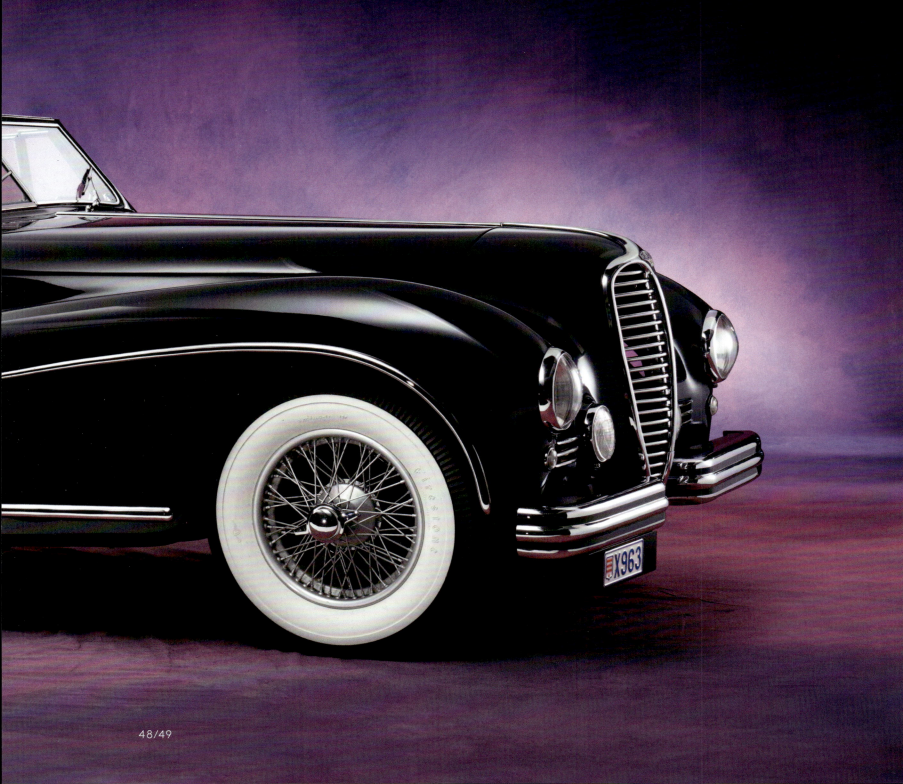

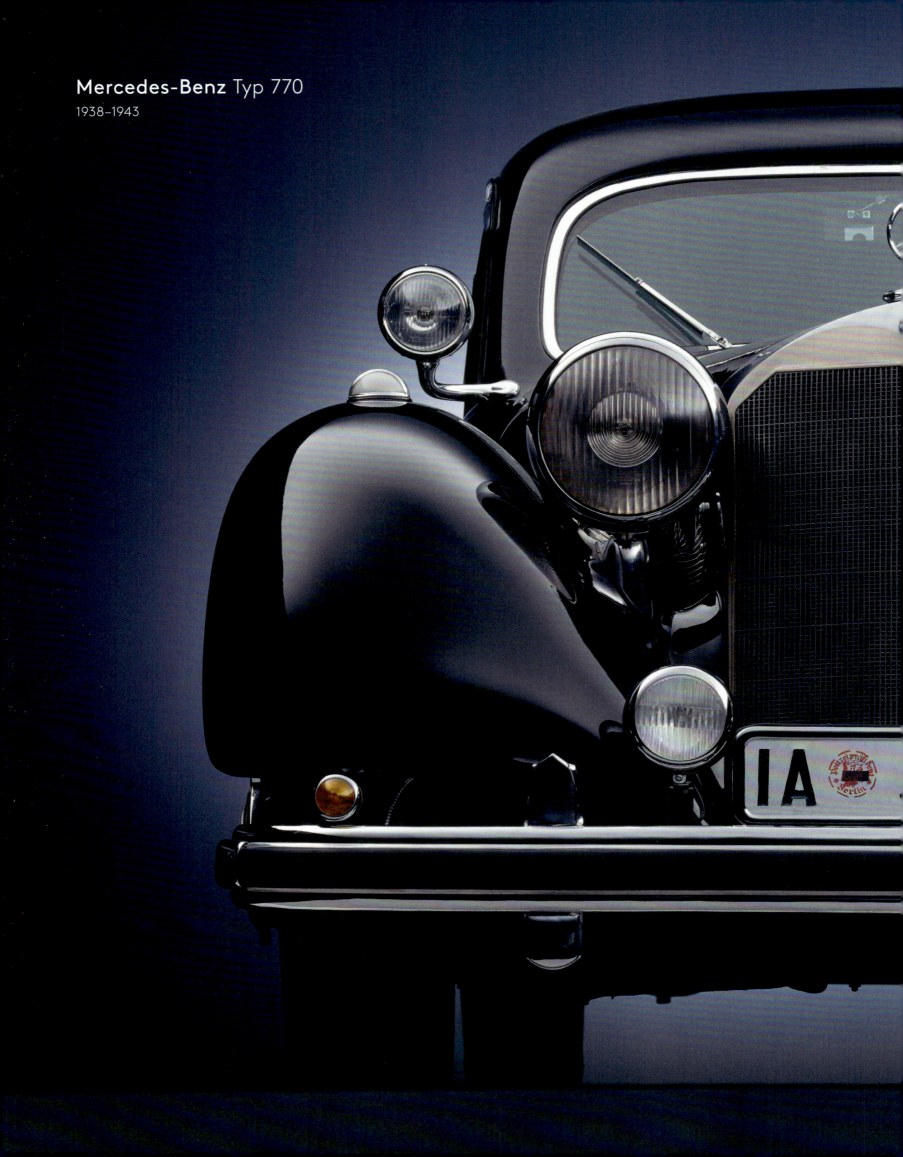

Mercedes-Benz Typ 770
1938–1943

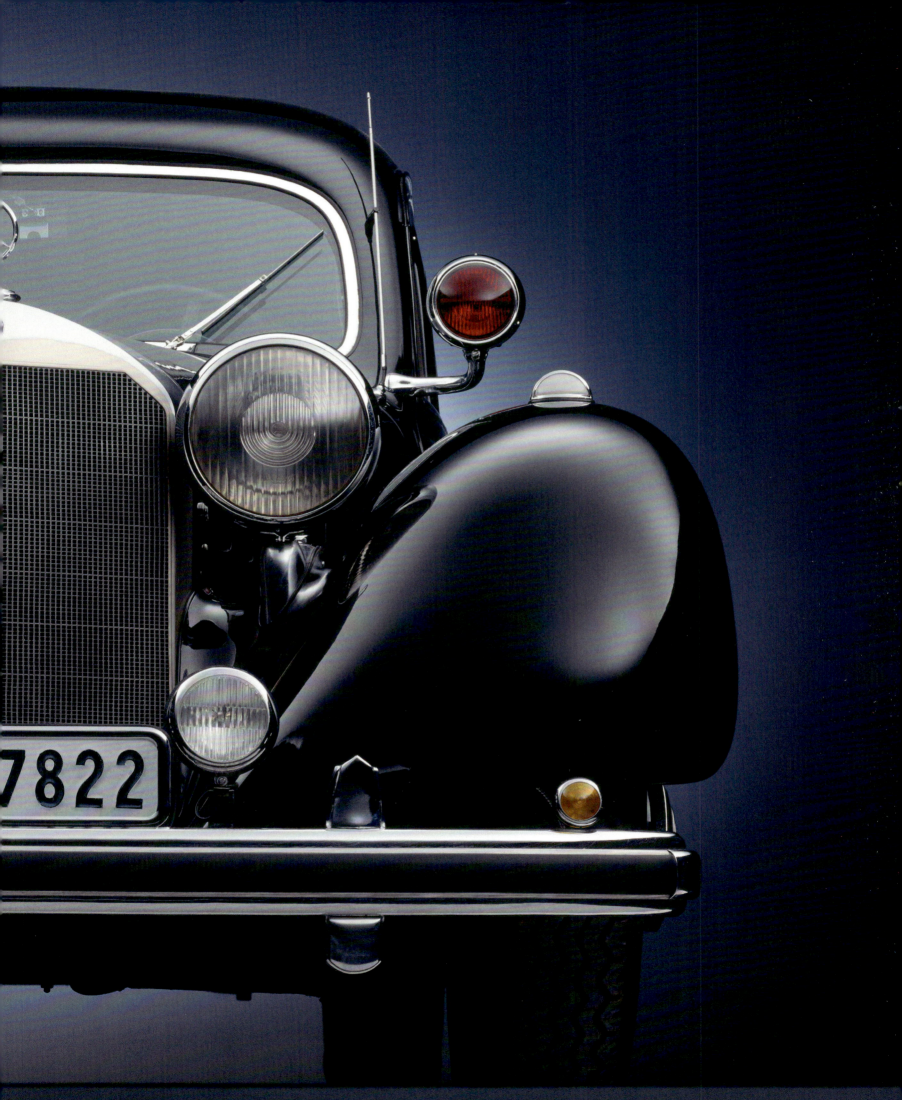

Citroën 11 CV
1934–1957

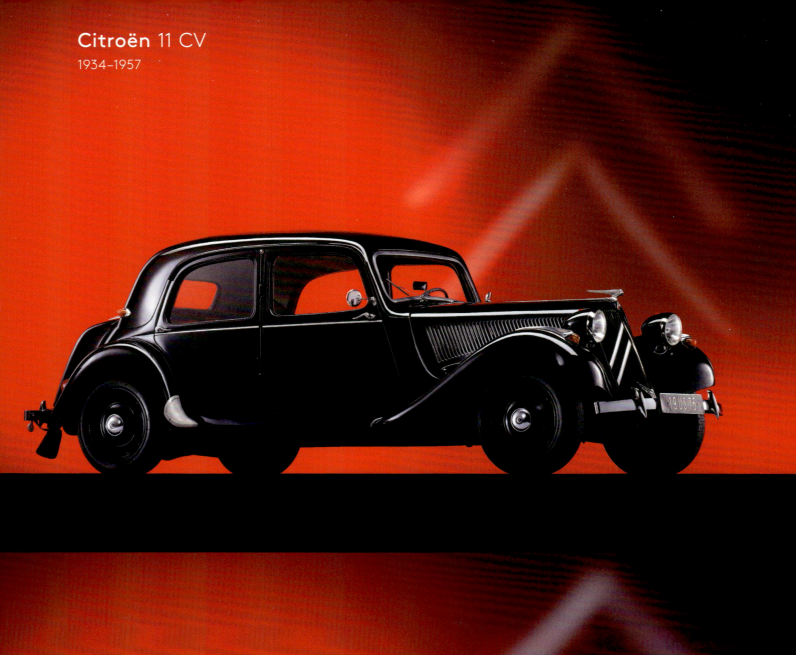
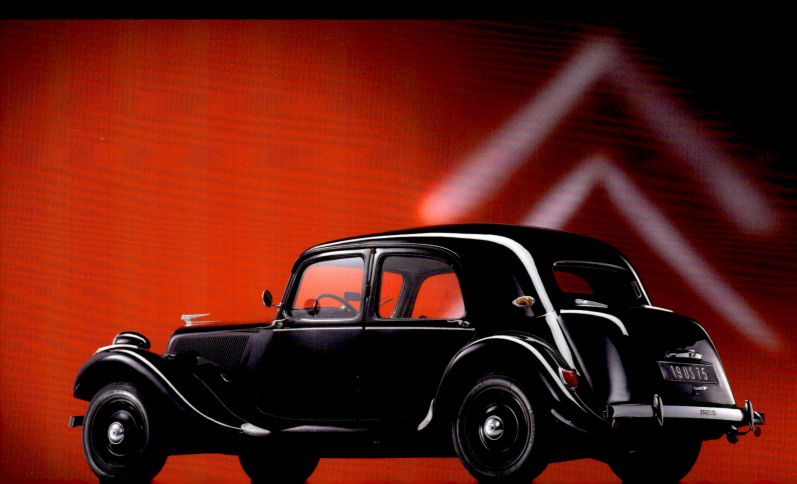

Citroën 15 CV
1938–1957

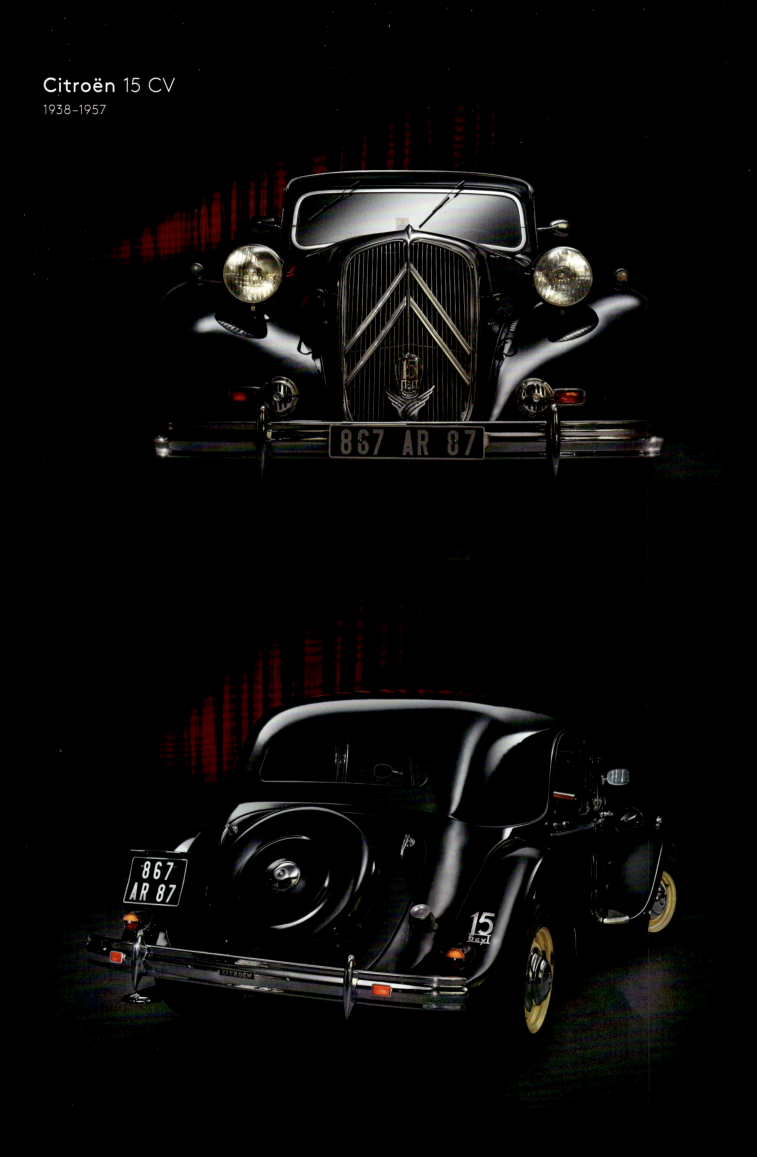

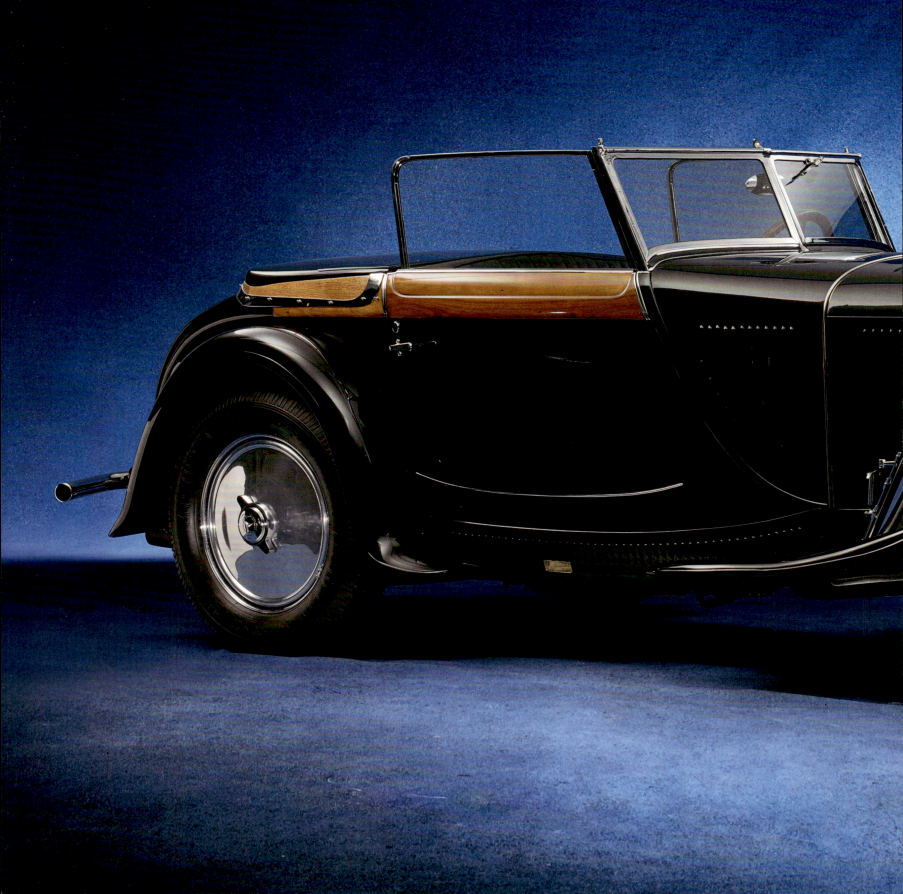

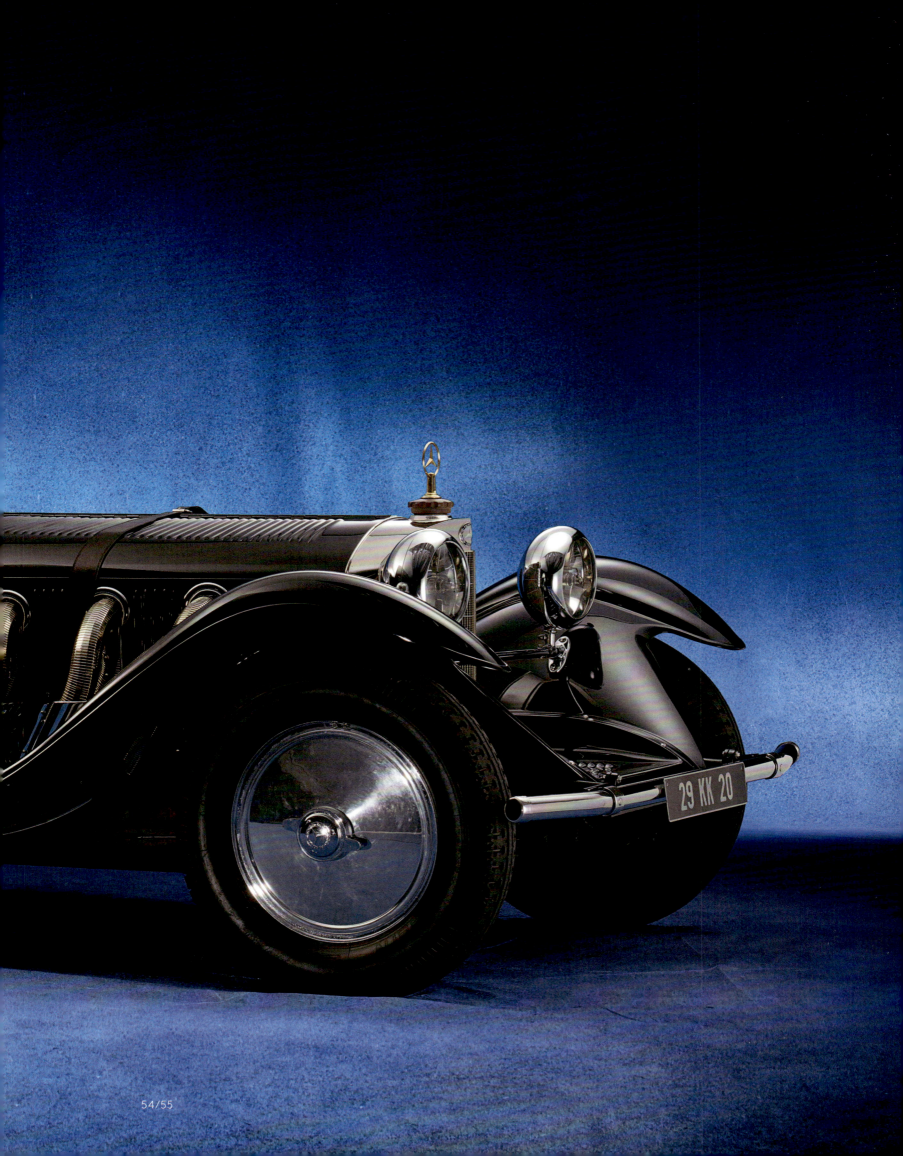

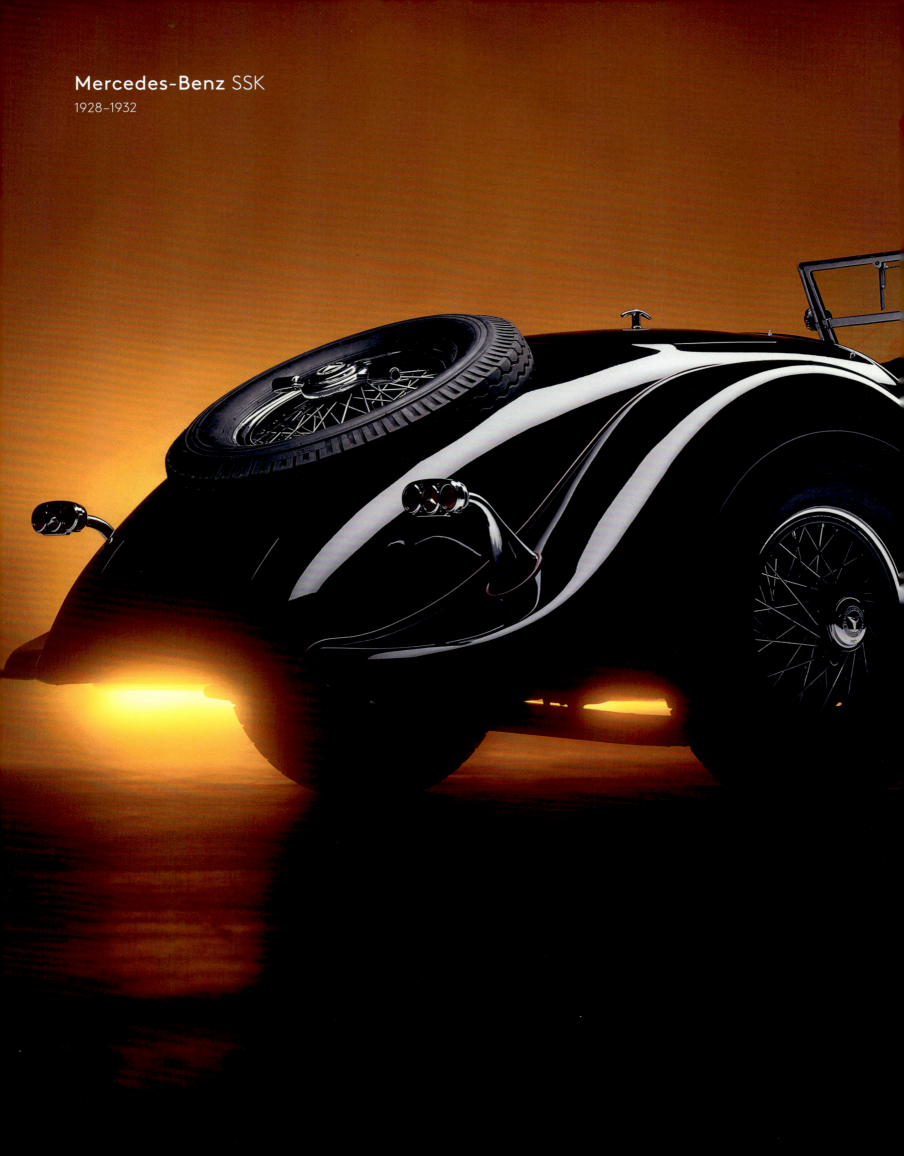

Mercedes-Benz SSK
1928–1932

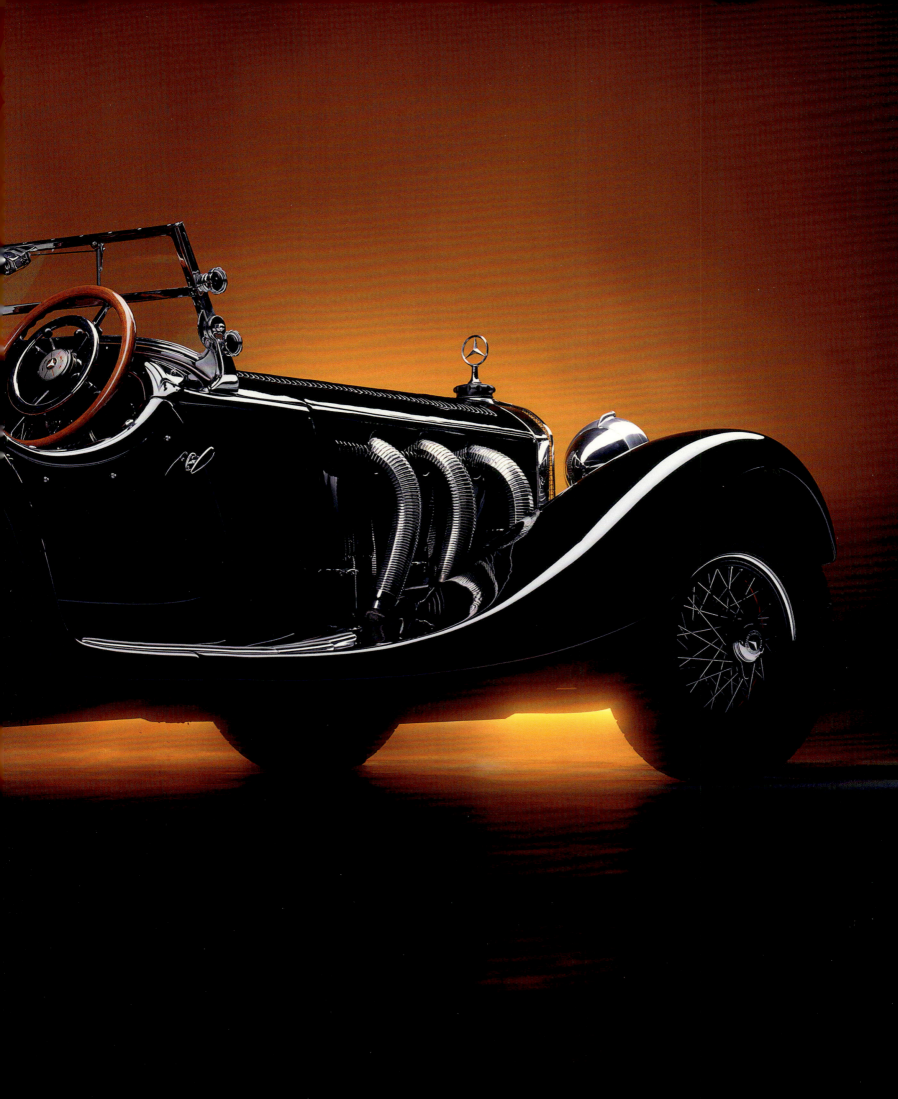

Opel RAK2
1928

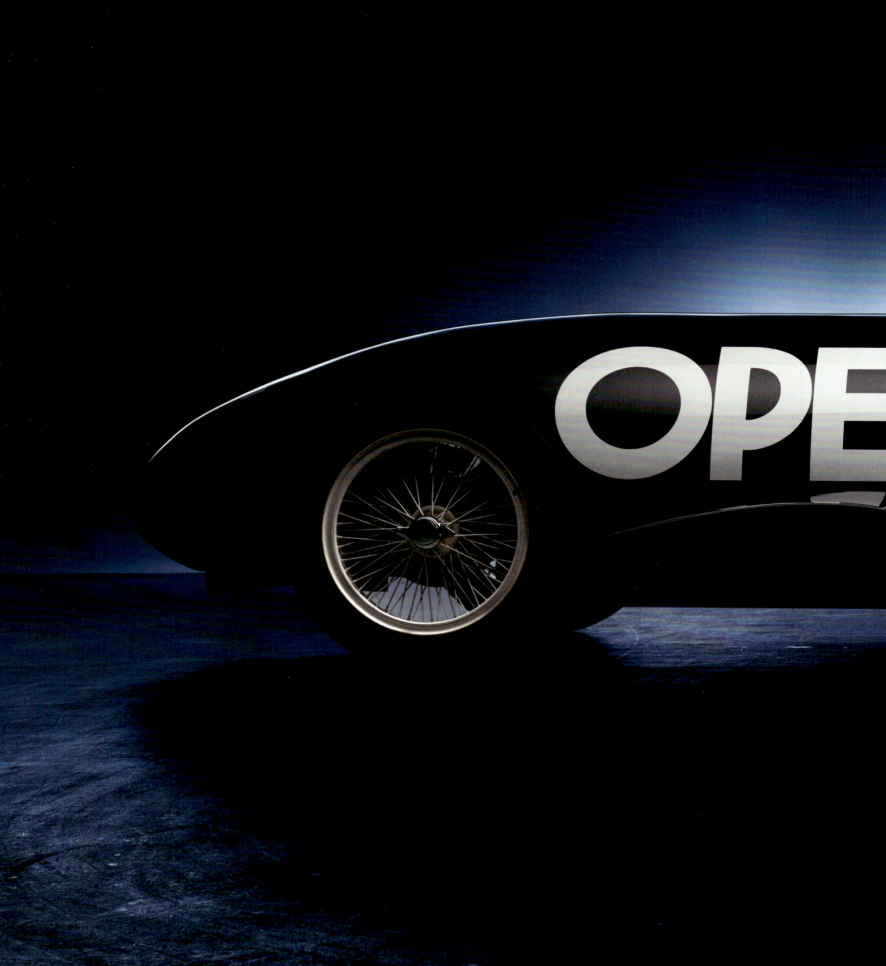

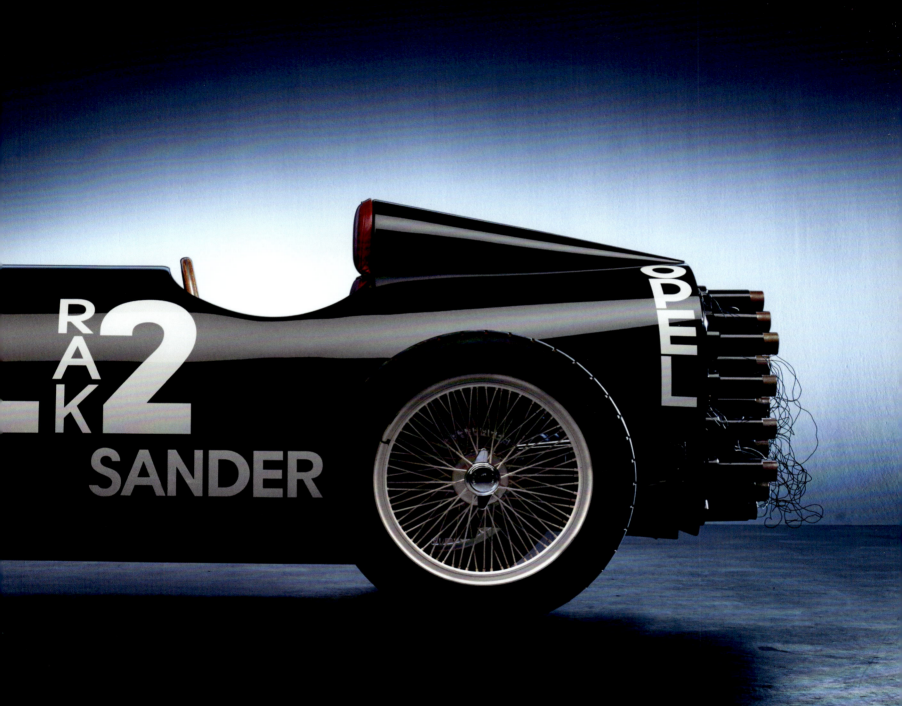

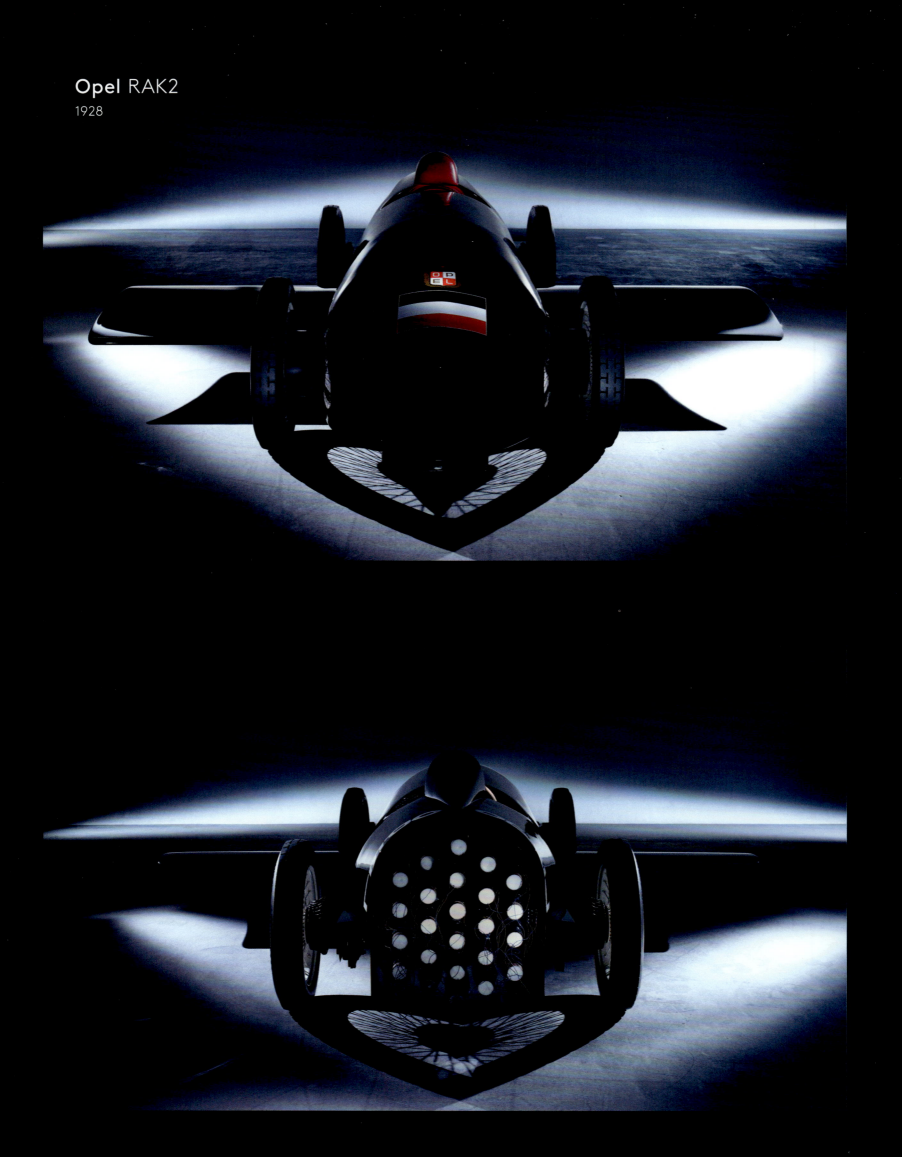

Opel RAK2
1928

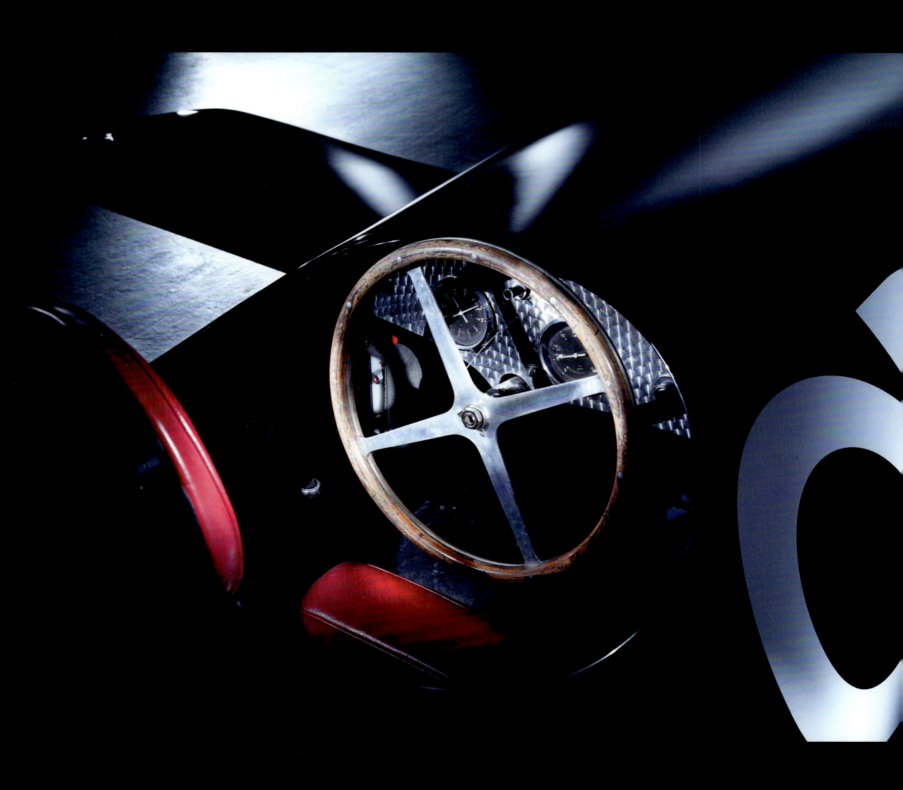

PAINT IT BLACK!

Konstantin Jacoby, Co-Founder of the Springer & Jacoby Advertising Agency

Because advertising in the 20th century ranked just above used car salesmen on the scale of serious and respectable professions, I didn't think twice about supplementing my ad writing income now and then by importing a rust-free Ferrari from California. Eventually, my ad writing income (rather than my import income) was enough that I could go down to the Ferrari dealer and bike home with a purchase agreement in my pocket. The model: Testarossa. Color: Red. Extras: None. Rebate: Also none. Wait time until delivery: 20 months.

And sometime during that 20-month wait, I saw this photo of Michael Jordan getting out of a black Testarossa. The vehicle seemed to have found its natural essence in black, like Air Jordan flying toward the basket. In 30 years of Ferrari fandom, I had never seen anything so awesome—and for the younger folks, the word "cool" still meant "cold" back then. But this was truly super cool.

And above and beyond that, I saw black as my way to avoid the impression of an ad man made good "getting his hip on" and driving up in a stylish red Ferrari. Back then, if you drove a black Ferrari, you were insane, or at least hopelessly devoid of style.

"Paint it black!"—and the dealer wrung his hands. "You'll never be able to resell it!" Unfortunately, he was right on that score—I only had to wait 10 years until black Ferraris became chic even to tanning salon owners looking for a used car.

But until then, I was happy in my little black box, whose ventilation grill made it look like a storage heater from the back. (Really, it did. Just look at pages 182/183 in this book.) In black, this car was somehow somber, quiet, more relaxed—more laid back than a typical entrance in a red Ferrari.

I didn't quite achieve the coolness of Jordan when I climbed out of my black Testarossa, office-job-pale and a little sweaty, but at least I was able to put the pedal to the metal—take that, Jordan!

PAINT IT BLACK!
Konstantin Jacoby, Mitbegründer der Werbeagentur Springer & Jacoby

Da im letzten Jahrhundert Werbeleute in der nach unten offenen Seriositätsskala sowieso nur knapp vor Gebrauchtwagenhändlern rangierten, fand ich nichts dabei, mein Textergehalt gelegentlich durch den Import eines rostfreien Ferrari aus Kalifornien aufzubessern. Irgendwann hat das mit dem Texten (weniger das mit dem Importieren) dazu gereicht, den Gang zum Ferrari-Händler anzutreten und mit einem Kaufvertrag wieder heimzuradeln. Modell: Testarossa, Farbe: rot, Extras: 0, Rabatt: ebenfalls 0, Lieferzeit: 20 Monate.

Und irgendwann in diesen 20 Monaten sah ich dieses eine Foto: Michael Jordan steigt aus einem schwarzen Testarossa. In Schwarz schien das Fahrzeug seine natürliche Daseinsform gefunden zu haben, so wie ‚Air' Jordan beim Anflug auf den Korb. Etwas Geileres hatte ich in über 30 Jahren Ferrari-Fantum noch nicht gesehen – für die Jüngeren: Das Wort „cool" bedeutete damals noch „kalt". Dieser Anblick war wirklich obercool.

Und obendrein sah ich in der Farbe Schwarz die Chance, dem unvermeidlichen Eindruck zu entgehen: Zu Geld gekommener Werbemann lässt es krachen und fährt stilecht im roten Ferrari vor. Im schwarzen Ferrari war man damals noch ein Irrer – oder wenigstens stillos.

„Paint it Black!" – der Händler rang die Hände: „Den kriegen Sie doch nie wieder verkauft!" Womit er dann leider recht hatte – ich musste halt auch nur 10 Jahre warten, bis Schwarz für Ferraris auch bei Gebrauchtwagen kaufenden Sonnenstudiobesitzern chic wurde.

Ich aber war bis dahin glücklich in meinem schwarzen Kasten, der von hinten mit seinem Lüftungsgitter auch noch aussah wie eine Nachtspeicherheizung – ja, schauen sie ruhig auf den Seiten 182/183 in diesem Buch nach. Das Schwarz machte dieses Auto eher nüchtern, ruhig, entspannter – irgendwie lässiger als so ein typischer Auftritt im roten Ferrari.

Ganz die Lässigkeit von Jordan habe ich natürlich nicht erreicht, wenn ich büroblass und leicht angeschwitzt aus der schwarzen Flunder kletterte. Aber dafür durfte ich damit Vollgas fahren – ätsch, Jordan!

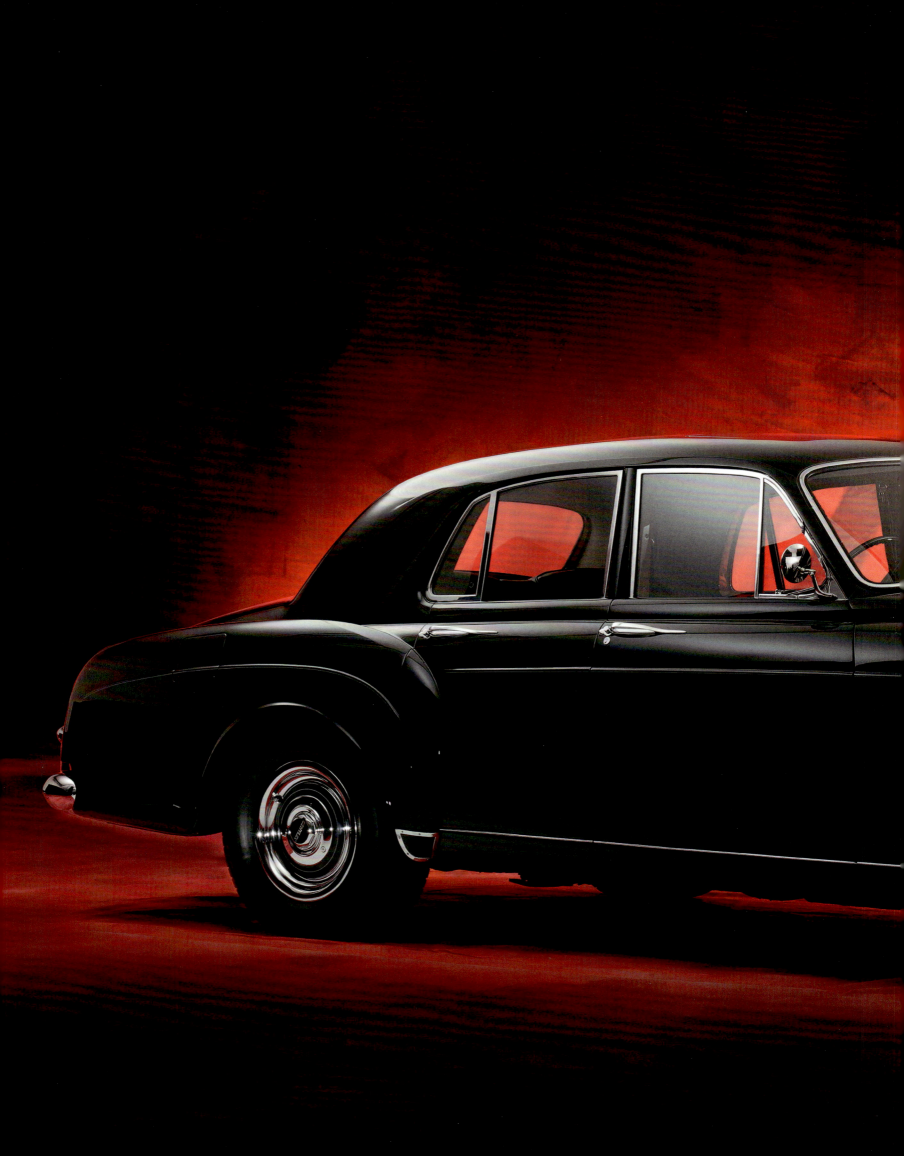

BLACK ELEGANCE

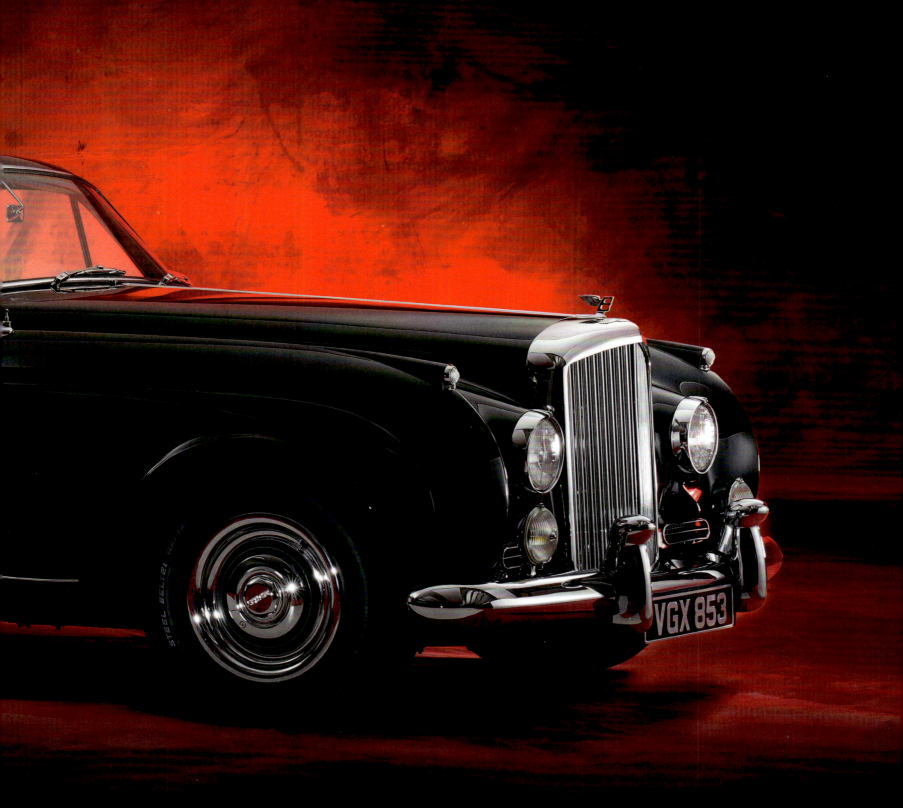

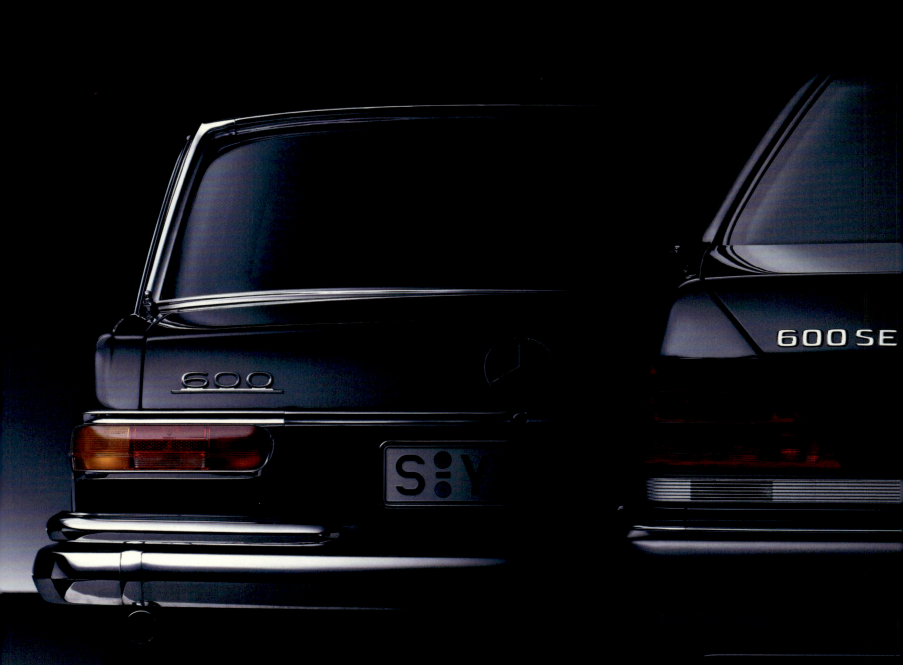

One look at the jet-black Bentley S1 Continental 4-Door Sports Saloon by H. J. Mulliner in a rare four-light configuration (64/65) is enough, and you know: *this* is the correct color for this epitome of British elegance. Well, all right, you might also be able to imagine the 4-Door Sports Saloon in dark blue or green, and you could even accept a burgundy one in your garage. But it's perfect in black.

So is black the quintessence of the concept of elegance? Probably, because this is the color that surrounds us at many elegant events. Tuxedos and tails? Always black. And isn't that little black dress the wife wears to the cocktail party the very ideal of good taste? We could even go on about the black robes the cardinals wear, although the bright red head covering dilutes the effect a bit.

The next collection of black cars shows us a representative collection from Stuttgart: the majestic 600, which maintained its reputation as one of the best cars in the world for over 20 years. Equally interesting: a comparison of the BMW 502 and the Mercedes-Benz "Adenauer" 300, both prestigious limousines that were state-of-the-art at the time. But it takes René Staud's lighting to see how modern the BMW is, how much it is defined by the wind tunnel, while its counterpart from Stuttgart places more value on form and dignity.

Of course, most of the models shown here are already elegant by their very nature, as the Jaguar 420, the Lincoln Continental Mk II or the fascinating Maserati A6G 2000 prove. But it is the black paint that reveals an additional dash of elegance, one that lends even the 1951 Hanomag Partner, a prototype that never went into production, the dimension of dignity this automobile deserves.

Ein Blick auf den tiefschwarzen Bentley S1 Continental 4-Door Sports Saloon von H. J. Mulliner in der raren 4-Light-Configuration (64/65) genügt und man weiß: Dies ist die korrekte Farbe für diesen Inbegriff britischer Eleganz. Nun gut, man könnte sich den 4-Door Sports Saloon auch in einem dunklen Grün oder Blau vorstellen; selbst in Burgundrot könnte man ihn in seiner Garage akzeptieren. Aber in Schwarz ist er perfekt.

Ist Schwarz nun also die Quintessenz des Begriffs „Eleganz"? Wahrscheinlich schon, denn diese Farbe begleitet uns bei vielen eleganten Events: der Smoking, der Frack – stets schwarz. Und gilt nicht das kleine Schwarze der Gattin beim Cocktailempfang als Inbegriff des guten Geschmacks? Man könnte sich nun auch noch über das Schwarz der Soutane der Kardinäle auslassen – das hier allerdings mit einer kardinalroten Kopfbedeckung etwas abgemildert wird.

Die nächste Kollektion schwarzer Fahrzeuge zeigt uns nun die repräsentativen Gefährte aus Stuttgart: den majestätischen 600er, der über 20 Jahre hinweg seinen Ruf als eines der besten Autos der Welt behaupten konnte. Genauso interessant: ein Vergleich des BMW 502 und des Mercedes-Benz „Adenauer" 300, beides Repräsentations-Limousinen, die damals State of the Art darstellten. Doch erst im Licht von René Staud erkennt man dann, wie modern und vom Windkanal geprägt der BMW dasteht, während sein Pendant aus Stuttgart doch mehr auf Form und Würde Wert legt.

Natürlich sind die hier gezeigten Modelle zum großen Teil per se bereits elegant, wie ein Jaguar 420, ein Lincoln Continental Mk II oder der faszinierende Maserati A6G 2000 beweisen. Doch erst in schwarzer Lackierung offenbart sich dieses zusätzliche Quantum Eleganz, dass selbst dem Hanomag Partner von 1951, einem nie in Serie gegangenen Prototypen, jenes Maß an Würde gibt, die dieses Automobil verdient hat.

Bentley Continental R-Type
1991–2002

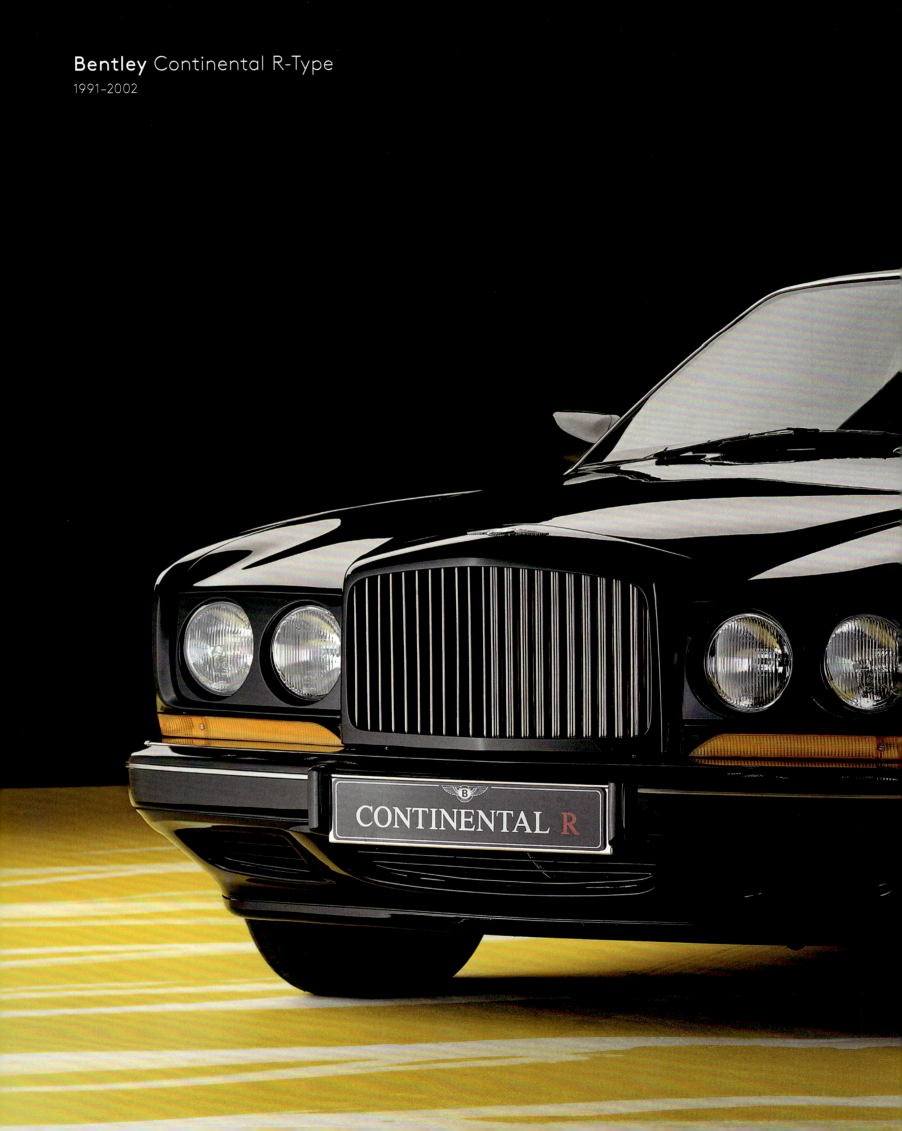

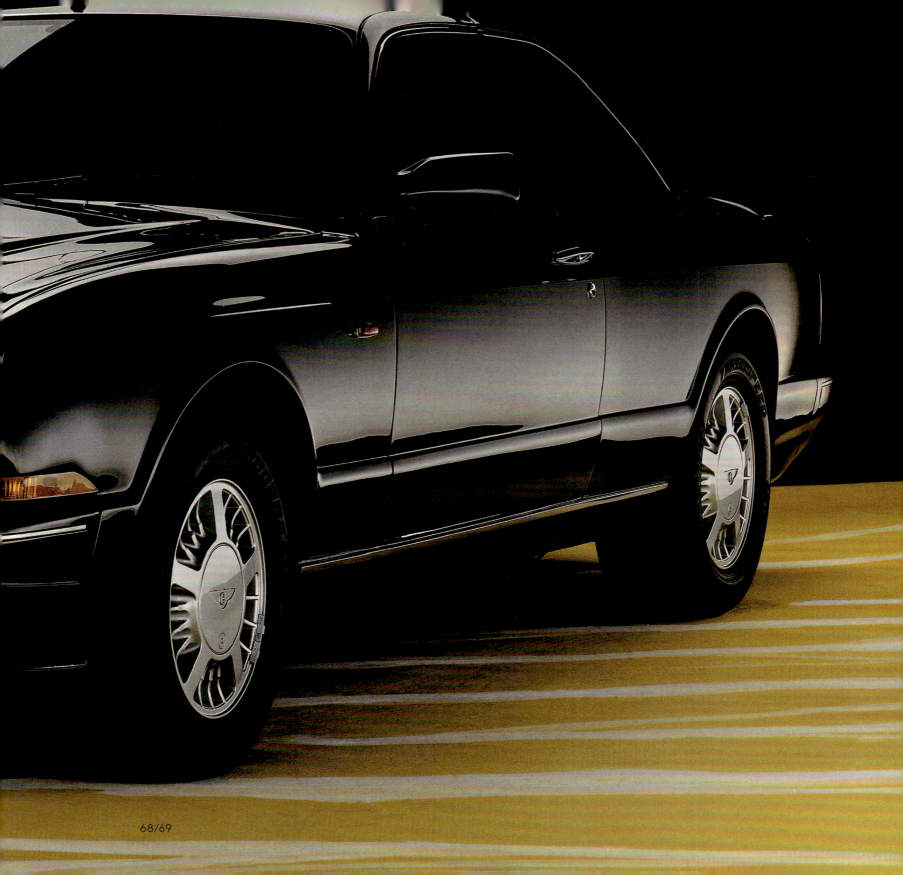

BMW 502
1952–1964

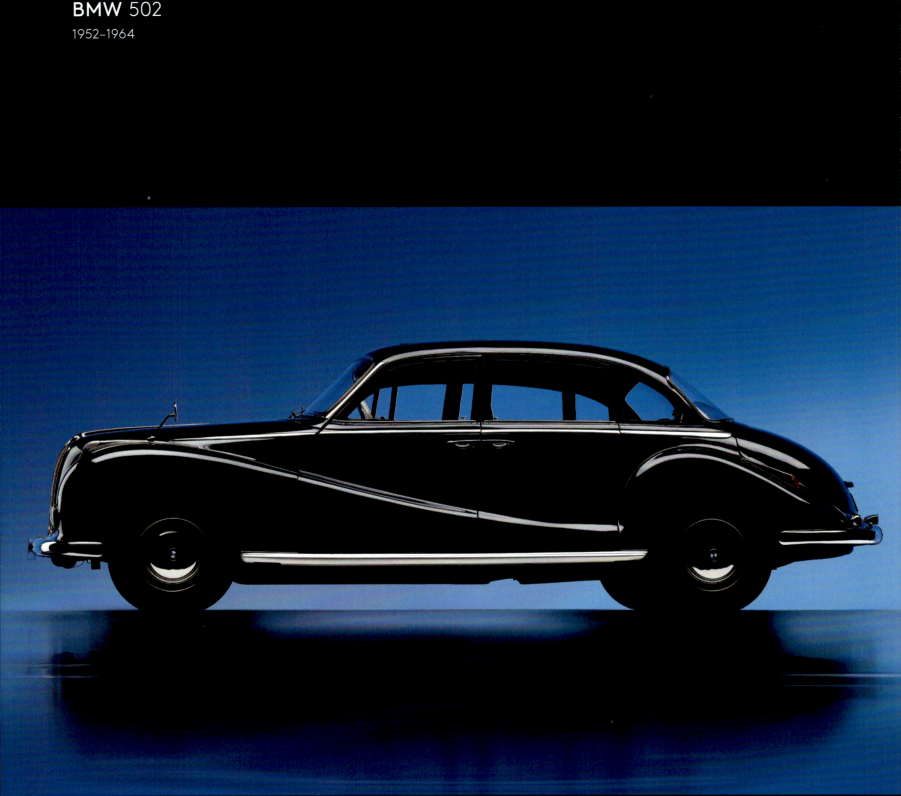

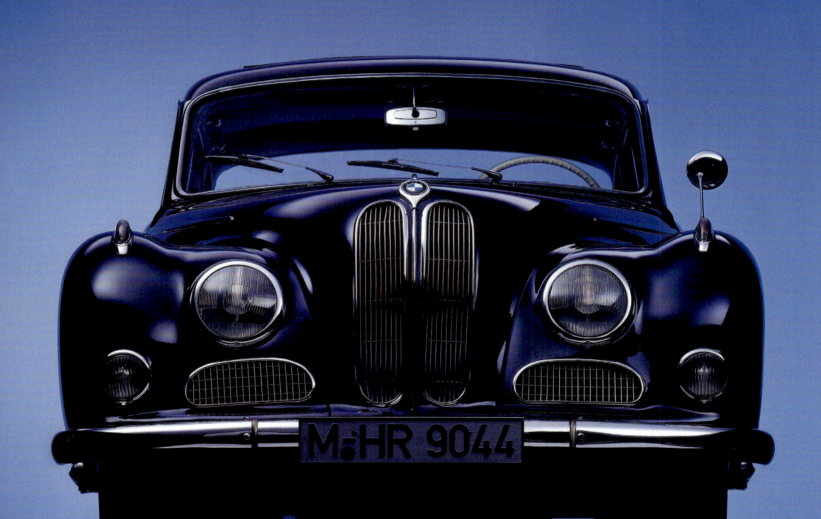

BMW Z3 Coupé
1998–1999

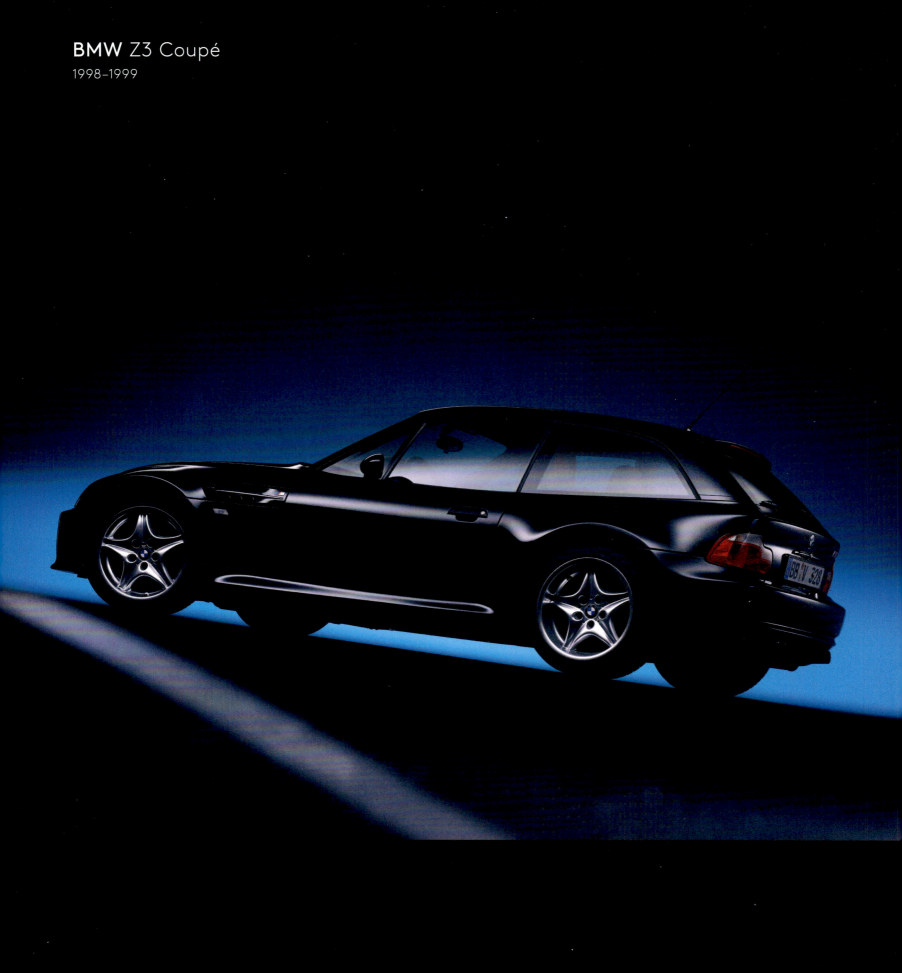

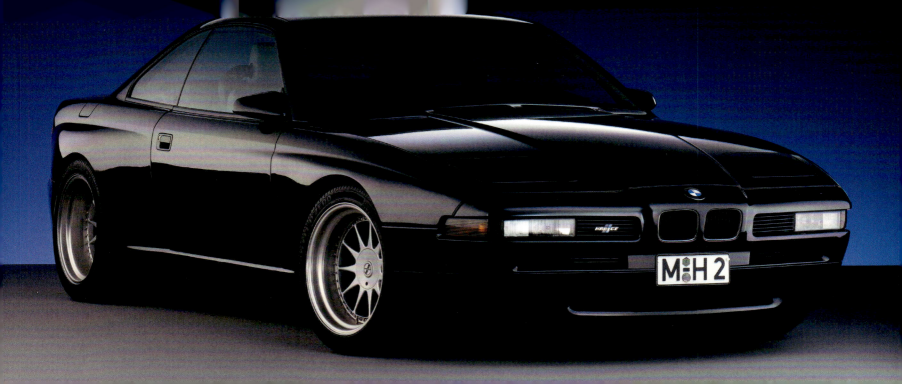

Aston Martin Virage
1988–1995

Lagonda Rapide
1961–1964

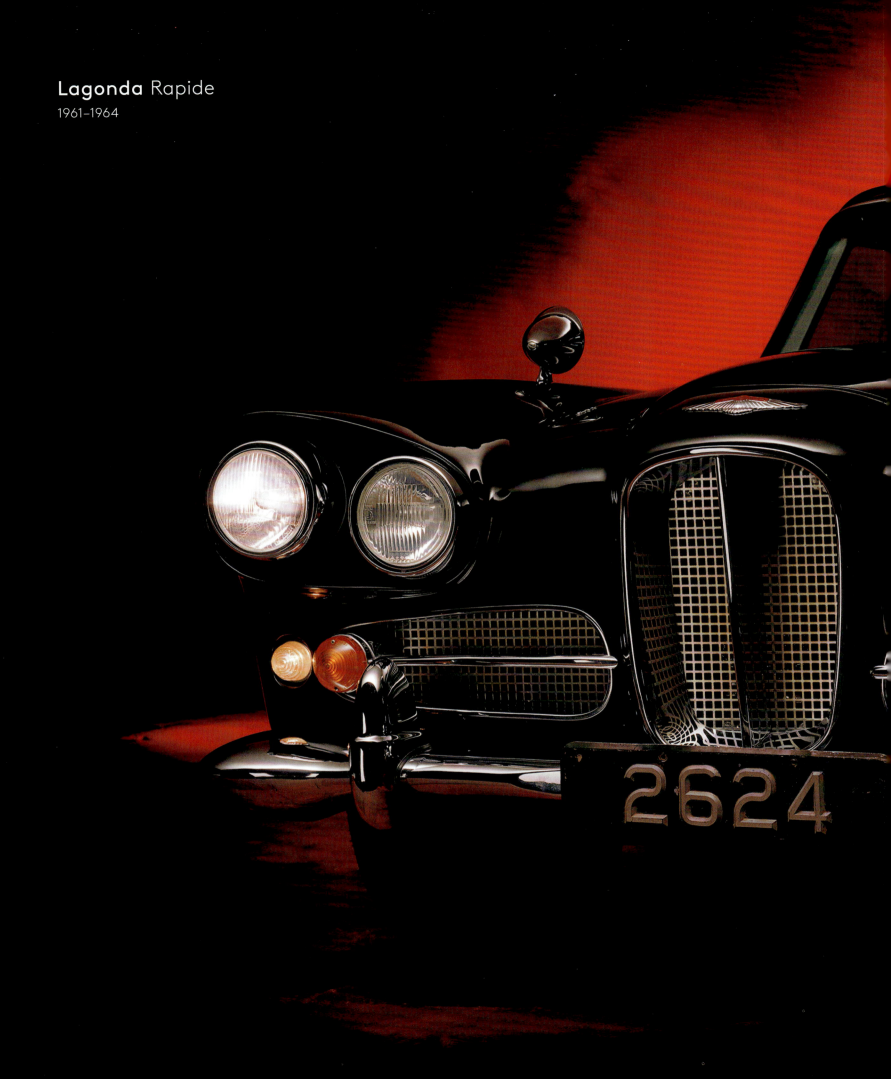

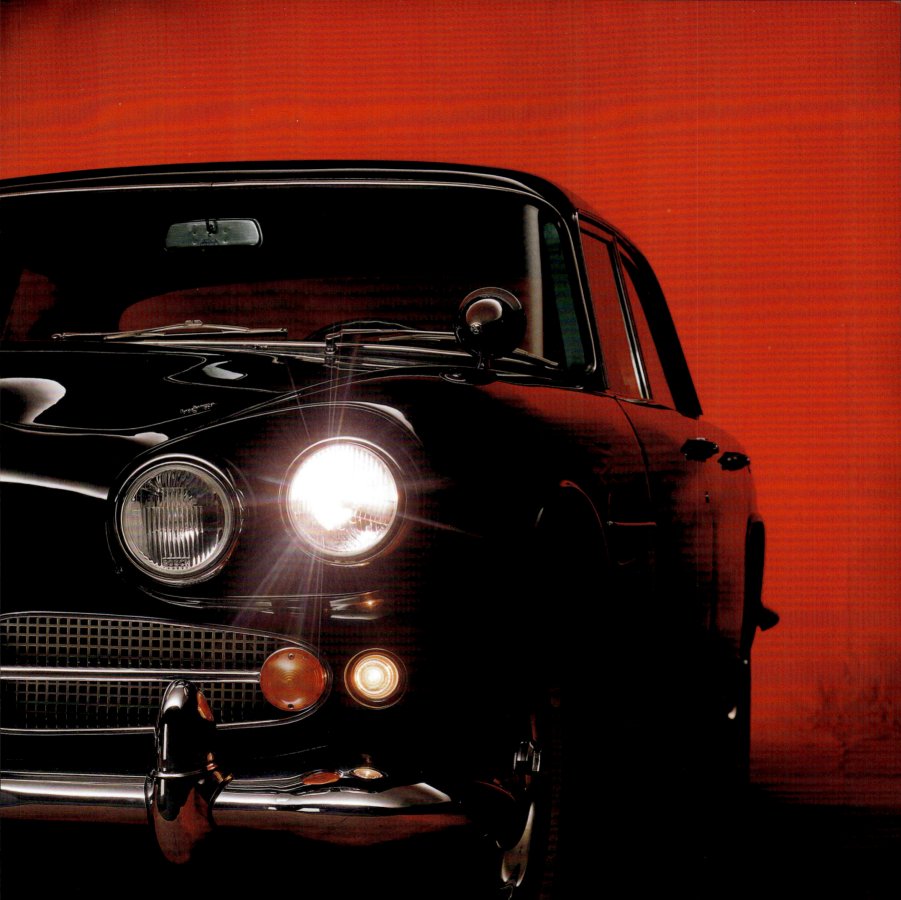

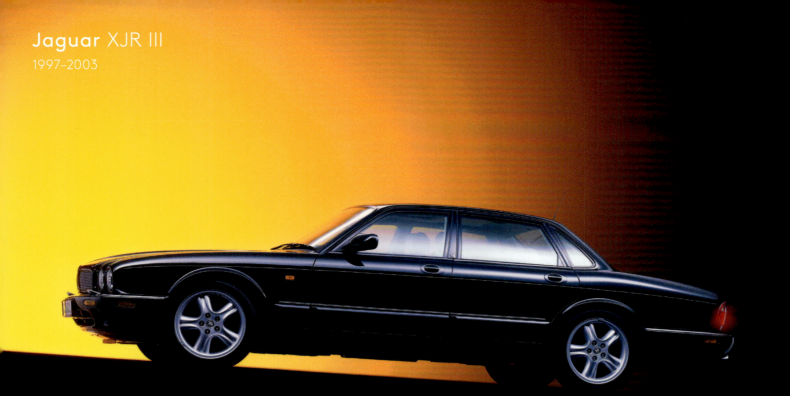

Jaguar XJR III
1997–2003

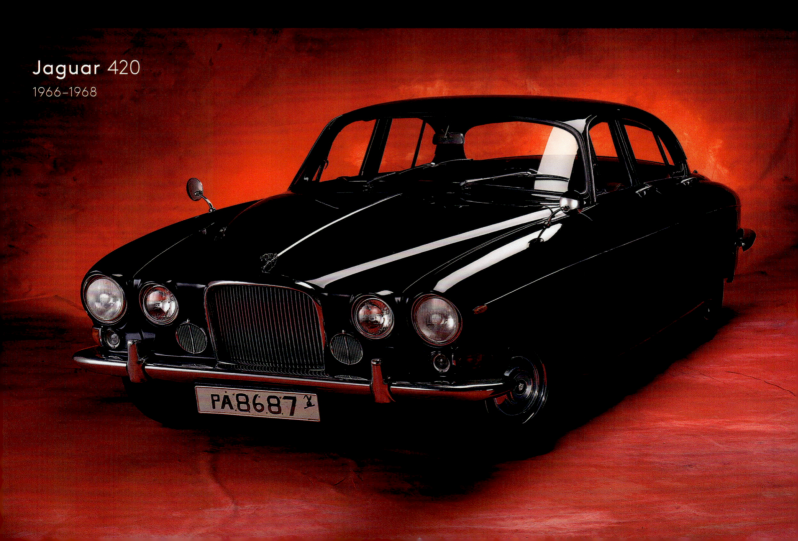

Jaguar 420
1966–1968

Mercedes-Benz 300
1952–1962

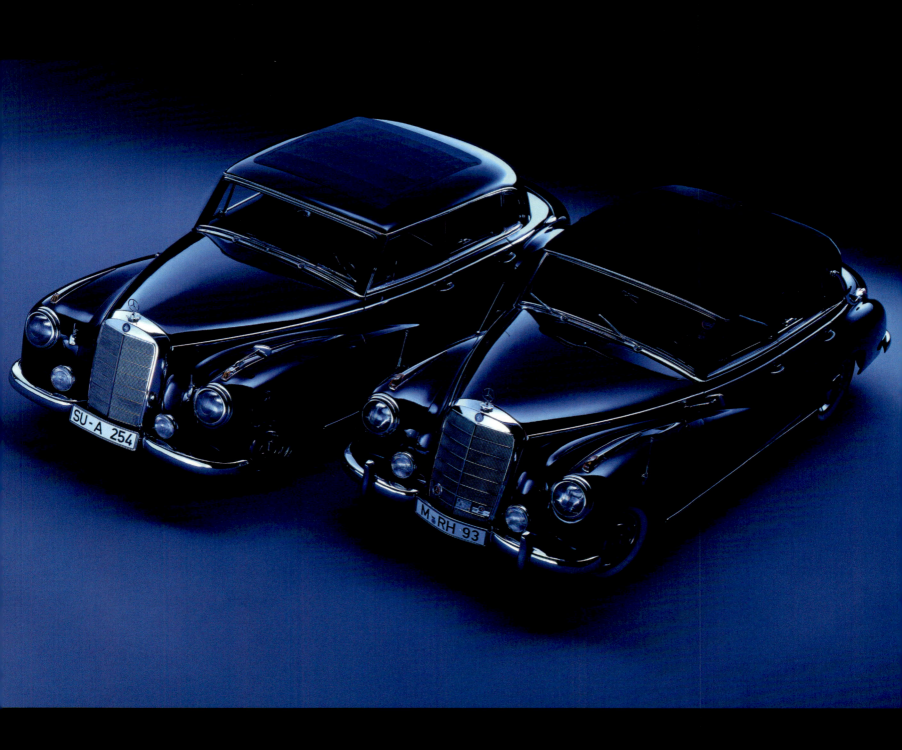

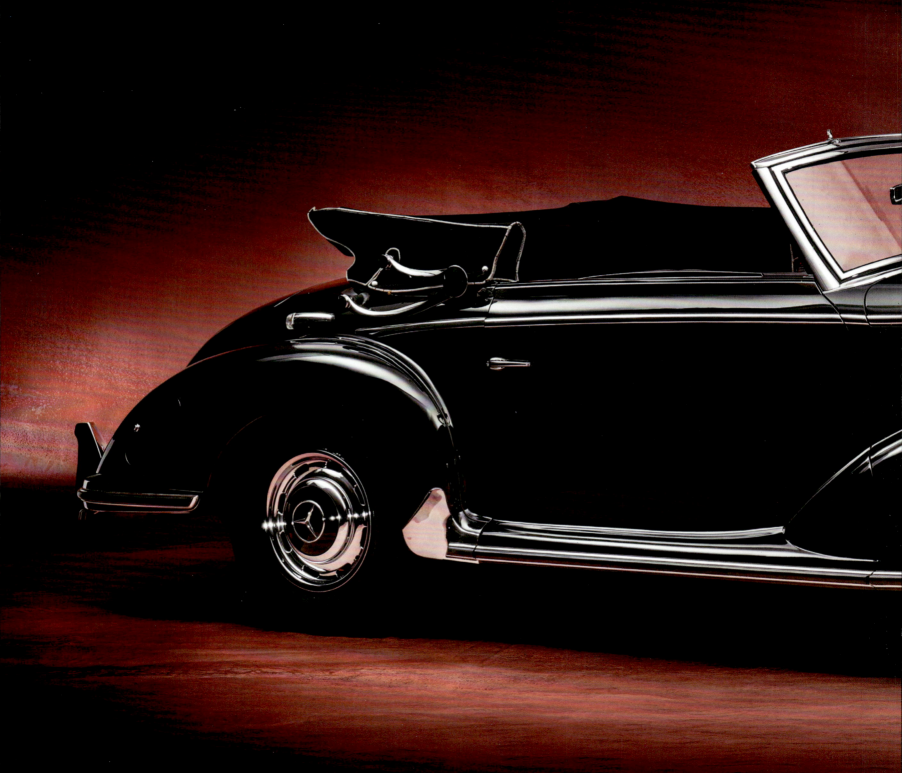

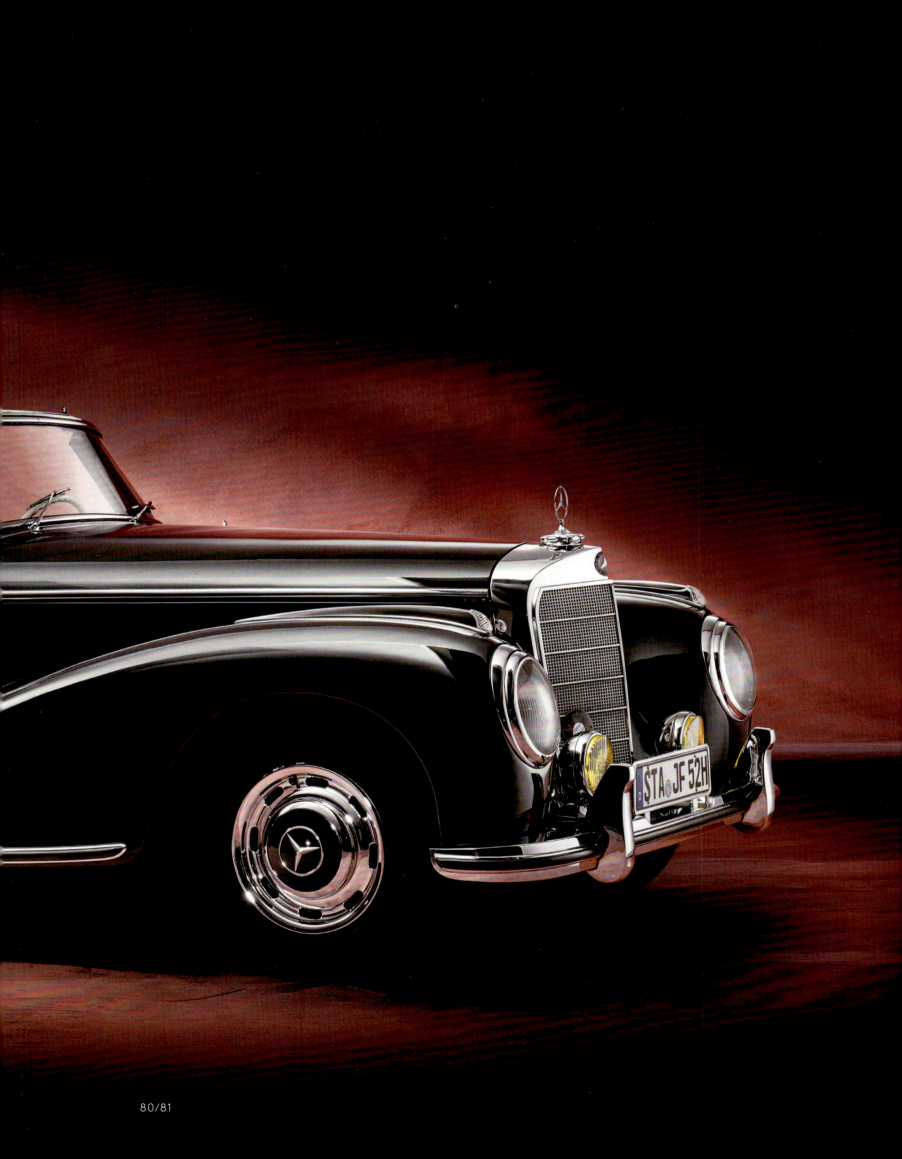

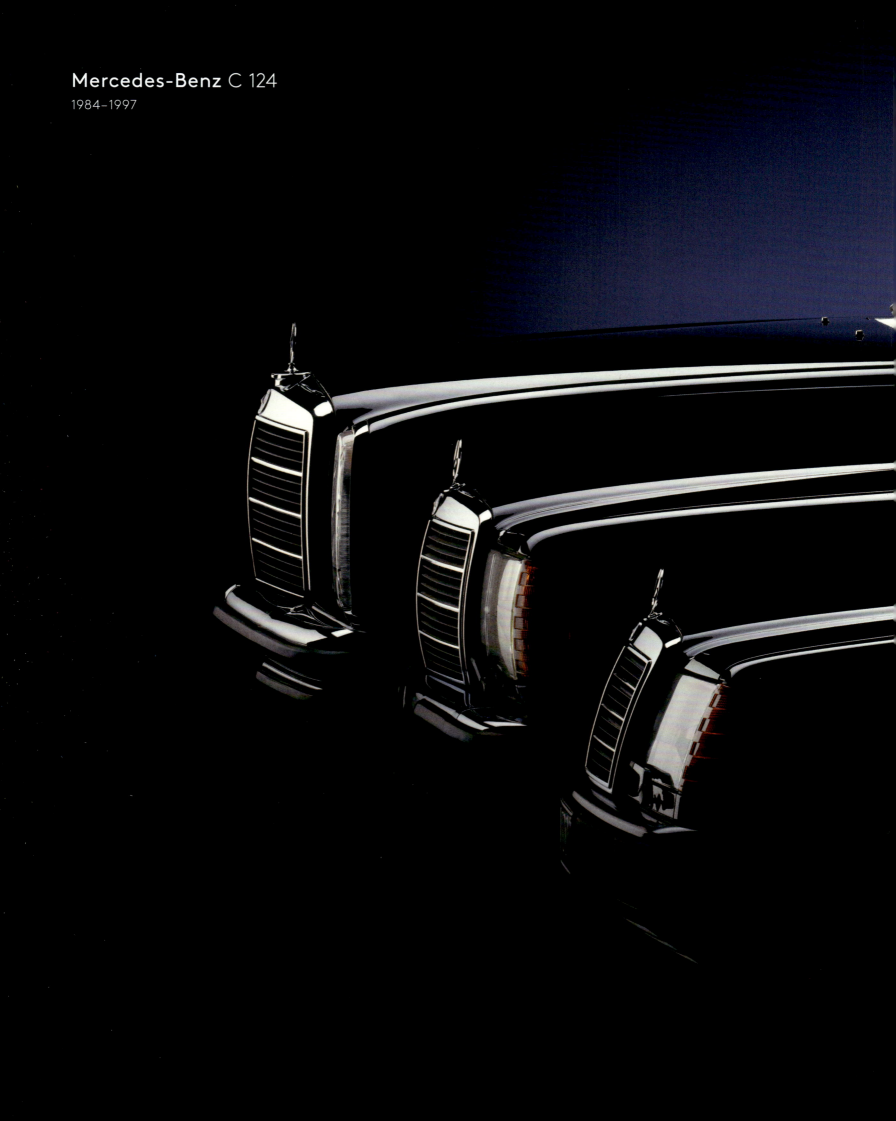

Mercedes-Benz C 124
1984–1997

Lincoln Continental Mk II
1956–1957

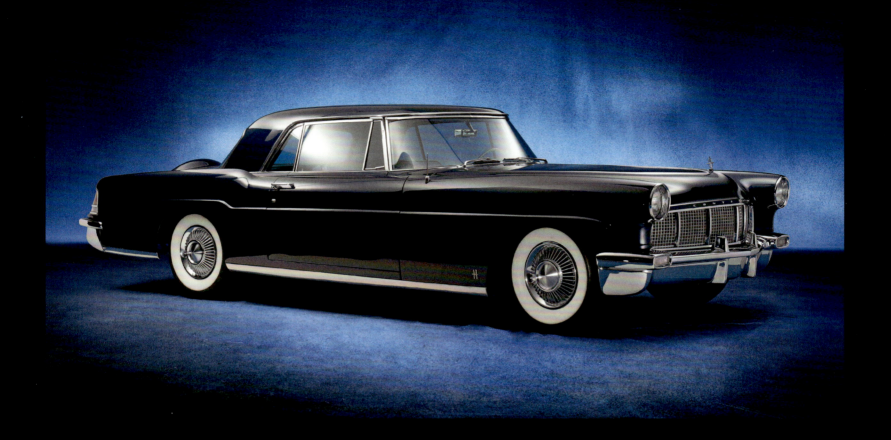

Hanomag Partner
1951

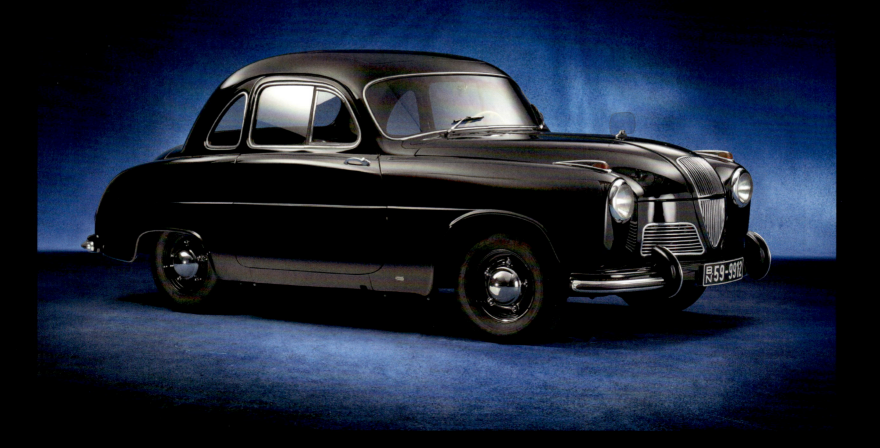

Maserati A6G 2000
1950–1951

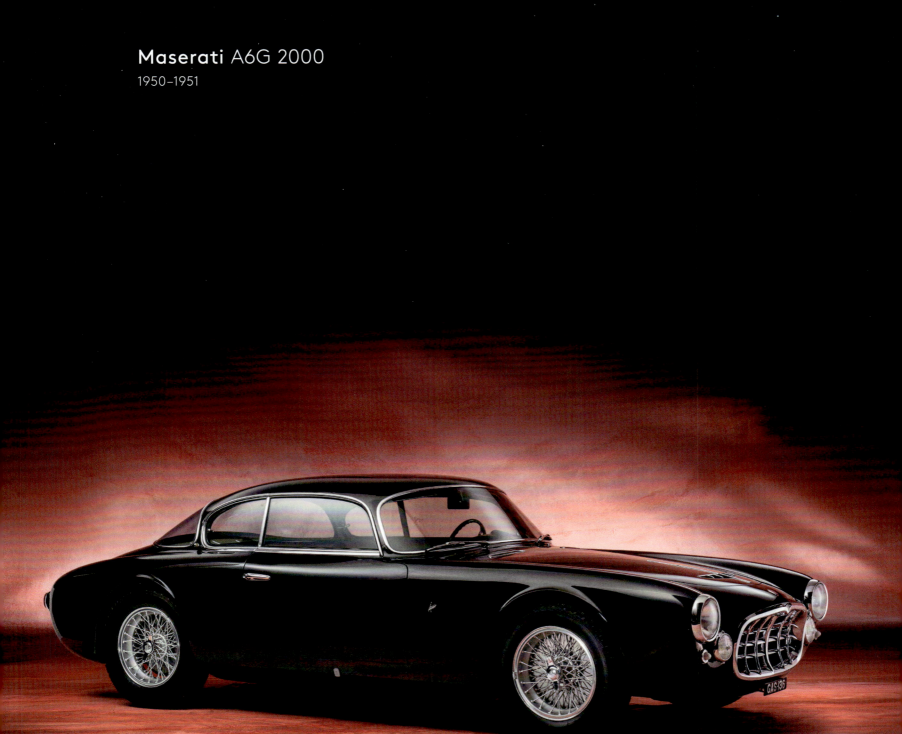

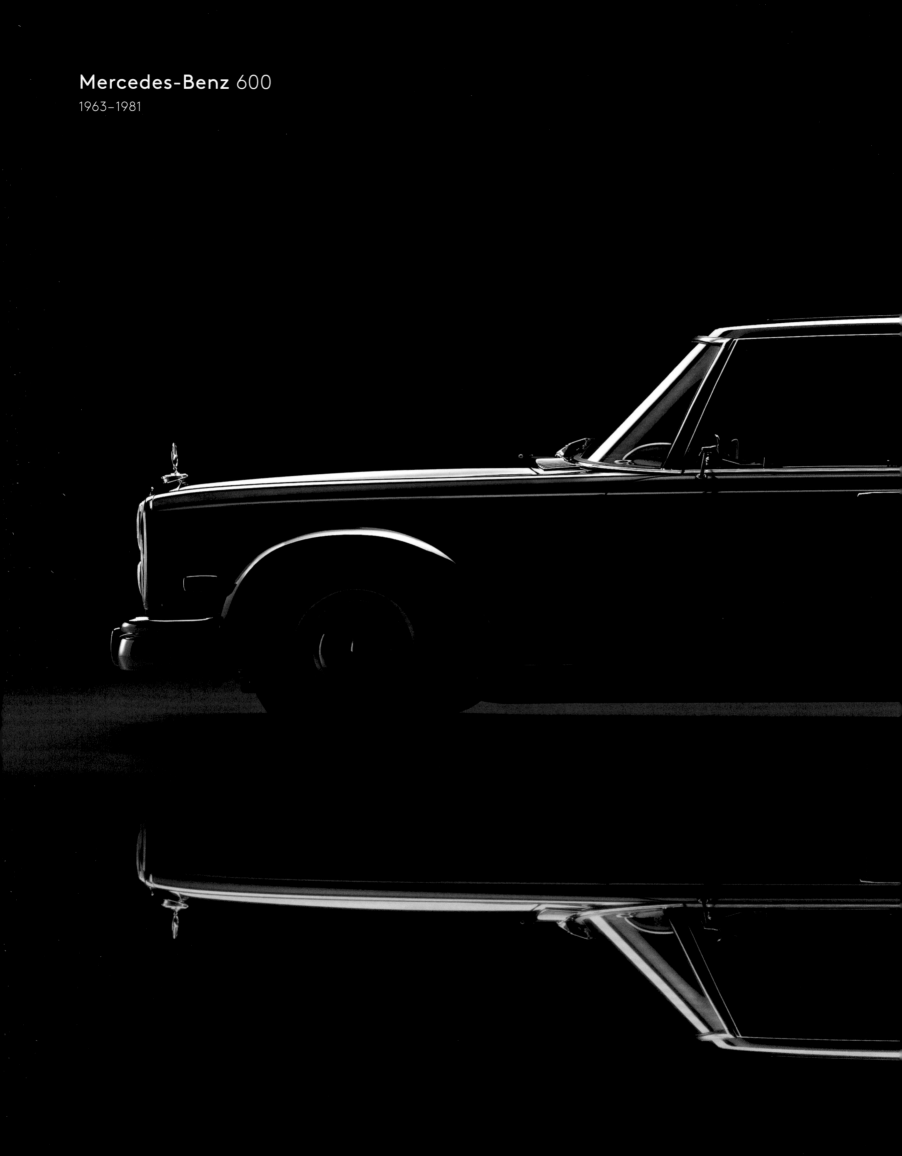

Mercedes-Benz 600

1963–1981

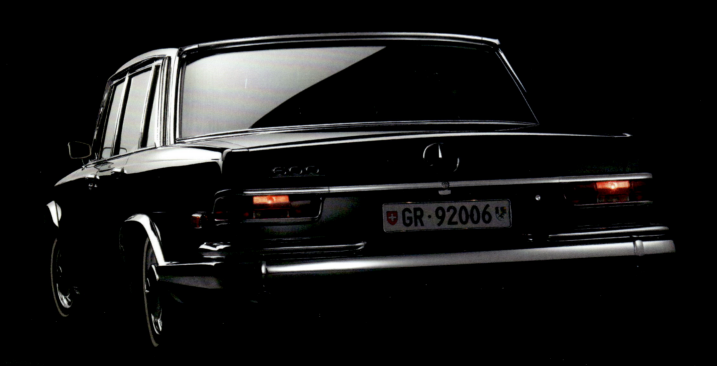

Mercedes-Benz 600
1963–1981

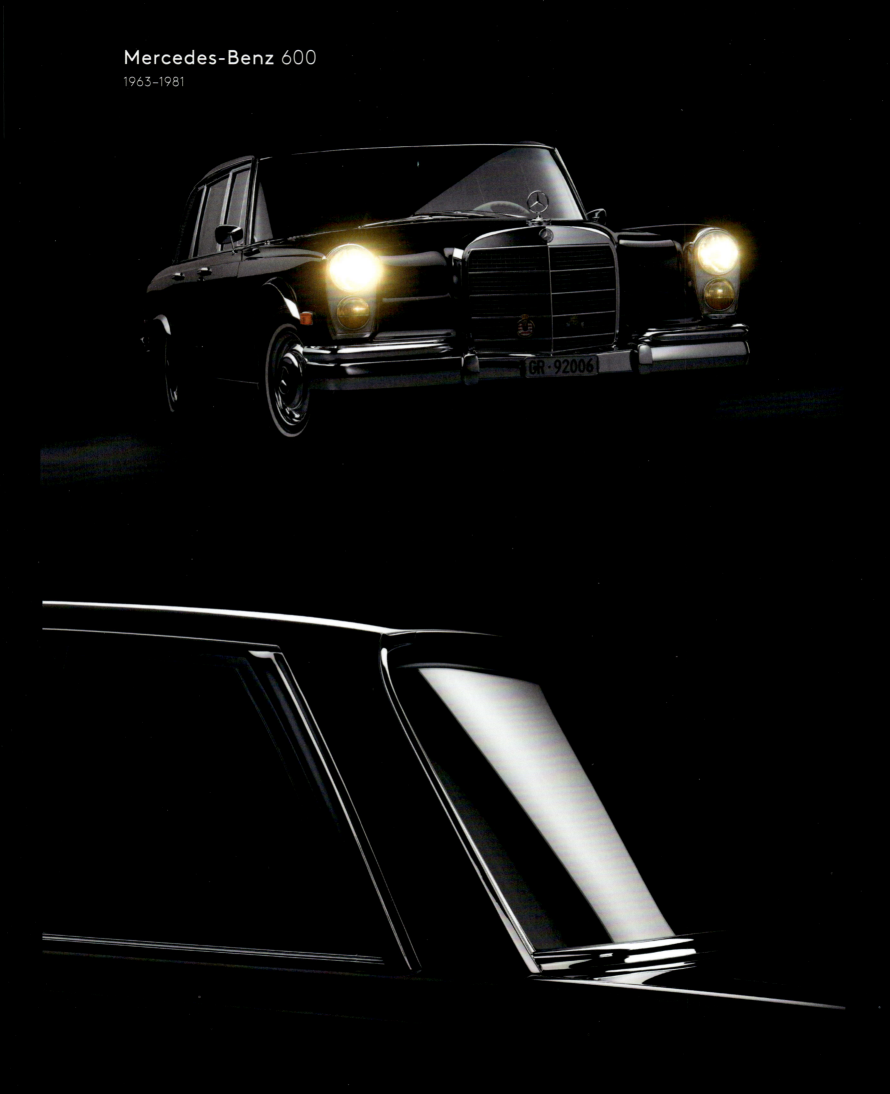

Volvo PV544
1958–1969

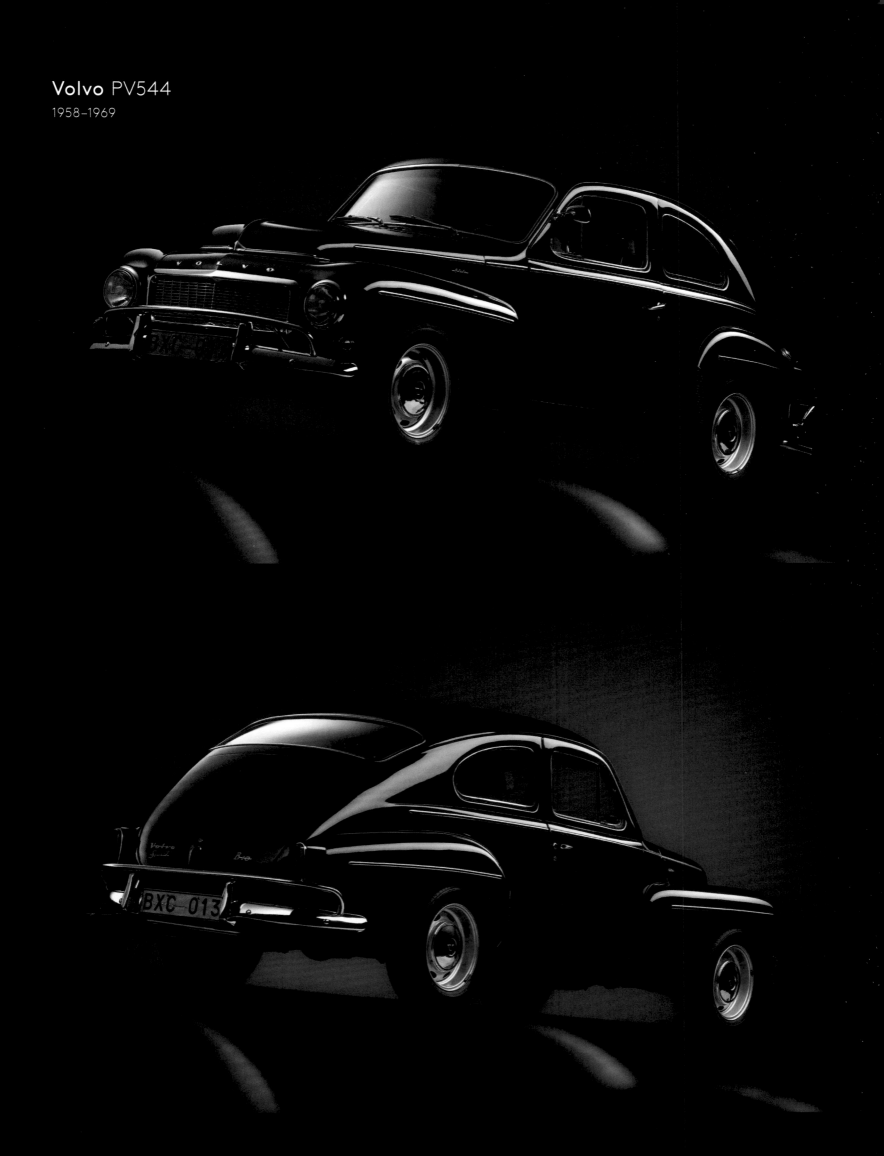

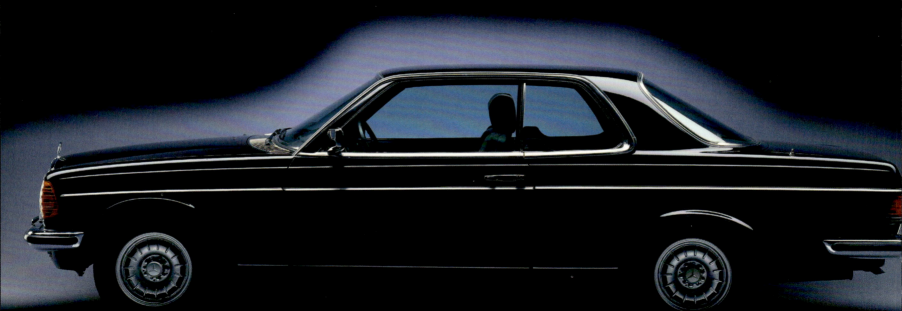

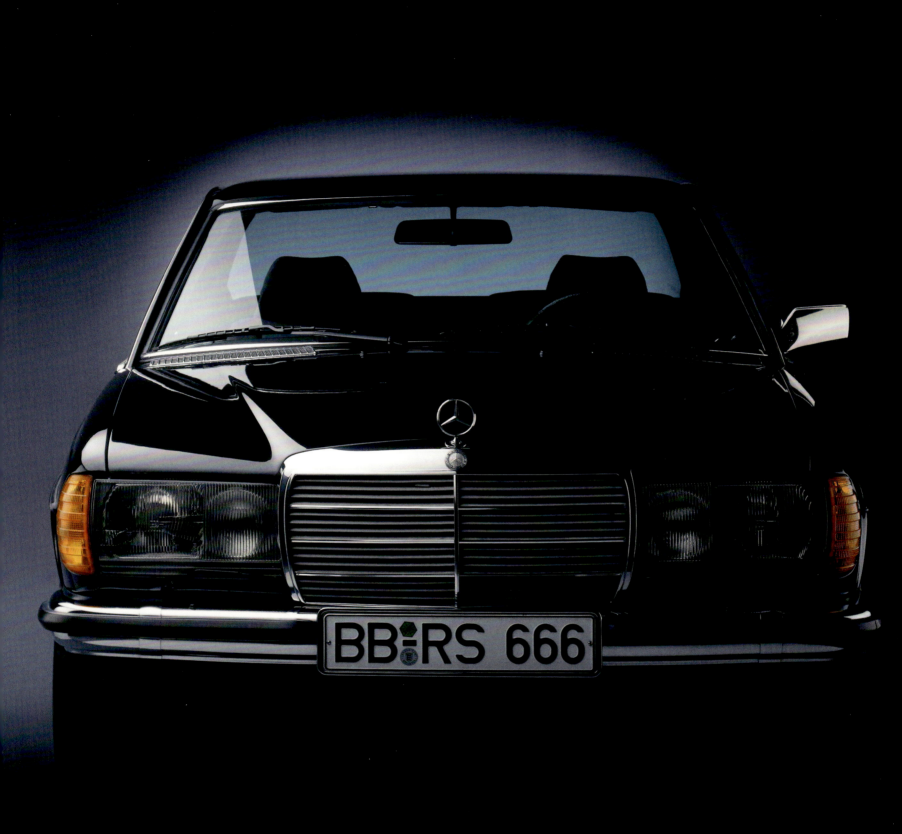

Mercedes-Benz 190 E 2.5-16 Evolution II
1990

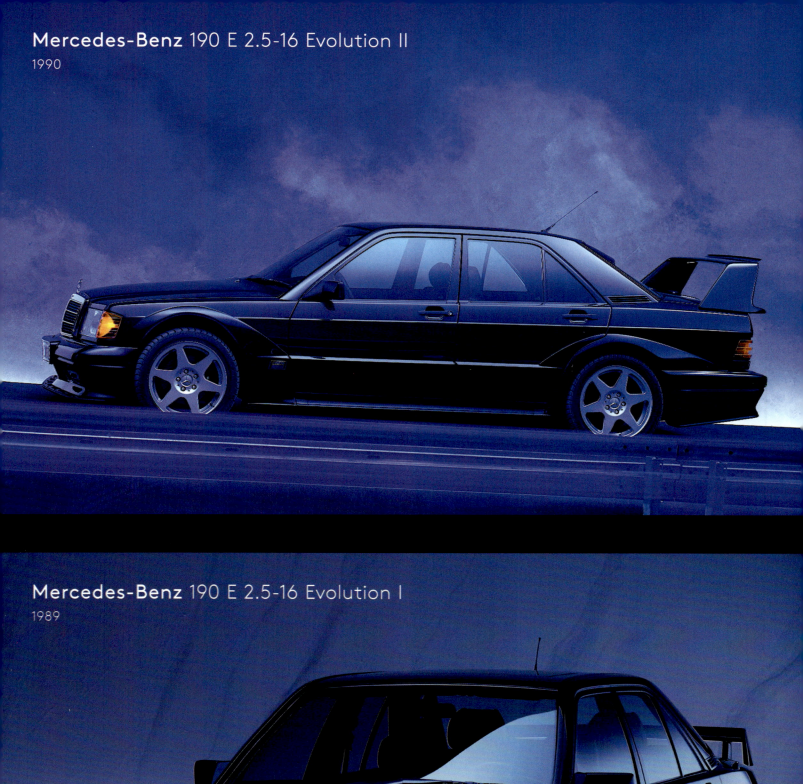

Mercedes-Benz 190 E 2.5-16 Evolution I
1989

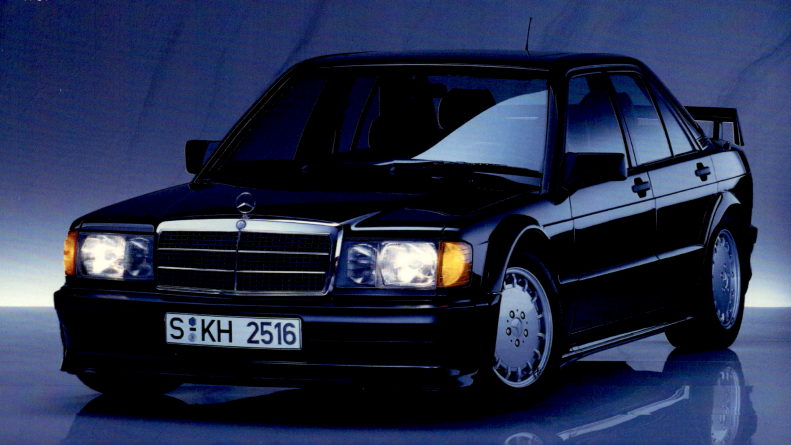

Mercedes-Benz 190
1982–1993

Mercedes-Benz C-Klasse
2000–2007

96/97

Mercedes-Benz SL 55 AMG

2001–2006

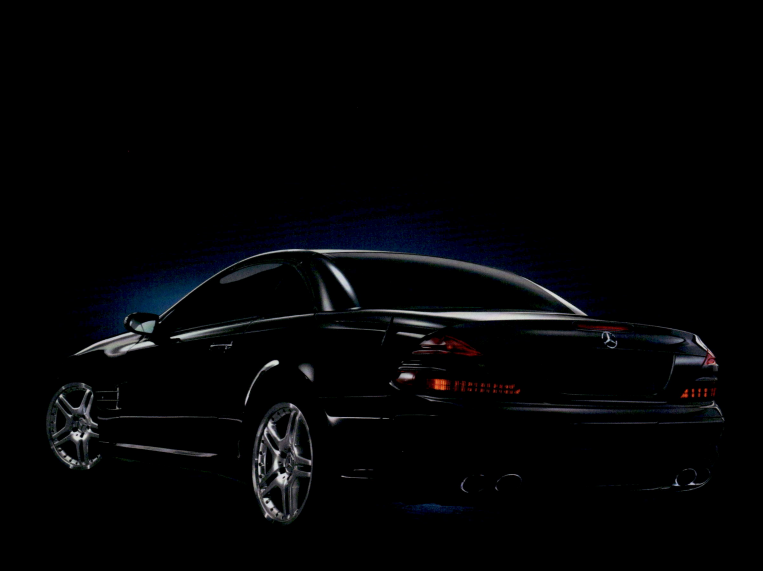

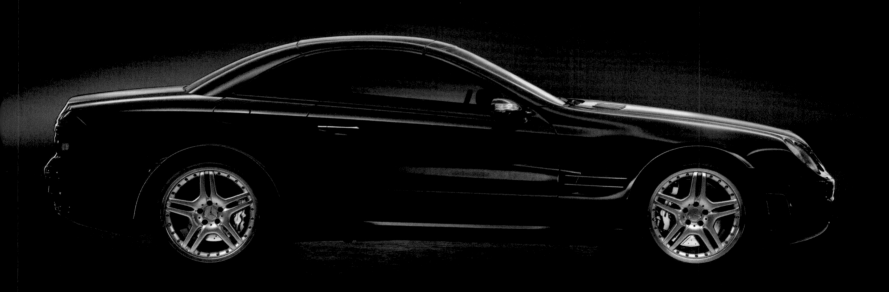

BLACK IS A NON-COLOR!
Stefan Sielaff, Director of Design, Bentley Motors Limited

It wasn't just Johann Wolfgang von Goethe and Johannes Itten who ranted like this in their color theories, but also my university professors more than 30 years ago, who were all adherents of Bauhaus doctrine.

Of course, from a strictly scientific perspective, black is indeed simply the lack of a light projection area. But there is always a psychological projection area as well. And it is a gigantic one where black is concerned. Particularly in automotive design, black is associated with power, status, elegance, and timelessness.

At Bentley, it is traditional for us to present our 1:1 design models in silver to ensure neutrality and comparability and to make it easier to focus on the pure shape of our sculptures. Now, however, we place a duplicate model in black next to the silver one so we can evaluate the interactions, proportions, and contrasts of the chrome applications on the body of the vehicle. Many luxury Bentley vehicles are used as official state vehicles or ordered as an elegant declaration of the owner's unusual lifestyle. And they are quite deliberate in their choice of black, because after all, "black is beautiful!"

SCHWARZ IST EINE UNFARBE!

Stefan Sielaff, Leiter Design, Bentley Motors Limited

So wetterten nicht nur Johann Wolfgang von Goethe und Johannes Itten in ihren Farbenlehren, sondern später auch meine von den Bauhaus-Doktrinen beseelten Dozenten vor mehr als 30 Jahren.

Natürlich ist Schwarz einfach nur der Mangel an Lichtprojektionsfläche – streng wissenschaftlich betrachtet! Aber: Es gibt immer auch eine psychologische Projektionsfläche. Und die ist bei der Farbe Schwarz gigantisch. Besonders im Automobildesign ruft Schwarz Assoziationen mit Macht, Status, Eleganz und Zeitlosigkeit hervor.

Traditionell präsentieren wir bei Bentley unsere 1:1-Designmodelle in Silber, um Vergleichbarkeit und Neutralität herzustellen. Es soll die Konzentration auf die pure Form unserer Skulpturen erleichtern. Neuerdings stellen wir jetzt aber auch ein Duplikat in Schwarz daneben, um die Wechselwirkungen, Proportionen und Kontraste der Chromapplikationen auf unseren Karosserien bewerten zu können. Denn viele Produkte der Luxusmarke Bentley werden als Staatskarossen oder als elegantes Statement eines außergewöhnlichen Lebensstils von unseren Kunden bestellt. Und das eben ganz bewusst in der Farbe Schwarz, denn: „Black is beautiful"!

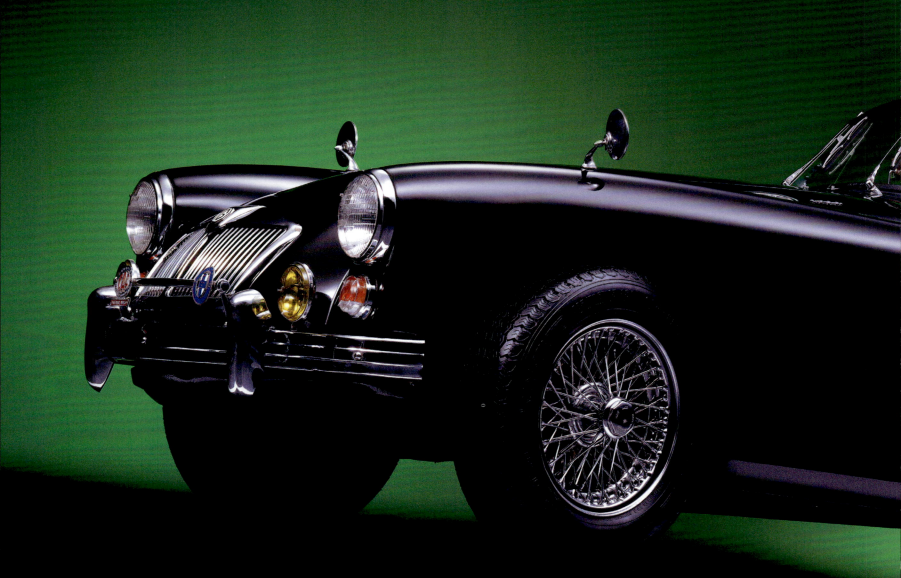

BLACK POWER

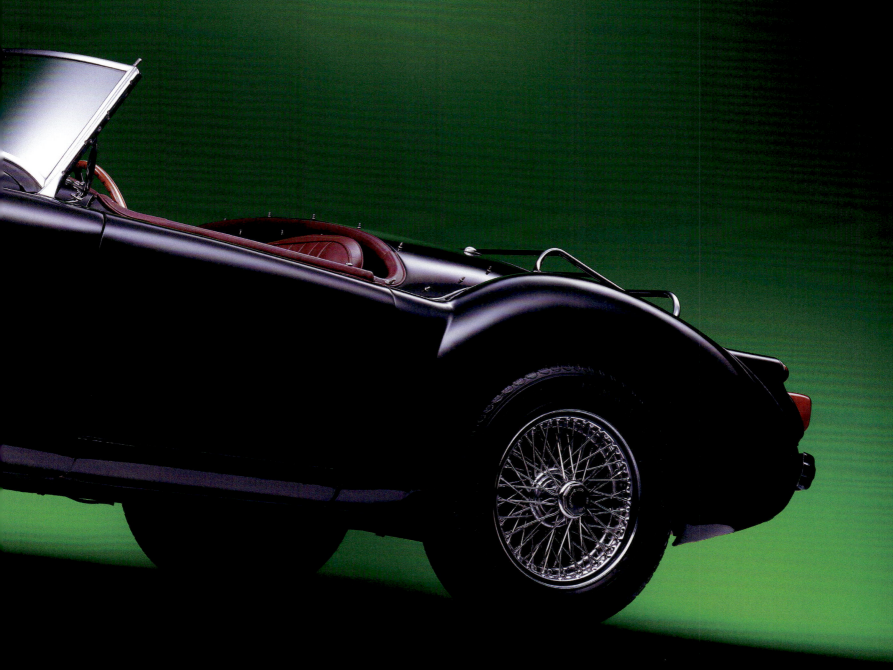

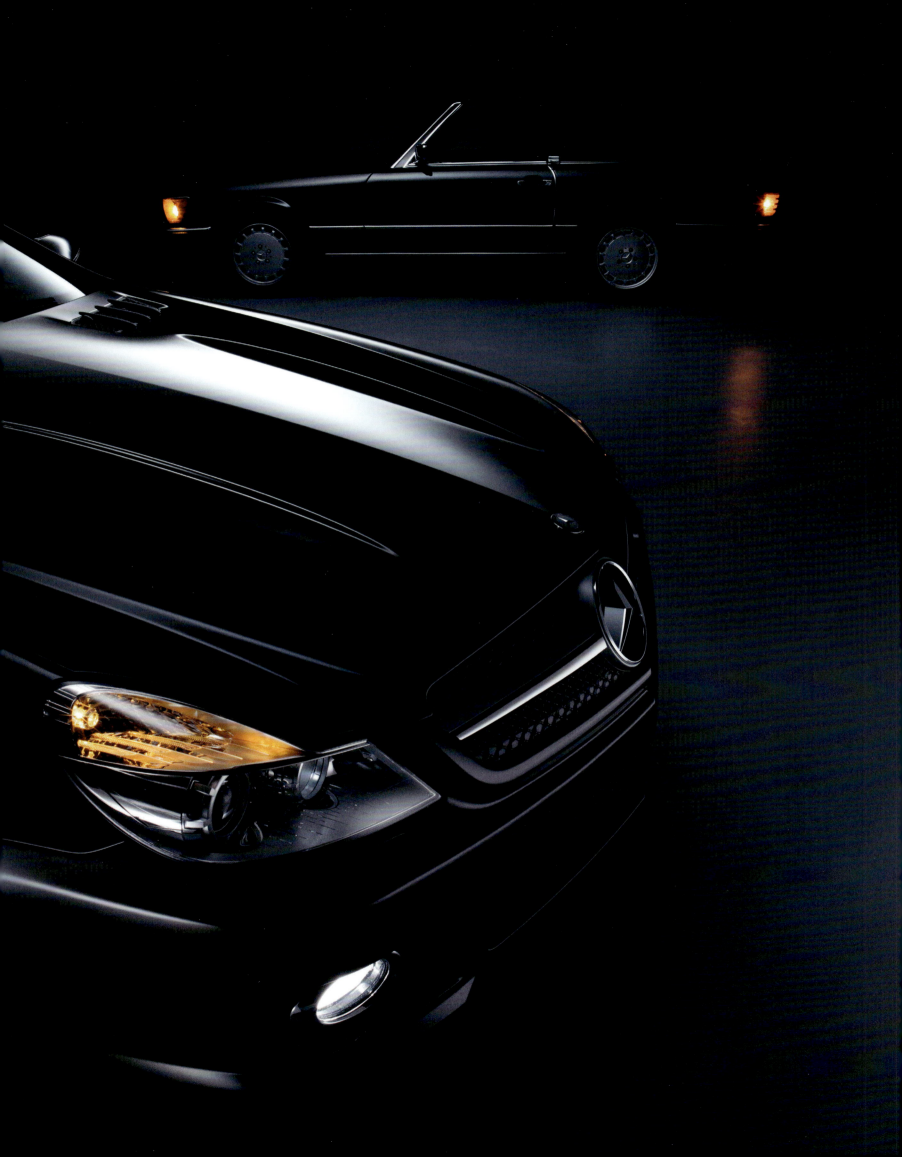

Even though Italian sports cars and race cars are usually painted red, and the Brits prefer theirs in British racing green, while the French make theirs blue, there is only one global color that perfectly expresses the strength and beauty of a sports car: black. And what better example is there than the mighty Maserati 450 S? Only ten were built in 1957–58, and it was the most powerful sports car of its day. And what color was this vehicle, the first to offer 400 hp? Black, of course. And how did Adam Opel AG paint its Opel Rekord C, the car then-Head of Sales Bob Lutz wanted to go into racing with? Also black. It's no wonder that this hot rod brimming with power, which was summarily banned from American tracks by General Motors' Board of Directors after only a few outings, quickly garnered the nickname "Black Widow."

Andrea Zagato, owner of legendary Italian design studio Carrozzeria Zagato, loves this color so much that both his personal and business cars have always been, and will always be, black. So it's no surprise that if it had been up to him, all 274 Roadster Zagato models he built, futuristic vehicles that have both sharp edges and rounded lines, would have been black, but the sales team insisted he also offer some in red and yellow. Today, a black R.Z. is a great rarity in any auto collection.

But back to the theme of power—when is a car truly powerful? This is not a simple question to answer, because it is, of course, about much more than what's under the hood. With enough muscle, any vehicle can be positioned as a sports car. The art lies in finding a package that allows the horsepower to achieve a harmonious fusion with the car's weight, body, and aerodynamic profile. The result is a large fleet of small, agile sports cars that can sometimes leave even the high-hp heroes in the dust. Of course, it's really perfect when power, body, and weight all connect at a very high level—then you get classics like the BMW 507, the Jaguar XK models, and the grandiose creations of Aston Martin. And if you really want to own an excess of horsepower, consider something from AMG. Even the dripping-with-power AMG CLK looks elegant and confident in black. It's just another example of the flexibility this non-color enjoys.

Auch wenn italienische Renn- und Sportwagen zumeist rot lackiert daherkommen und sich die Briten ihre Sportwagen gerne in British Racing Green und die Franzosen ihre in Blau bemalen, so gibt es doch weltweit nur eine Lackierung, mit der Kraft und Herrlichkeit eines Sportwagens perfekt dargestellt werden: Schwarz. Welcher Wagen könnte dies besser repräsentieren als der mächtige Maserati 450 S, der – von 1957 bis 1958 in nur zehn Exemplaren gebaut – der stärkste Sportwagen seiner Zeit war. Was für eine Farbe das erste dieser 400 PS leistenden Geschosse hatte? Natürlich Schwarz. Und wie lackierte die Adam Opel AG den Opel Rekord C, mit dem der damalige Vertriebs-Vorstand Bob Lutz in den Rennsport gehen wollte? Ebenfalls schwarz. Kein Wunder, dass dies vor Kraft strotzende Gefährt, das übrigens nach wenigen Einsätzen vom General Motors-Vorstand in den USA wieder von den Rennstrecken verbannt wurde, rasch den Namen „Schwarze Witwe" erhielt.

Andrea Zagato, der Inhaber des legendären italienischen Designstudios Carrozzeria Zagato, liebt diese Farbe so sehr, dass seine Privat- und Dienstwagen immer schwarz lackiert waren und sind. Da verwundert es nicht, dass er auch die 274 gebauten, futuristischen, gleichermaßen kantig und abgerundeten Roadster Zagato am liebsten nur in Schwarz ausgeliefert hätte – doch der Vertrieb bestand auch auf den Farben Rot und Gelb. So gehört ein schwarzer R.Z. heute zu den großen Raritäten in jeder Kollektion.

Aber zurück zum Thema Power – wann hat ein Wagen tatsächlich Power? Das ist keine einfach zu beantwortende Frage, denn es sollte natürlich nicht nur die zur Verfügung stehende Kraft ins Kalkül gezogen werden. Mit viel Leistung kann sich jedes Fahrzeug sportlich positionieren. Die Kunst besteht darin, ein Package zu finden, in dem die Power harmonisch mit dem Gewicht, dem Fahrwerk und der Aerodynamik verschmilzt. Daraus resultiert dann eine Vielzahl von kleinen, agilen Sportwagen, die zuweilen sogar den PS-Helden davonfahren können. Perfekt wird es natürlich, wenn sich Leistung, Fahrwerk und Gewicht auf hohem Niveau verbünden – das Ergebnis sind dann Gefährte wie der BMW 507, die Jaguar XK-Modelle oder die grandiosen Geschöpfe des Hauses Aston Martin. Und wer Leistung im Überfluss besitzen möchte, kann zu den Modellen von AMG greifen. Dabei wirkt selbst der kraftstrotzende AMG CLK mit schwarzer Lackierung elegant und selbstbewusst. Ein weiterer Beweis für die Flexibilität, die diese Nicht-Farbe auszeichnet.

Alfa Romeo Roadster Zagato
1992–1993

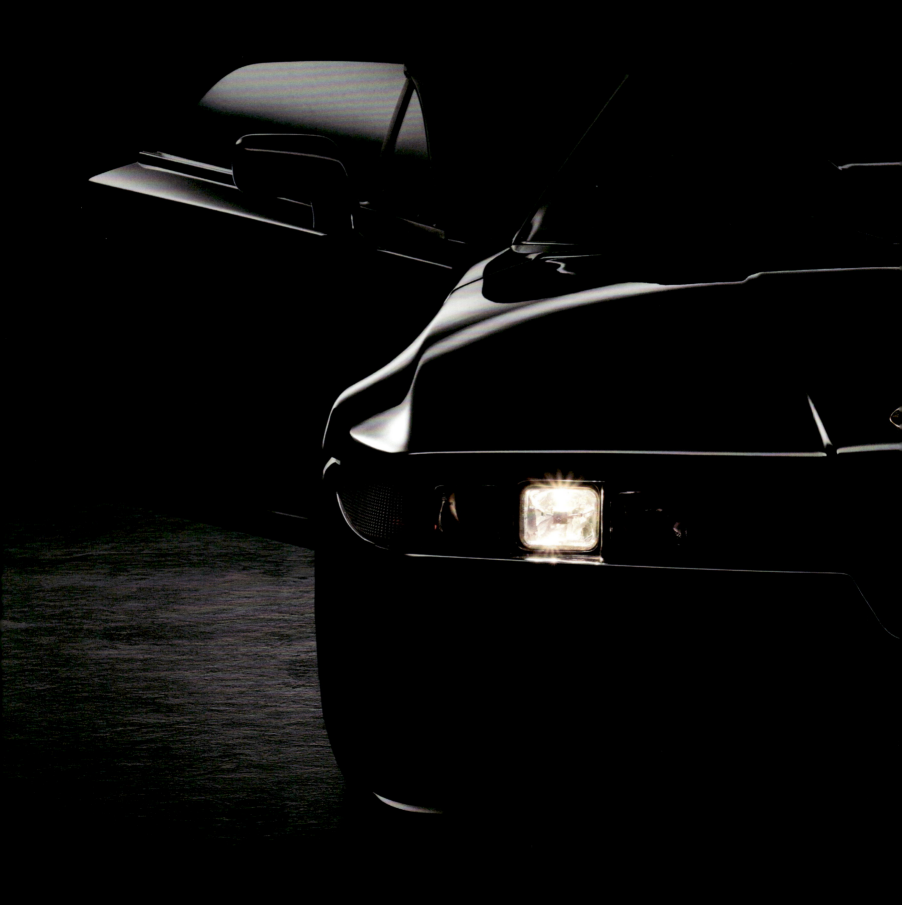

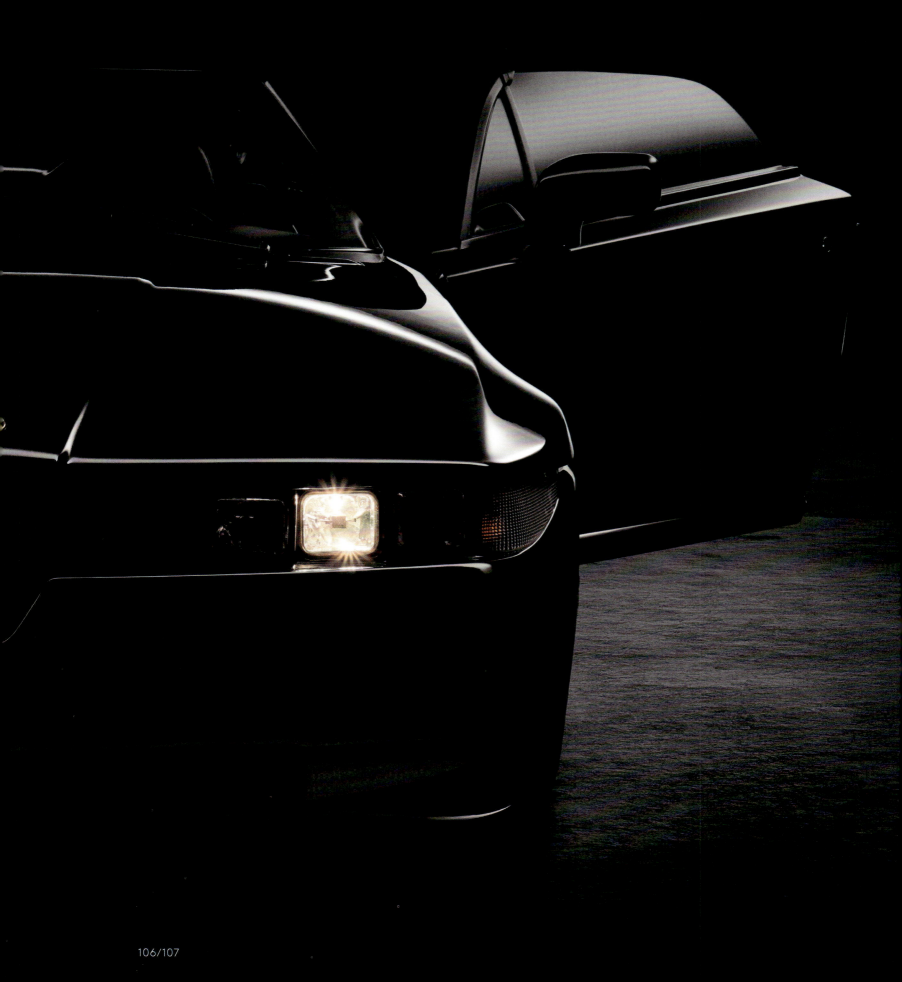

Alfa Romeo Roadster Zagato

1992–1993

Alfa Romeo Spider 2.0 Serie 4

1990–1993

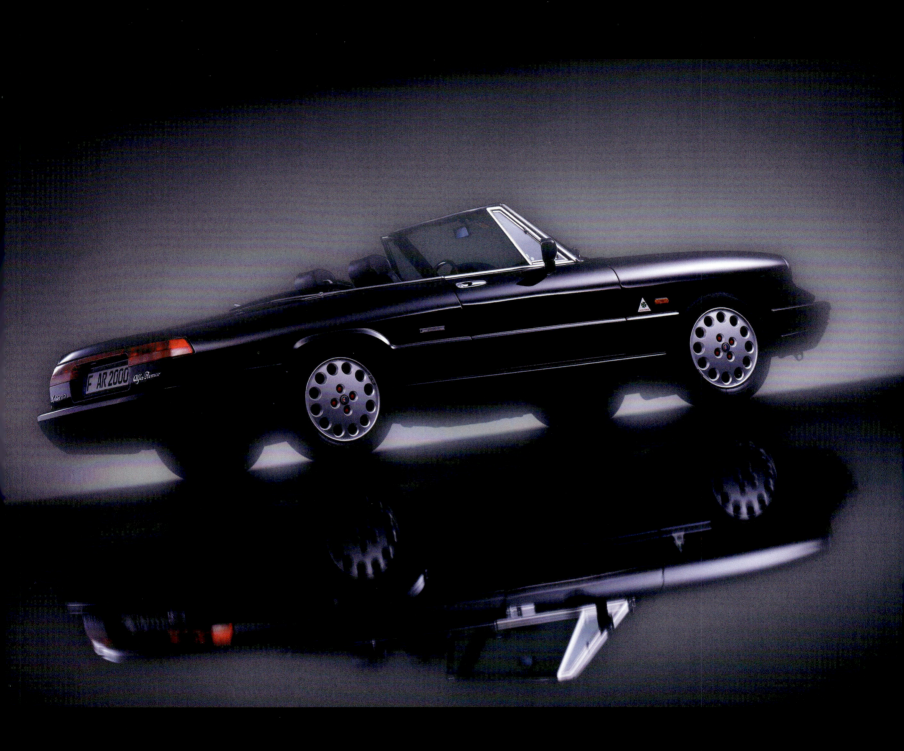

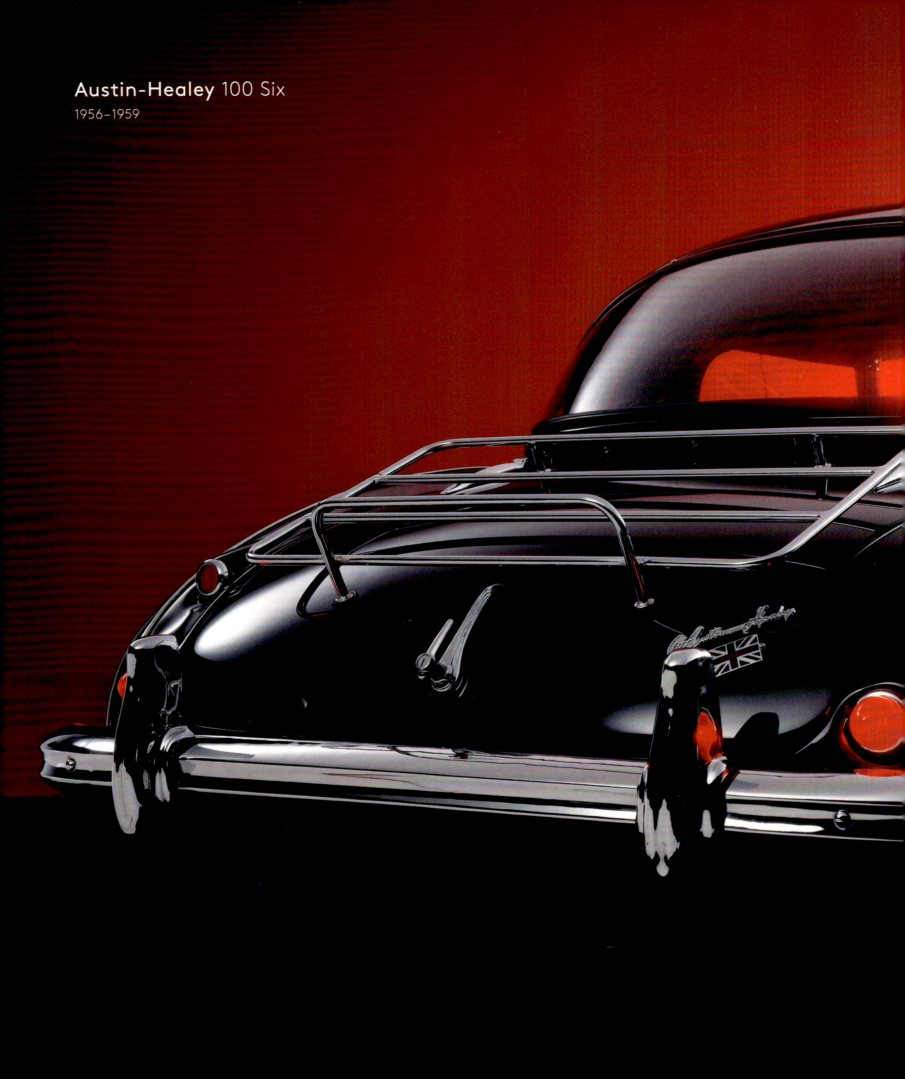

Austin-Healey 100 Six
1956–1959

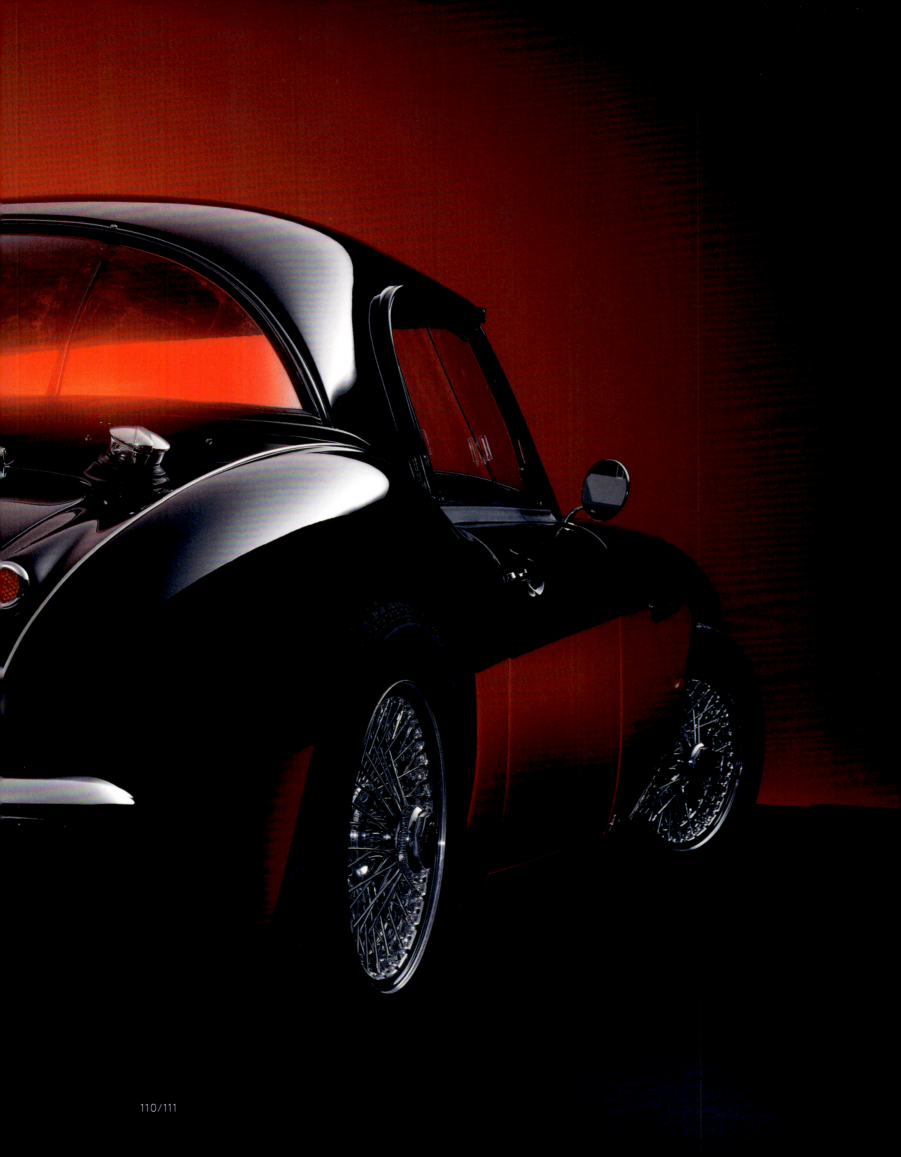

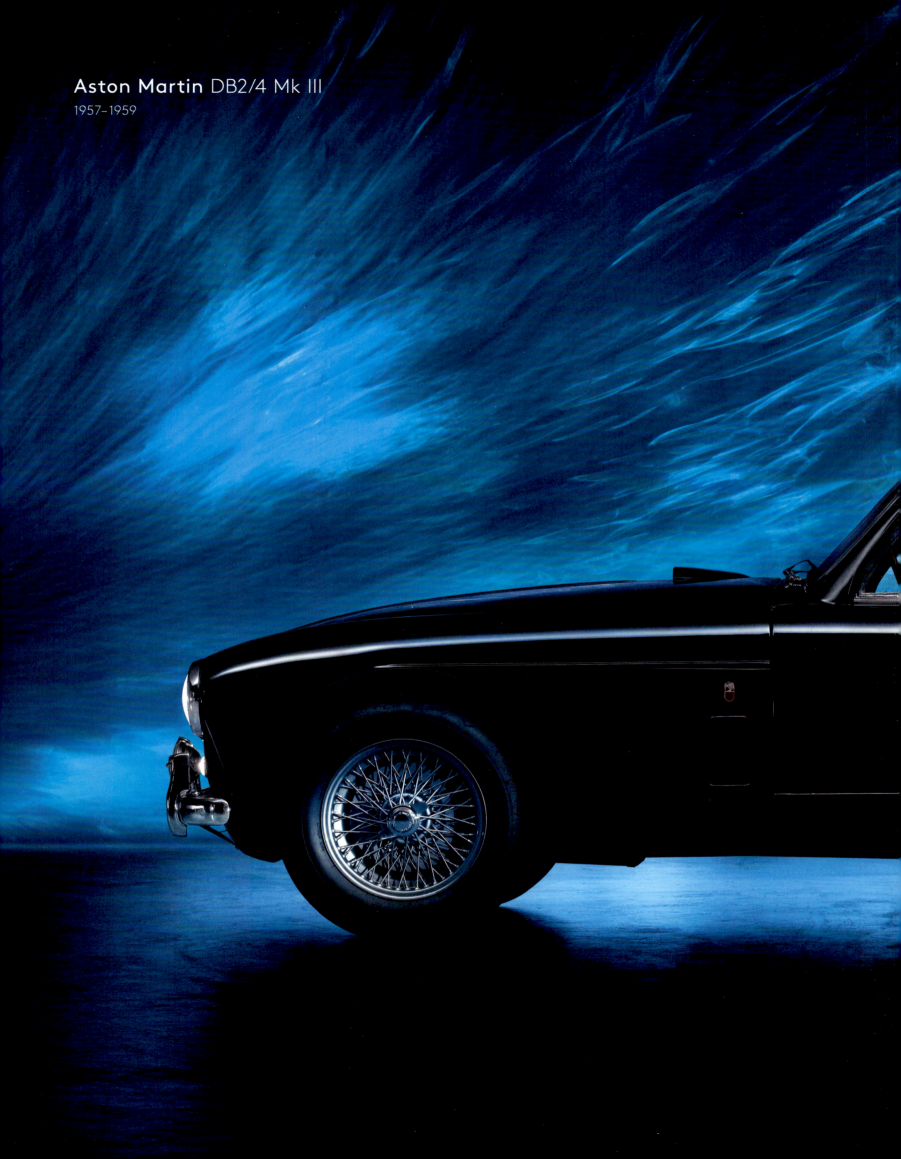

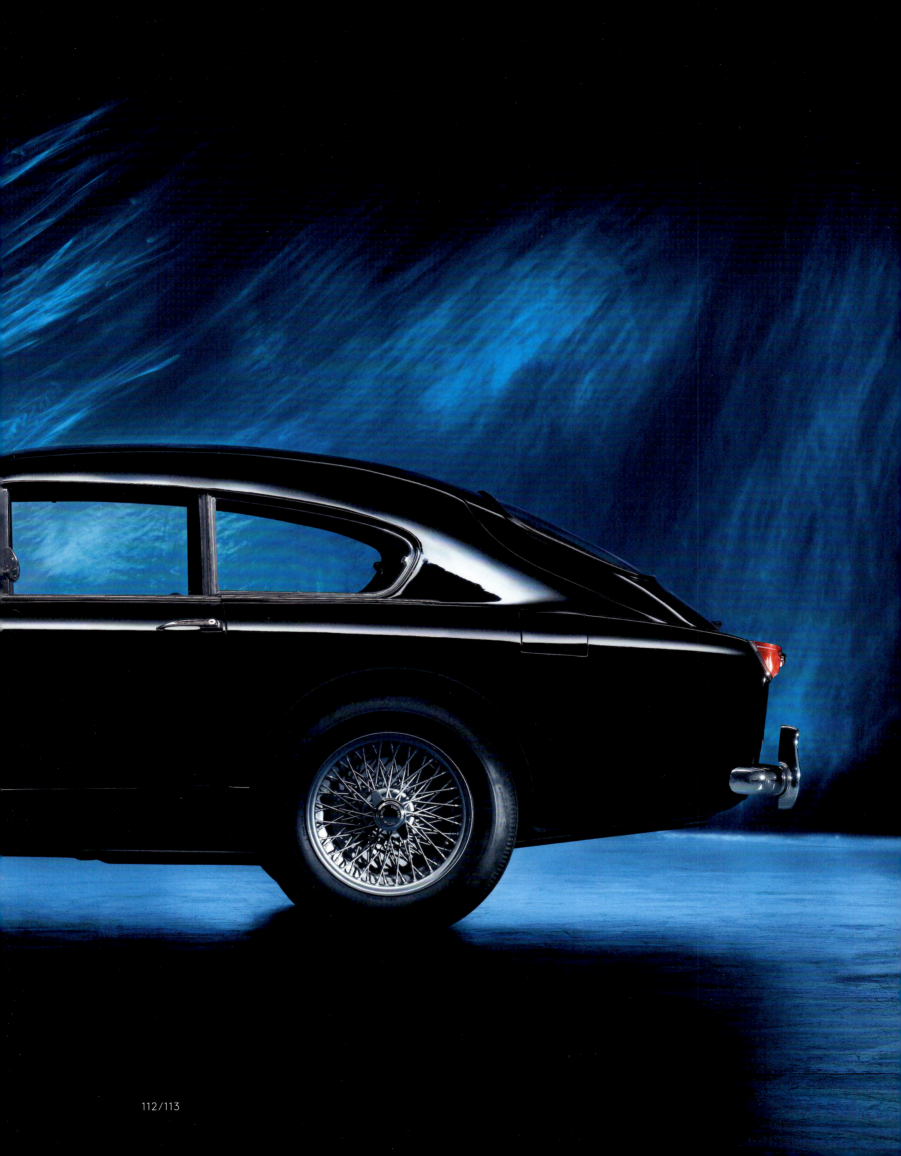

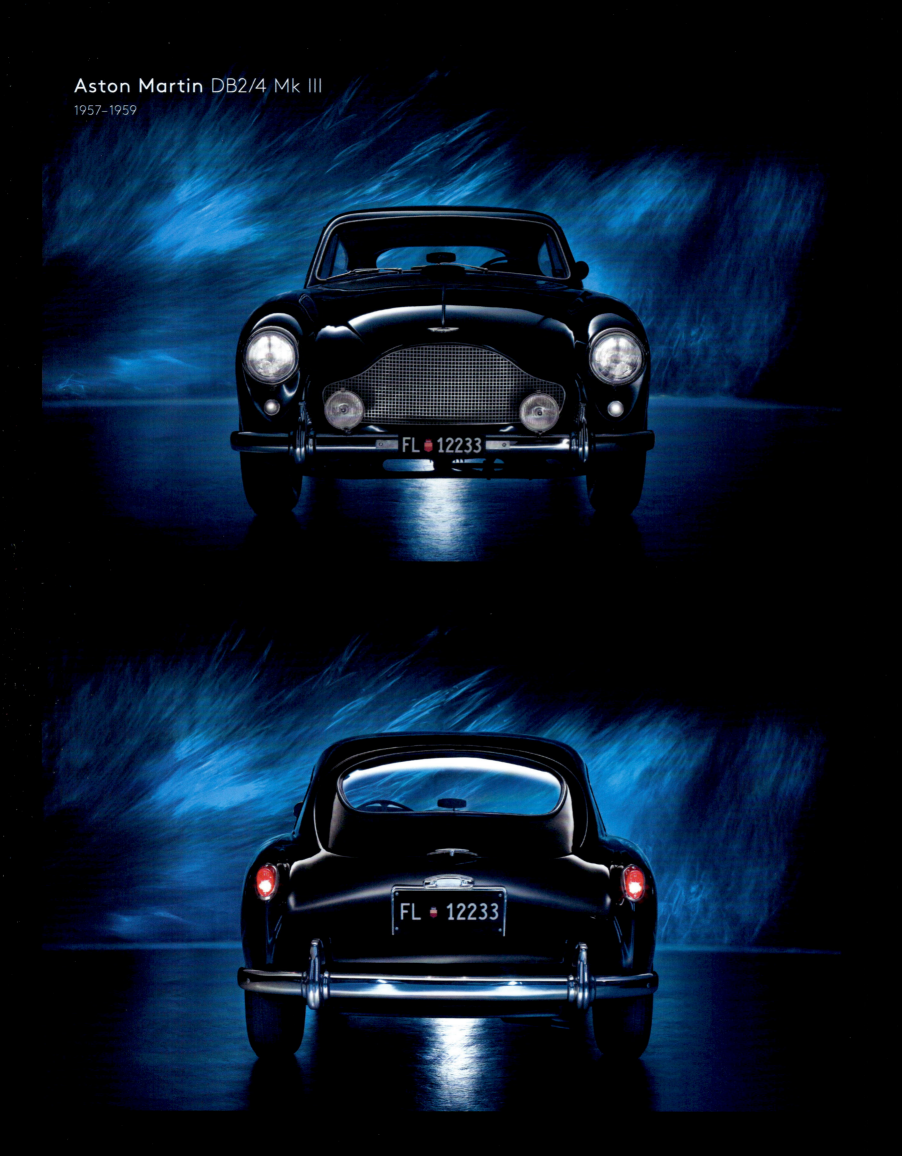
Aston Martin DB2/4 Mk III
1957–1959

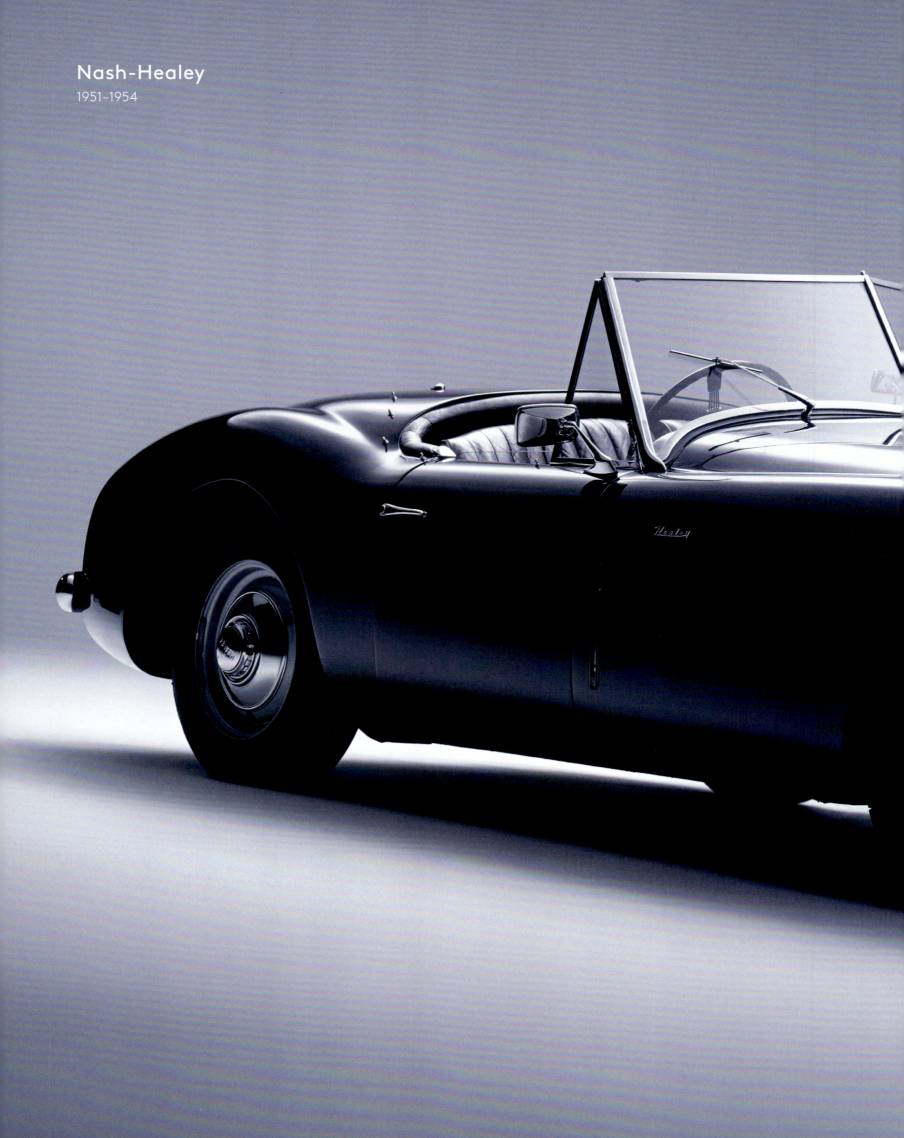

Nash-Healey
1951–1954

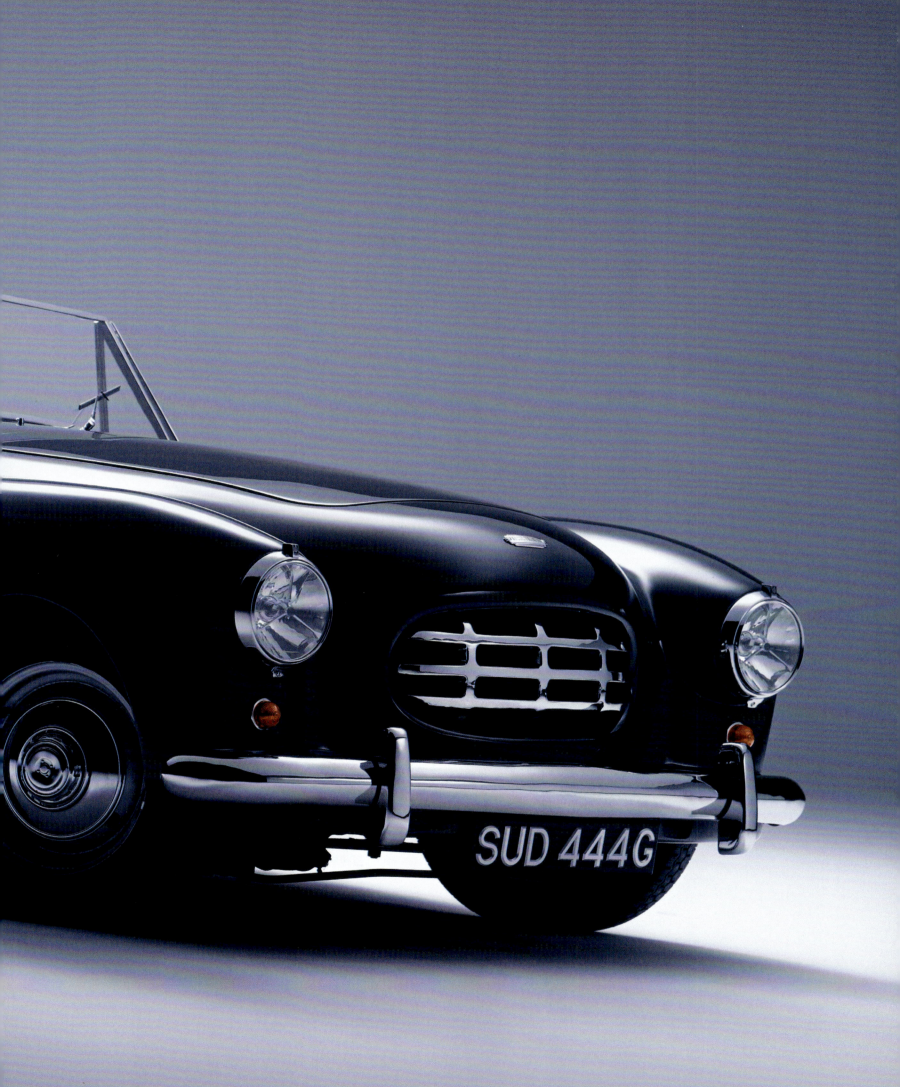

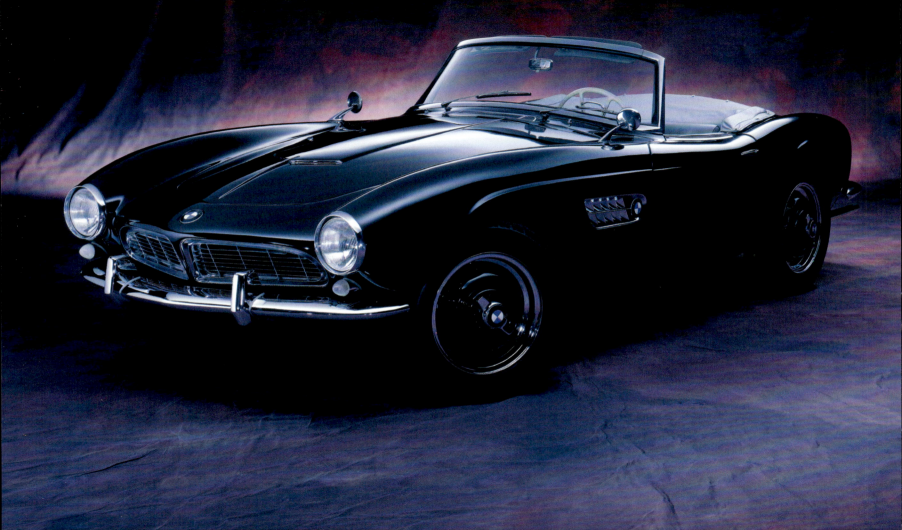

BMW 3.0 CSL

1971–1975

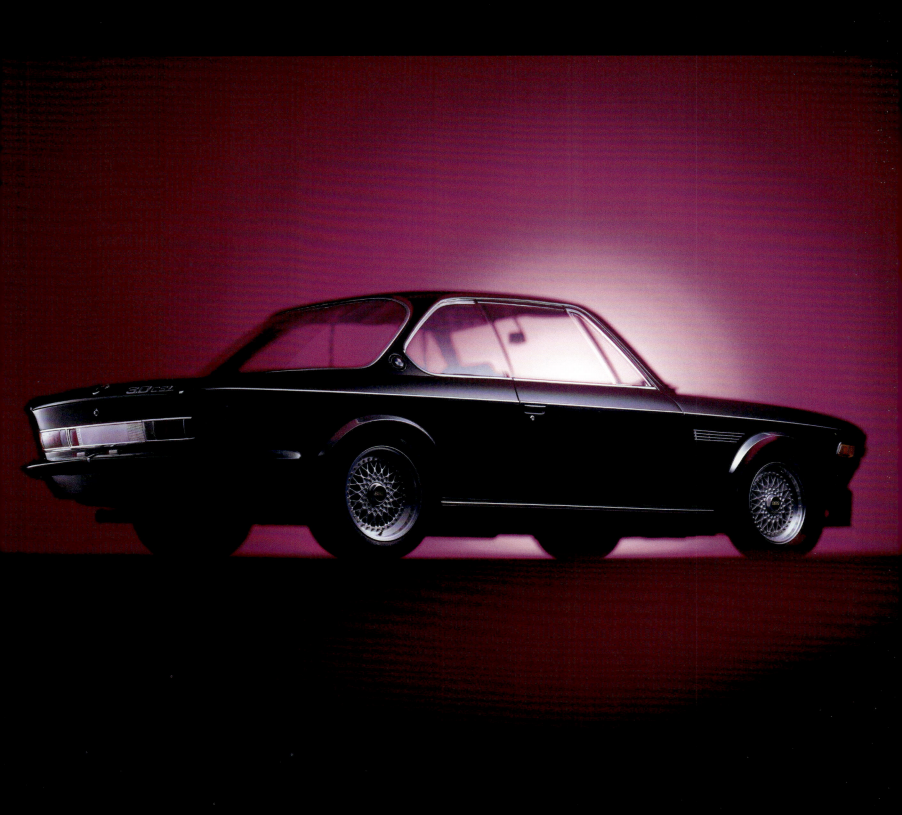

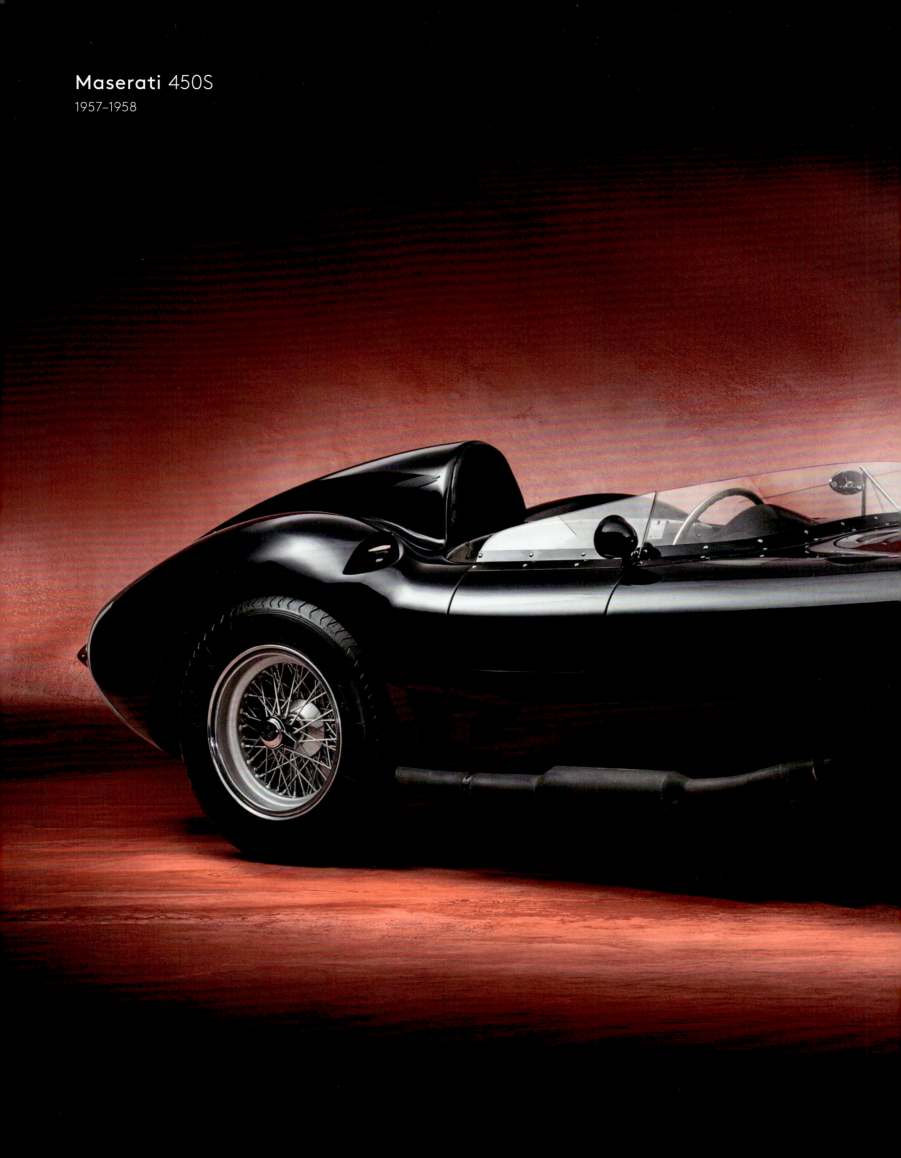

Maserati 450S
1957–1958

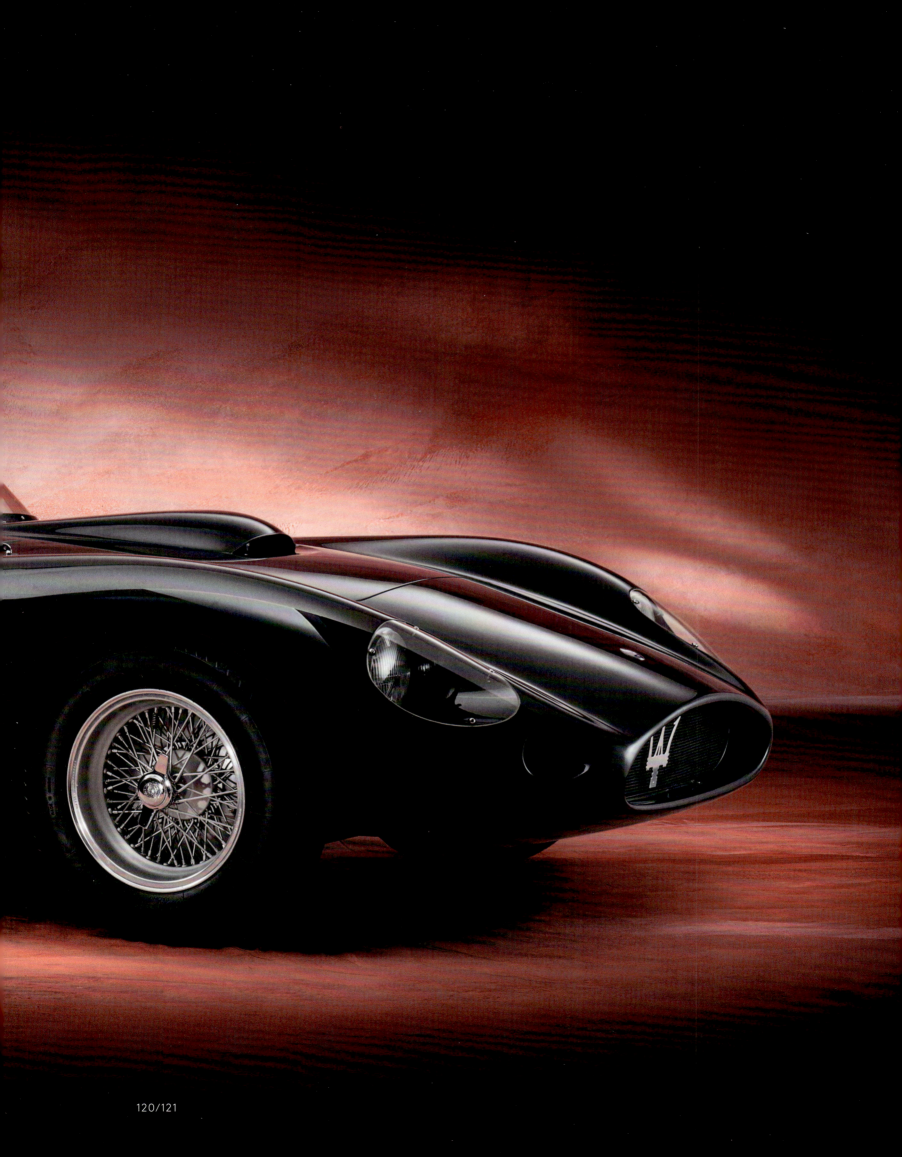

Opel Rekord C „Schwarze Witwe"
1967

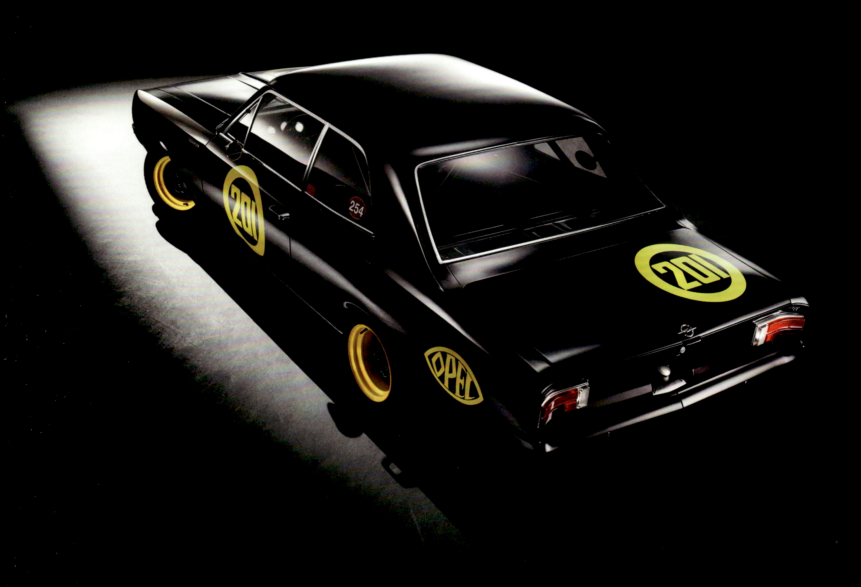

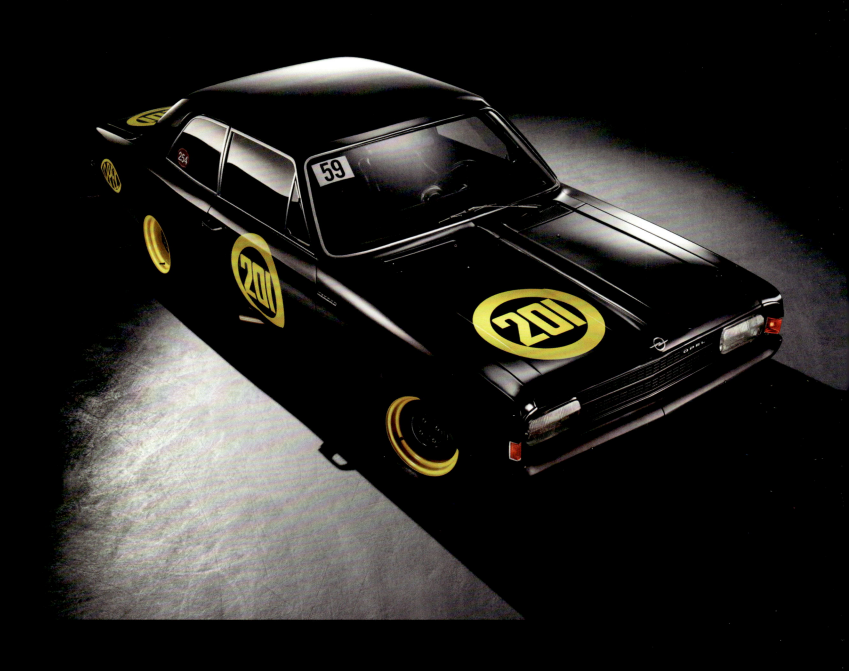

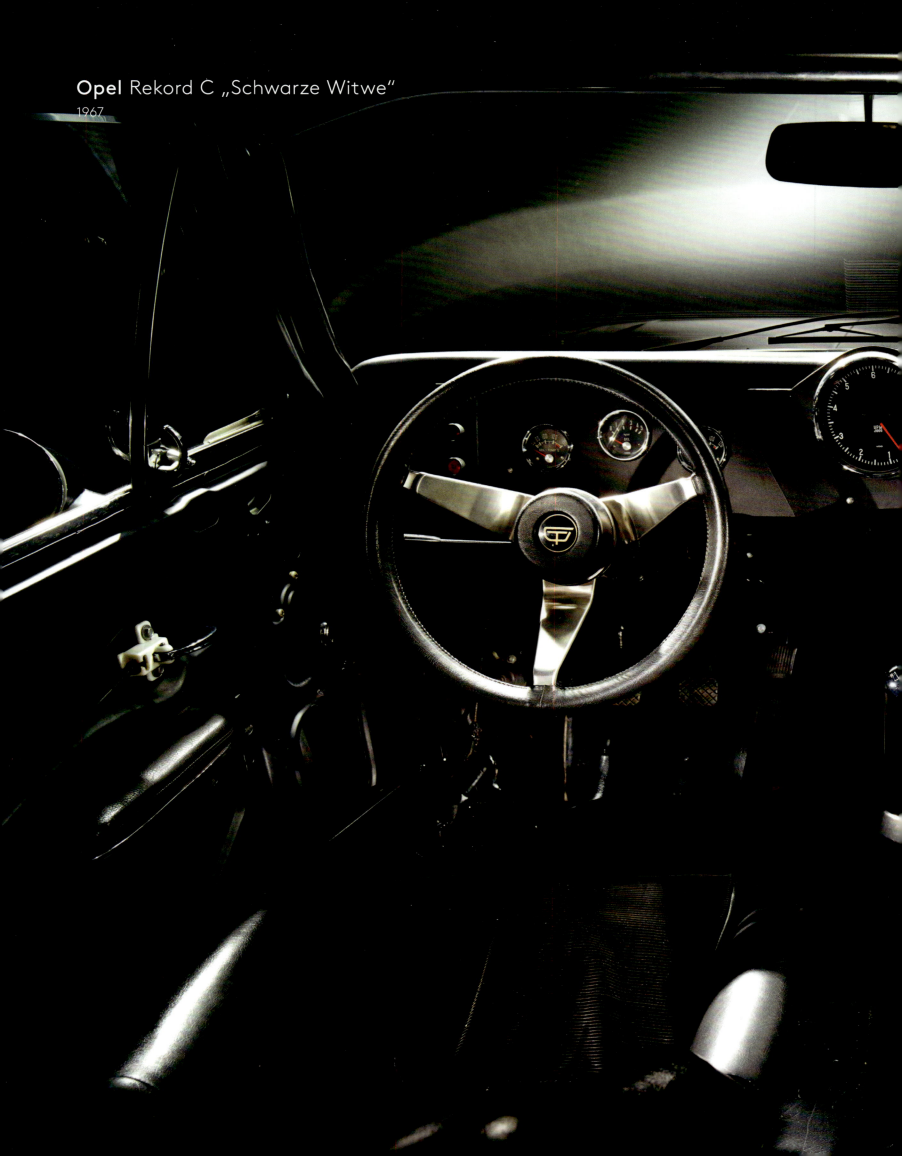
Opel Rekord C „Schwarze Witwe"
1967

Morgan Plus 8
1968–2004

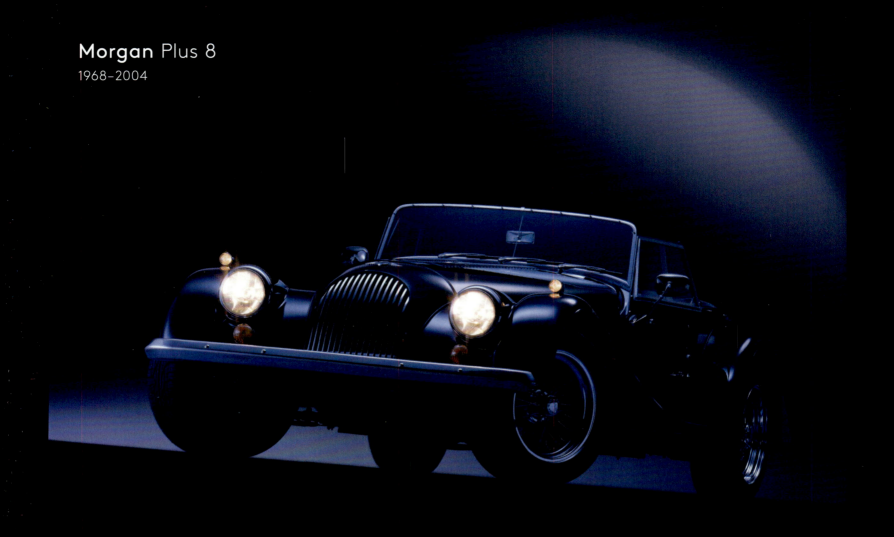

MG B Roadster
1962–1980

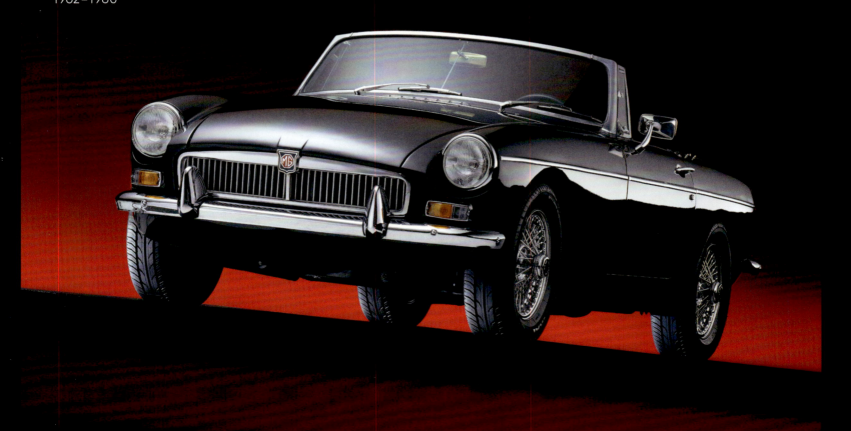

Jaguar XK 140
1954–1957

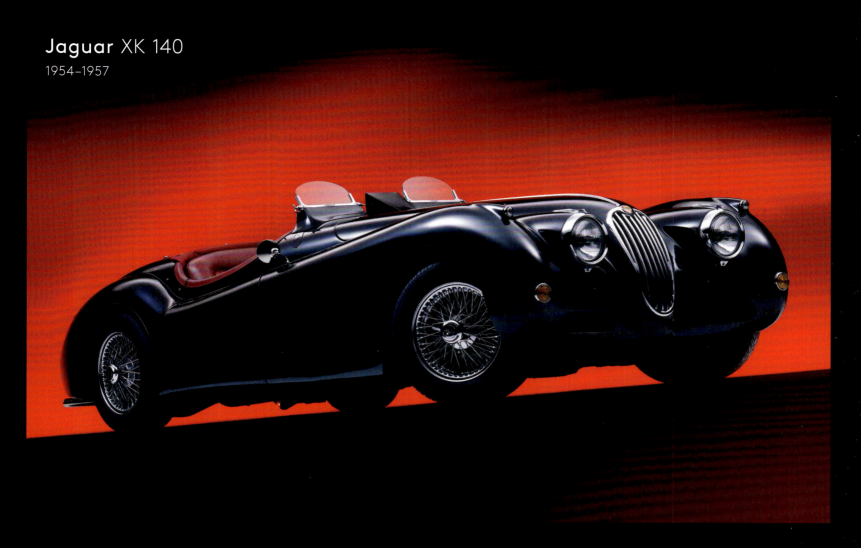

Jaguar XK 140
1954–1957

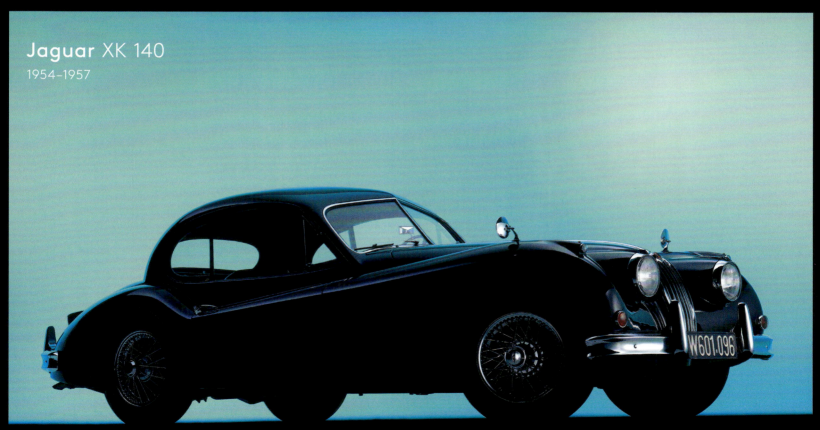

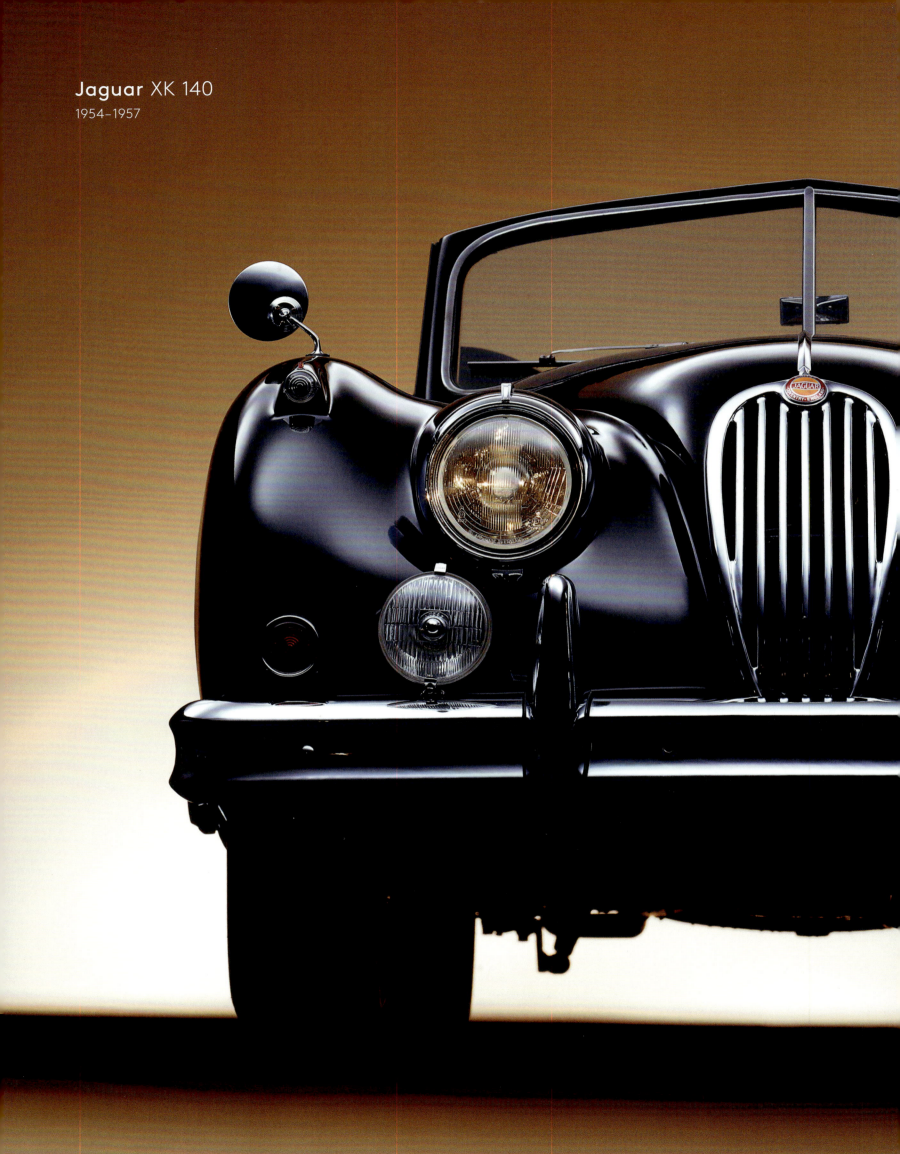

Jaguar XK 140
1954–1957

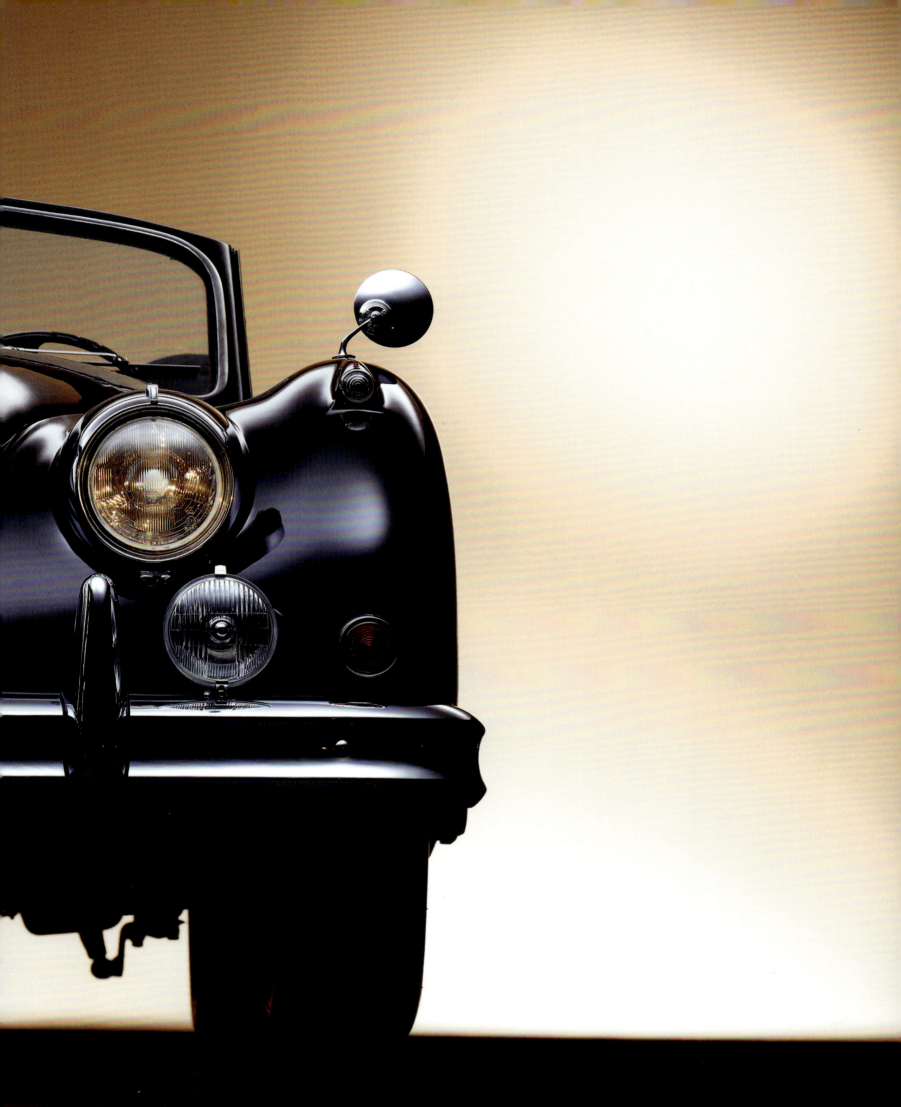

BLACK: THE COLOR FOR ARCHITECTS?

Prof. Werner Sobek, Founder and Owner, Werner Sobek Group

"Why do architects wear black?" asks a little book that was published in 2008 by Springer Verlag. Editor Cordula Rau asked 100 architects why they wear black. The variety in their answers is enormous, not to mention colorful. As one would expect, there was no agreement why architects (supposedly) always wear black—or whether they actually do it at all. Asking myself this question, I feel just the same. I like to wear suits in muted colors—but they don't have to be black. And a *white* shirt with it is a must. But what about other areas of my life? Many of my past and present cars have been black. It really brings out the message the car's contours are trying to convey. But an Aston Martin in metallic silver also makes a great impression.

It's the same with my work as an architect and engineer. Black plays only a very subordinate role in my designs. To borrow a comparison from Anselm Kiefer (from his acceptance speech for the German Booksellers' Peace Prize on October 19, 2008 in St. Paul's Church in Frankfurt), I would describe my creative work as thinking and working with three-dimensional images, in only half-conscious compositions of material, of color and light, sounds, smells. In this sea of initial uncertainties, blurry notions, from which concrete buildings and tangible landscapes will arise, the sciences are my home base, the immovable islands of what I think I know for sure. "I swim to them, from one to the next; between them, without them, I am lost."

As a scientist, I think in mathematically defined correlations, in structures and systems. And still, despite all of the rationality, peace and security it gives me, science alone will never completely satisfy me. Not when there are things like an agitated, staggering red that can turn our whole mood upside down. Not when there are melodies that can make us cry. Not when there are paintings like the impressions of Montagne Sainte-Victoire by Cézanne. All of these things speak of, to use a wonderful turn of phrase from Gottfried Schatz, "a magical land beyond science." This land is my home. The most important principle that underpins my work is the search for beauty arising from the simple and the minimal. Many times, this beauty can only be shown in black. But just as frequently, it needs a contrast to bring out its special aspects—maybe a different color, or maybe just a nuancing of reflections and brightness. The art lies in finding the right balance in such cases—not just for architects, but for everyone else as well. In the photos shown here, René Staud does an outstanding job showing how you strike this balance: simple, minimal, beautiful. And black is welcome, but never to the exclusion of everything else.

SCHWARZ: FARBE DER ARCHITEKTEN?

Prof. Werner Sobek, Gründer und Eigentümer, Werner Sobek Group

„Why do architects wear black?" fragt ein kleines Büchlein, das 2008 im Springer-Verlag erschien. Die Herausgeberin Cordula Rau hat 100 Architekten befragt, warum sie Schwarz tragen. Die Vielfalt der Antworten ist extrem groß, um nicht zu sagen: bunt. Wie kaum anders zu erwarten, herrschte bei den Befragten keine Einigkeit darüber, warum Architekten (angeblich) immer Schwarz tragen – und ob sie es überhaupt tun. Ähnlich geht es mir selbst, wenn ich mir diese Frage stelle. Ich trage gerne Anzüge in gedeckten Farben – es muss aber nicht unbedingt Schwarz sein ... Und: Dazu gehört auf jeden Fall ein *weißes* Hemd. Wie sieht es in anderen Bereichen aus? Viele meiner Autos waren bzw. sind schwarz. So kommt die Formensprache der Karosserie besonders gut zur Geltung. Aber ein Aston Martin in Silber Metallic wirkt auch sehr gut.

Ähnlich sieht es bei meiner Arbeit als Architekt und Ingenieur aus. Bei meinen Entwürfen spielt Schwarz nur eine sehr untergeordnete Rolle. Ein Gleichnis von Anselm Kiefer (aus einer Dankesrede anlässlich der Verleihung des Friedenspreises des Deutschen Buchhandels am 19.10.2008 in der Frankfurter Paulskirche) heranziehend beschreibe ich mein eigenes gestalterisches Schaffen als ein Denken und Arbeiten in dreidimensionalen Bildern. In häufig nur erahnten Kompositionen aus Material, aus Farbe und Licht, aus Klängen, aus Gerüchen. In diesem Meer der anfänglichen Ungewissheiten, Unschärfen, aus dem einmal konkrete Gebäude und konkrete Landschaften entstehen werden, bilden die Wissenschaften meine festen Inseln. Die Inseln meiner vermeintlichen Gewissheiten. „Ich schwimme zu ihnen, von einer zur anderen; dazwischen, ohne sie, bin ich verloren".

Als Wissenschaftler denke ich in mathematisierbaren Zusammenhängen, in Strukturen und Systemen. Und doch, trotz aller dabei erfahrenen Ratio, Ruhe und Sicherheit, kann mich die Wissenschaft allein nie ganz befriedigen. Gibt es doch Dinge wie ein aufrührend taumelndes Rot, das unsere Seelenstimmung umzustürzen vermag. Gibt es doch Melodien, die uns zum Weinen bringen. Gibt es doch Bilder wie die von Cézanne geschaffenen Impressionen der Montagne Sainte-Victoire. Allesamt erzählen sie, um es mit einer wunderbaren Formulierung von Gottfried Schatz auszudrücken, „von einem verzauberten Land, das jenseits der Wissenschaft liegt". Dieses Land ist meine Heimat. Das wichtigste Prinzip, das meiner Arbeit zugrunde liegt, ist für mich die Suche nach dem Schönen, das sich aus dem Einfachen und dem Minimalen entwickelt. Oft lässt sich dieses Schöne alleine mit Schwarz abbilden. Aber genauso oft braucht es auch einen Kontrast, um das Besondere herauszuheben – vielleicht eine andere Farbe, vielleicht aber auch nur eine Nuancierung der Reflexionen und der Helligkeit. Hier die richtige Balance zu finden ist die große Kunst – nicht nur für Architekten, sondern auch für alle anderen Gestalter. René Staud zeigt mit seinen hier dokumentierten Fotoarbeiten in herausragender Art und Weise, wie man eine solche Balance findet: einfach, minimal, schön. Und gerne auch schwarz. Aber nie ausschließlich.

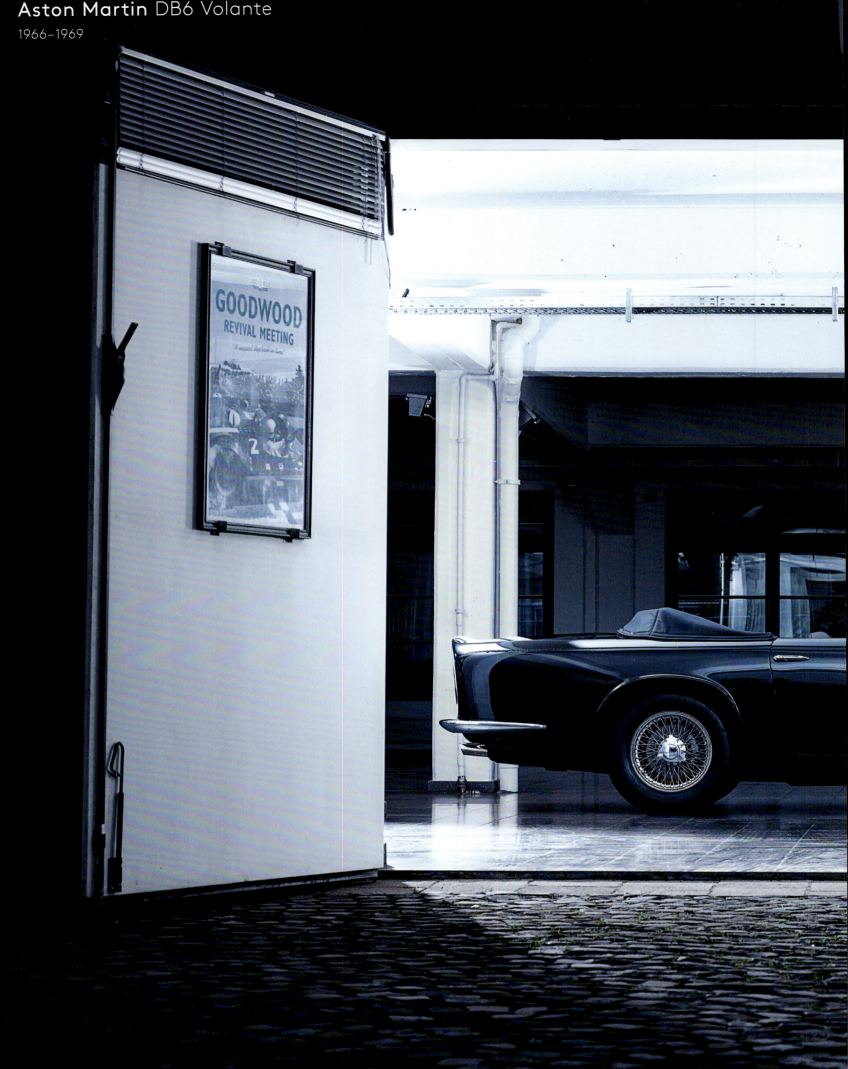

Aston Martin DB6 Volante
1966–1969

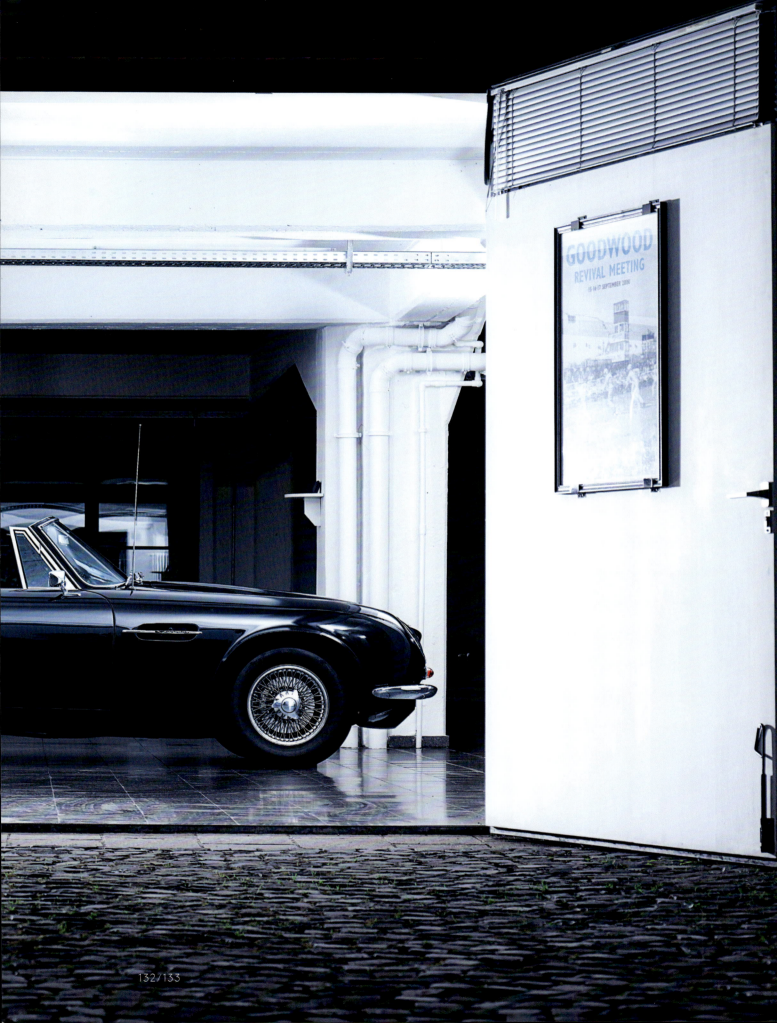

Austin-Healey 3000 Mk III
1963–1967

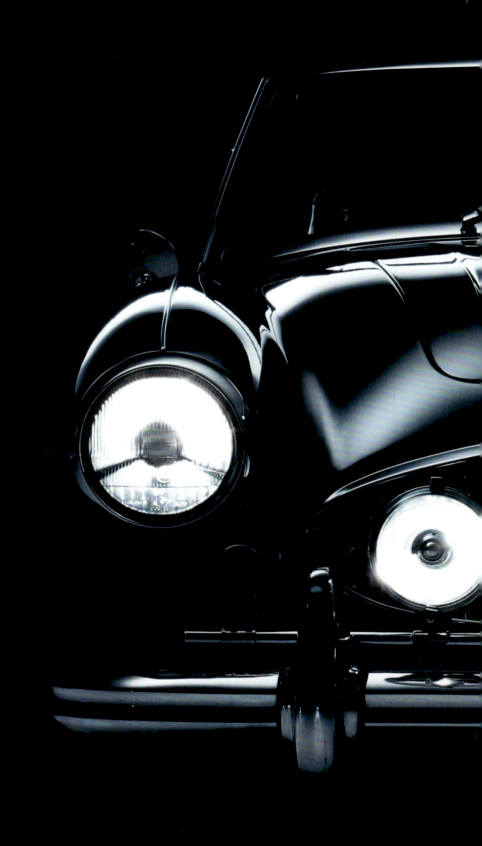

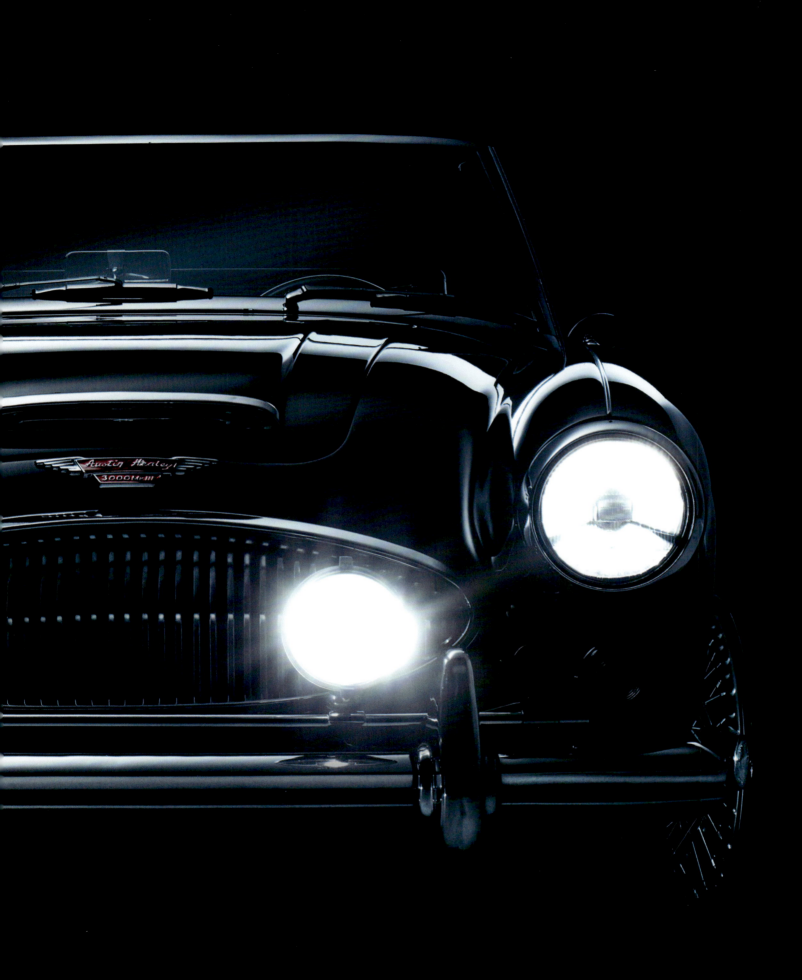

Porsche 912
1965–1969

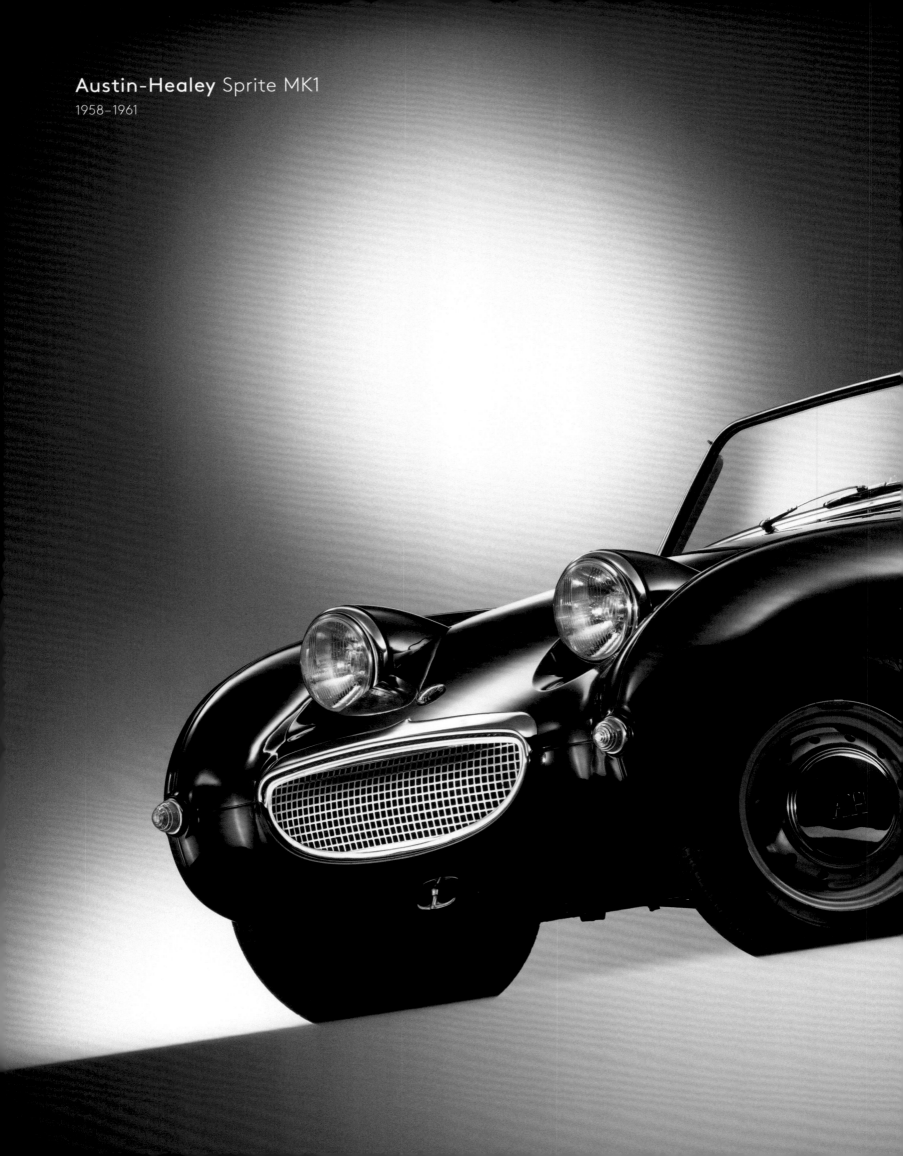

Austin-Healey Sprite MK1
1958–1961

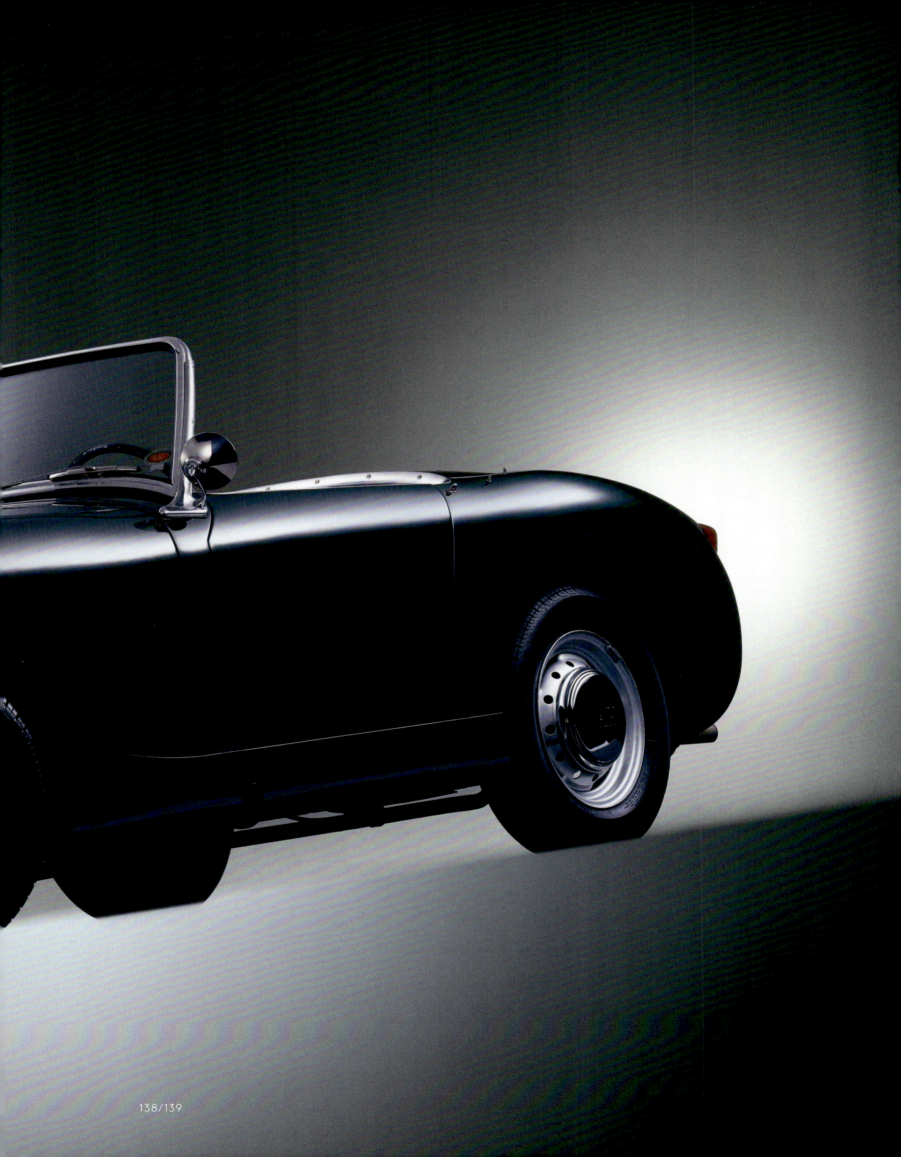

Mercedes-Benz 190 SL

1955–1963

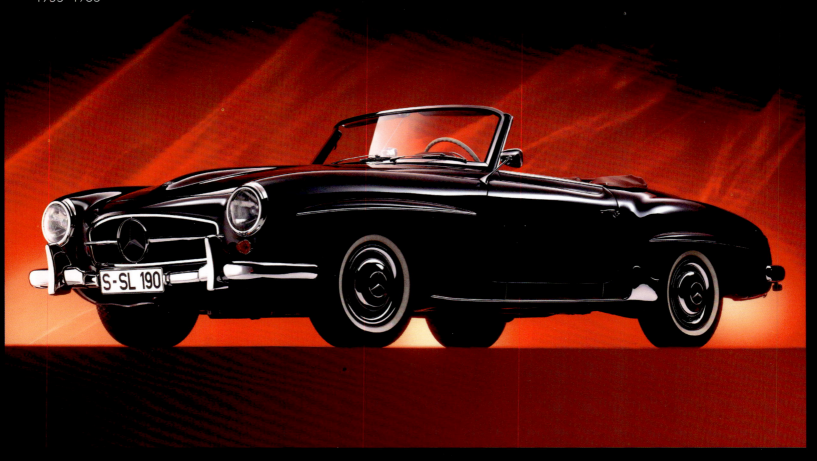

Mercedes-Benz 230 SL

1963–1967

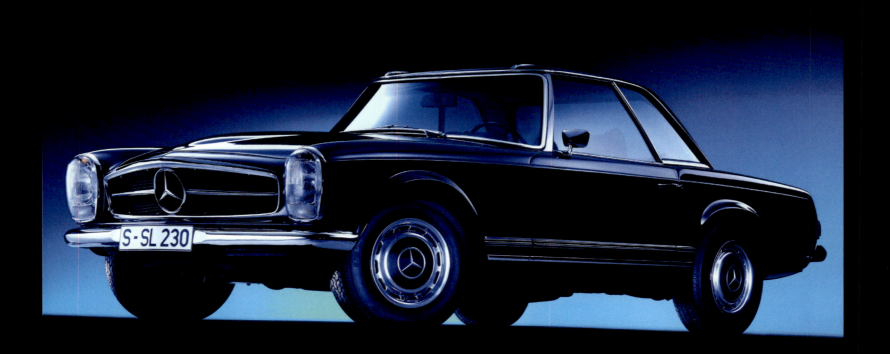

Mercedes-Benz SLK
1996–2004

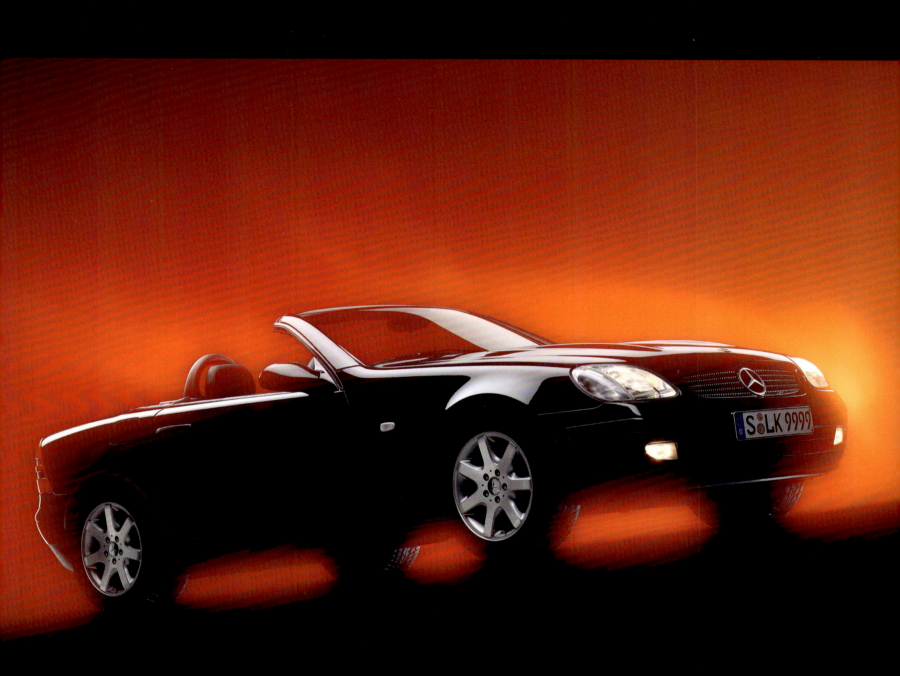

Porsche 964 Andial
1990

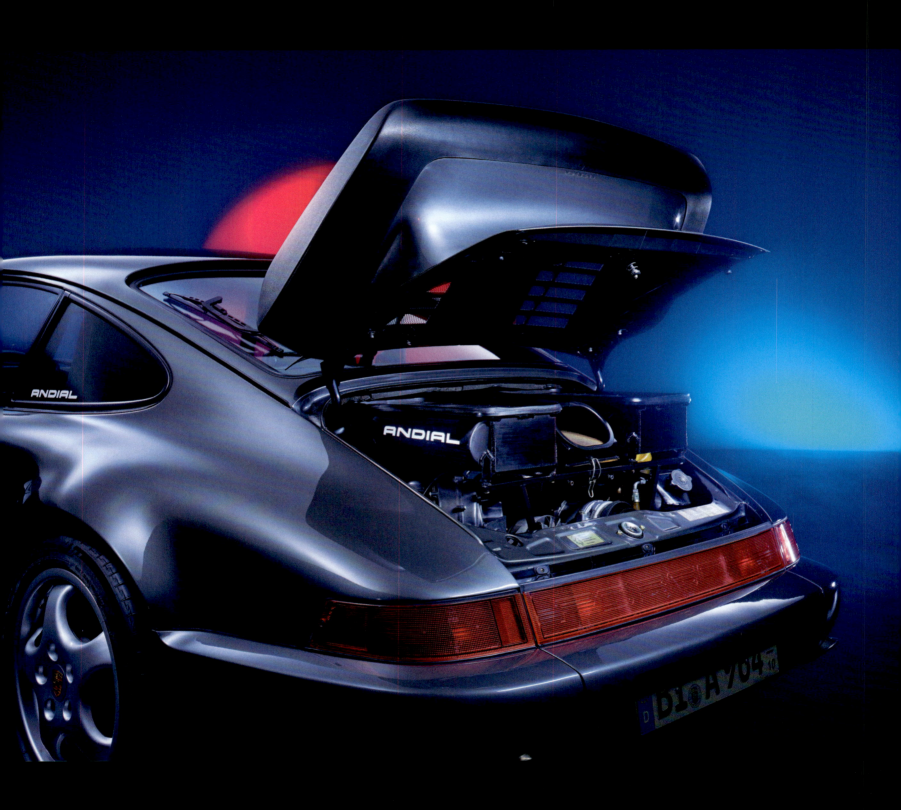

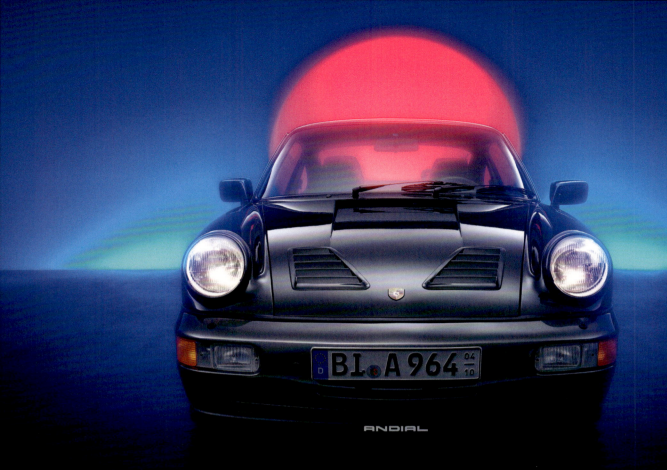
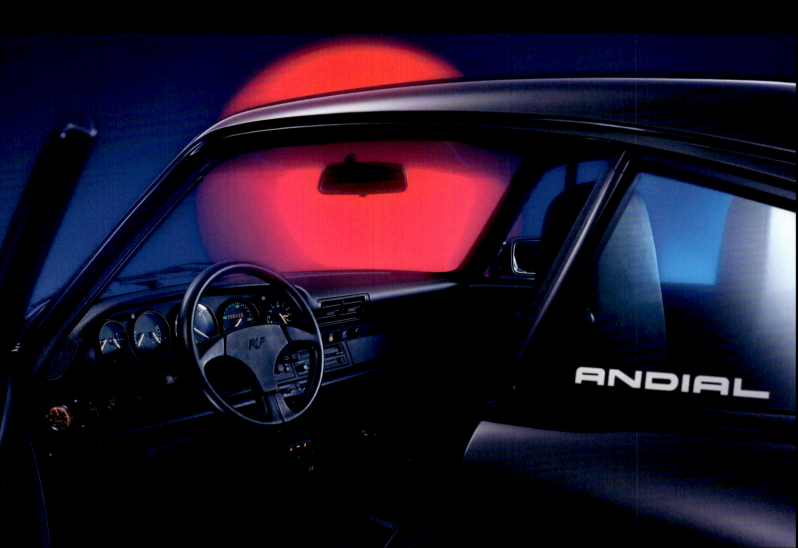

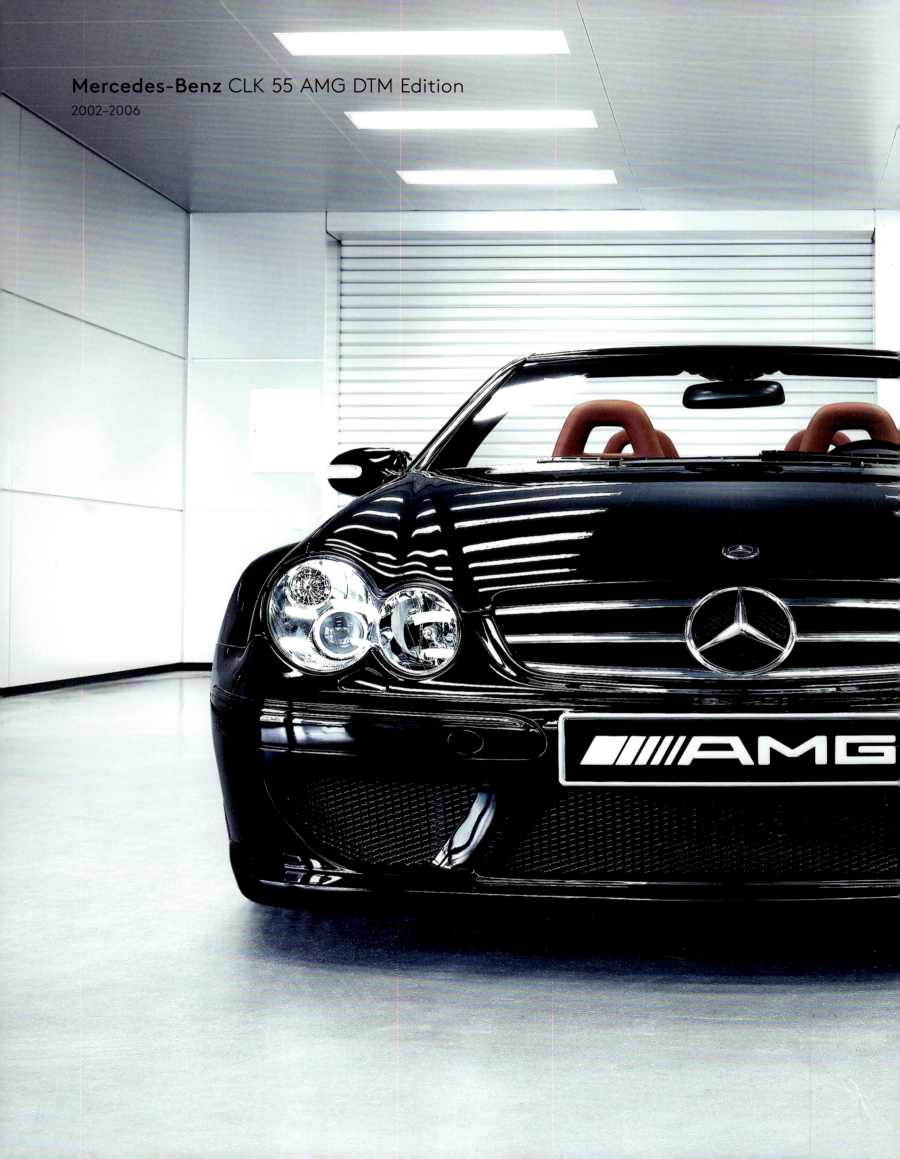

Mercedes-Benz CLK 55 AMG DTM Edition
2002–2006

Mercedes-AMG G63 6x6

2013–2015

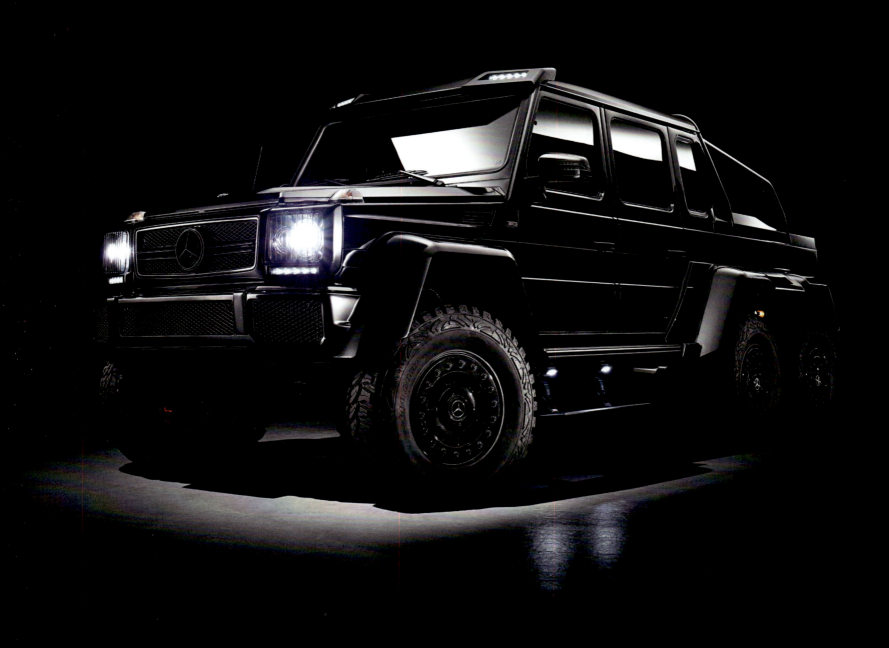

Mercedes-AMG G63 6x6
Mercedes-AMG GT50

2017

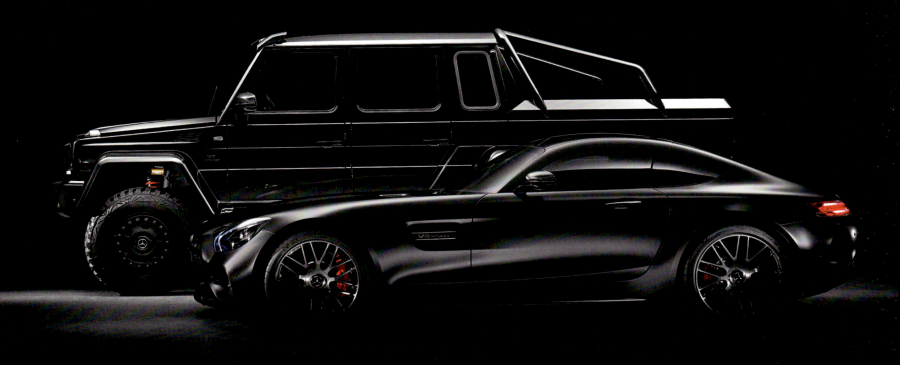

146/147

Bugatti Chiron
since/seit 2016

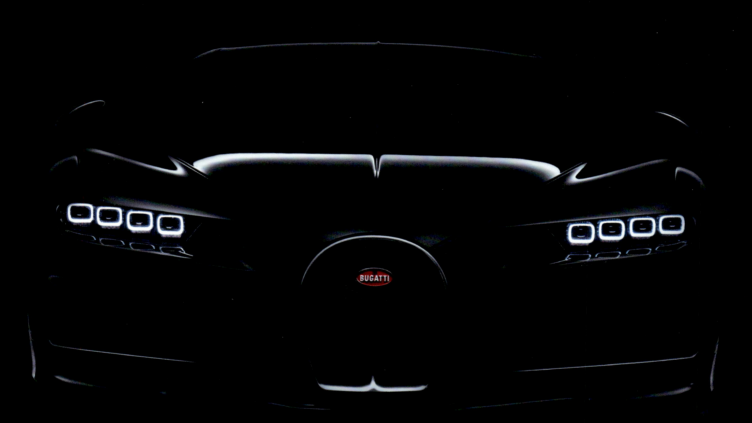

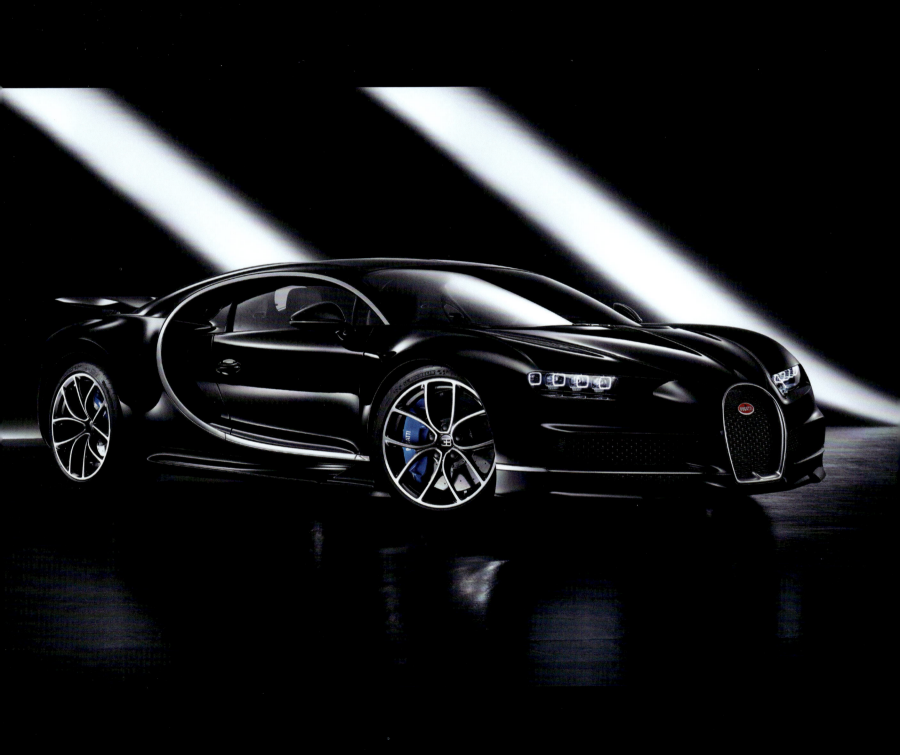

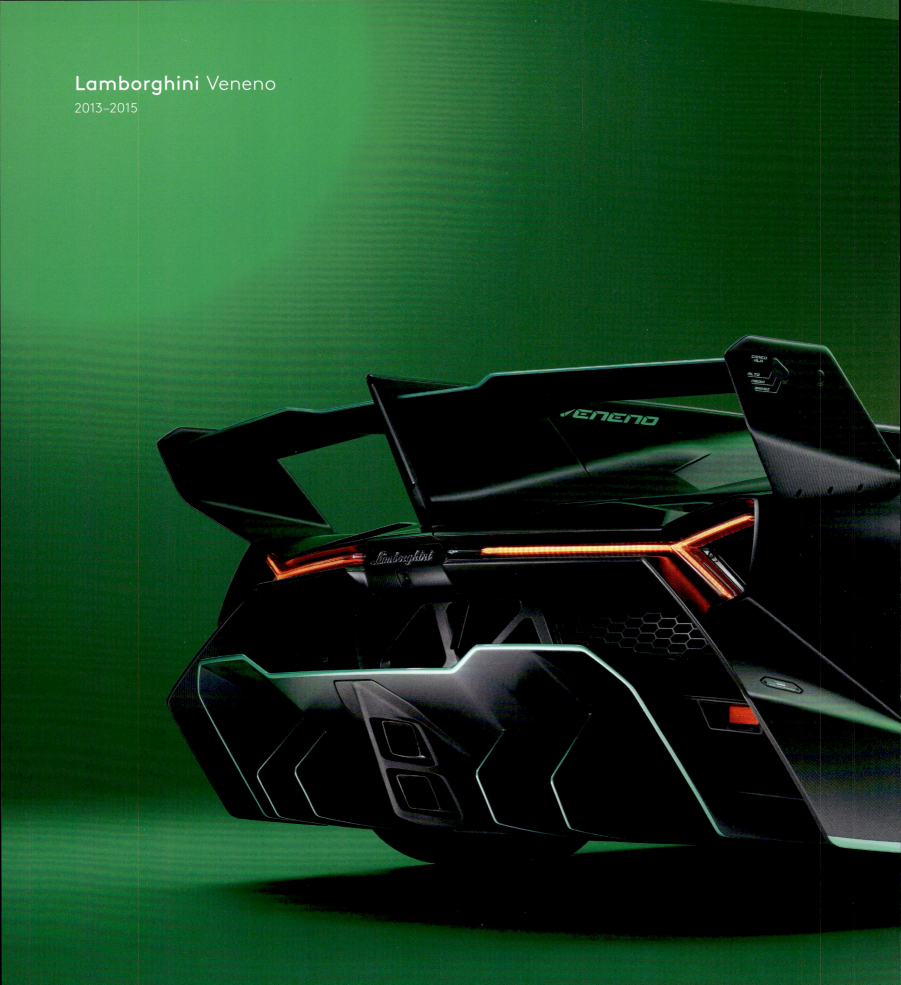

Lamborghini Veneno
2013–2015

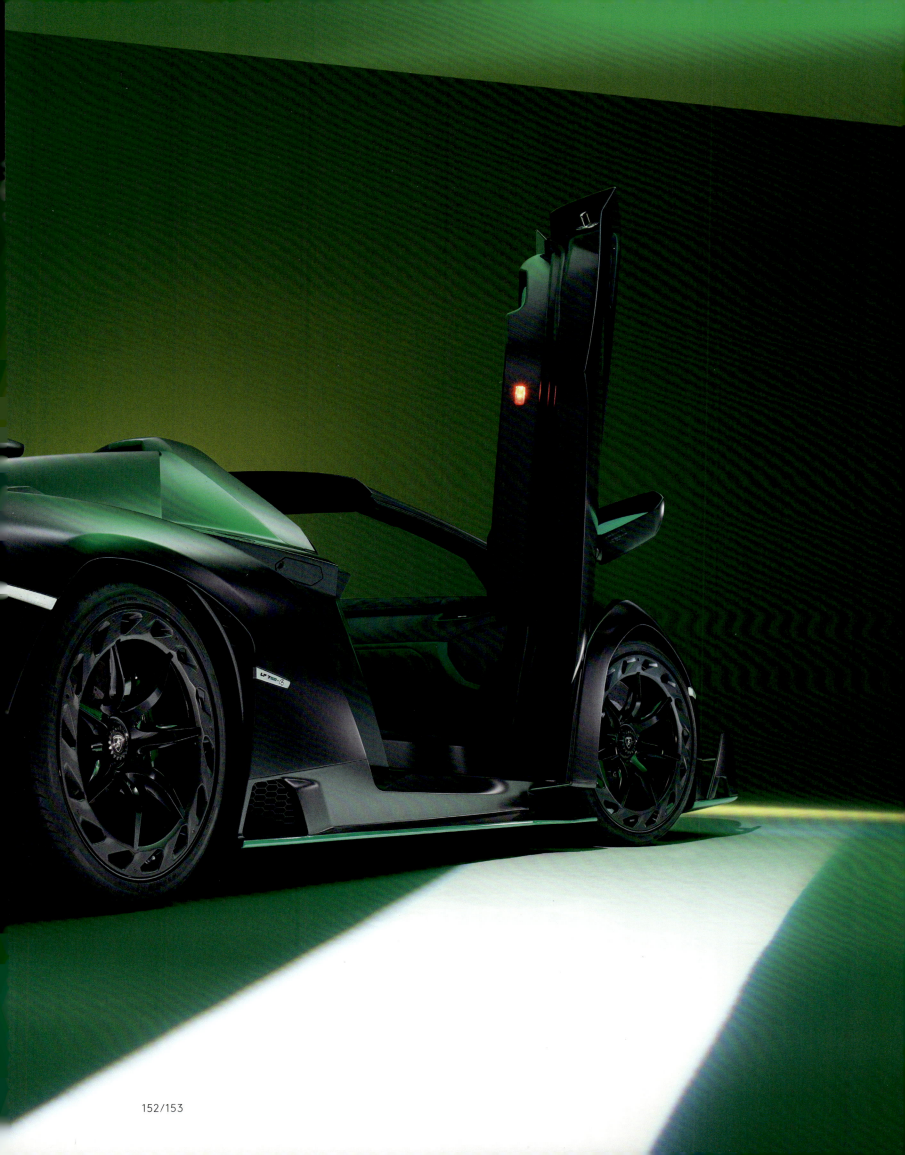

DARK COLORFUL NIGHT THOUGHT

David Staretz, Automobile journalist

Black is gray that has been enriched with pensiveness, the radical multicolor.

In four-color printing, the most convincing black is made by mixing black and blue and red and yellow.

Black has as many shades as silence.

Its presumed clarity saves us from having to question its intentions and variations.

Still: there is the black of ravens and of the night, the black of fading senses and the black of printed letters, the stifling black of the paternoster elevator cabins as they rumble through the basement every morning, and the black of the women our loneliness pines for.

Black is our origin.

Black poses puzzles: the refrigerator is one of them, assuming that the light actually goes out as soon as we close the door.

DUNKEL BUNTES NACHT GEDACHT

David Staretz, Autojournalist

Schwarz ist das mit Nachdenklichkeit angereicherte Grau, das radikale Bunt.

Im Vierfarbdruck wird das überzeugendste Schwarz mit Blau und Rot und Gelb hergestellt.

Schwarz hat so viele Schattierungen wie die Stille.

Seine vermeintliche Eindeutigkeit erspart uns das Hinterfragen seiner Absichten und Variationen.

Jedoch: Es gibt das Schwarz der Raben und der Nacht, das Schwarz der schwindenden Sinne und das Schwarz der gedruckten Lettern, das augendrückende Schwarz der Paternosterkabinette, wenn sie morgens den Keller durchpoltern, und das Schwarz der Frauen, nach dem sich unsere Einsamkeit verzehrt.

Schwarz ist unsere Herkunft.

Schwarz gibt Rätsel auf, der Kühlschrank ist eines davon, sofern es stimmt, dass dieses Licht tatsächlich verlöscht, sobald wir die Türe geschlossen haben.

But who knows that for sure?

And there are black cars, more alarming, more puzzling, more readily showing the dirt, more reduced to their essential form, more reprehensible or solemn than all colors. Rare implosions of the street scene that punch holes in our retinas as they abstain from color stimuli.

We have learned to perceive black as antagonism, which can act as a catalyst and color enhancer: colors are only colorful in the presence of black, light is defined by dark, white by black. There isn't a car out there that wouldn't benefit from a coat of black paint—this effect is not confined to the large sedans, either.

Henry Ford may have recognized this ("You can have a Model T in any color, as long as...") along with makers of heavy motorcycles. Anyone who has ever seen a Vincent Black Prince, this largest-body of all large-body motorcycles, can feel the special pull of black magic.

Paint never gleams more exquisitely than in its substantial reduction to shapes that seem to be created by this impenetrable substance—black penetrates far beneath the surface and creates its own dimensions.

Nearly all of the automakers are happy to charge extra and require special orders for this effect. However, the physical effect (increased heating) is more of a disadvantage—the fact that black gives owners hell and creates an associated need to buy air conditioning may actually net them additional prestige points.

A magnificent color that requires all the light in the world and only allows brightness as a reflection.

Serious cities like New York, which are especially good spots for black limousines, are reflected especially well in the play of shadows along the skyline—like in a Saul Steinberg print.

Ahh—every car is a *grand piano* here, heavy, full of secrets, and imbued with meaning. The weight of the heat glimmers on their distorted flanks, and round clouds rise as if from the bottom of the ocean to the surface.

Now and then the red or yellow from a neon sign flows over the hood. At night, strings of lights and the pinpoints of headlights glitter on the newly deepened darkness. Raindrop ink surrounds the thousand microcosms of the night.

Impenetrably tinted panes deepen the reflection of saturnine elegance into something threatening. The effect of targeted accents cuts like a knife: black is the only color that allows new cars to cross the bridge into legendary status, that creates a kind of present of the virtual past, if you still get what I mean there—I mean this search for values, for content, for holding your breath for *cults* and *legends* and our pretentious surfing through the ages.

Black paint can serve this entire spectrum of longings without driving the level of obtrusiveness too high. At least for now, as long as black remains a relatively rare color, as though there were an international commission setting quotas for black cars.

A magnificent color that requires all the light in the world…

Aber wer weiß das schon?

Und es gibt die schwarzen Autos, alarmierender, rätselhafter, schmutzanfälliger, formreduktiver, verwerflicher oder feierlicher als alle Farbe. Rare Implosionen des Straßenbildes, die unter Verzicht auf Farbenreize Löcher in unsere Netzhaut stempeln.

Wir haben gelernt, Schwarz als Antagonismus zu empfinden, der als Katalysator und Farbverstärker wirken kann: Farben werden erst durch die Anwesenheit von Schwarz bunt, Helles definiert sich durch Dunkles, Weiß durch Schwarz. Es gibt kein Auto, das durch schwarze Lackierung nicht gewönne – dieser Effekt bleibt nicht allein den großen Limousinen vorbehalten.

Henry Ford mag das erkannt haben („Sie können das Modell T in jeder Farbe erhalten, vorausgesetzt ...".) und die Fabrikanten schwerer Motorräder. Wer je eine Vincent Black Prince gesehen hat, dieses karosseriereichste aller schweren Zweiräder, spürt diesen speziellen Reiz schwarzer Magie.

Lack glänzt nie so delikat wie in seiner gehaltvollen Reduktion auf Formen, wenn sie von dieser undurchdringlichen Substanz erzeugt scheinen – Schwarz dringt tief unter die Oberfläche und erzeugt seine Masse selbst.

Autohersteller lassen sich diesen Effekt fast durchwegs durch Aufpreis und Sonderbestellung honorieren. Dabei ist der physikalische Effekt (der Aufheizung) eher nachteilig zu bewerten – dass schwarz die Hölle heiß macht, kann durch den bedingenden Bedarf einer Klimaanlage allerdings noch weitere Prestigepunkte bringen.

Grandiose Farbe, die alles Licht der Welt benötigt und in der Reflexion nur Hellem stattgibt.

Unverspielte Städte wie New York, die sich besonders gut für schwarze Limousinen eignen, finden sich im Schattenriss der Skylines besonders treffend widergespiegelt – wie in einer Grafik von Saul Steinberg.

Ahh – jedes Auto ein *Grand Piano* hier, geheimnisvoll, tonnenschwer und von Bedeutung durchsetzt. Flimmernd ruht das Gewicht der Hitze auf ihren verzerrenden Flanken, Wolkenballen scheinen wie vom Meeresgrund an die Oberfläche zu steigen.

Hin und wieder fließt das Gelb oder Rot einer Neonreklame über den Bug. Nachts gleißen Lichterketten und Scheinwerferpunkte auf dem abermals vertieften Dunkel. Regentropfentinte schließt den tausendfachen Mikrokosmos der Nacht ein.

Undurchdringlich getönte Scheiben vertiefen den Abglanz finsterer Eleganz ins Bedrohliche. Scharf schneidet die Wirkung gezielter Akzente: Schwarz ist jedoch die einzige Farbe, die neuen Autos die Brücke zu historischer Größe legt, also eine Art Gegenwart virtueller Vergangenheit erzeugt, falls ich mich da noch verständlich machen kann – ich meine diese Suche nach Werten, nach Inhalten, nach Innehalten, nach *Kult* und *Legende* und unser anmaßendes Zappen durch die Zeiten.

Schwarzer Lack kann hier ganze Register von Sehnsüchten bedienen, ohne die Aufdringlichkeit auf die Spitze zu treiben. Jedenfalls vorläufig, solange er so gleichmäßig rar bleibt, als herrsche eine internationale Kommission zur Kontingentierung schwarzer Autos.

Grandiose Farbe, die alles Licht der Welt benötigt ...

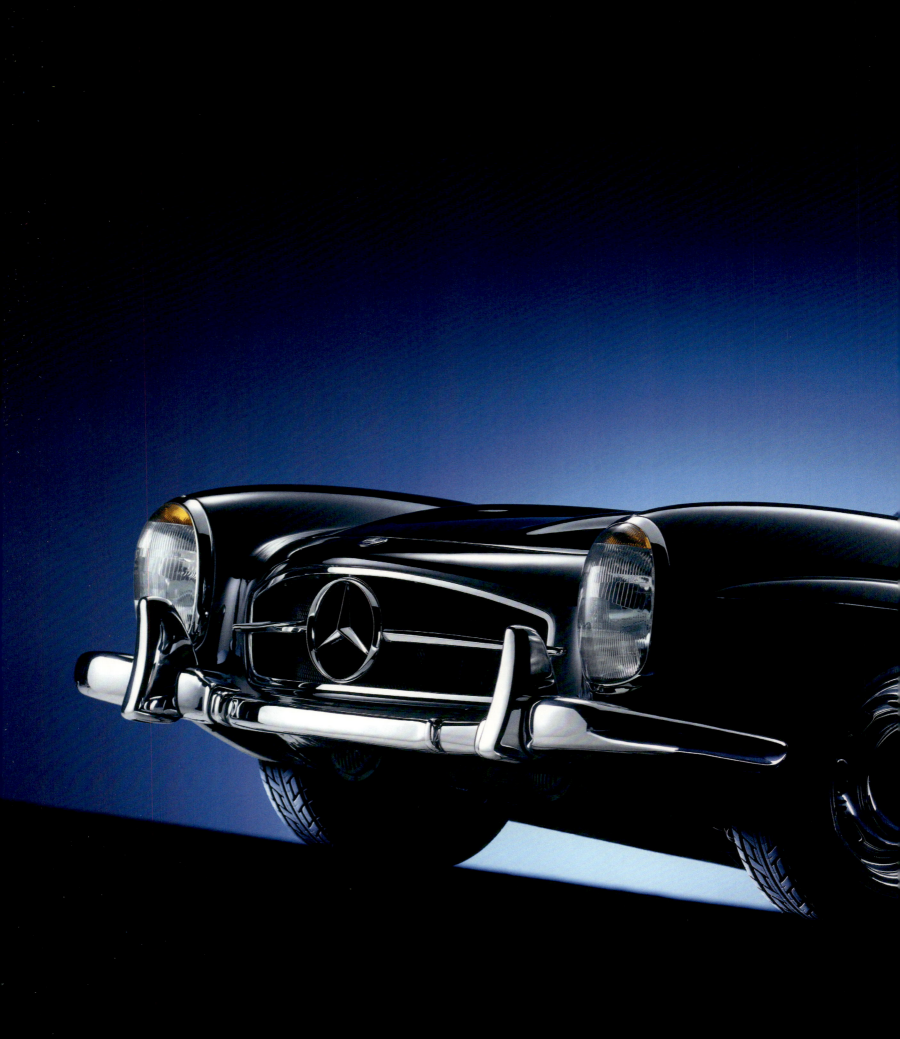

BLACK
LEGENDS

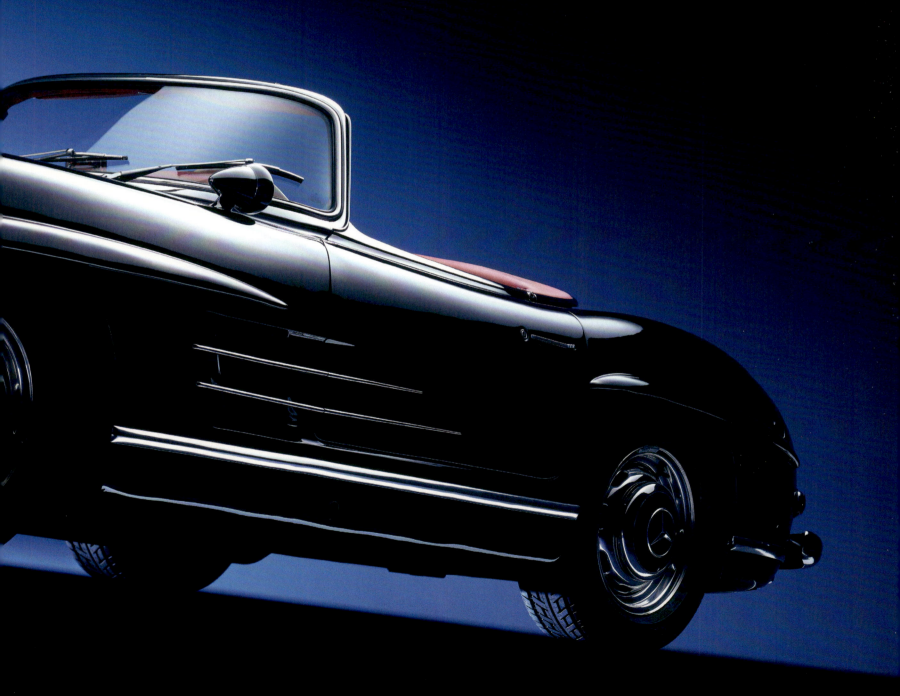

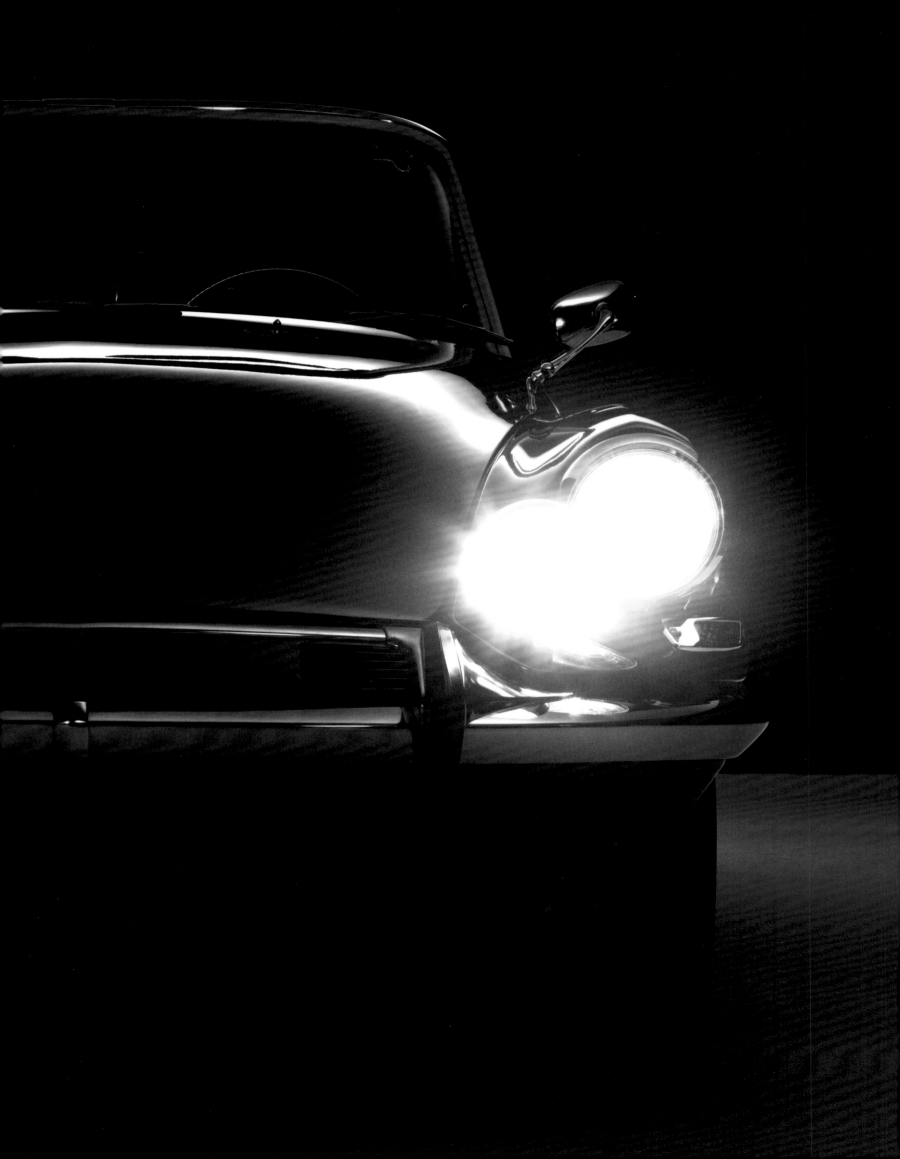

The word legend originally meant an unsubstantiated story. It allows the narrator to move away from verifiable facts and let his imagination run wild. And if enough people believe the content of this unsubstantiated message and spread it to others, then it picks up momentum and eventually mutates into a reality that people accept as true. This development also applies to numerous cars. The only question left is, which models deserve to be called legends? Which ones correctly bear that desgination?

For example, let's take the black Mercedes-Benz 300 SL Roadster, whose, sporty, muscular, yet elegant lines are so masterfully captured by René Staud on the intro page for this chapter. No one will deny that the 300 SL—whether as a gullwing coupe or a roadster—is rightfully deemed a legend. But what entitles this vehicle to the noble title of "Legend"? Five criteria come to mind: first and foremost, the tradition and innovative history of the manufacturer. Next, the car should have some new technical features. Success on the racing circuit is certainly helpful, as is great aesthetic appeal. And last but not least, a limited production run is also a big plus. Let's see how well the 300 SL fits these criteria: Mercedes-Benz invented the automobile. The 300 SL had the first engine with fuel injection and a lighter welded steel tube frame. Four wins in five races in 1952 and F1 championships in 1954 and 1955 for Mercedes also help its case. And the 300 SL's timeless beauty is obvious. And so we come to the production figure: with more than 1000 made, it's pretty high, but still acceptable.

Of course, not all legends can always fulfill every criterion. A Studebaker Avanti's beauty is debatable, and a Monteverdi 375/4 is not particularly innovative. But what all of these vehicles have in common is personality—they have that head-turning "something special" about them. And everyone agrees that black paint does an especially good job at showcasing this personality. Admit it: doesn't a black Ferrari Testarossa exude far more elegance and nobility than its mundane red cousin?

Hinter dem Wort Legende verbirgt sich ursprünglich eine unverbürgte Erzählung. Der Erzähler kann also beruhigt auf belegbare Tatsachen verzichten und der Phantasie freien Lauf lassen. Und wenn genügend Hörer den Inhalt dieser unverbürgten Message glauben und sie dann selbst weiterverbreiten, dann gewinnt sie an Fahrt und mutiert eines Tages qua Masse zu einer Realität, die als wahr wahrgenommen wird. Eine Entwicklung, die natürlich auch etliche Fahrzeuge betrifft. Bleibt die Frage: Welche Modelle dürfen sich Legenden nennen? Welche tragen diese Auszeichnung zu Recht?

Nehmen wir beispielsweise den schwarzen Mercedes-Benz 300 SL Roadster, dessen sportliche, muskulöse und dennoch eleganten Linien René Staud auf der Einleitungsseite zu diesem Kapitel so meisterhaft herausgearbeitet hat. Niemand wird bezweifeln, dass der 300 SL – egal ob als „Flügeltürer"-Coupé oder als Roadster – zu Recht das Prädikat „legendär" trägt. Doch was berechtigt nun zu dem Adelstitel Legende? Da wären zunächst einmal fünf zu erfüllende Eigenschaften: an erster Stelle die Tradition und Innovationsbereitschaft des Herstellers, dann sollte der Wagen über technische Neuerungen verfügen. Erfolge im Motorsport sind immer gut zur Legendenbildung, so wie auch eine gelungene Ästhetik geschätzt wird. Und last, but not least, hilft eine geringe Stückzahl ebenfalls sehr. Betrachten wir unter diesen Gesichtspunkten den 300 SL: Da wäre Mercedes-Benz als Erfinder des Automobils. Dazu kommen der erste Einspritzmotor und ein filigraner Rohrrahmen. Vier Mercedes-Siege bei fünf Rennen im Jahr 1952 und die WM-Titel 1954 und 1955 zählen ebenfalls. Und dass der 300 SL zeitlos schön ist, steht ebenfalls außer Frage. Bleibt die Stückzahl: Sie ist mit mehr als 1000 Exemplaren schon relativ hoch, aber noch akzeptabel.

Nun können nicht immer alle Legenden auch alle Kriterien erfüllen. So ist ein Studebaker Avanti nicht zwangsläufig schön oder ein Monteverdi 375/4 nicht besonders innovativ. Doch allen diesen Fahrzeugen ist gemeinsam, dass sie etwas Besonderes ausstrahlen – dass sie „Personality" haben. Und unbestritten ist auch, dass die schwarze Lackierung diese Personality besonders gut herausarbeitet. Und strahlt nicht sogar ein schwarzer Ferrari Testarossa viel mehr Aristokratie und Eleganz aus als sein profan-rotes Pendant?

Porsche 911 (996)
1997–2006

Citroën DS
1955–1975

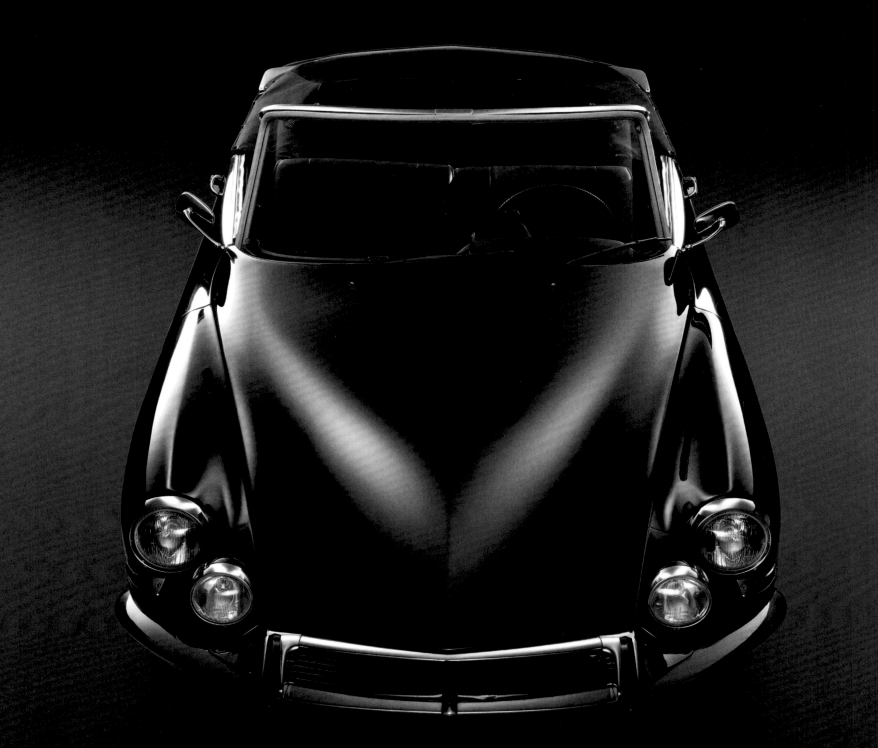

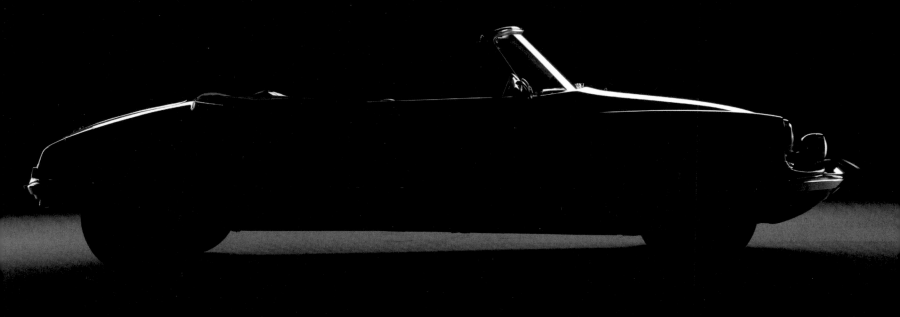

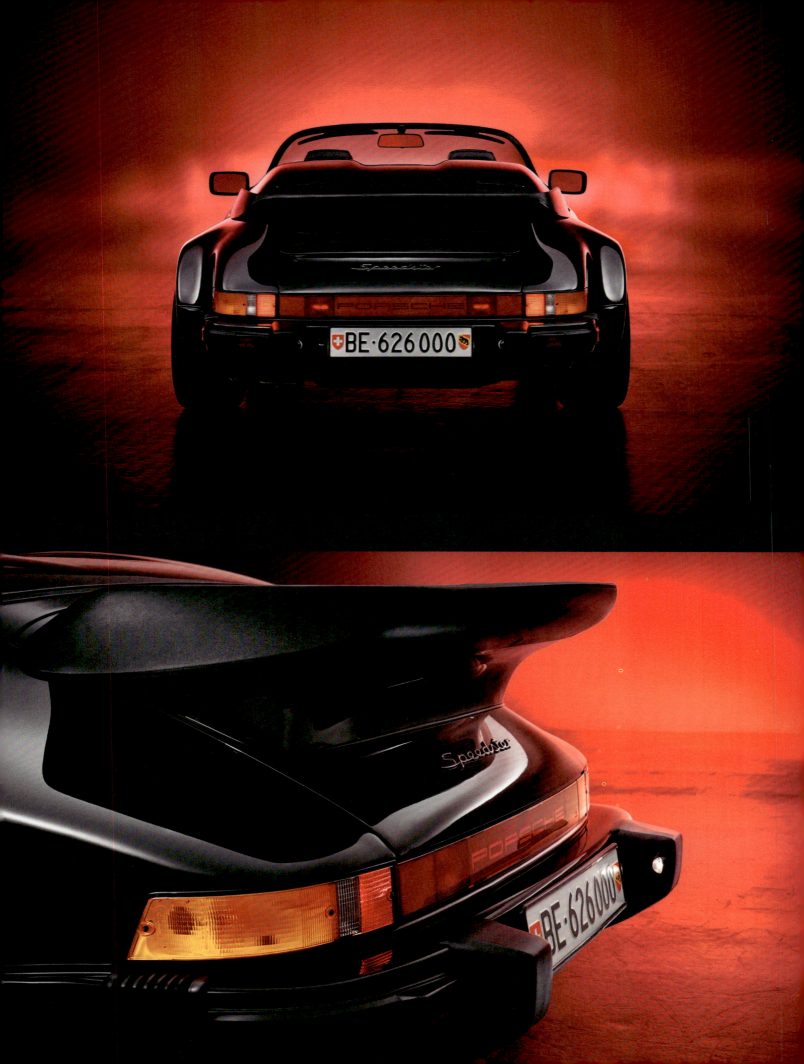

Porsche 911 Speedster
1989

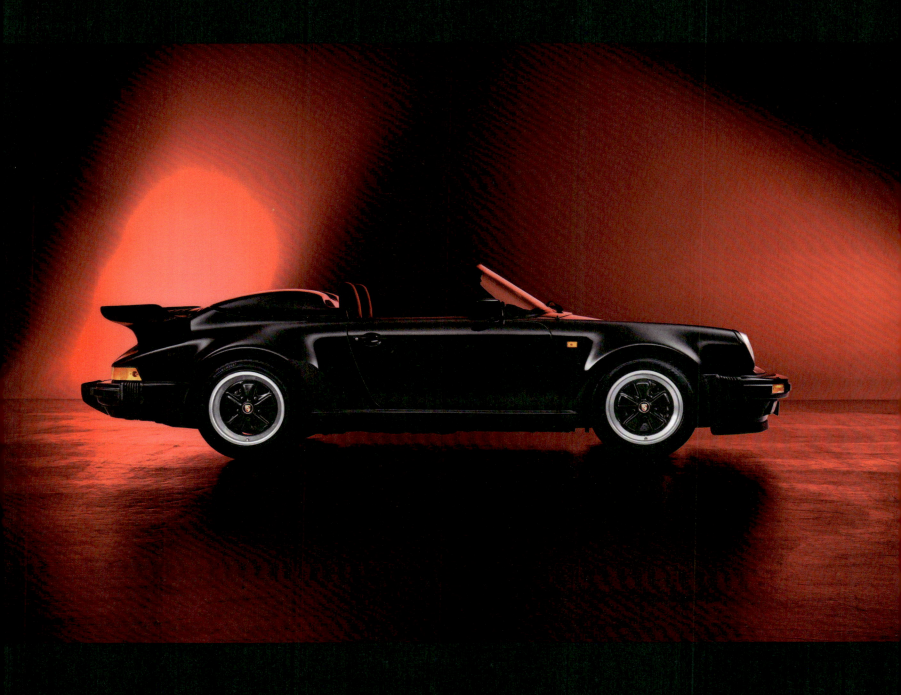

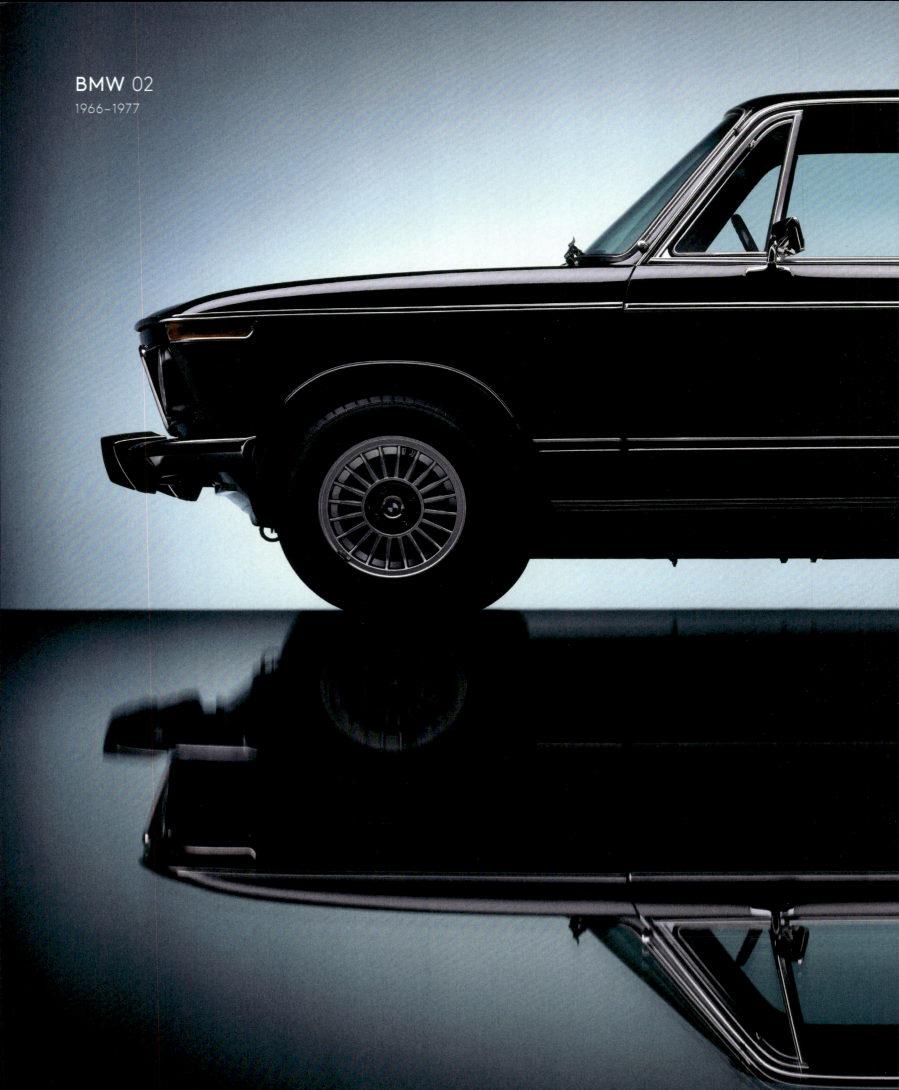

BMW 02
1966–1977

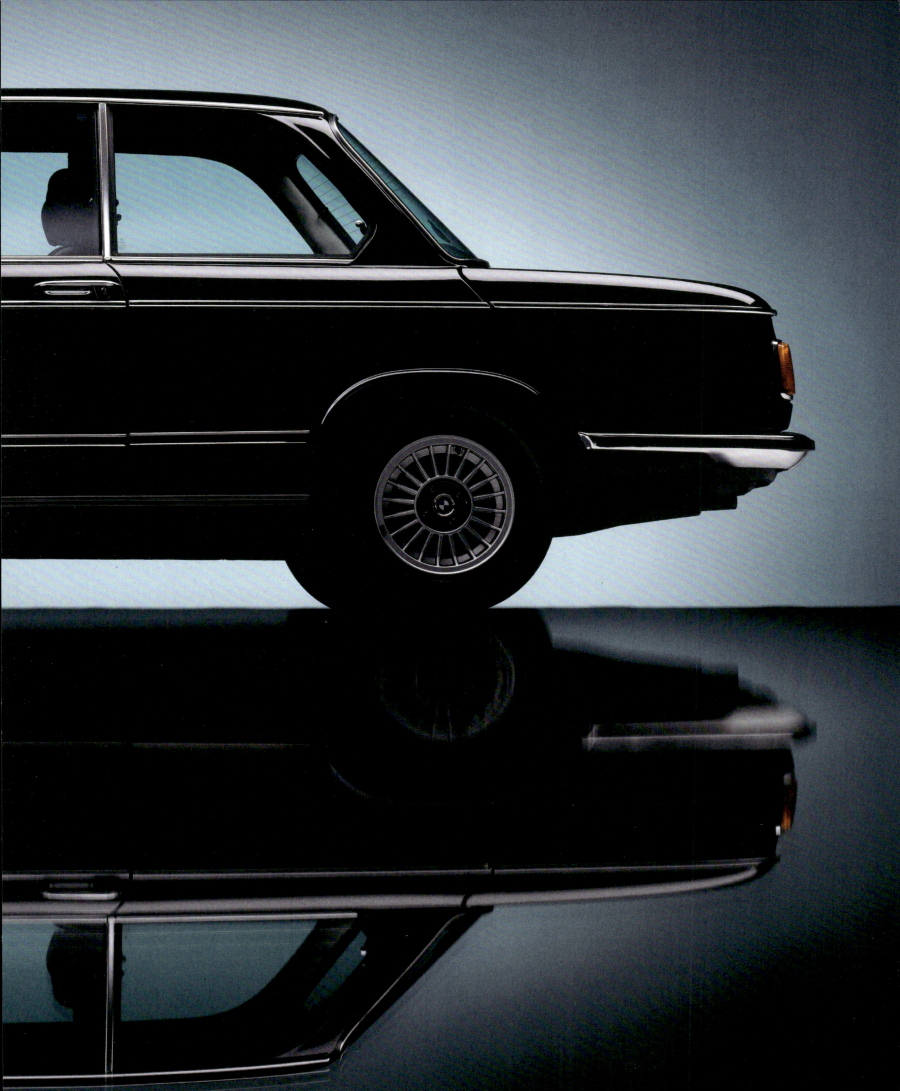

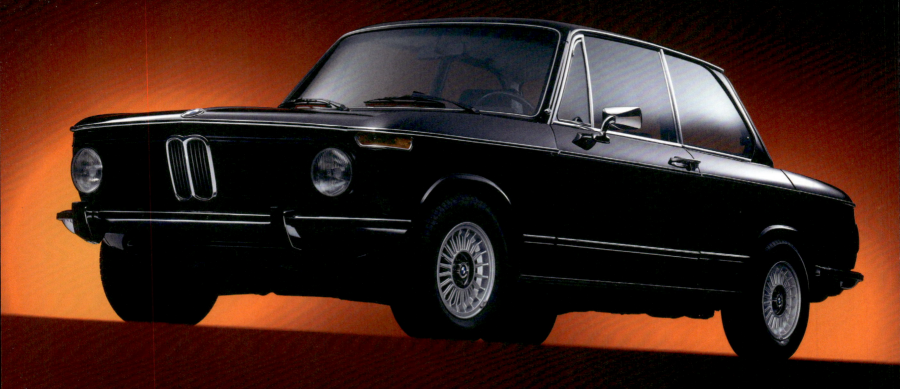

Fiat 124 Sport Spider
1966–1982

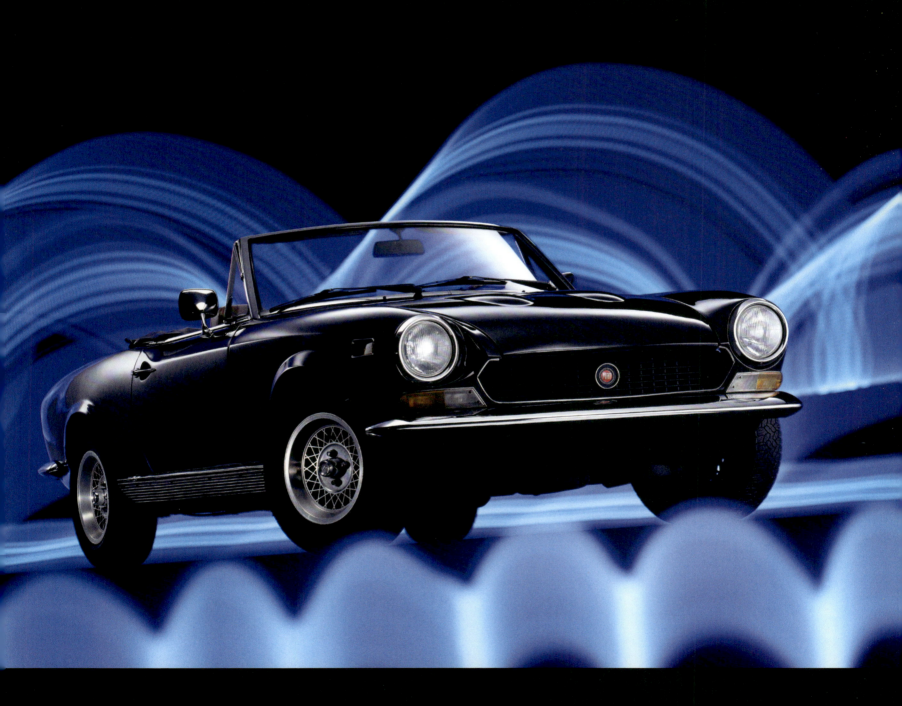

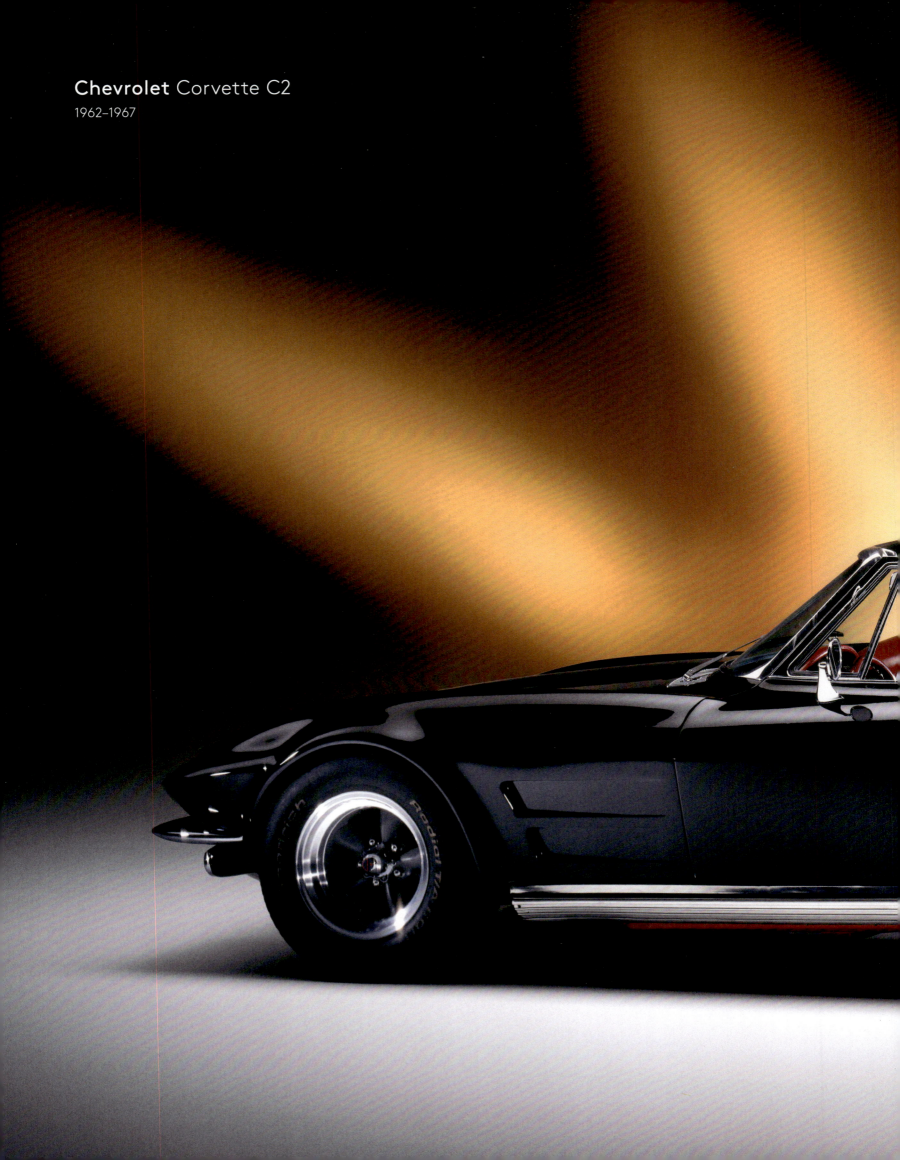

Chevrolet Corvette C2
1962–1967

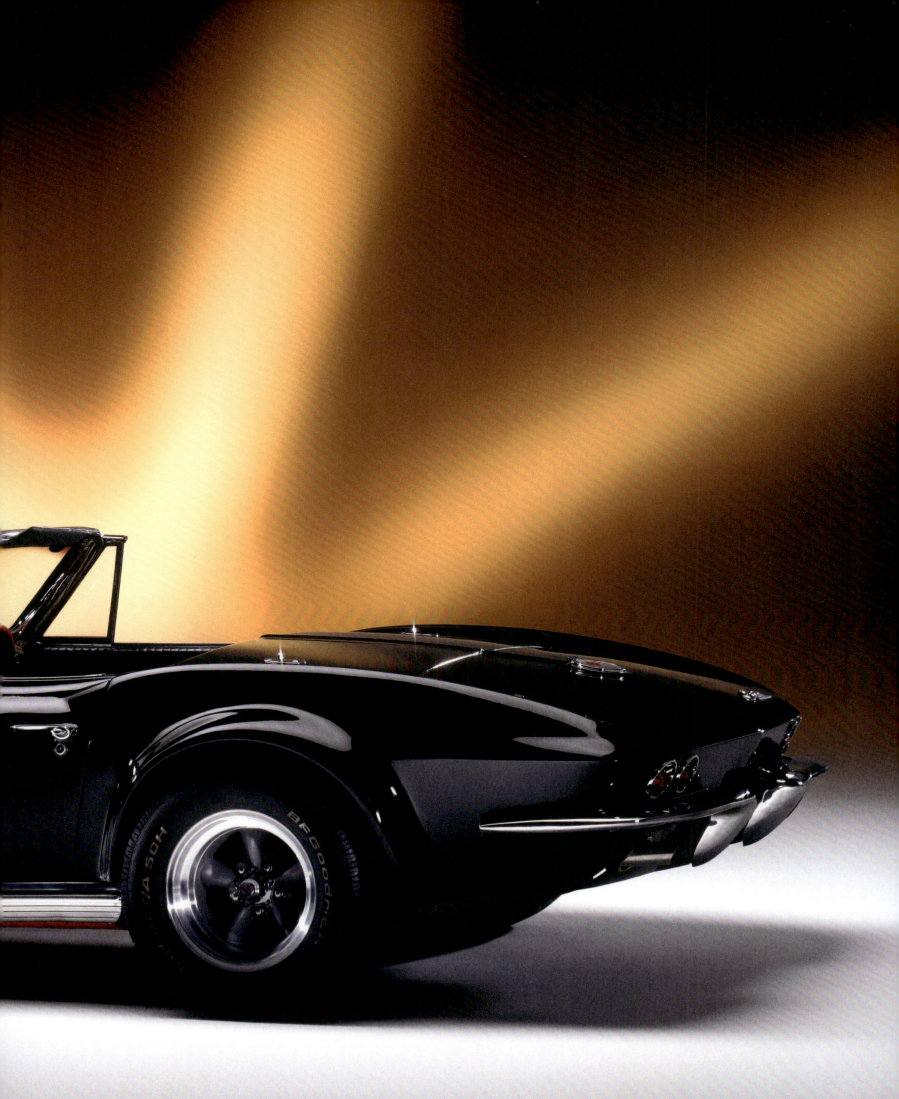

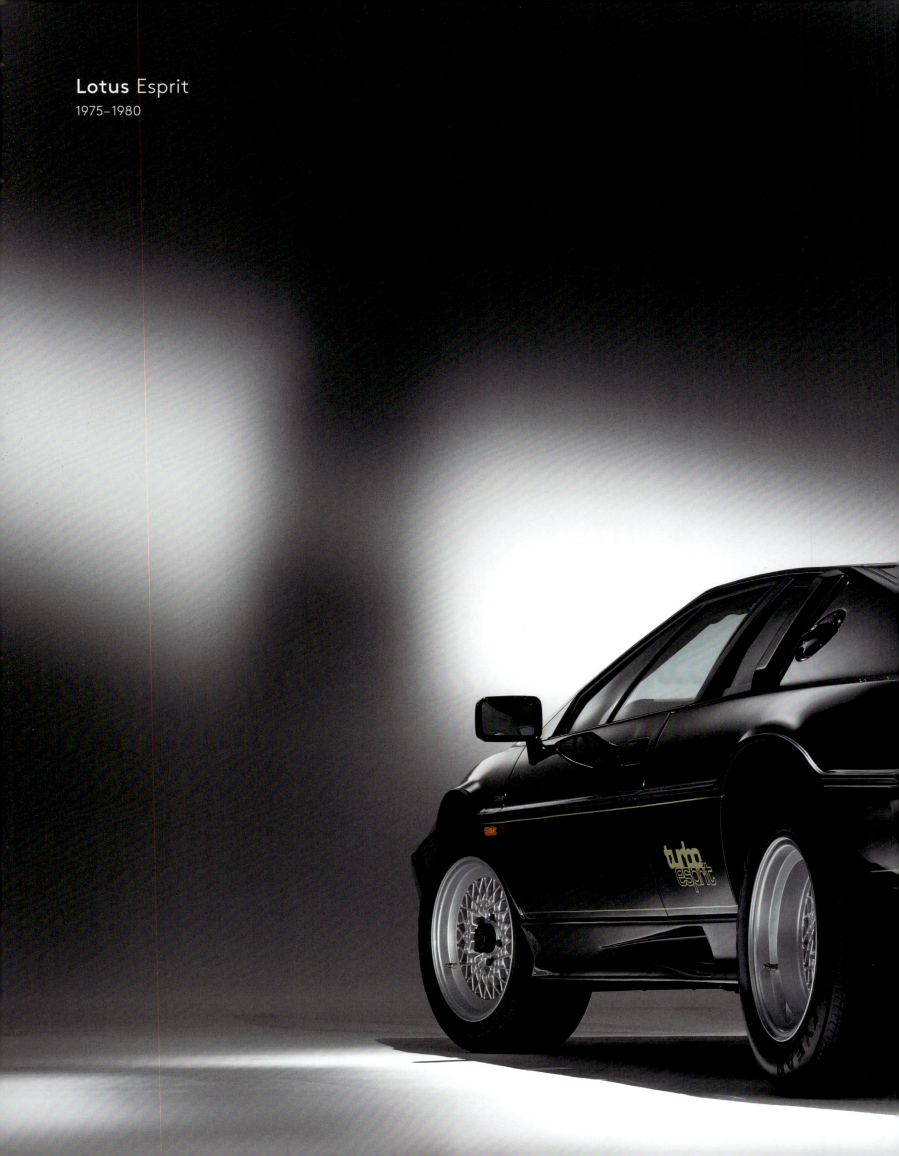

Lotus Esprit
1975–1980

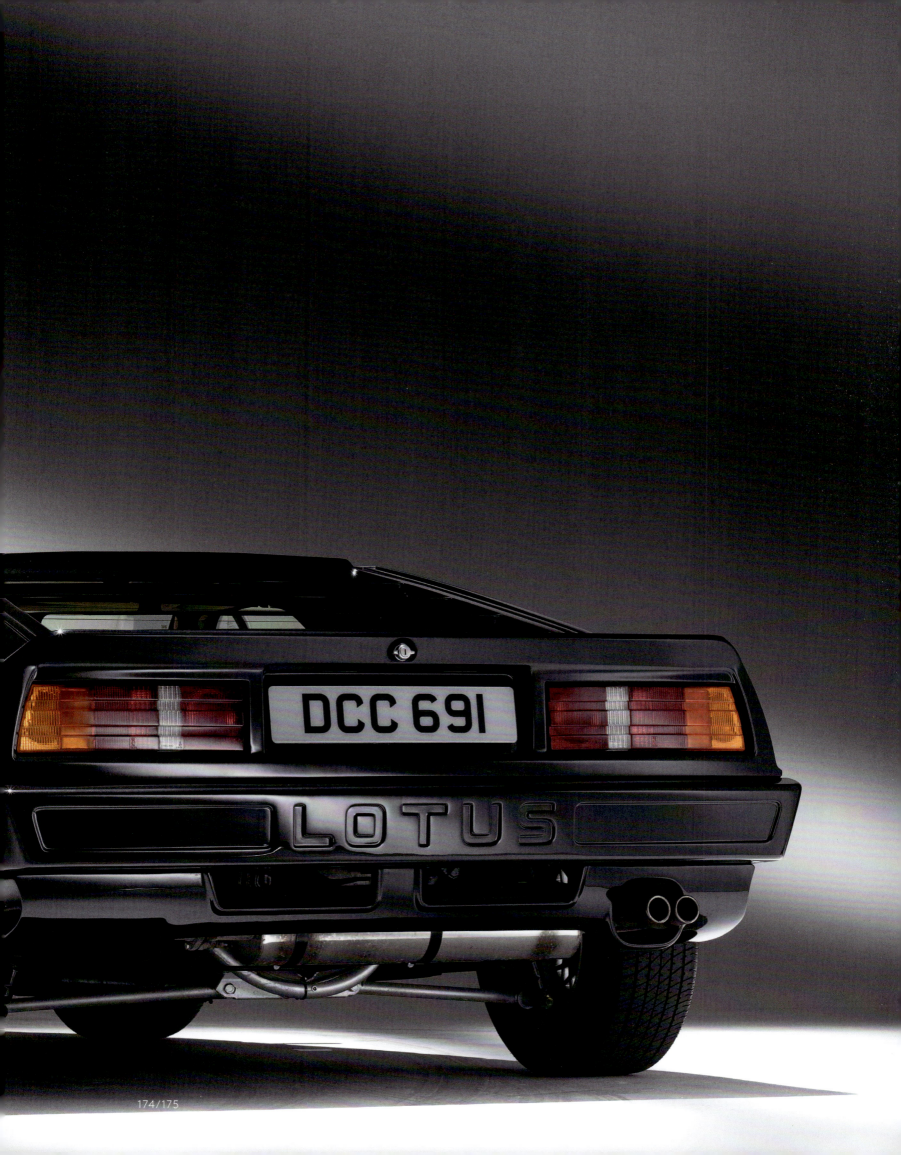

Porsche 356
1948–1965

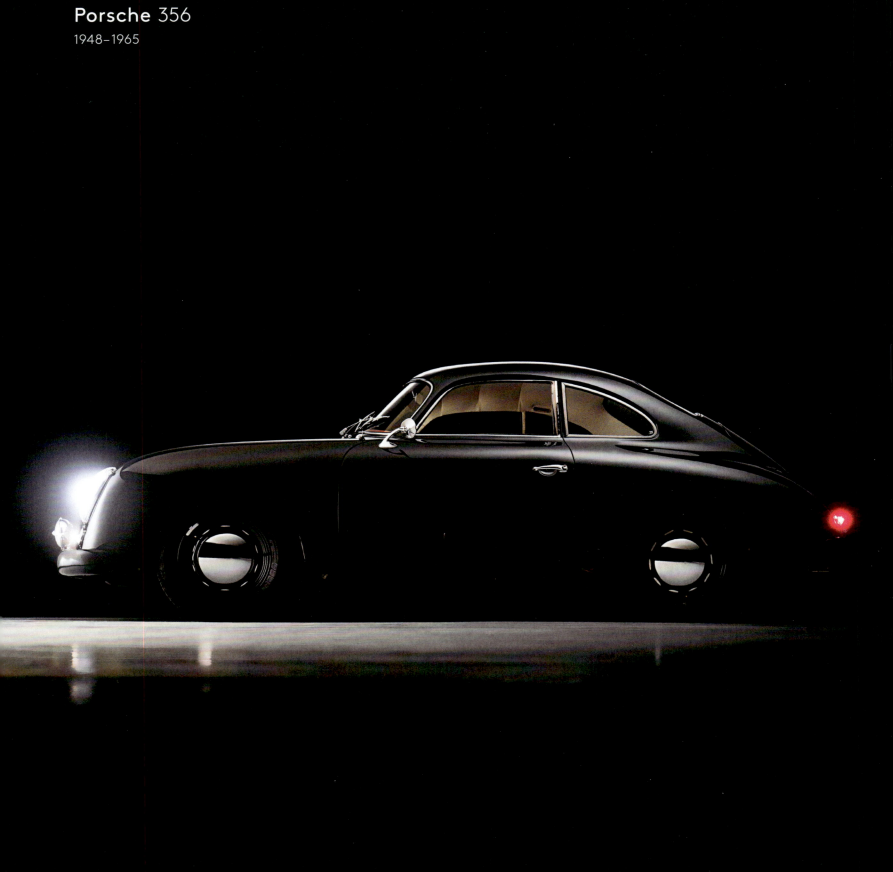

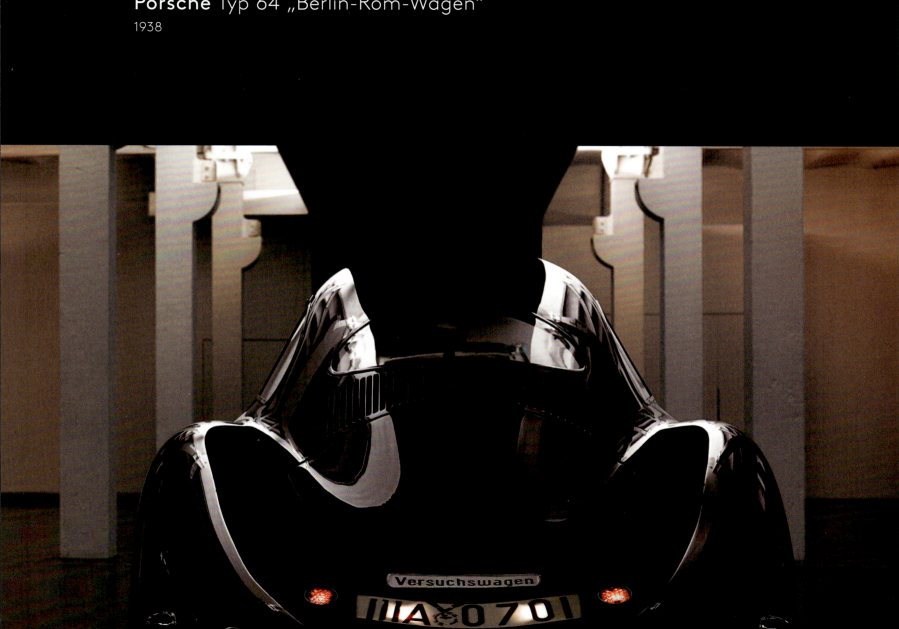

Porsche Typ 64 „Berlin-Rom-Wagen"
1938

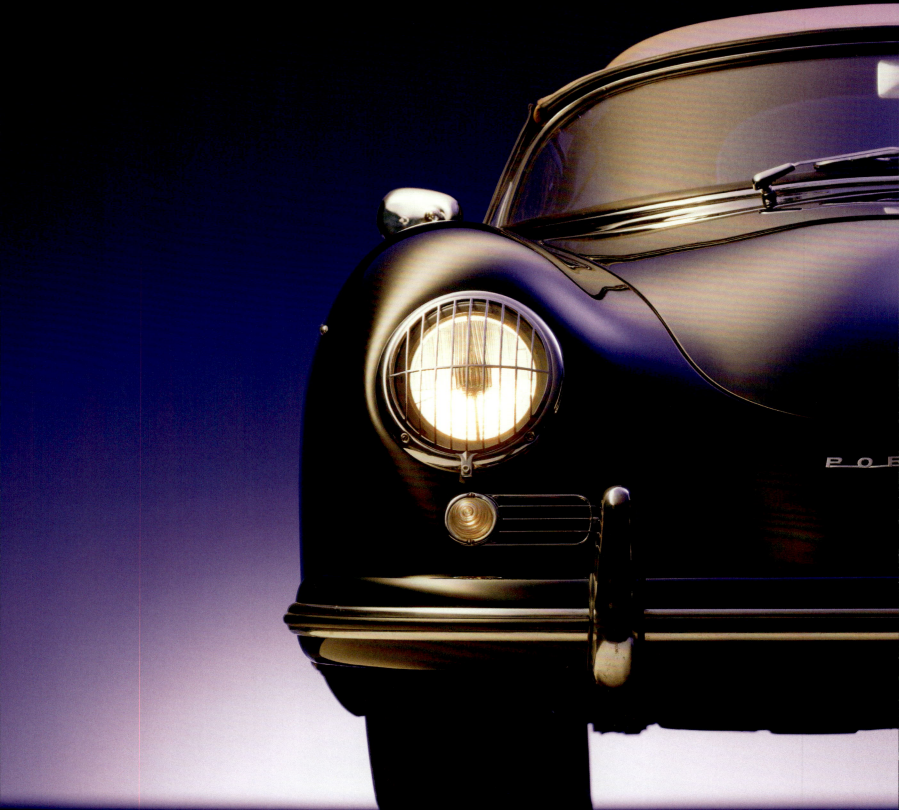

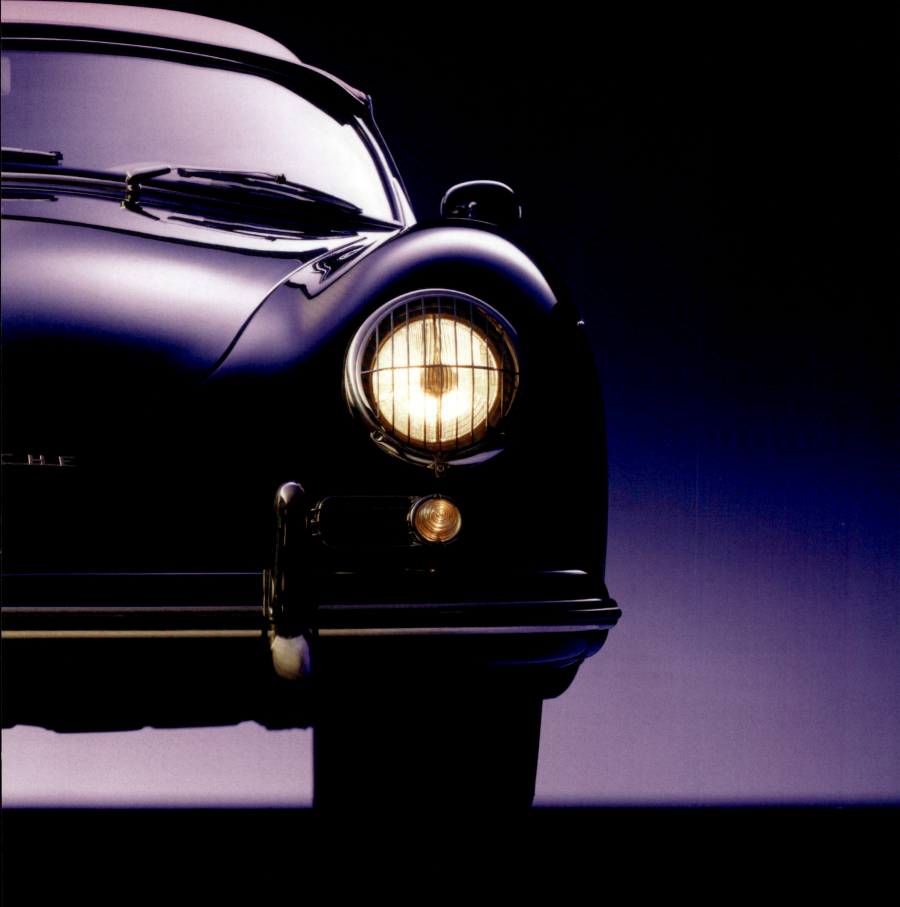

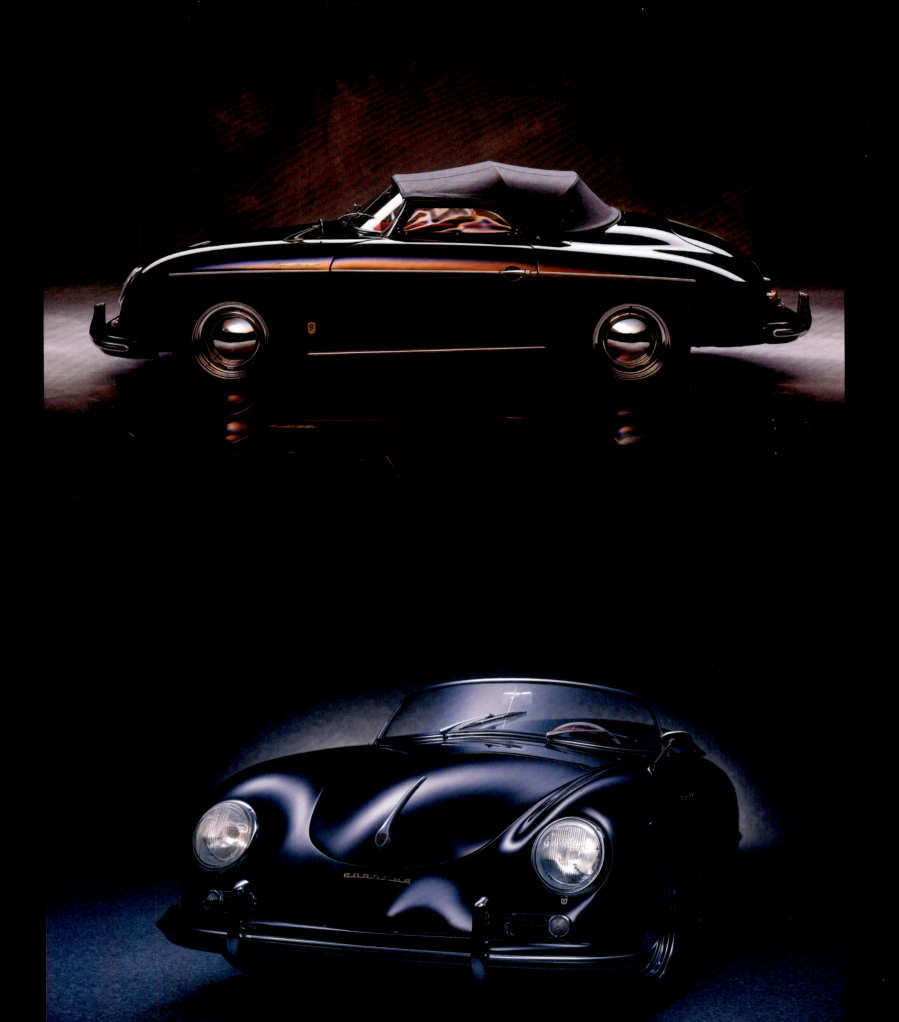

Porsche 356 Speedster
1955–1959

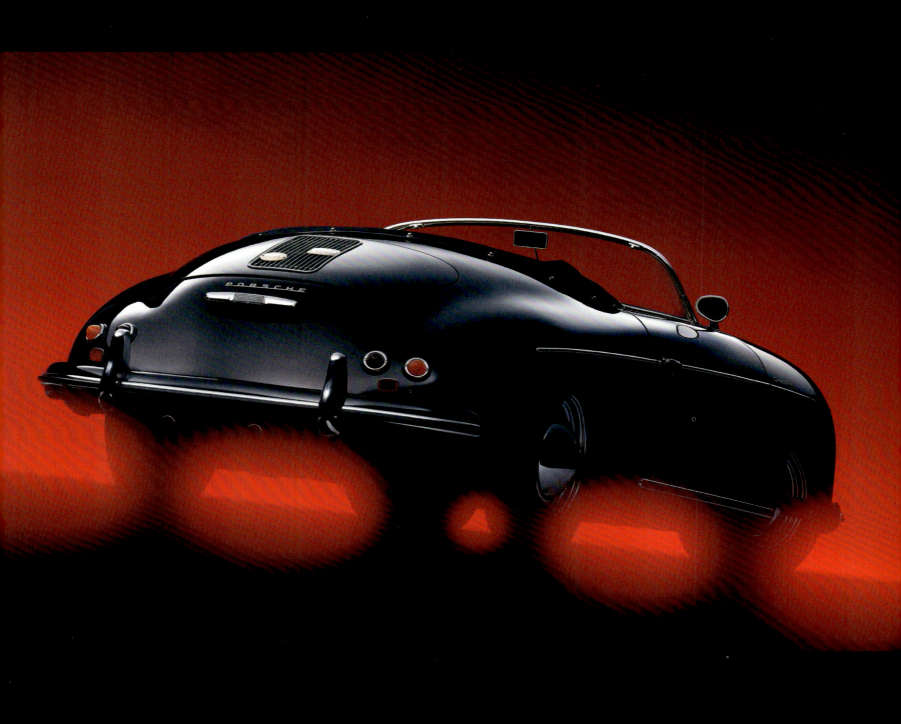

Ferrari Testarossa
1984–1996

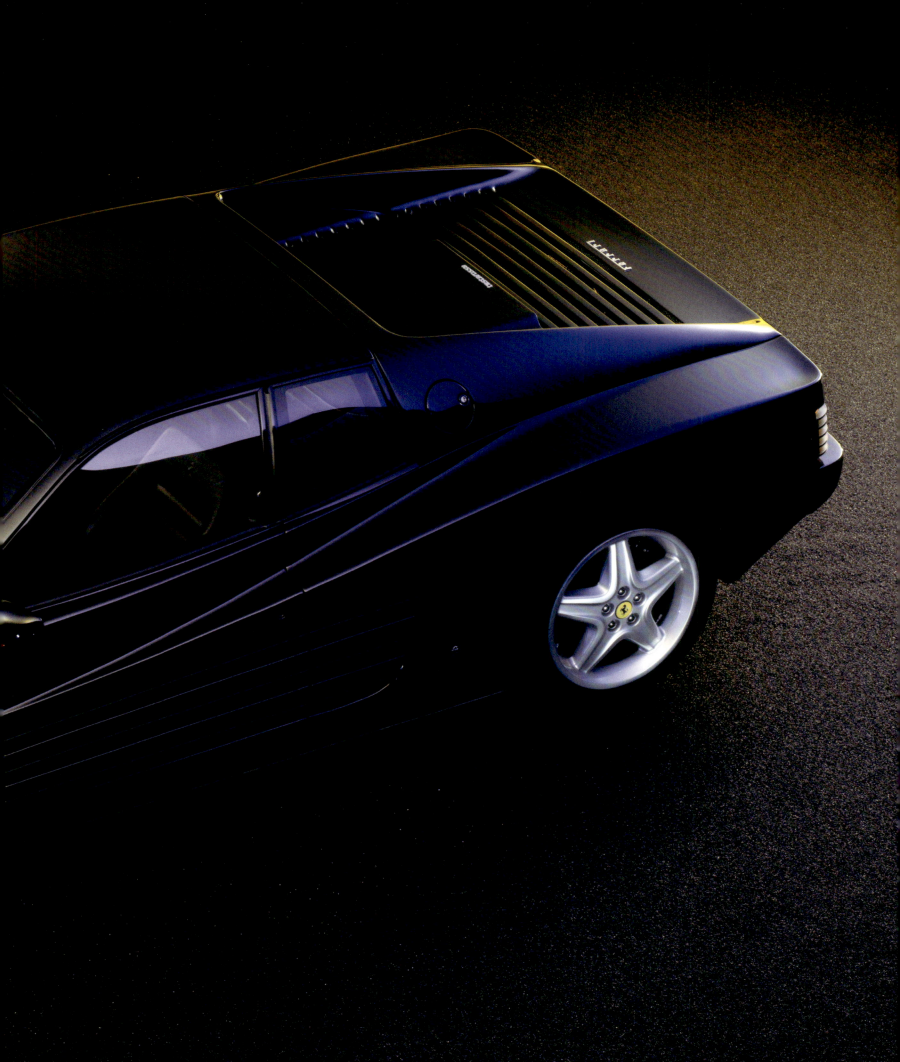

Opel Kapitän '54
1953–1955

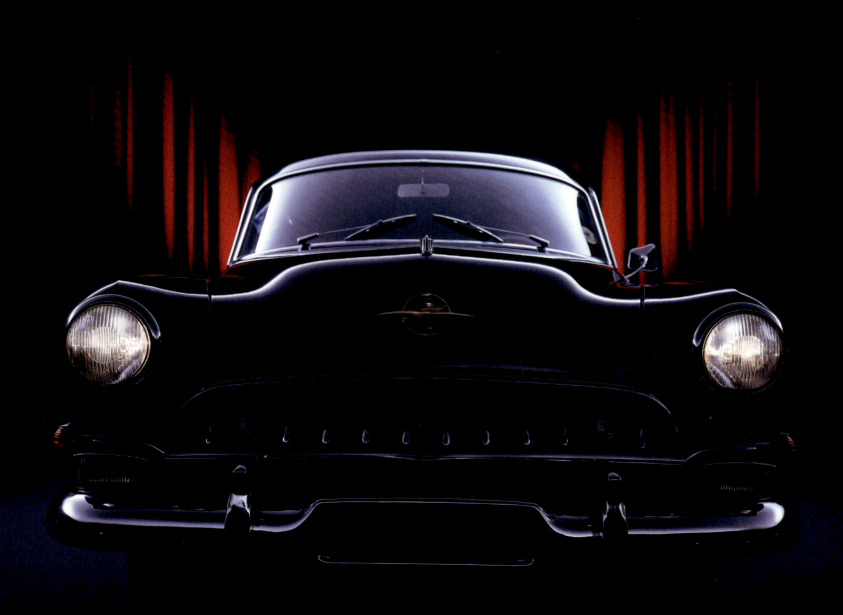

THE "COLOR" BLACK

Prof. Michael Ulbig, Ophthalmologist, Senior Physician, Klinik rechts der Isar

Informally, we speak of both black and white as colors. What color did you pick for your new car? Black! According to color theory, black and white are not colors at all; they are non-colors or so-called achromatic colors. The human eye has three different color receptors in the retina called cones. There are blue cones, green cones, and red cones. We perceive all other colors as a mixture of these three colors. The picture on older color TVs consisted solely of tiny little dots in these three colors that coalesced into what our eyes saw as a moving picture with many different hues. The cones are at the point of sharpest visual acuity deep inside the retina. People can only perceive colors that fall within the spectrum of the cones. Insects, for example, can also see infrared with their specialized eyes. In the peripheral layers of the retina, we have rods, which are the receptors for seeing light and darkness.

So how do we see black? Black means the deepest darkness, which is practically non-existent in today's cities; this is why people talk about light pollution as a kind of environmental pollution. An object that we perceive to be black absorbs all incoming wavelengths of light. If, on the other hand, an object reflects all incoming wavelengths of light, it looks white. A car that is painted red reflects only the red wavelength of light and stimulates the red cones in the eye. Blue or green cars stimulate only the blue or green cones. A purple car stimulates both the red and blue cones, and we perceive it as purple. We need some light or brightness from some source to perceive colors. "At night, all cats are gray," and even an orange car can appear gray to us. This is because we rely more on our rods and less on our cones to see in the dark.

As a young man, I once had quite a scare one night in the 1970s when my bright orange BMW 2002 suddenly looked mouse-gray. By the way, many men have a genetic defect that makes them red-green color-blind. Maybe that's why black cars are so popular? Older people often have trouble differentiating between shades of blue and have trouble seeing the difference between dark blue and black.

Is that why older people prefer to drive white cars? A black car absorbs all wavelengths of light, so it reflects only a smooth surface—the gleam of the paint or the top layer of clearcoat. A matte black surface reflects almost nothing, which is why they used to paint the hoods of road rally cars or cars competing in 24-hour races matte black in the 1960s—to minimize glare from reflections. Some well-known examples of this include the Opel Rally Kadett, the early Ford Capri RS, and Alpina touring cars. Currently, cars painted or coated entirely in matte black are trendy. Black metallic paints have been popular for a long time, but the small metal particles in the paint do make it somewhat reflective. This makes the black metallic paint look like a dark anthracite metallic color to our eyes rather than a true deep black. Black paint's reduced reflectivity makes black cars heat up more when they are parked in the sun. The interior gets several degrees hotter than in an identical white vehicle. The trendiness of black cars has been one factor responsible for the near-universal inclusion of air conditioners in vehicles.

What makes black paint black? Black pigments are mixed into the paint—in earlier times, that generally meant soot. Rubber tires are also black because carbon black is mixed into the raw material. One could mix in other pigments to make the tires different colors. For example, there was one snow tire with a blue tread.

So when you look at the beautiful black cars in this book, you are seeing "achromatic" cars whose paint does not reflect any specific wavelength or challenge the color vision of the human eye. Even if you are among the unlucky color-blind segment of our readership, you will derive great enjoyment from this book.

DIE „FARBE" SCHWARZ

Prof. Michael Ulbig, Augenspezialist, Oberarzt, Klinik rechts der Isar

Umgangssprachlich sprechen wir von Schwarz und auch Weiß als Farben. In welcher Farbe hast du deinen neuen Wagen bestellt? In Schwarz! Von der Farbenlehre her sind Schwarz und Weiß aber gar keine Farben, es sind Nichtfarben oder sogenannte unbunte Farben. Unser menschliches Auge hat in der Netzhaut drei verschiedene Rezeptoren für das Farbensehen, die man als Zapfen bezeichnet. Es gibt Blau-, Grün- und Rotzapfen. Alle anderen Farbtöne sehen wir als Mischtöne dieser drei Farben. Auch das Farbbild der Fernsehröhre bestand aus lauter winzigen kleinen Punkten dieser drei Farben, die dann für unser Auge zu einem bewegten Bild verschiedener Farbtöne verschmolzen. Die Zapfen finden sich an der Stelle des schärfsten Sehens, zentral in der inneren Netzhaut. Der Mensch kann auch nur Farben innerhalb des Spektrums der Zapfen sehen. Insekten können beispielsweise mit ihren spezialisierten Augen auch Infrarot erkennen. In der peripheren menschlichen Netzhaut gibt es die Stäbchen, welche die Rezeptoren für das hell und dunkel Sehen sind.

Wie sehen wir nun schwarz? Schwarz bedeutet entweder tiefe Dunkelheit, wie es sie heute in Städten kaum noch gibt, man spricht daher auch schon von Lichtverschmutzung als einer Art Umweltbelastung. Ein als schwarz wahrgenommener Gegenstand absorbiert alle einfallenden Wellenlängen des Lichts. Reflektiert ein Gegenstand dagegen alle einfallenden Wellenlängen des Spektrums, erscheint er weiß. Ein rot lackiertes Auto reflektiert nur die rote Wellenlänge des Lichts und reizt im Auge die Rotzapfen. Analog ist es bei blauen oder grünen Autos. Ein violettes Auto erregt die Rot- und die Blauzapfen und wir sehen es dann violett. Um Farben zu sehen, brauchen wir also Licht beziehungsweise eine gewisse Helligkeit. „Bei Nacht sind alle Katzen grau" und selbst ein oranges Auto kann dann grau erscheinen. Das liegt daran, dass wir bei Dunkelheit vermehrt mit den Stäbchen und weniger mit den Zapfen der Netzhaut sehen.

In den 1970er Jahren habe ich mich als junger Mann einst erschrocken, als mir nachts mein inka-oranger BMW 2002 plötzlich als mausgrau erschien. Eine große Zahl der Männer in der Bevölkerung hat übrigens genetisch eine Farbsinnstörung im Wellenlängenbereich von rot und grün. Vielleicht sind auch deshalb schwarze Autos so beliebt? Ältere Menschen können Blautöne oft nicht mehr gut unterscheiden und haben Mühe, Dunkelblau und Schwarz zu unterscheiden.

Fahren Senioren daher lieber weiße Autos? Ein schwarzes Auto absorbiert also sämtliche Wellenlängen, es reflektiert nur über eine glatte Oberfläche, also den Glanz des Lacks oder den oberflächlichen Klarlack. Eine mattschwarze Fläche reflektiert fast gar nicht, deshalb hat man in den 1960er Jahren die Motorhauben von Rallyefahrzeugen oder von Autos für 24-Stunden-Rennen mattschwarz lackiert, um Blendung durch Reflexionen zu mindern. Bekannte Beispiele waren der Rallye-Kadett von Opel, der frühe Ford Capri RS oder die Renntourenwagen von Alpina. Derzeit sind komplett matt lackierte oder folierte Autos in Mode. Schon lange sind auch schwarze Metalliclacke populär. Diese haben aber eine gewisse Reflexion durch die im Lack befindlichen Metallpartikel. Dadurch erscheint Schwarzmetallic dem Auge nicht als Tiefschwarz, sondern eher als sehr dunkles Anthrazitmetallic. Die mangelnde Reflexion von schwarzem Lack führt auch zu der vermehrten Aufheizung schwarzer Autos, die in der Sonne geparkt werden. Es wird darin einige Grad heißer als in einem identischen weißen Wagen. Nicht zuletzt hat die Mode der schwarzen Autos auch zur flächendeckenden Ausstattung mit Klimaanlagen geführt.

Was macht schwarzen Lack schwarz? Es werden schwarze Pigmente beigemischt, früher war das meist Ruß. Auch der Gummireifen ist schwarz, da der Rohmasse Ruß beigemischt wird. Man könnte die Gummireifen durch andere Pigmente auch farbig machen. Es gab zum Beispiel einmal Winterreifen mit einer blauen Lauffläche.

Wenn Sie also in diesem Buch die wunderschönen schwarzen Autos anschauen, dann sehen Sie „unbunte" Autos deren Lack keine spezifische Wellenlänge reflektiert, und das Farbensehen des menschlichen Auges nicht herausfordert. Auch wenn Sie zu denjenigen gehören, die eine genetisch bedingte Farbsinnstörung haben, werden Sie sich an diesem Buch erfreuen.

Alfa Romeo 6C 2500

1939–1952

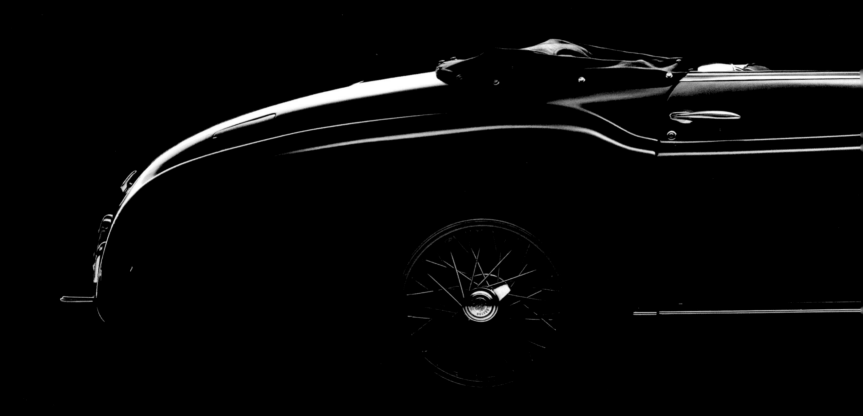

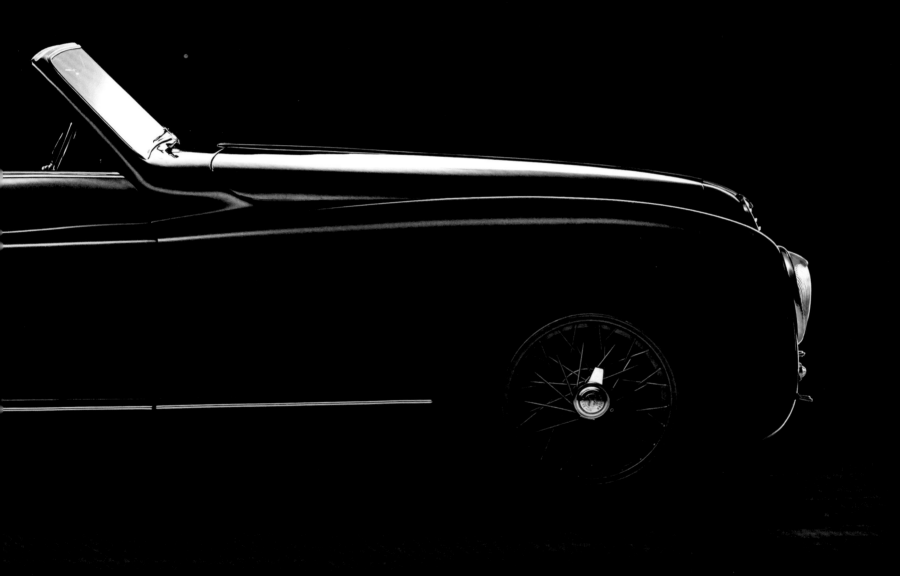

Alfa Romeo 6C 2500

1939–1952

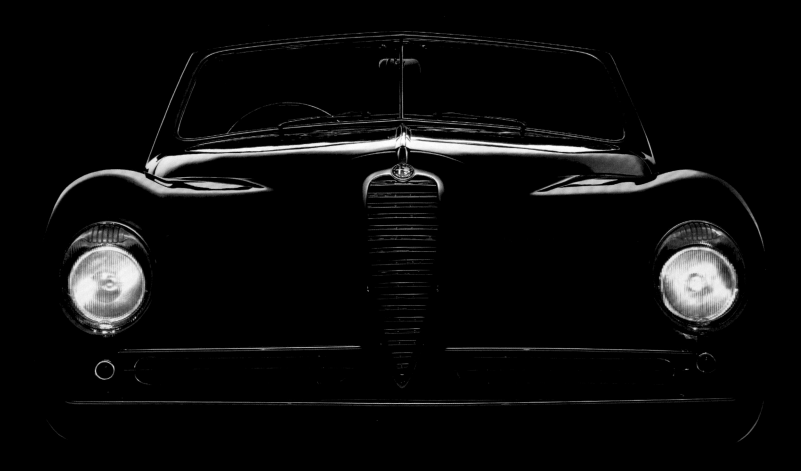

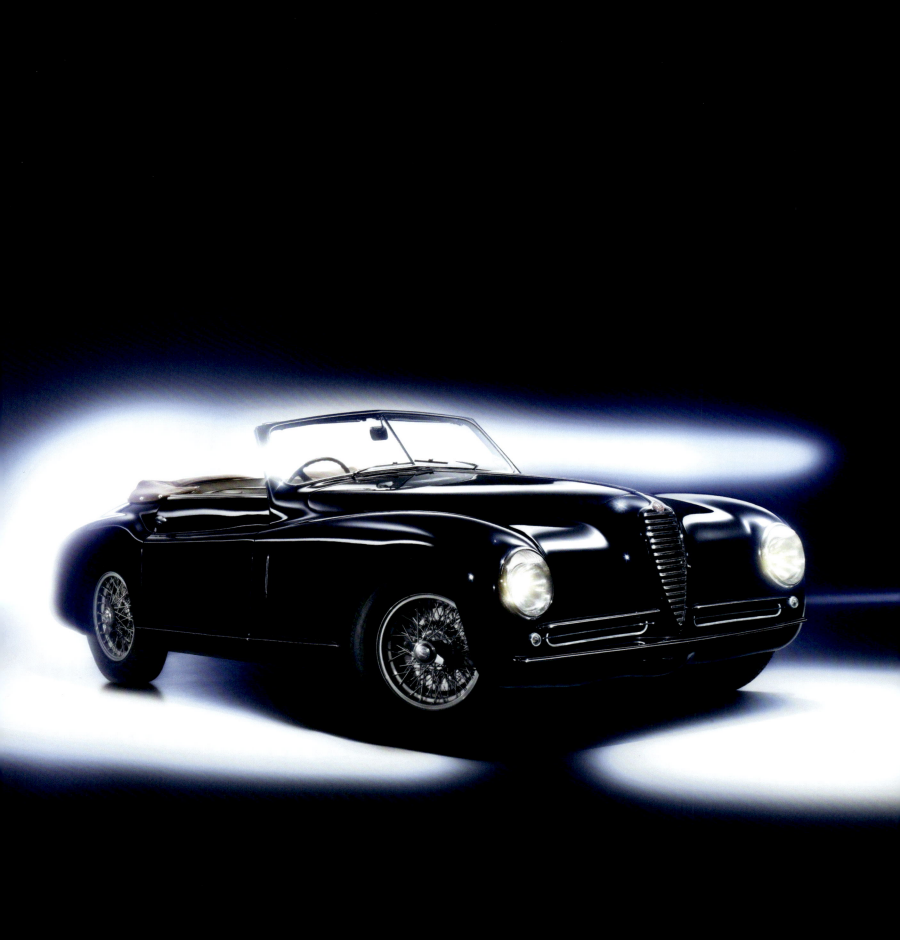

Jaguar E-Type Series 1
1961–1966

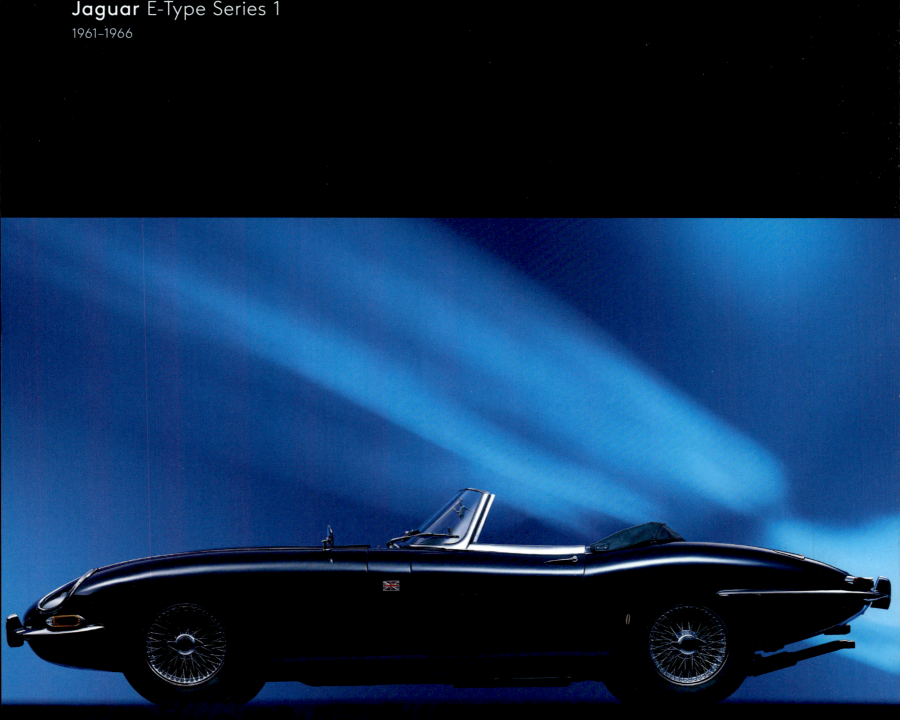

Studebaker Avanti

1962–1963

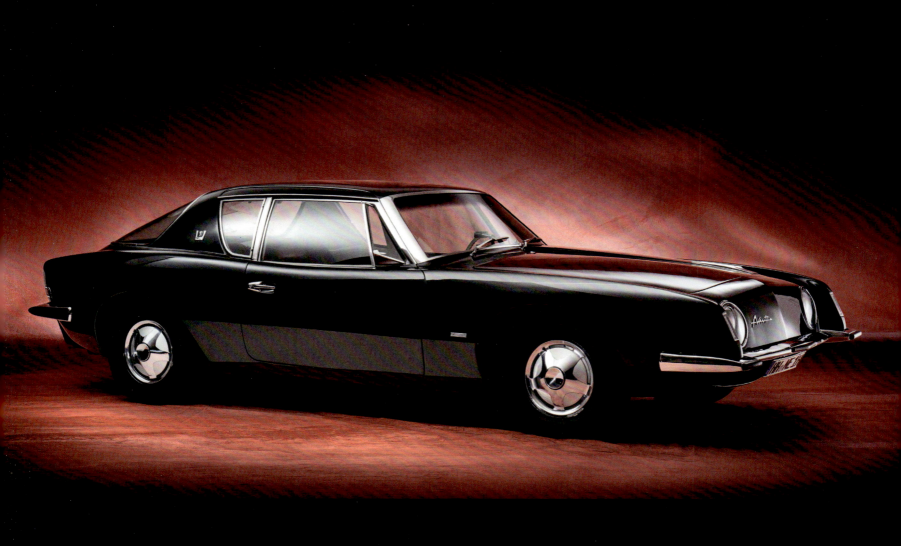

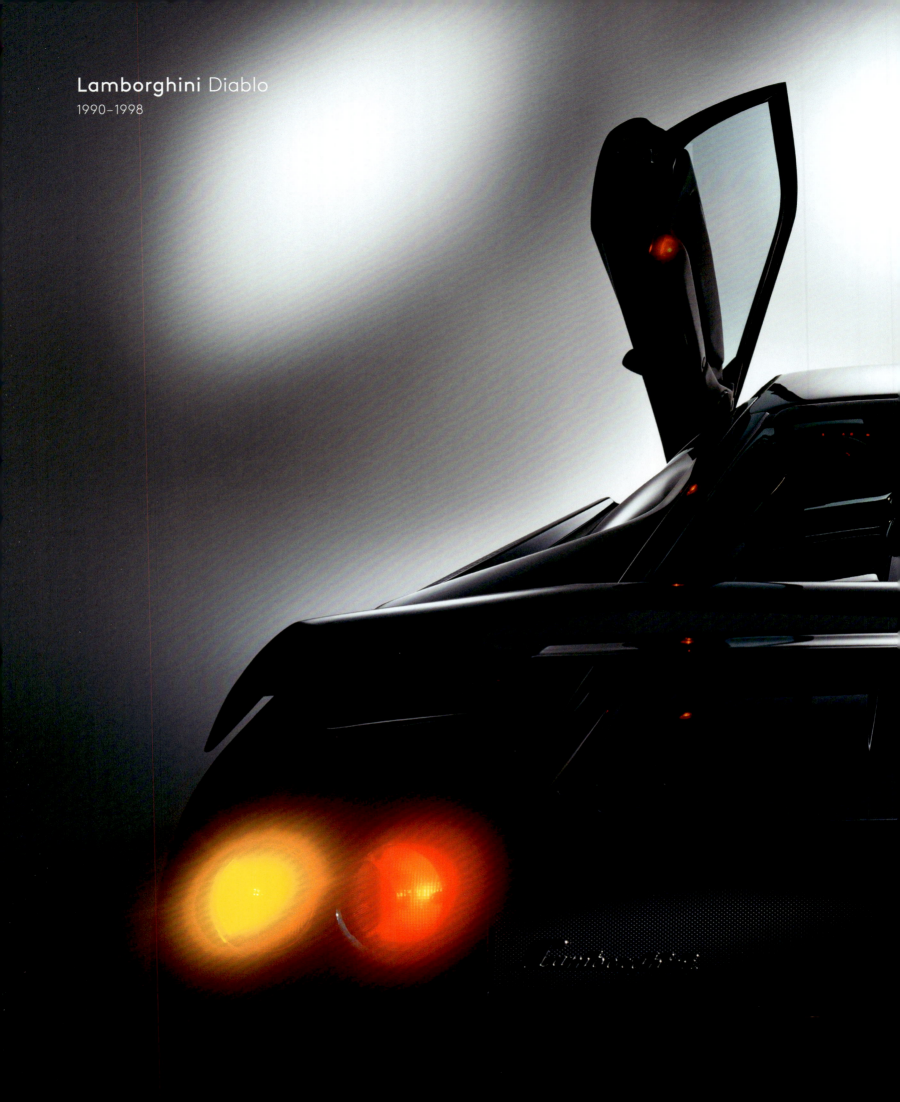

Lamborghini Diablo
1990–1998

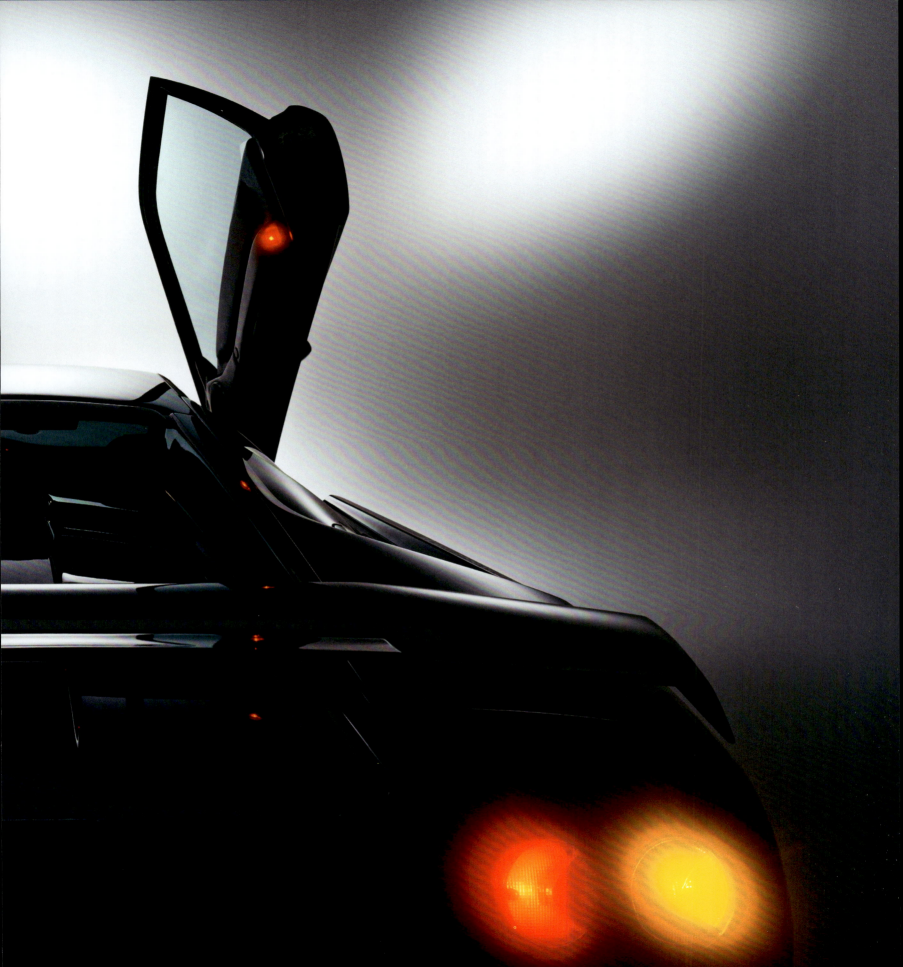

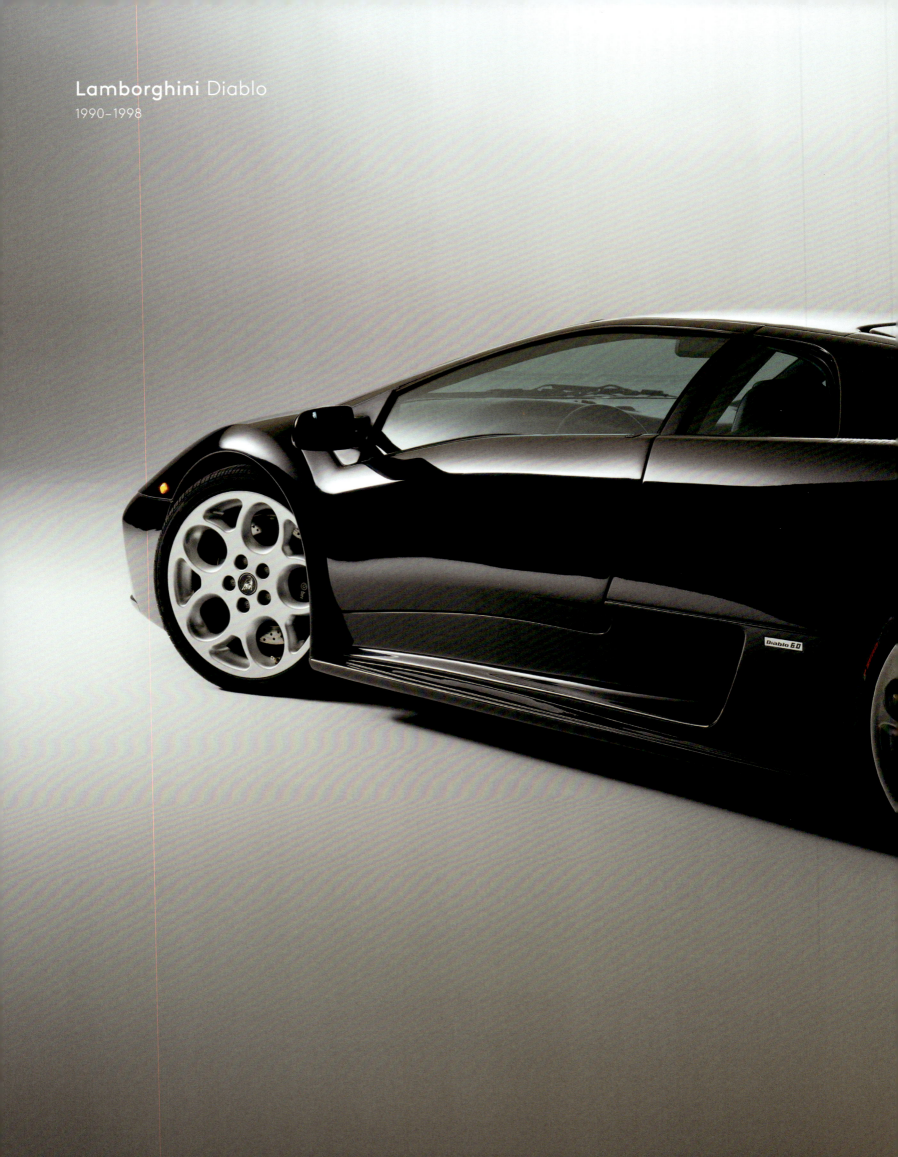

Lamborghini Diablo
1990–1998

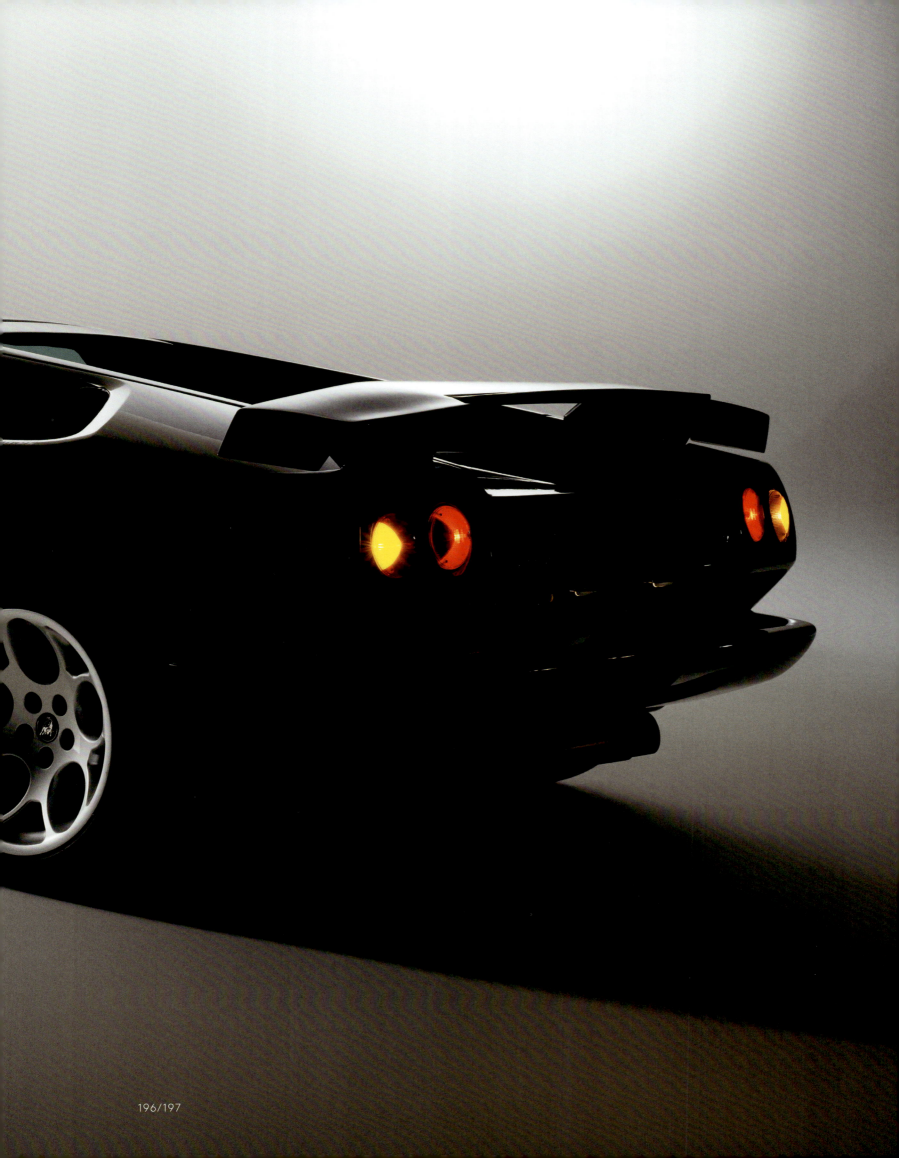

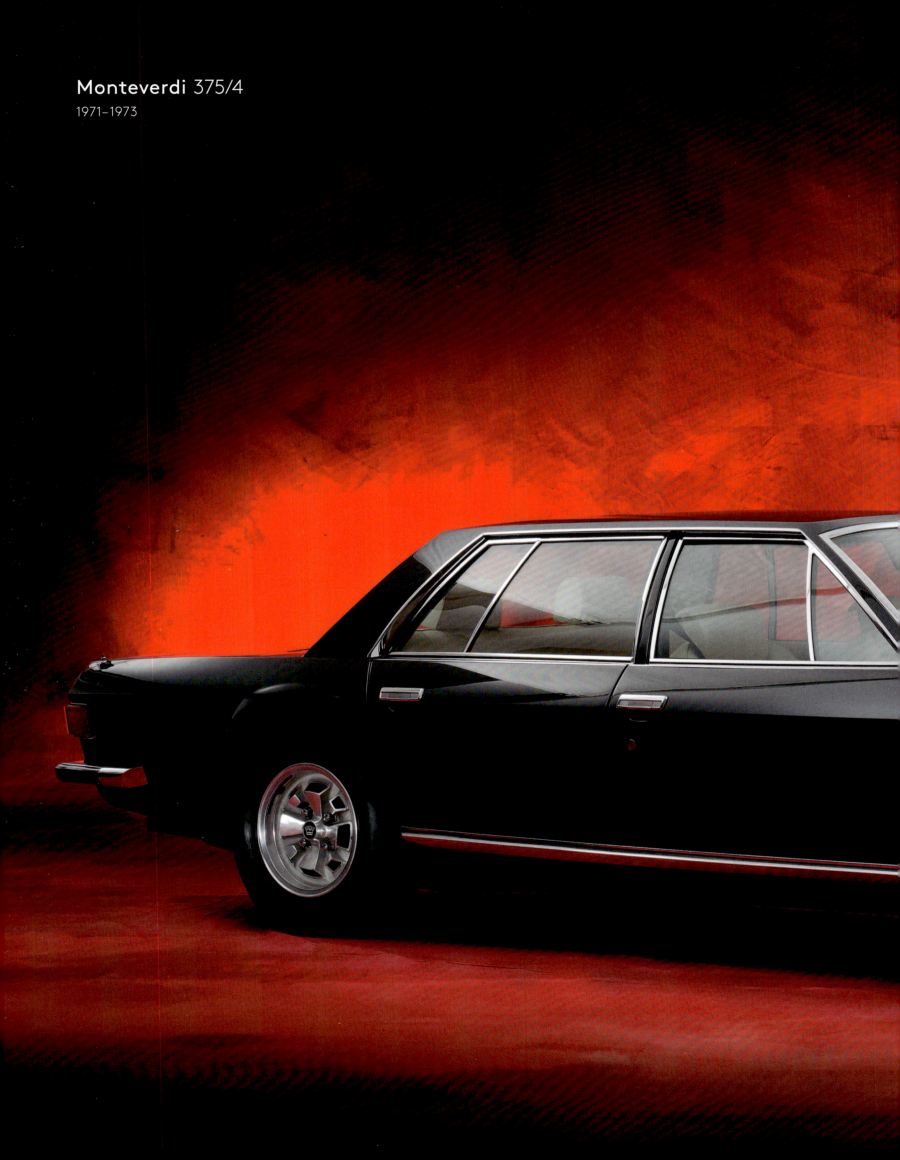

Monteverdi 375/4
1971–1973

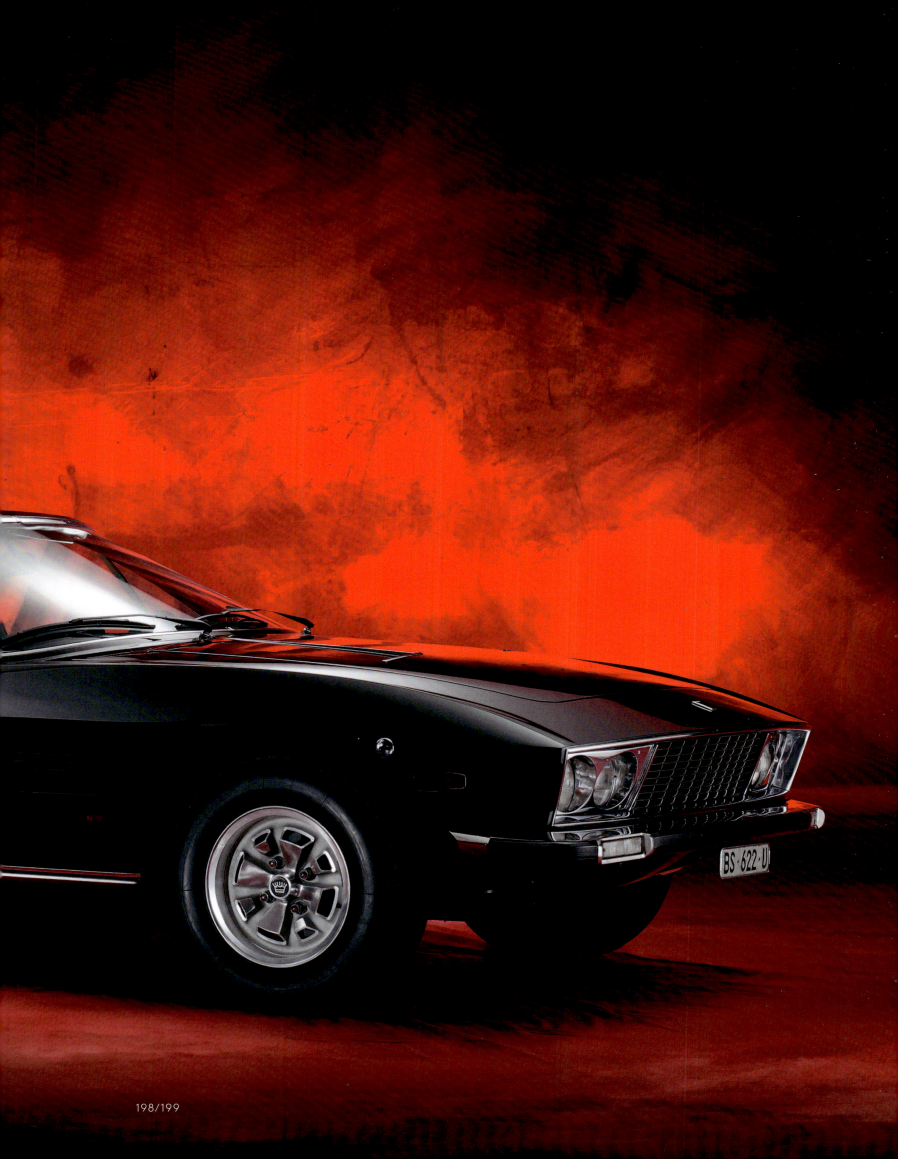

Porsche 911 G-Modell
1973–1989

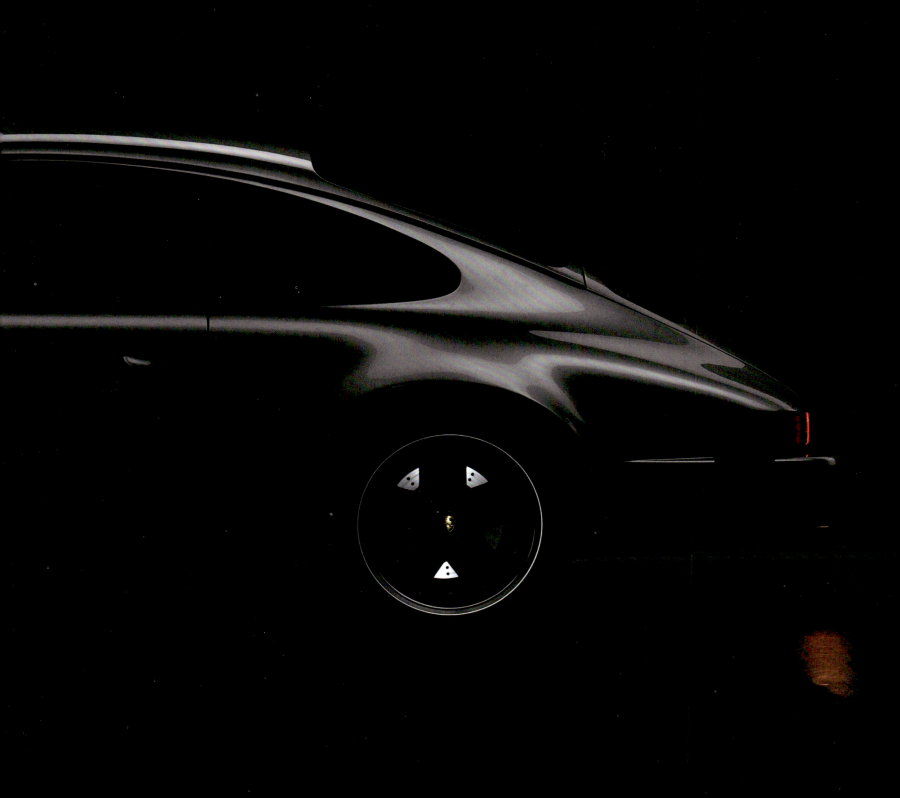

Porsche 911 G-Modell
1973–1989

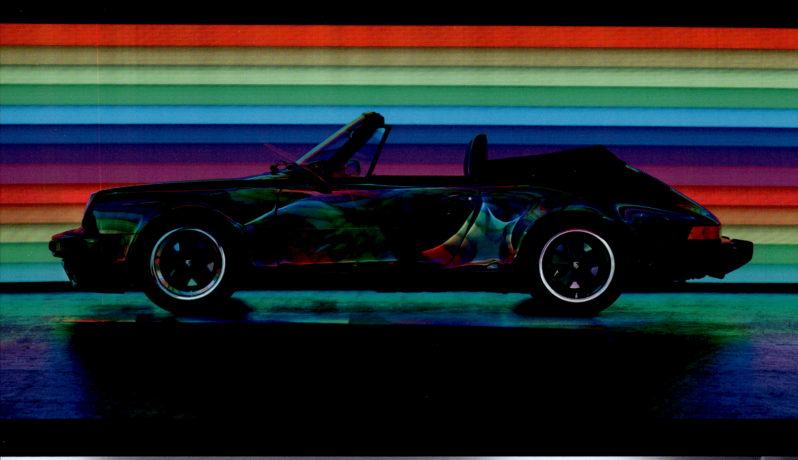

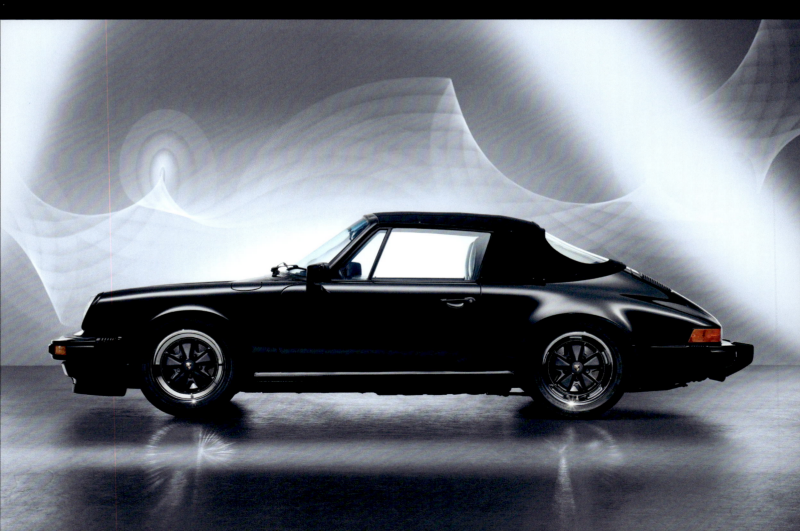

Porsche Carrera GT
2003–2006

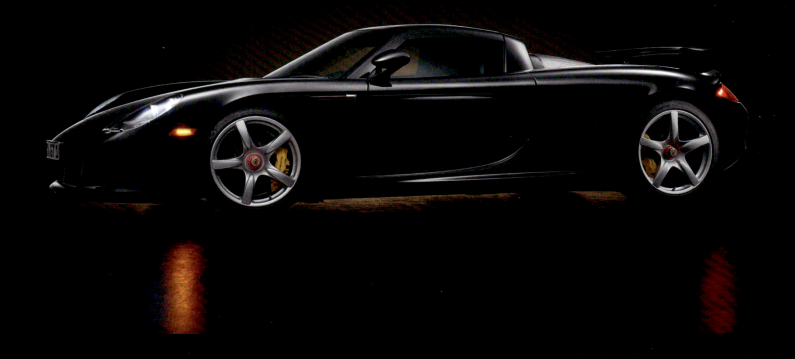

Porsche 911 Targa
50 years of Porsche Design
Limited Edition, 2022

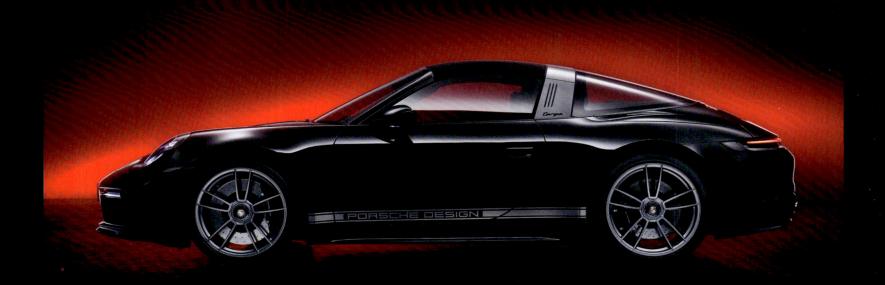

Mercedes-Benz 300 SL Coupé
1954–1957

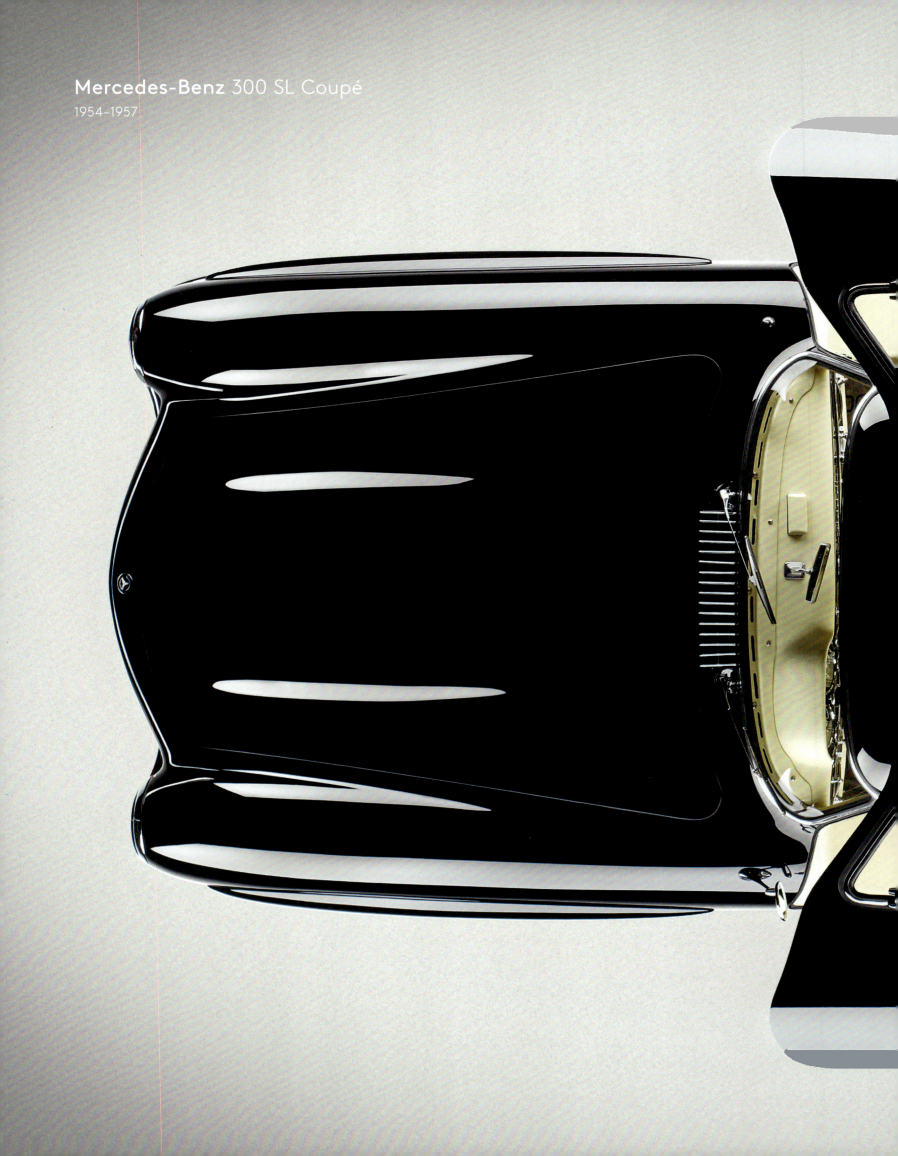

Mercedes-Benz 300 SL Coupé
1954–1957

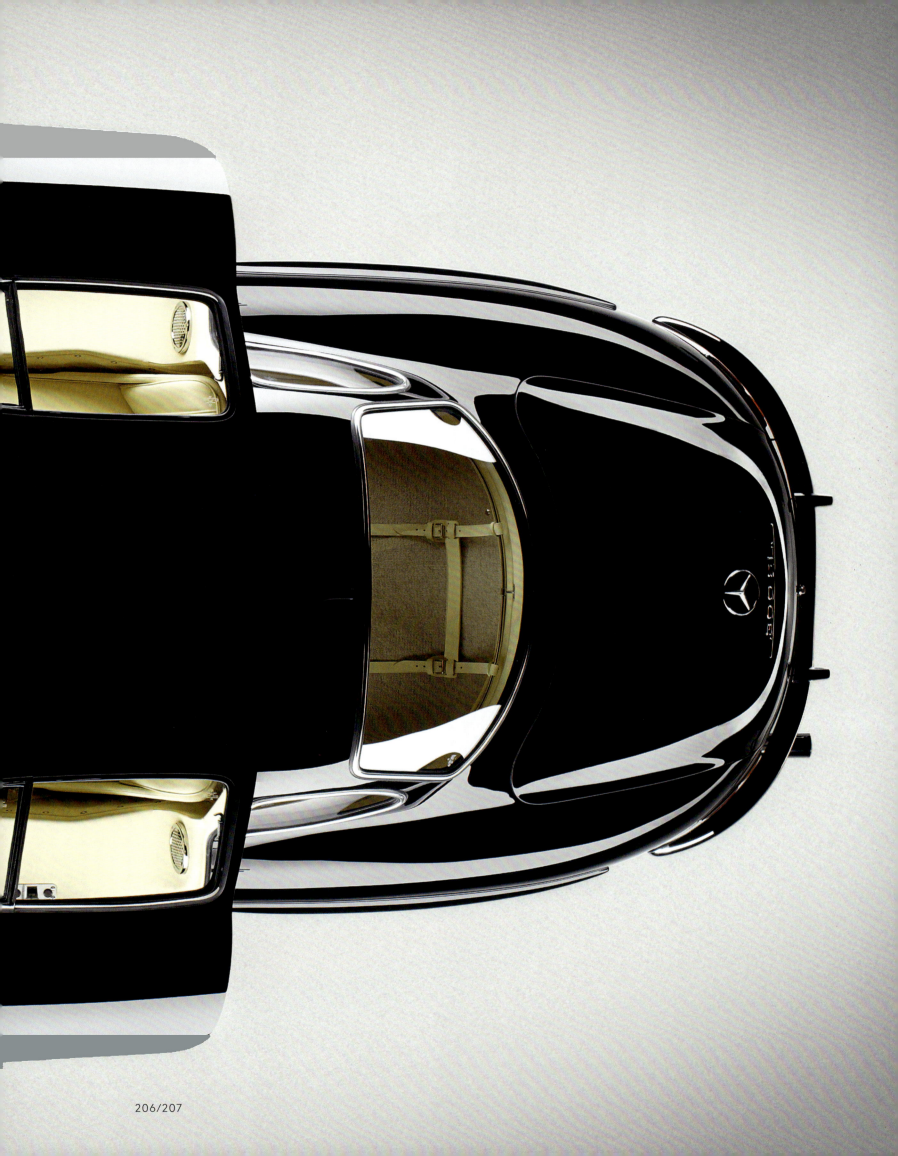

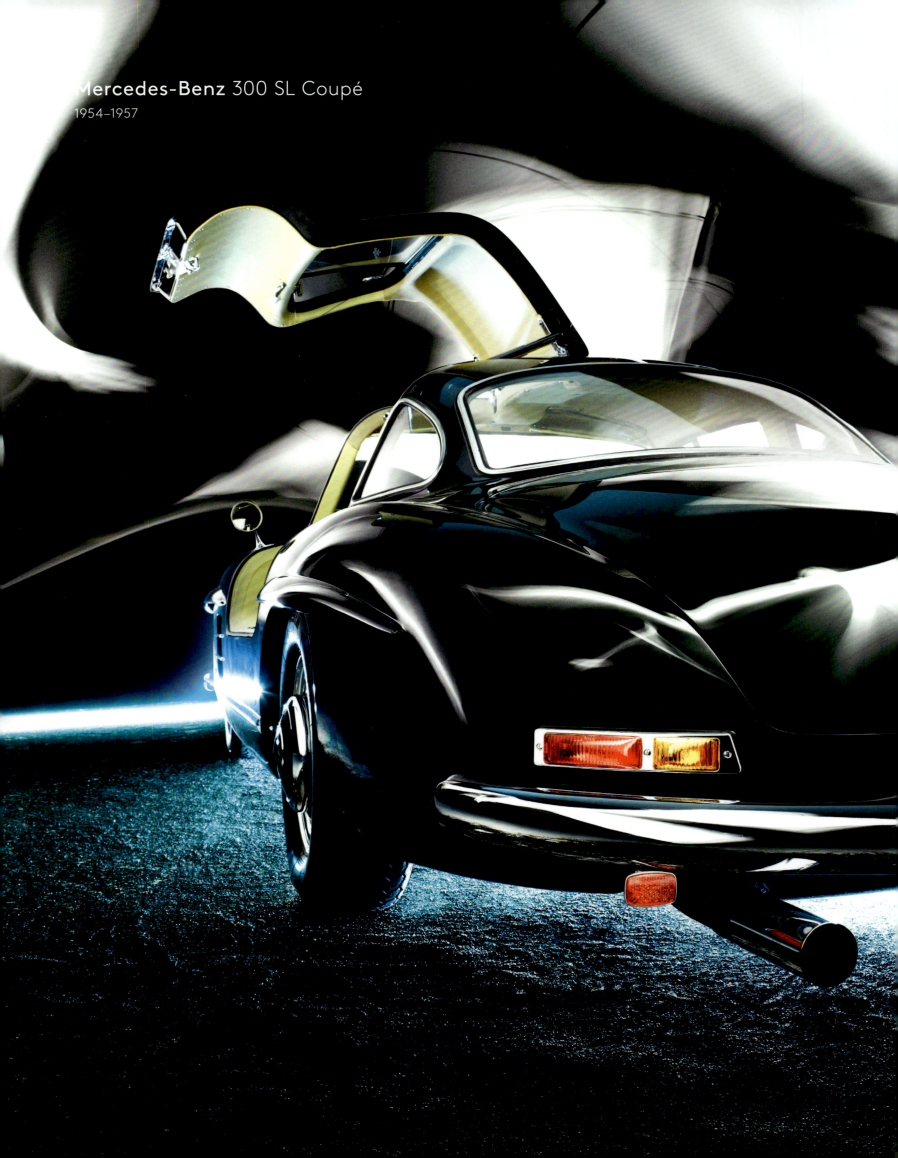

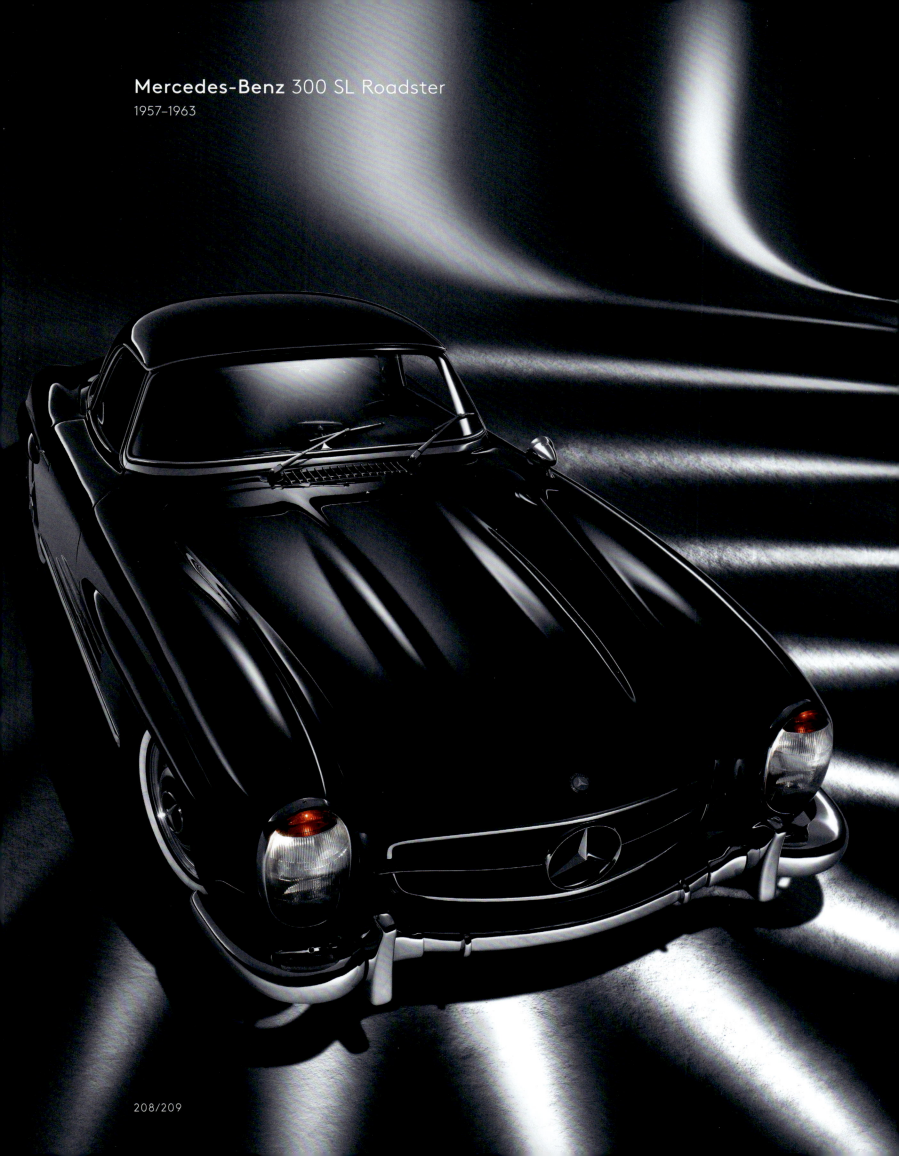

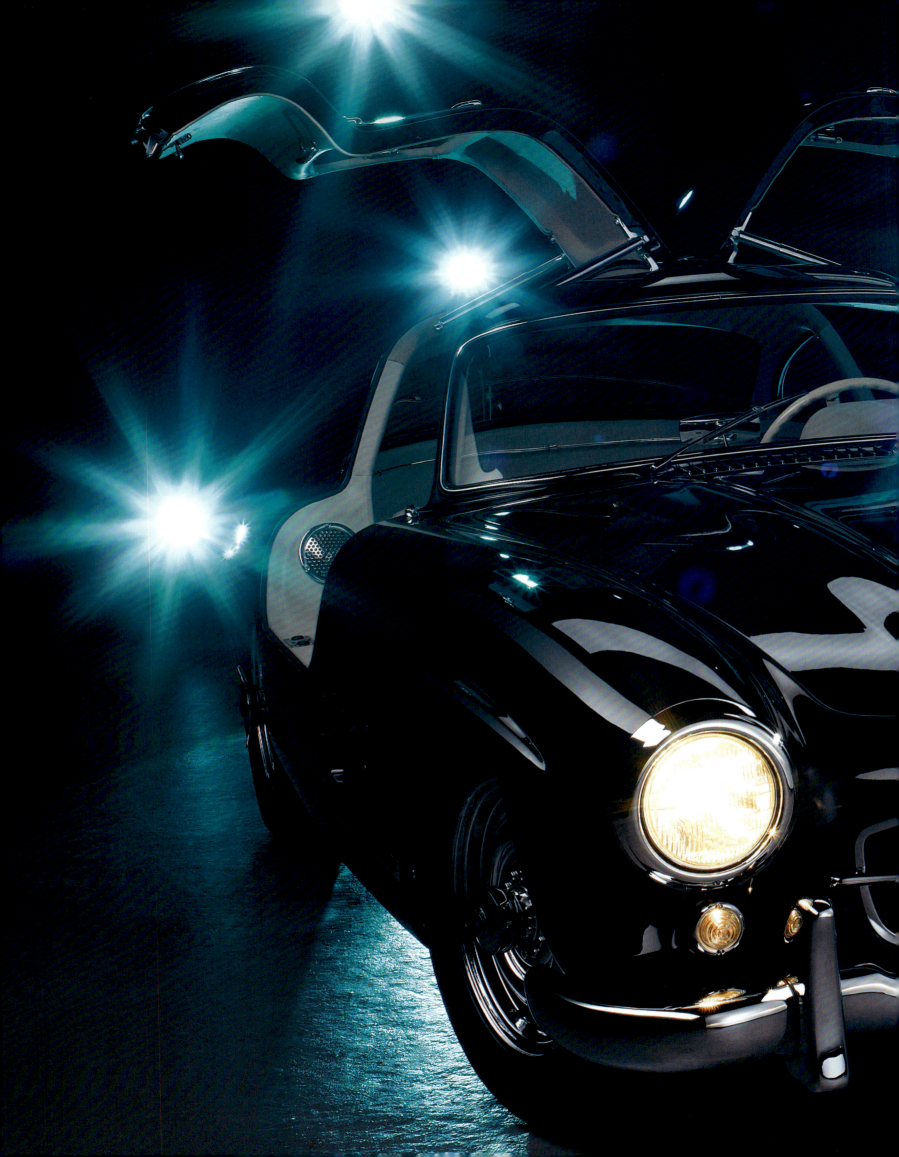

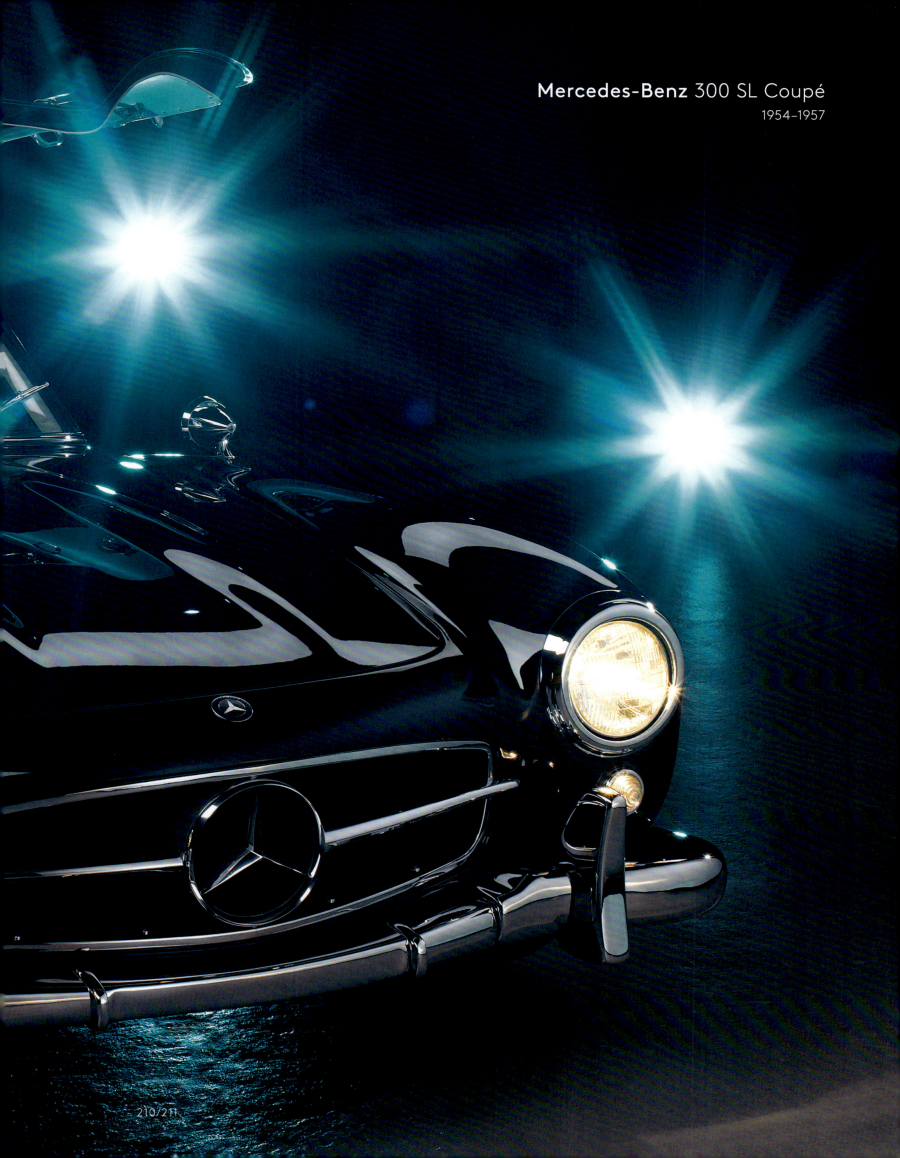

Mercedes-Benz 300 SL Coupé
1954–1957

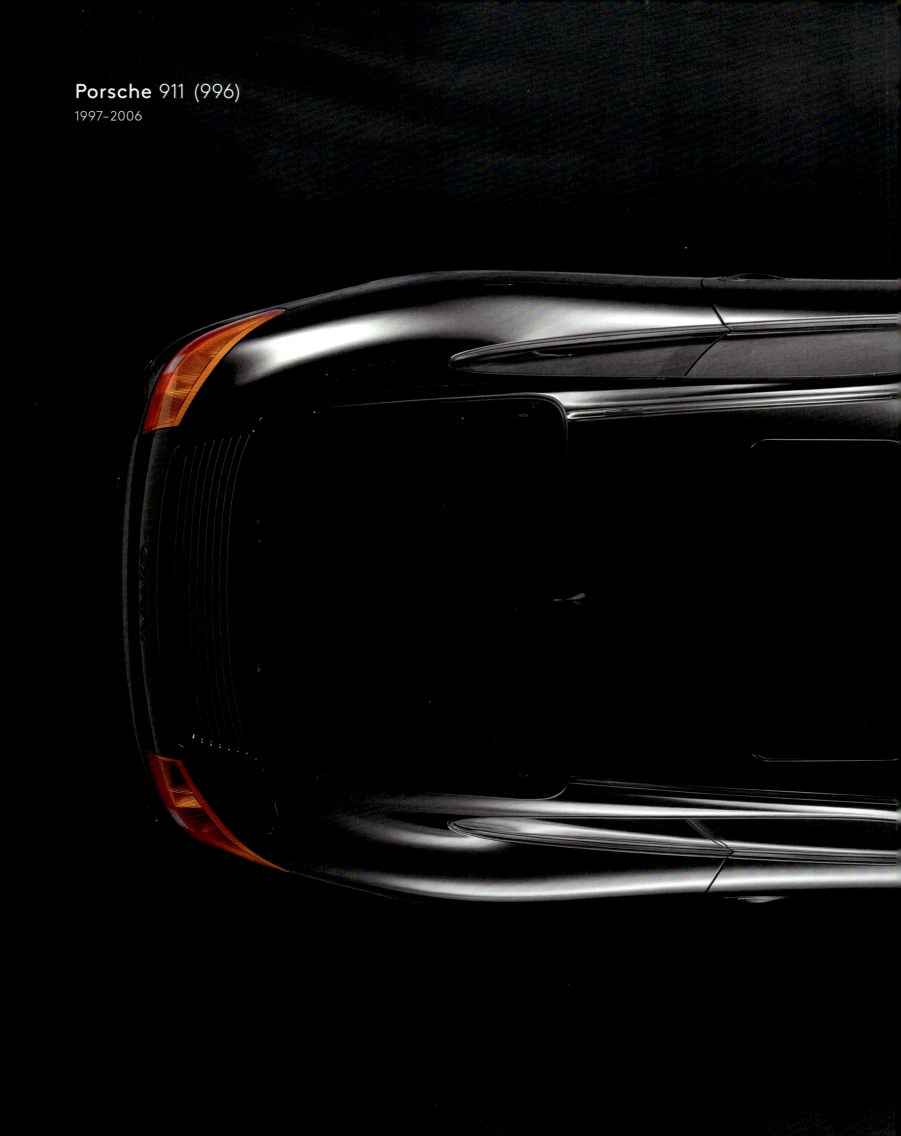

Porsche 911 (996)
1997–2006

BLACK IS AN INSPIRATION

Interview with Prof. Gorden Wagener, Head of Design, Daimler AG

Many designers have a great affinity for the color black. Why is that the case?
Above all, black is timeless, which is surely because it's not really a color. Black also stands for tradition and established values, and it lends any design a certain elegance and exclusiveness. Think of the black-tie dinner or the little black dress, to name just two examples.

Might it be because people have to deal with colors every day? That at some point, people want to reduce the multitude of colors—which are subject to the whims of fashion—down to a non-color, namely black?
Black is definitely a kind of color reset button for my color and trim team. It is often the very first element from which we create something new. It is an oasis where you can gather, a place from which new creativity can take root. Black can also be combined wonderfully with any other color, which is important.

Today, most cars roll off the line in black, silver, and anthracite—do you regret the loss of color variety?
In general, we haven't lost the wide range in our color palettes, but the weighting of the colors has changed, of course. It is subject to societal trends and influenced by new technologies. Themes like sustainability or digitalization can be captured very well via color choices.

Are there colors that just naturally look great on cars? And are there colors that have become very predictable—for example, many people expect certain Italian cars to come only in red, and are people now focusing on the elegance of the car's silhouette to the point of absurdity?
The color underscores the vehicle's proportions. That's why darker colors tend to be used more for luxurious color schemes on larger sedans. But the most important thing is that the color must be perfectly matched to the vehicle's silhouette. If you do that, you're not following a trend, you're starting one. You may even be creating a future classic.

Do colors affect the shape a vehicle takes? Do some models end up looking a certain way precisely because they look especially elegant and sophisticated in black? And is it perhaps easier to "sell" black cars because they have consciously decided not to participate in the colorful world around them?
The color is designed for the vehicle, not the other way around. The color designer is included in the formal design process and is inspired by the shape the vehicle takes. He thinks about which colors and effects he would like to use to show the vehicle's form to its greatest advantage. Black cars tend to feel proportionally smaller, while white adds visual volume. And black is indeed a big seller because it stands for luxury and sportiness at the same time. A black S-Class maximizes the car's elegance, while black in an A-Class creates a dynamic, sporty, youthful feel. For Mercedes-Benz, black (along with gray) is our brand color. Our entire corporate design is in black and silver—the silver star on a black background.

What does the color black mean to you, Gorden Wagener, as a person and as a designer? Is it a non-color that inspires you, challenges you? Or is it "just" another color that the market demands? And last but not least, what do you think about white, the other non-color? Does it have a similar meaning? Is it equally difficult to understand? Does it also have an impact on the vehicle's silhouette?
"Black is beautiful." And black is definitely an inspiration, because as I said, it often stands for new beginnings. As a designer, I have to leverage its ability to strike new chords and send our brand down new roads. By the way, I frequently wear black. Black underscores the nature of your personality because it always sits quietly in the background. You'll never be fashionably dressed that way, but you'll always be sure of your style and sophistication. Like black, white is also not a color and therefore also very timeless. In my mind, it stands primarily for modernity, clarity, and high-tech. And I am definitely making a statement with white. Ever since Dieter Rams and his Braun designs came along, white products have been very popular, and Apple and its products have certainly amplified that trend even further. For example, I always drive white cars with black accents.

SCHWARZ IST EINE INSPIRATION

Interview mit Prof. Gorden Wagener, Leiter Design, Daimler AG

Viele Designer haben eine große Affinität zu der Farbe Schwarz. Woran könnte das liegen?
Schwarz ist vor allem zeitlos, was sicherlich daran liegt, dass es eben keine Farbe ist. Zudem steht Schwarz für Tradition und etablierte Werte und es verleiht jedem Design eine gewisse Erhabenheit und Exklusivität. Als Beispiel: der schwarze Anzug sowie das kleine Schwarze.

Liegt es an der Tatsache, dass man sich täglich mit Farben auseinandersetzen muss? Dass man die Vielfalt der Farben – die ja auch Moden unterliegen – irgendwann auf eine Nicht-Farbe, nämlich Schwarz reduzieren möchte?
Schwarz ist für mein Color & Trim Team durchaus eine Art Farb-Reset. Es steht oftmals als absoluter Anfang, woraus etwas Neues entsteht. Der Ruhepol, an dem man sich sammelt und von dem aus neue Kreativität entstehen kann. Schwarz lässt sich zudem mit allen Farben am besten kombinieren, was wichtig ist.

Der Großteil der Fahrzeuge wird heute in den Farben Schwarz, Silber und Anthrazit bestellt – bedauern Sie den Verlust der Vielfältigkeit?
Generell ist die Vielfalt der Farbtöne nicht weniger geworden. Die Gewichtung der Farben ändert sich natürlich. Sie unterliegen gesellschaftlichen Trends, werden beeinflusst durch neue Technologien. Themen wie Nachhaltigkeit oder Digitalisierung lassen sich sehr gut an Farbthemen festmachen.

Gibt es Farben, die Automobilen besonders gut stehen? Gibt es Farben, an denen man sich irgendwann sattgesehen hat – so wie die Öffentlichkeit manche italienischen Fahrzeuge nur in Rot akzeptiert und darüber die Eleganz der Formen ad absurdum führt?
Ein Farbton unterstreicht die Proportionen eines Fahrzeugs. Daher werden beispielsweise dunklere Töne eher für die luxuriösere Farbwelt der größeren Limousinen kreiert. Das wichtigste allerdings ist: Der Farbton muss perfekt der Silhouette des Fahrzeugs angepasst werden. Auf diese Weise unterwirft man sich keinem Trend, sondern schafft ihn selbst. Möglicherweise gelingt einem damit sogar ein Klassiker der Zukunft.

Wirken sich Farben auf Formen aus? Entstehen manche Modelle in der letztlich gültigen Form auch deswegen, weil sie in Schwarz besonders elegant, besonders edel wirken? Und sind Exponate gerade in Schwarz nicht besonders schwierig zu „verkaufen"? Weil sie sich der Farbigkeit der Umwelt bewusst entziehen?
Die Farbe wird für die Form designt. Nicht anders herum. Der Farbdesigner ist in den formalen Gestaltungsprozess eingebunden und wird durch die entstehende Form inspiriert. Er überlegt sich, welche Farben und auch welche Effektgeber er einsetzen möchte, um die Form optimal zu unterstützen. Fahrzeugproportionen in Schwarz wirken in der Regel kleiner, während Weiß das Volumen optisch vergrößert. Und Schwarz verkauft sich sehr gut, denn es steht für Luxus und Sportlichkeit gleichermaßen. Eine S-Klasse in Schwarz zeigt das höchste Maß an erreichbarer Eleganz während Schwarz für die A-Klasse für Dynamik, Sportlichkeit und Jugendlichkeit steht. Für Mercedes-Benz ist Schwarz neben Silber zudem unsere Markenfarbe. Unser gesamtes Corporate Design ist in Schwarz und Silber gehalten, der silberne Stern auf schwarzem Grund.

Was bedeutet die Farbe Schwarz für den Menschen und den Designer Gorden Wagener? Ist das eine Nicht-Farbe, die ihn inspiriert – ihn herausfordert? Oder ist es „nur" eine andere Farbe, die der Markt eben fordert. Und last, but not least: Wie denkt der Designer Wagener über die andere Nicht-Farbe: Weiß. Hat sie eine ähnliche Bedeutung? Ist sie ähnlich schwierig zu greifen? Hat auch sie Auswirkungen auf die Formgestaltung?
„Black is beautiful". Und Schwarz ist definitiv eine Inspiration, denn wie gesagt, es steht häufig für den Neuanfang. Als Designer muss ich diese Gabe, Neues zu beginnen, neue Wege für unsere Marke zu gehen, leben. Ich trage übrigens häufig Schwarz. Schwarz unterstreicht den Charakter einer Persönlichkeit, da es sich als Farbe zu keiner Zeit in den Vordergrund drängt. Man ist damit nicht unbedingt modisch, dafür aber immer stilsicher und exklusiv gekleidet. Weiß ist ebenso wie Schwarz keine Farbe und damit sehr zeitlos. Es steht meiner Meinung nach vor allem für Modernität, Klarheit und Hightech. Und ich setze mit Weiß definitiv ein Statement. Weiße Produkte sind seit Dieter Rams und seinem Braun-Design sehr beliebt und dieser Trend wurde sicher durch Apple und seine Produkte nochmals verstärkt. Ich fahre zum Beispiel immer weiße Autos mit schwarzen Akzenten.

BLACK ETERNITY

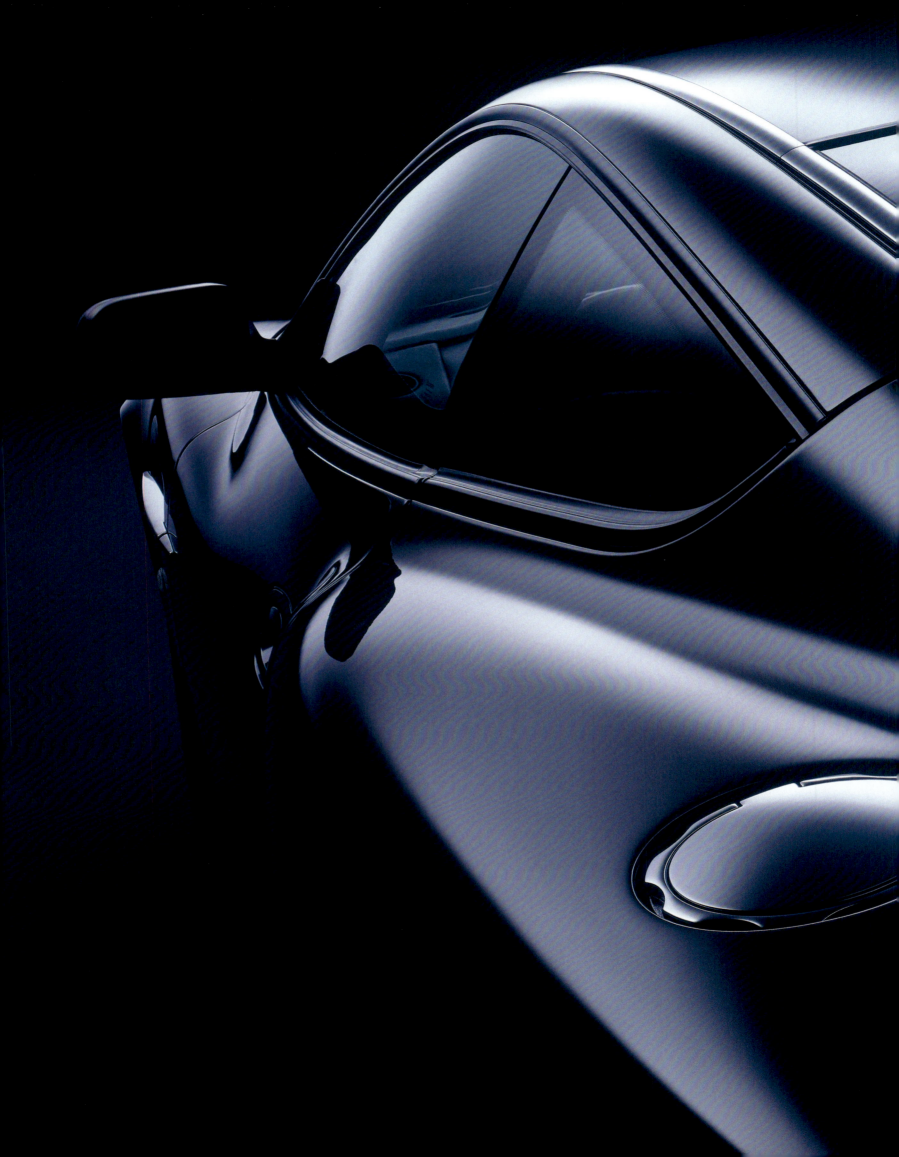

Black for all eternity? In the end, yes, actually, because at some point far in the future, the color black will have won out. But that date is so unimaginably distant that we need not fear it. We still have countless opportunities to light up our world in bright colors. And still, the "un-color" black seems to fascinate us in a way other colors do not. Want proof? Just look at the sheer number of black cars people order and buy. The reasons are readily apparent: black offers elegance and solidity. And the fact that black cars hold their value well surely helps the argument along. People seem to accept that it also means they have to wash and wax their cars more often.

And truly, the models shown on the following pages seem to be made for eternity: a Bentley Continental Coupé, the various Aston Martin vehicles, and the Mercedes-Benz AMG line—you really can't imagine them in any color other than black. Particularly the AMG SLS with its open gullwing doors seems like a clone of its 1954 cousin catapulted forward into the present day— and the Maybach Exelero V12 Biturbo could appear in the next Star Wars movie as Darth Vader's Imperial street cruiser. And that brings us to the somewhat darker side of power—to the cars whose aggressive silhouettes, obsession with horsepower, and the associated noise factor tend to polarize people. To, for example, the Audi R8 V10, the perfect antithesis to the long-mystified Porsche 911. Or to the automobiles from Sant'Agata, like the Lamborghini Gallardo, and their counterparts from Maranello: Here as well, it is easy to argue that they fulfill their role much better in black than in the now dime-a-dozen color red.

Clearly, the color black has a number of interesting characteristics: it lends dignity to elegance, it adds status without being elitist. And finally, it can be evil and aggressive as well—or to put it a bit more casually, stick a nice sharp elbow into someone's ribs now and again. Probably, its many varying manifestations are precisely what makes black, this color that is so hard to pin down, so very irresistable.

Schwarz bis in alle Ewigkeit? Letztlich wohl ja, denn eines sehr fernen Tages wird die Farbe Schwarz gewonnen haben. Aber das liegt in einer so unfassbar entfernten Zukunft, dass wir uns nicht vor ihr fürchten müssen. Deshalb bleiben uns noch unzählige Gelegenheiten, unsere Welt in bunten Tönen auszuleuchten. Und dennoch scheint die Nicht-Farbe Schwarz ein besonderes Faszinosum darzustellen. Der Beweis dafür: die schiere Zahl der Fahrzeuge, die in Schwarz geordert werden. Die Gründe dafür liegen auf der Hand: Die Farbe bietet Eleganz und Gediegenheit. Dass dies auch mit einem relativ geringen Wertverlust einhergeht, hilft argumentativ sicherlich auch etwas weiter. Dass das Gefährt dafür etwas öfter gewaschen und poliert werden sollte, wird dagegen akzeptiert.

Und tatsächlich wirken die Modelle auf den folgenden Seiten ja wie für die Ewigkeit geschaffen: Ein Bentley Continental Coupé, die diversen Aston Martin-Geschosse und die Mercedes-Benz AMG-Modelle – man kann sie sich ja eigentlich nur in Schwarz vorstellen. Besonders der AMG SLS wirkt mit seinen geöffneten Flügeltüren wie ein in die Jetztzeit geschleuderter Klon seines Bruders aus dem Jahr 1954 – und der Maybach Exelero V12 Biturbo könnte in der nächsten Star Wars-Episode Darth Vader als imperialer Straßenkreuzer dienen. Kommen wir also zu der etwas dunkleren Seite der Macht – zu den Gefährten, die mit ihrem aggresiven Äußeren, ihrer Lust an der Leistung und der damit durchaus auch verbundenen Geräuschentwicklung polarisieren. Zum Audi R8 V10 beispielsweise, der den perfekten Gegenpol zum längst mystifizierten Porsche 911 darstellt. Oder nehmen wir die Gefährte aus Sant'Agata, wie beispielsweise den Lamborghini Gallardo, und deren Gegenspieler aus Maranello: Auch hier kann man problemlos konstatieren, dass sie die ihnen zugedachte Rolle schwarz lackiert eigentlich viel besser ausfüllen als in dem mittlerweile zur Dutzendware verkommenen Rot.

Offenbar verfügt die Farbe Schwarz über eine Vielzahl von Eigenschaften: Sie verleiht der Eleganz Würde, sie bringt Status und ist dennoch nicht elitär. Und last, but not least, kann sie auch aggressiv und böse sein – und salopp gesagt auch hin und wieder die Ellbogen ausfahren. Wahrscheinlich ist es diese Vielzahl an Erscheinungsformen, die diese so schwierig zu handhabende Farbe Schwarz so unwiderstehlich macht.

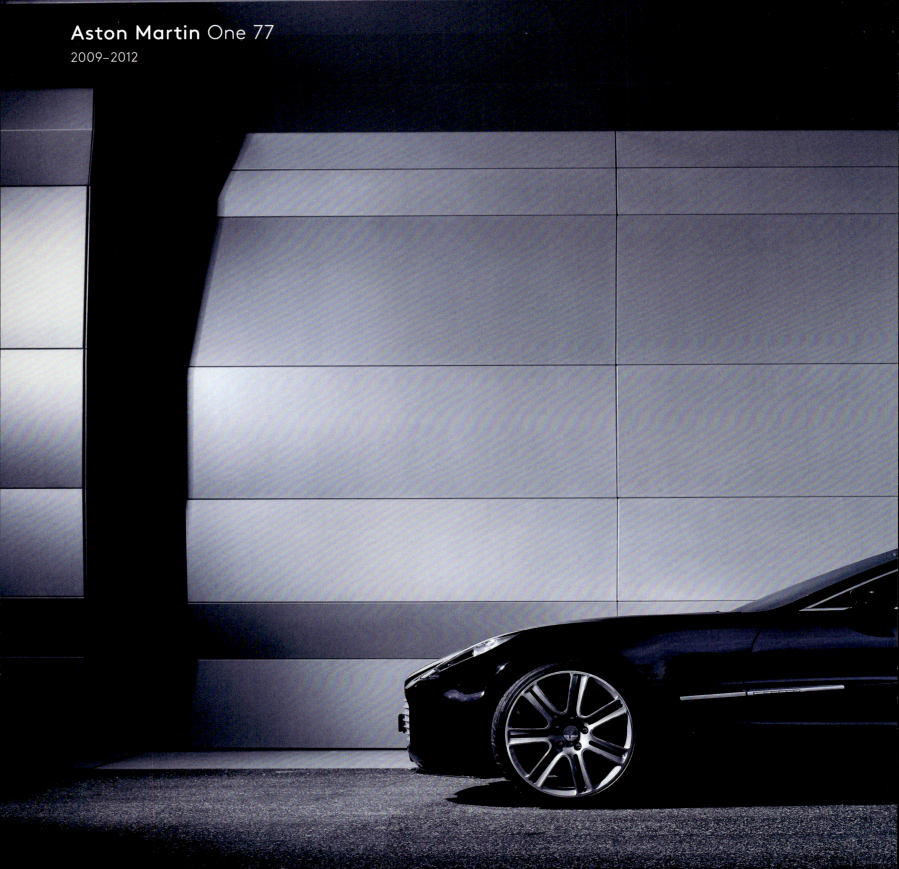

Aston Martin One 77
2009–2012

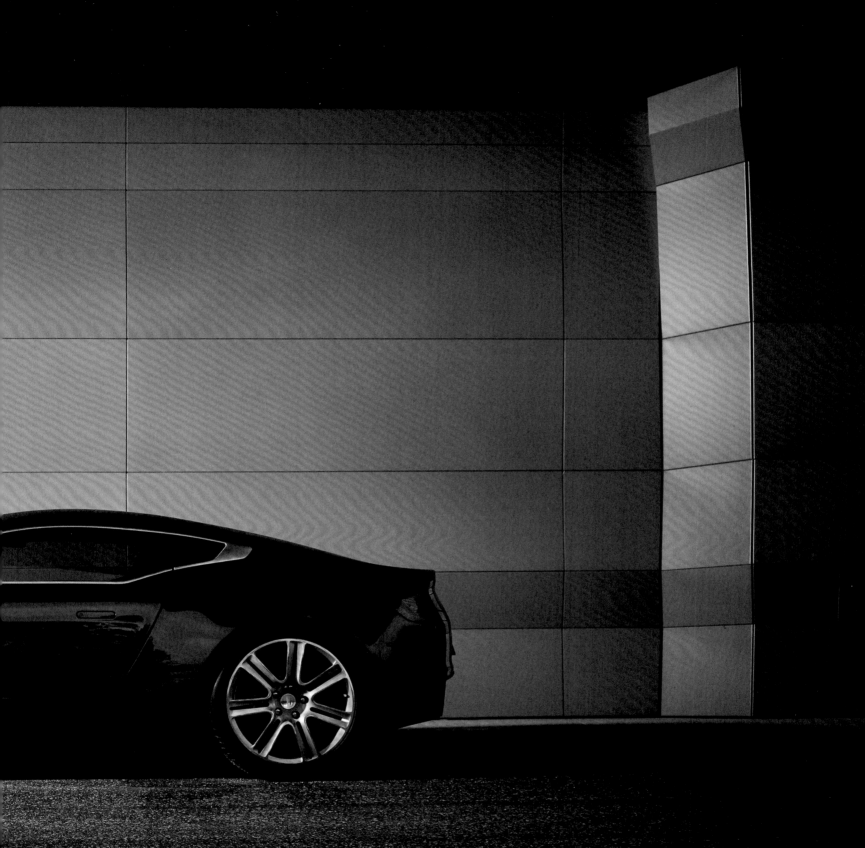

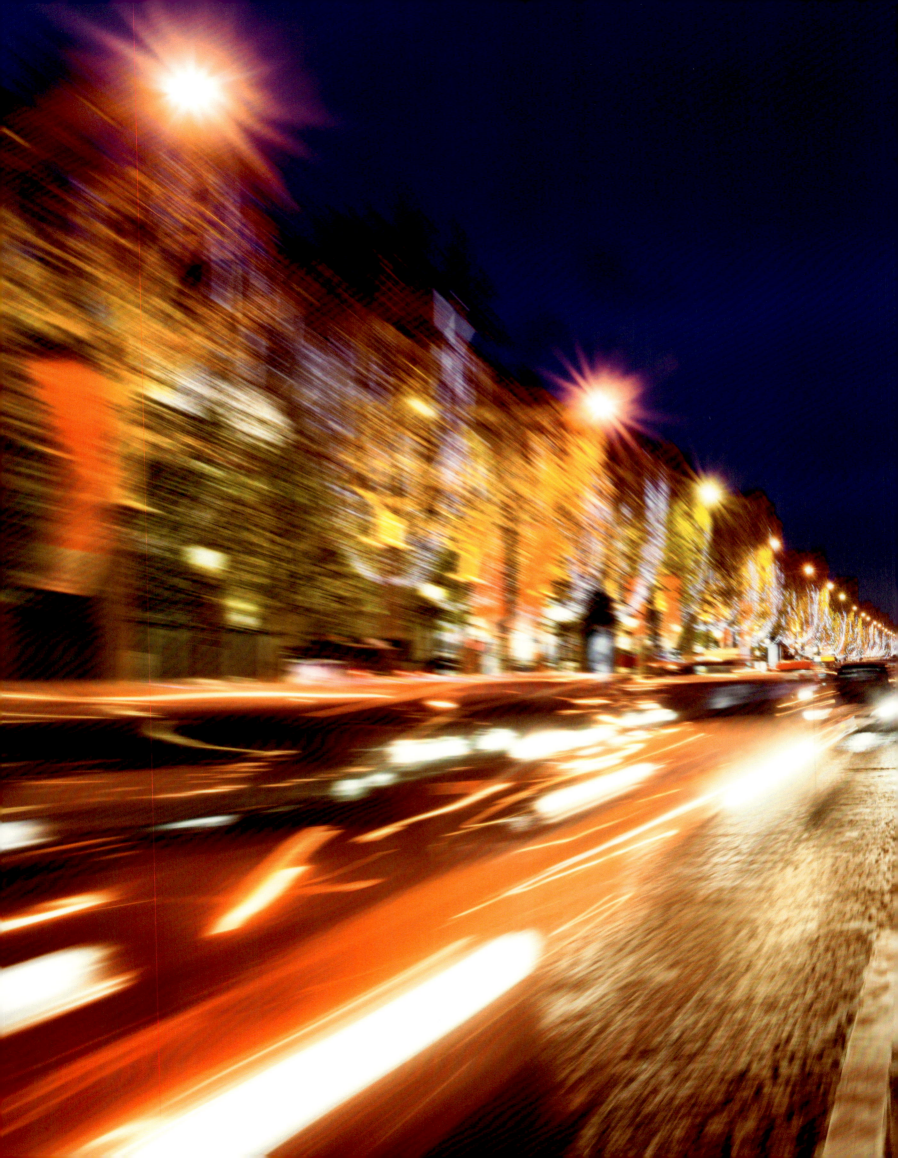

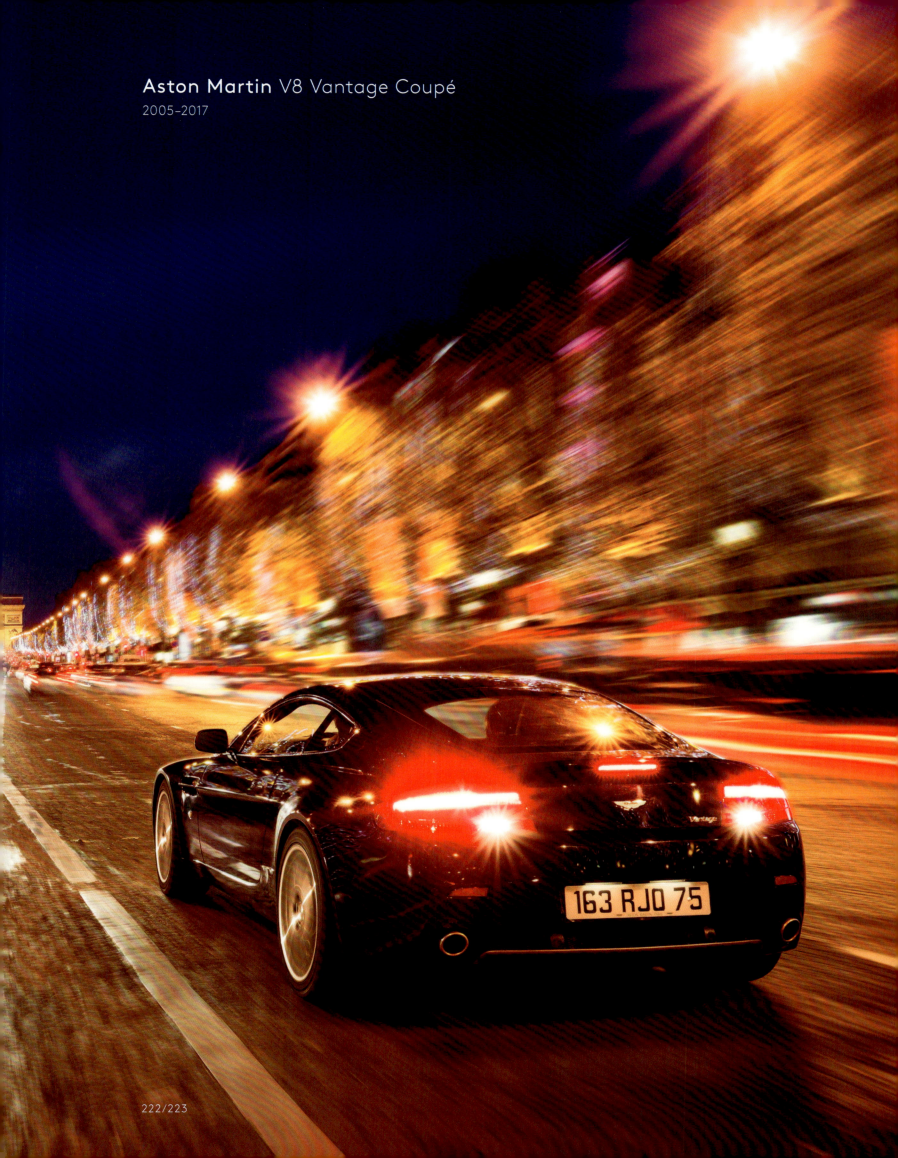

Aston Martin Vanquish
2001–2007

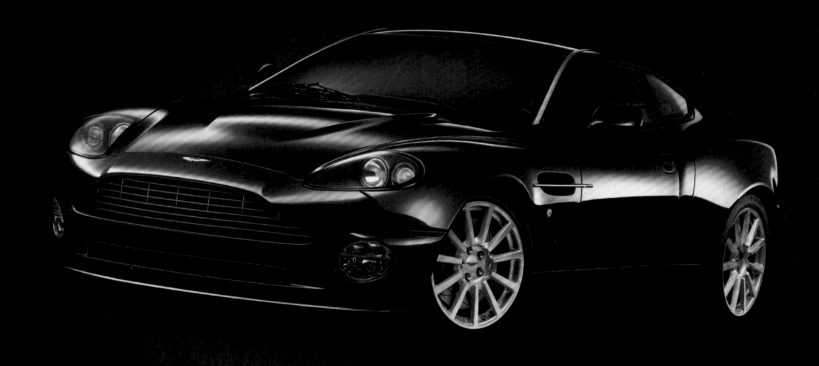

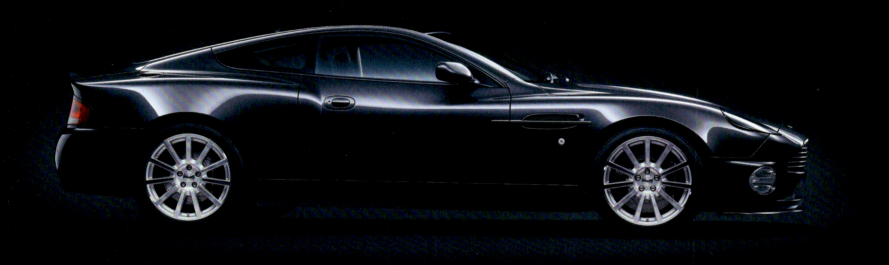

Mercedes-AMG S 63 Coupé

2017–2020

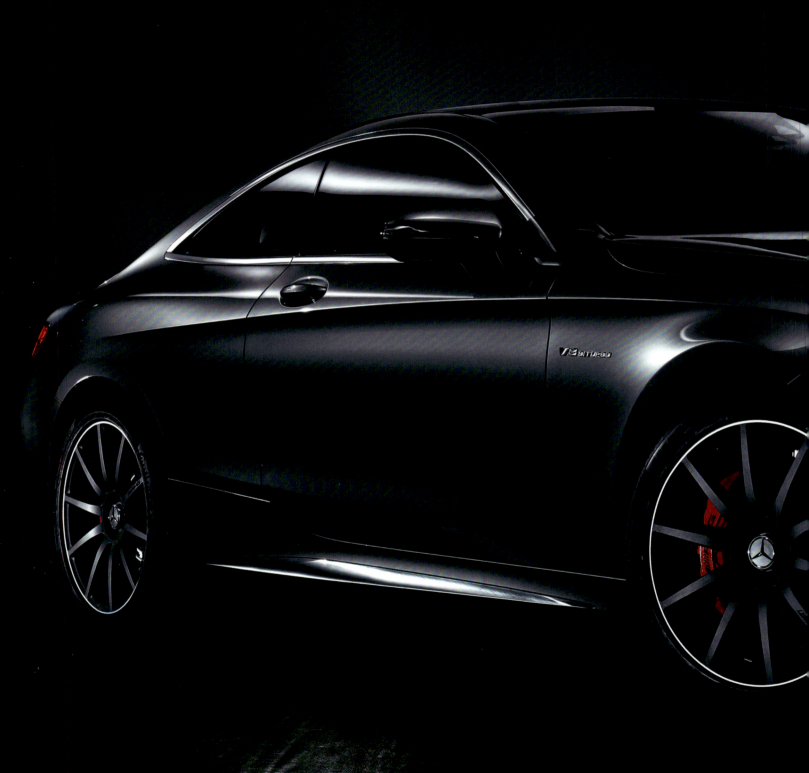

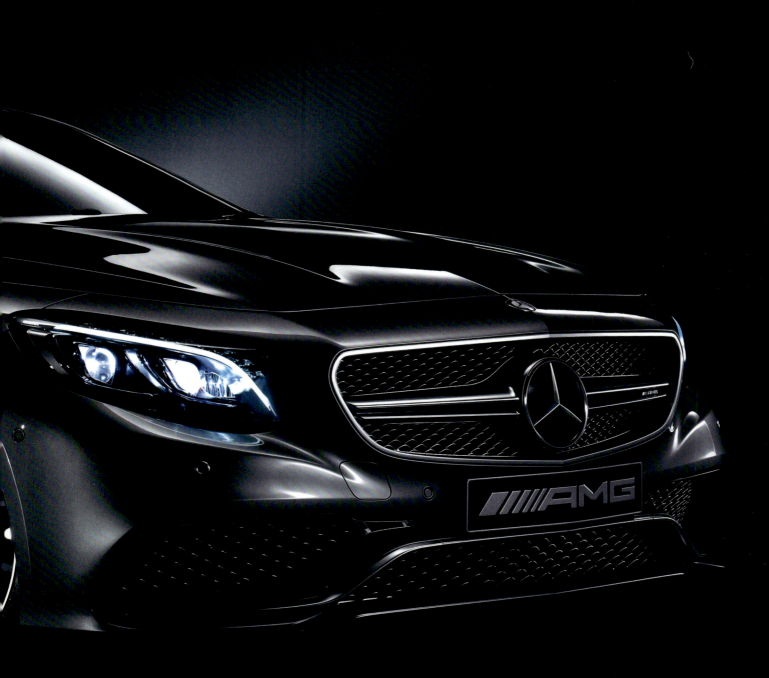

Mercedes-AMG GT
2015–2021

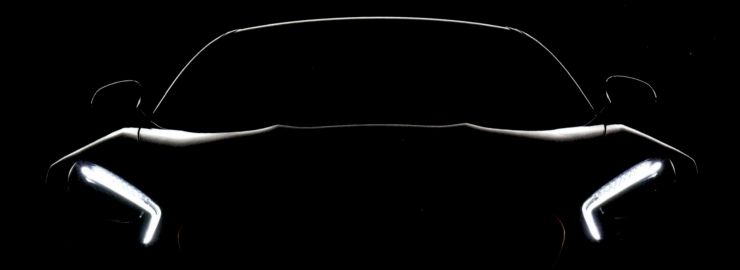

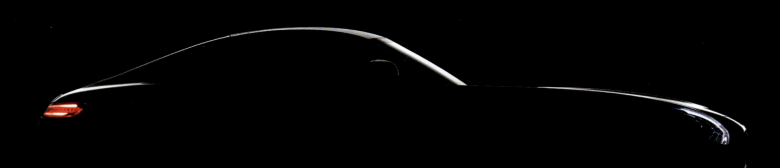

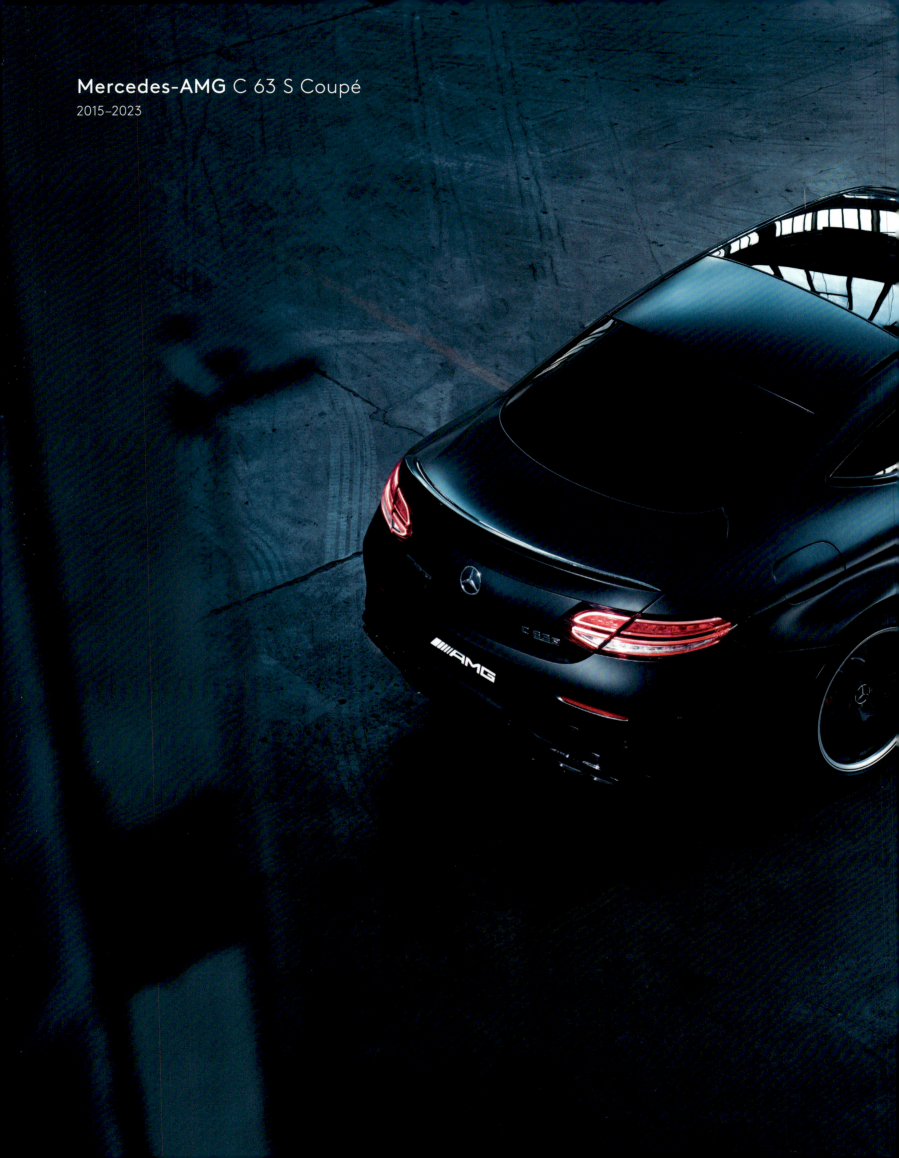

Mercedes-AMG C 63 S Coupé
2015–2023

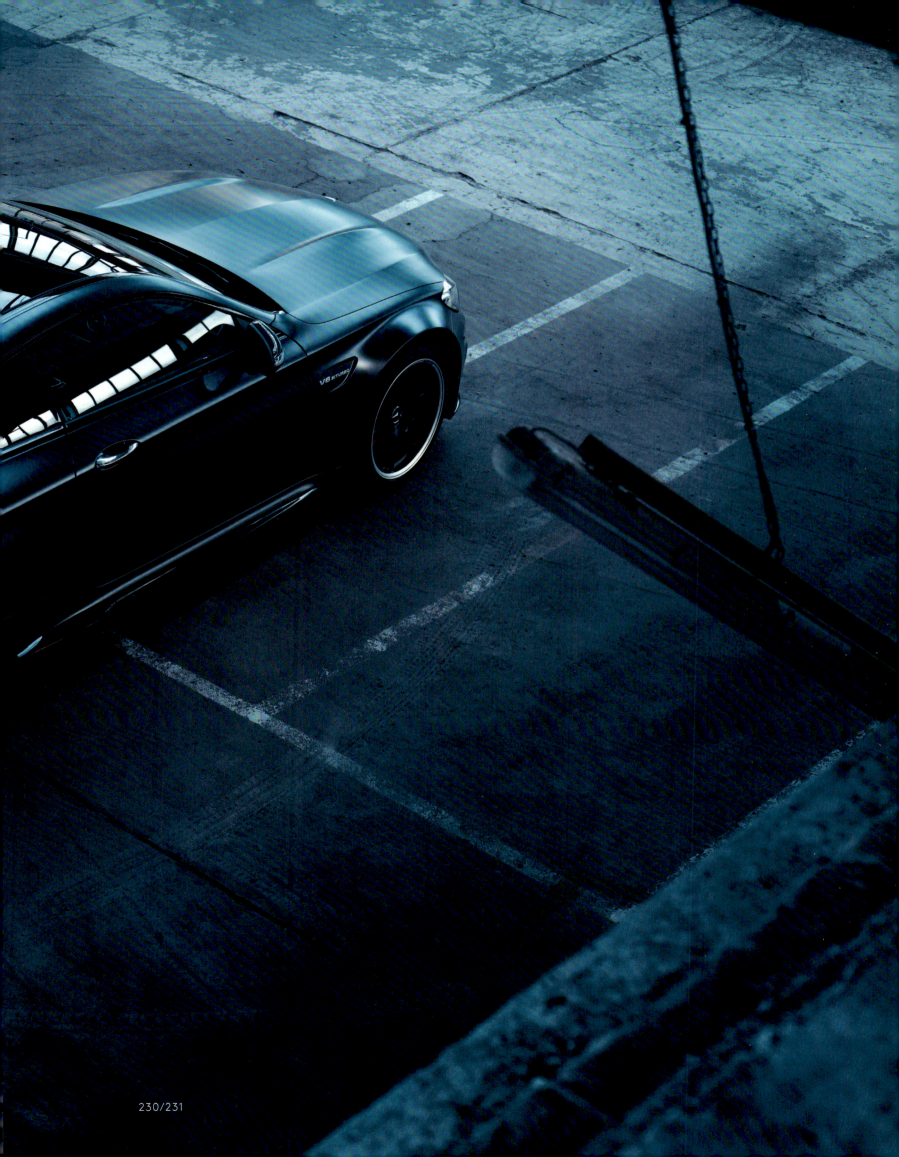

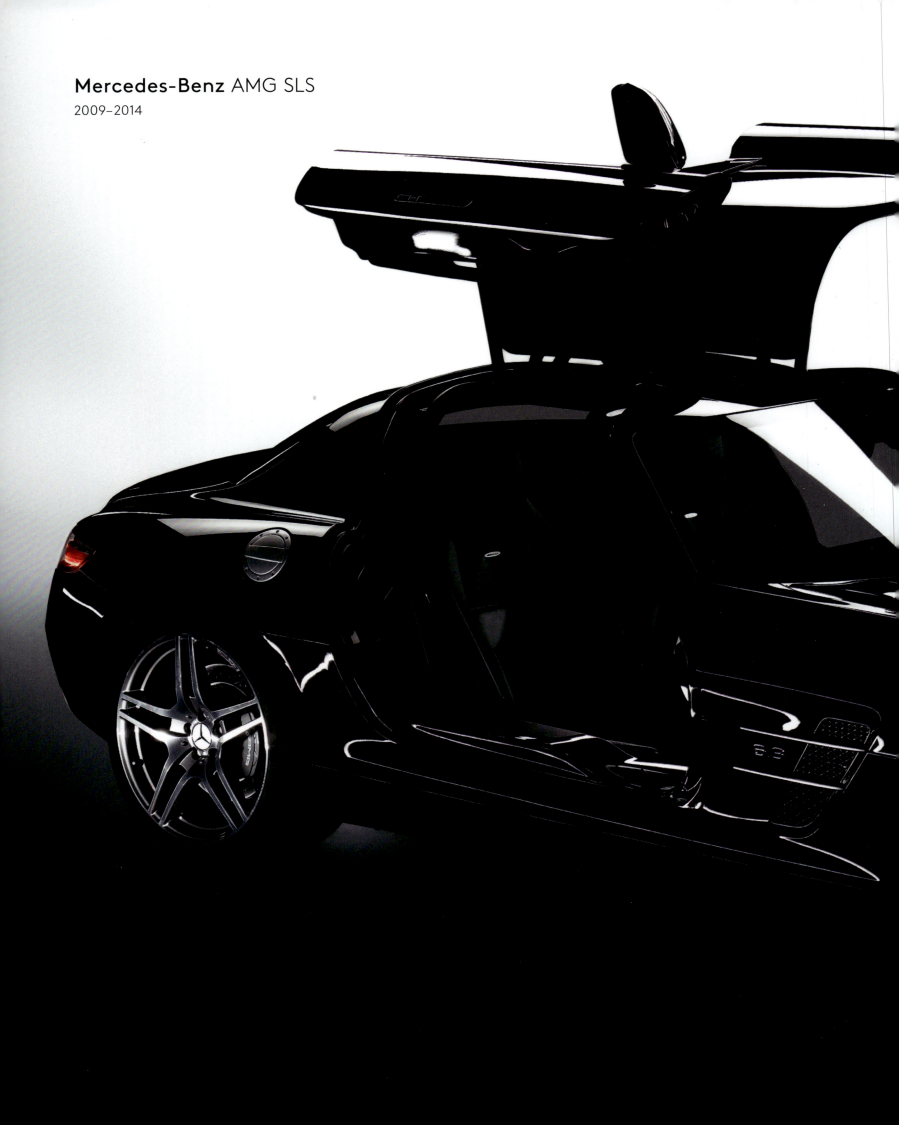

Mercedes-Benz AMG SLS
2009–2014

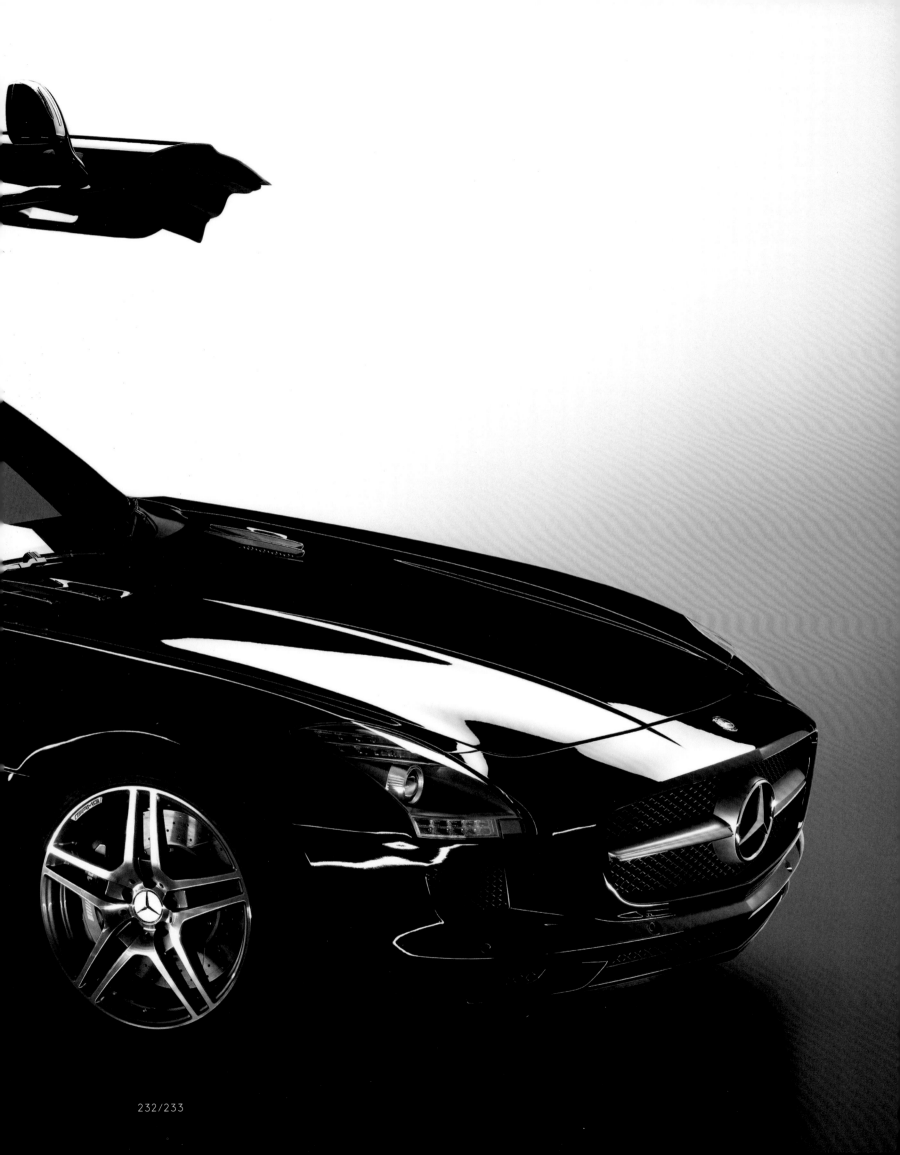

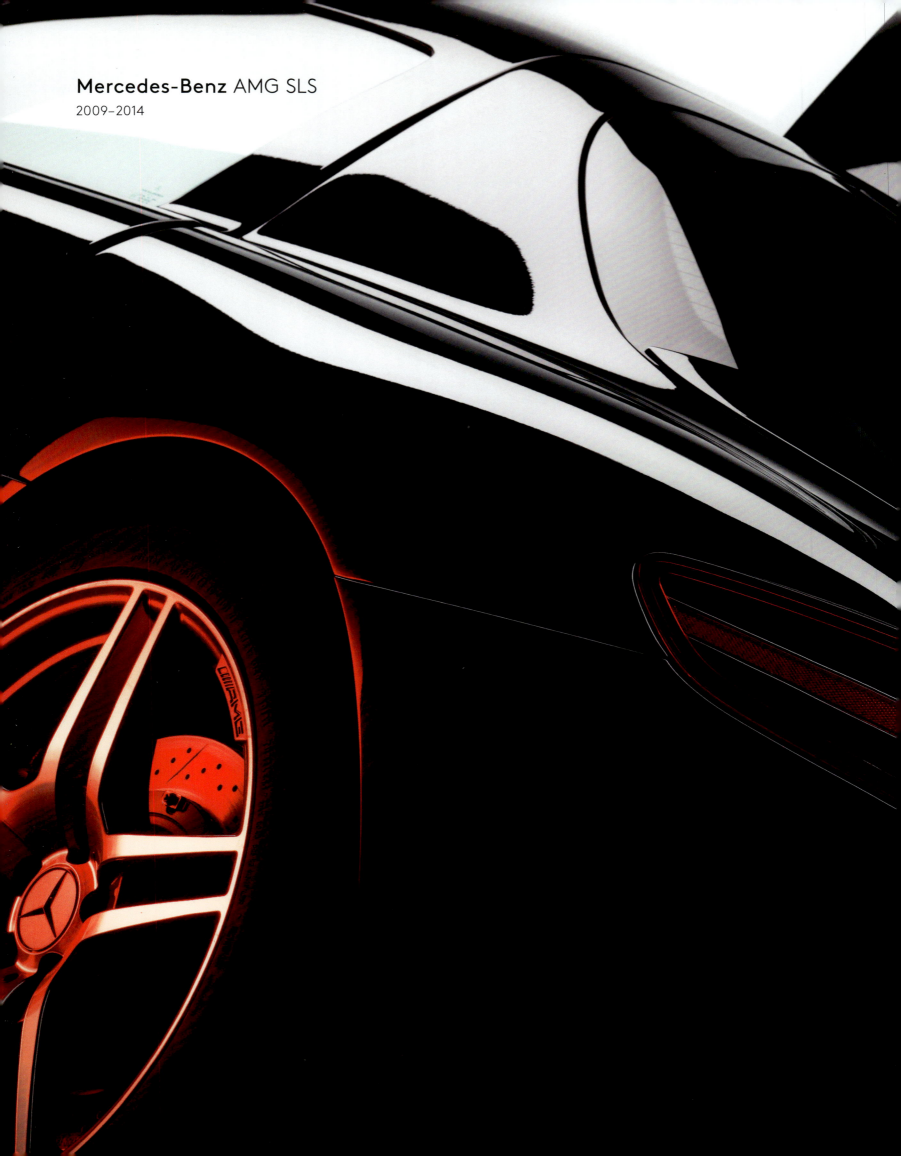

Mercedes-Benz AMG SLS
2009–2014

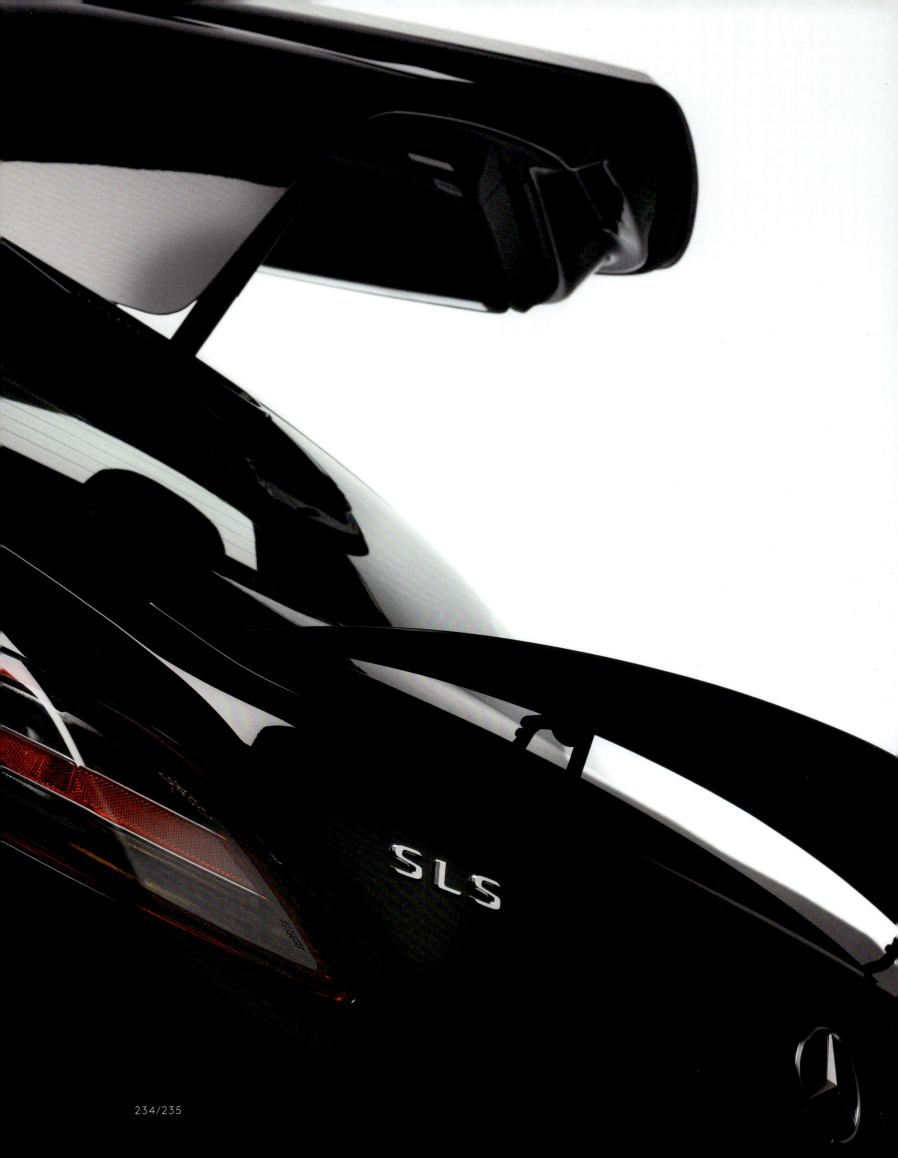

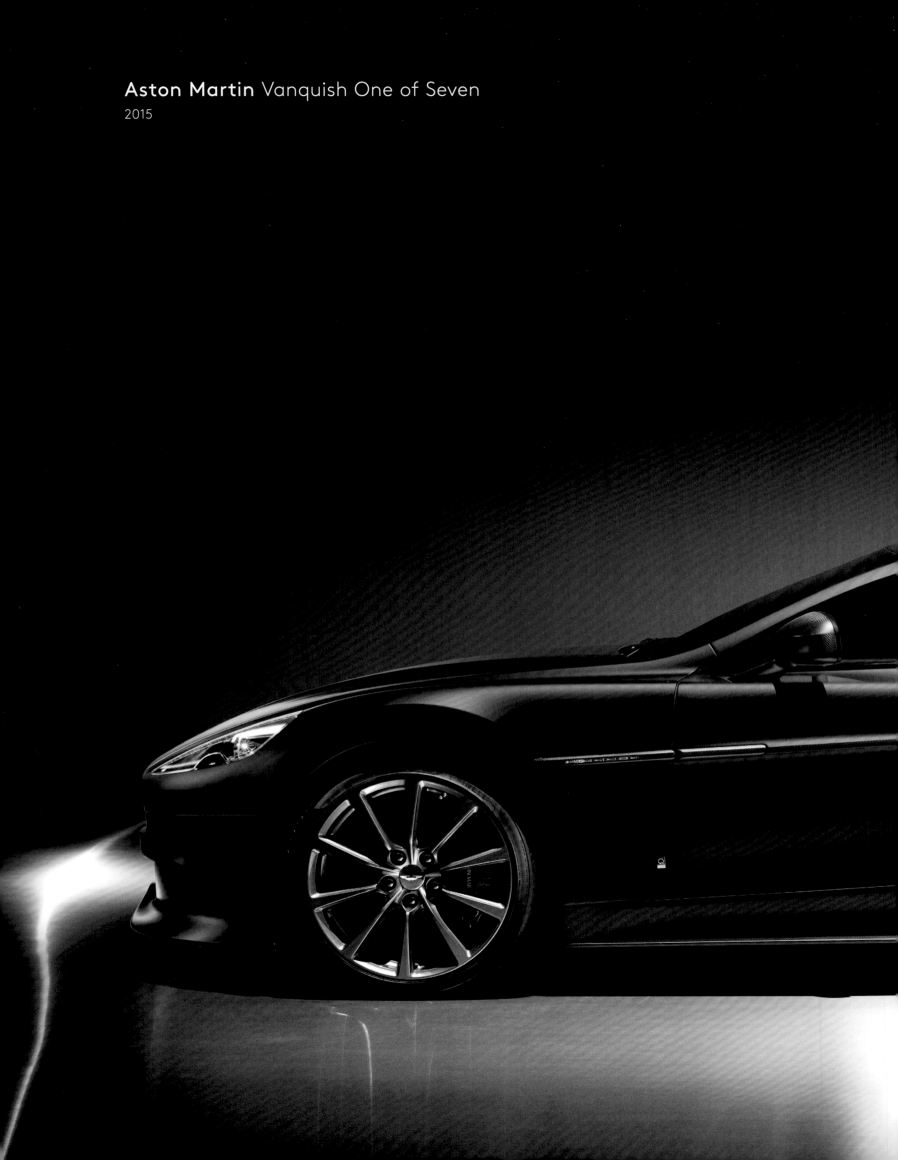

Aston Martin Vanquish One of Seven
2015

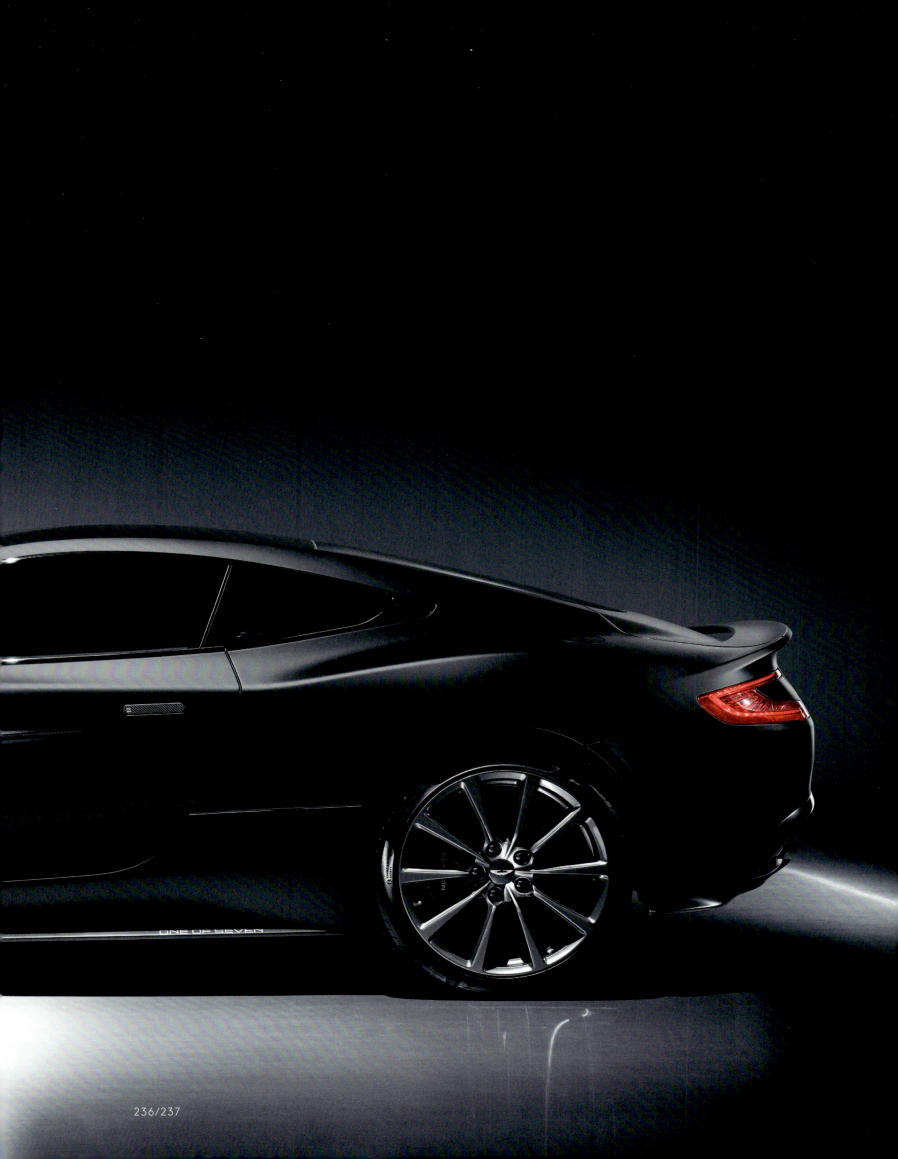

Aston Martin Vanquish One of Seven
2015

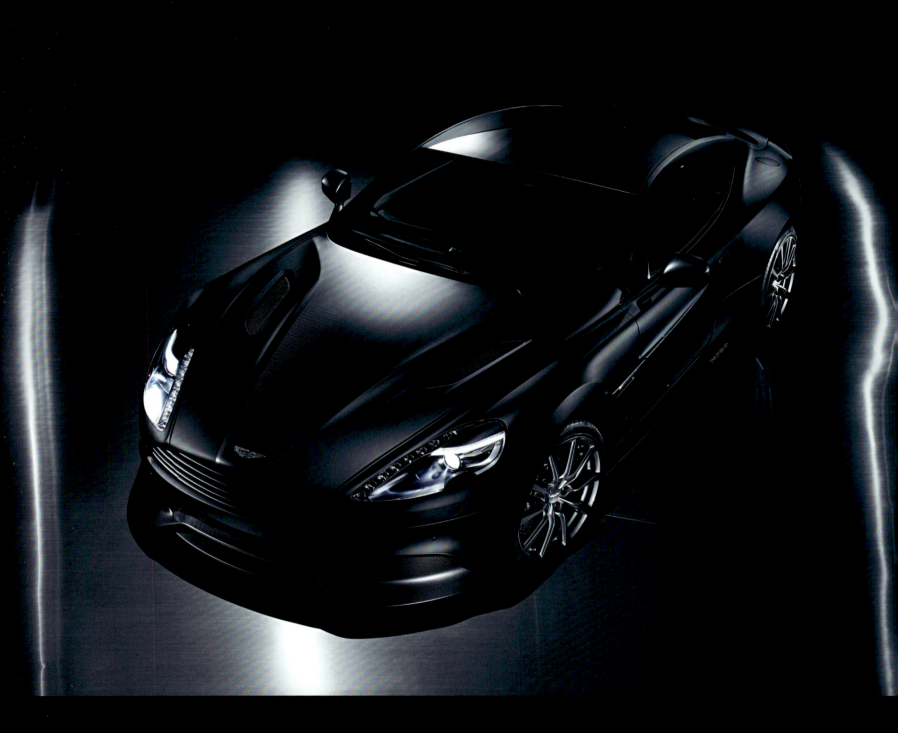

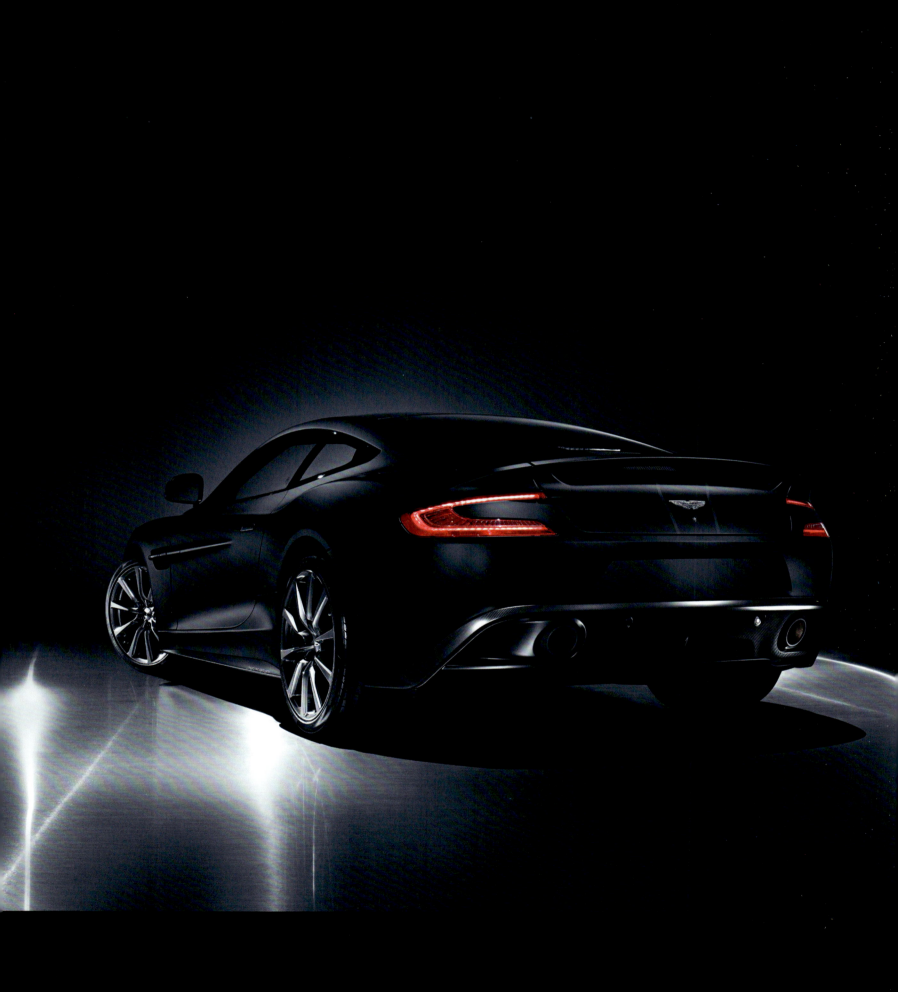

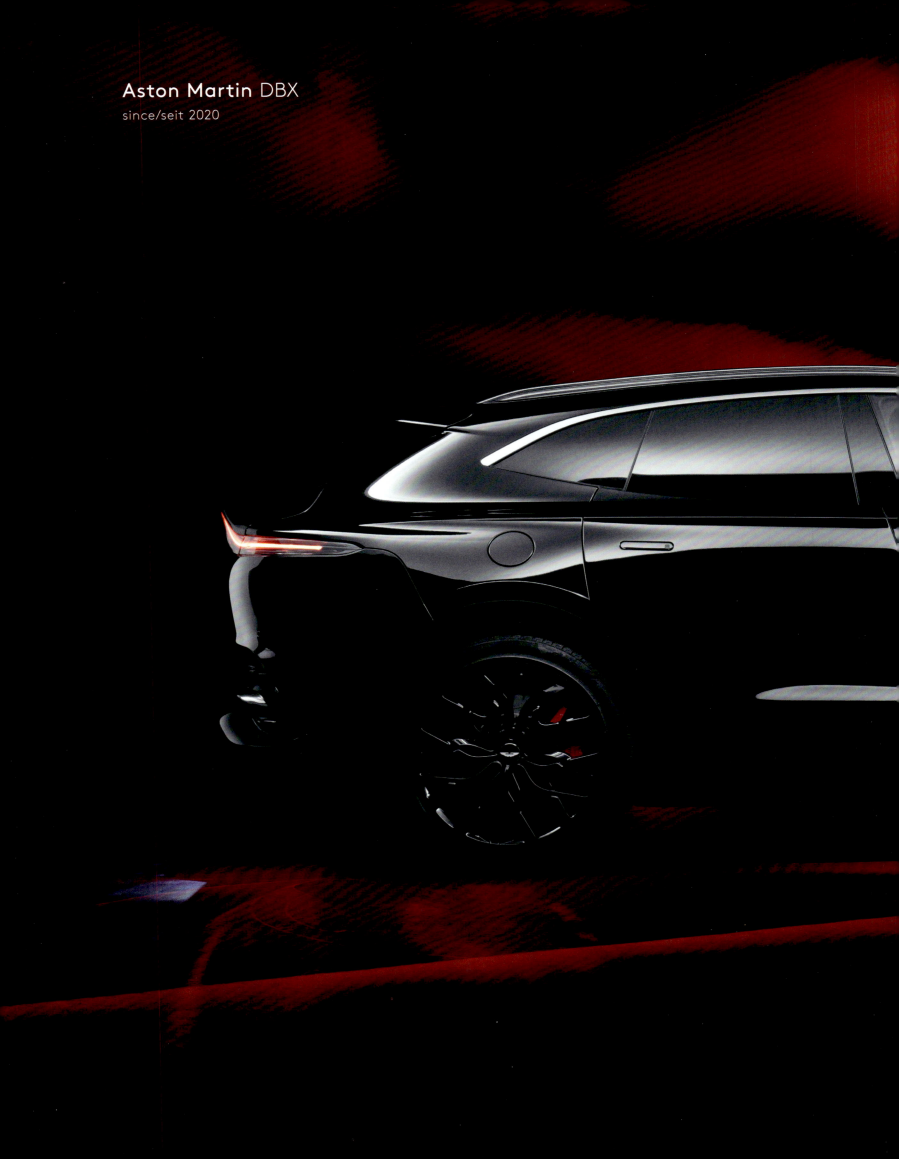

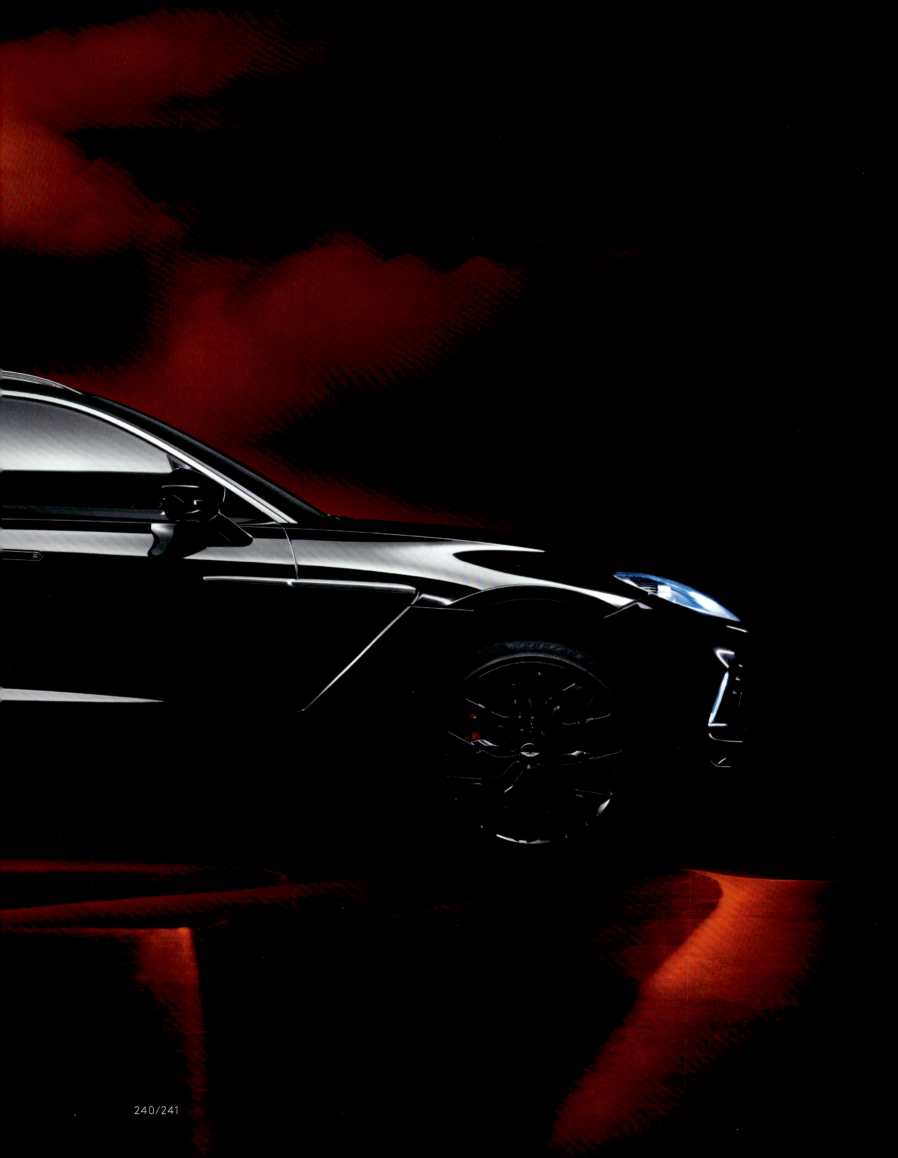

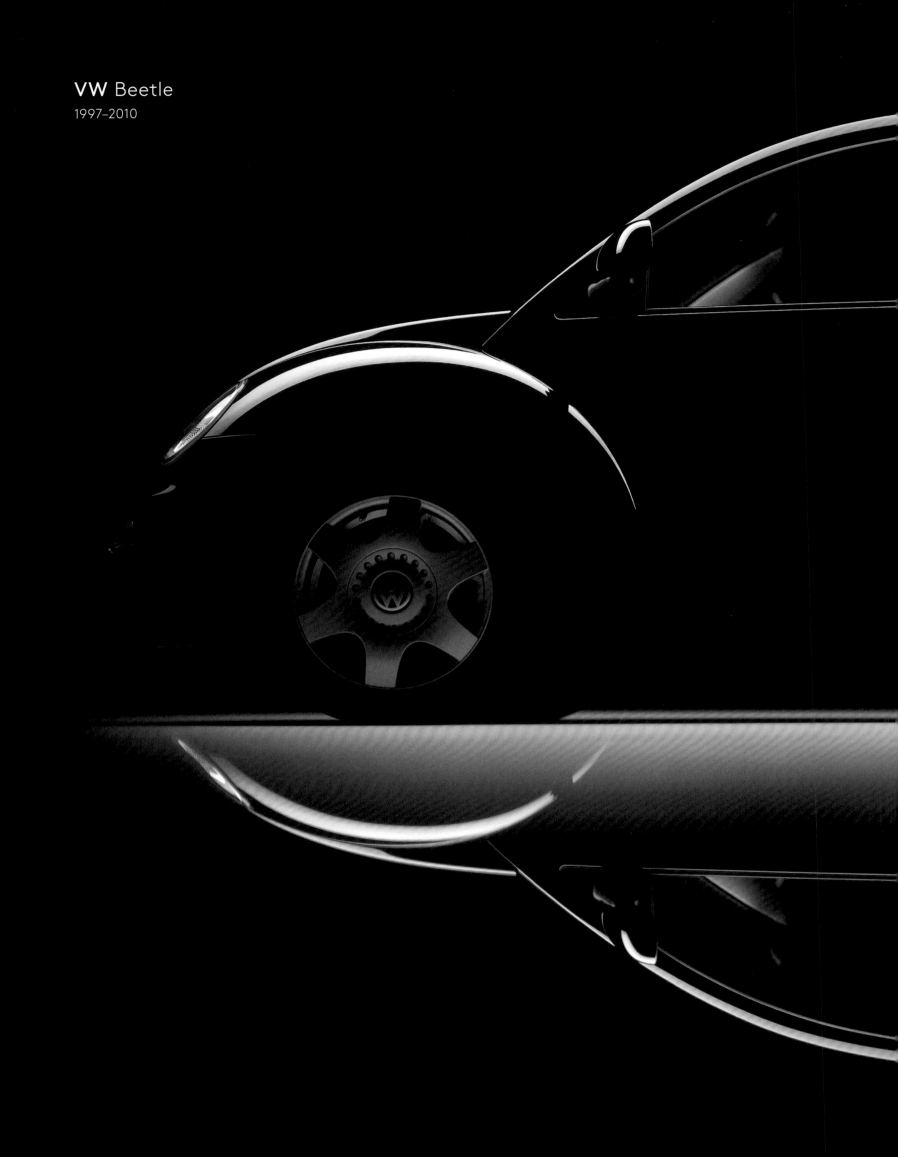

VW Beetle
1997–2010

VW Beetle
1997–2010

THE SYNTHESIS OF POWER

Dr. Andrea Michele Zagato, CEO of Zagato

Black magically adorned my first car: a 1992 Alfa Romeo SZ. It was an unconventional choice, the only specimen in this color in the entire production run (which was, of course, painted red). It was a particular combination, an exaltation of the Total Black configuration: black for the bodywork, for the spoilers and for the leather interior. Since then, all my cars (SUVs, coupés or sedans) and my bikes have always been this color. Nevertheless, I don't think I was influenced by Henry Ford's famous slogan or even by fashion trends, which idolize the importance of black and declare it "indispensable."

Black summarizes the extremes of the dichotomy facing design: exclusivity and broad appeal. Everyone is fascinated by black: a symbol of elegance and purity, underlining the continuous relationship between the volumetric lines of an object and the space accommodating it. Apparently, it leaves forms without volume, flat. In reality, it is the synthesis of power: very simply, black models define the perimeter and caress the silhouette. Black cars, in my view, enhance the expressiveness of the front: the headlights and grille stand out more, as when observing the eyes and smile of a person of color. This is particularly true in the absence of light.

Black cars seem lower: the body is glued to the wheels and the wheel arches. Black, moreover, has the ability to correct defects, while white, at times, is merciless in highlighting them. Finally, black cars, as well as motorbikes, express a special, unique aggressiveness. In fact it is extremely rare, if not almost impossible, to see a white Harley Davidson or Ducati Monster!

KRAFT PUR

Dr. Andrea Michele Zagato, Geschäfstführer von Zagato

Die Farbe Schwarz zierte auf magische Weise mein erstes Auto: einen 1992er Alfa Romeo SZ. Die Wahl war deshalb unkonventionell, weil es das einzige Exemplar dieser Farbe in der gesamten (natürlich rot lackierten) Baureihe war. Die spezielle Farbzusammenstellung trieb die Konfiguration „Total Black" auf die Spitze: die Karosserie, die Spoiler, die Lederausstattung – alles war schwarz. Seitdem hatten alle meine Autos (SUVs, Coupés und Limousinen) und meine Motorräder diese Farbe. Trotzdem würde ich nicht sagen, dass ich von Henry Fords berühmtem Slogan oder gar von Modetrends beeinflusst wurde, die die Bedeutung von Schwarz verklären und es für „unverzichtbar" halten.

Schwarz fasst die Extreme des Dilemmas zusammen, vor dem jeder Designer steht: Exklusivität und Massentauglichkeit. Alle sind von Schwarz fasziniert. Als Symbol für Eleganz und Reinheit unterstreicht es die anhaltende Beziehung zwischen den volumetrischen Linien eines Objekts und dem Raum, der es umgibt. Auf den ersten Blick raubt Schwarz den Formen das Volumen, macht sie flach. In Wirklichkeit ist es Kraft pur: Ganz einfach, schwarze Modelle definieren den Umriss und streicheln die Silhouette. In meinen Augen verstärken schwarze Autos die Ausdruckskraft der Frontpartie: Scheinwerfer und Kühlergrill treten deutlicher hervor, ungefähr so wie die Augen und das Lächeln eines Menschen mit dunkler Hautfarbe. Im Dunkeln ist dieser Effekt besonders ausgeprägt.

Schwarze Autos wirken niedriger: Die Karosserie klebt auf den Reifen und Radkästen. Schwarz besitzt zudem die Fähigkeit, Fehler zu korrigieren, während Weiß sie mitunter gnadenlos hervorhebt. Und schließlich strahlen schwarze Autos, ebenso wie Motorräder, eine besondere, einzigartige Aggressivität aus. Genau genommen ist es extrem selten, wenn nicht so gut wie unmöglich, eine Harley Davidson oder Ducati Monster in Weiß zu sehen!

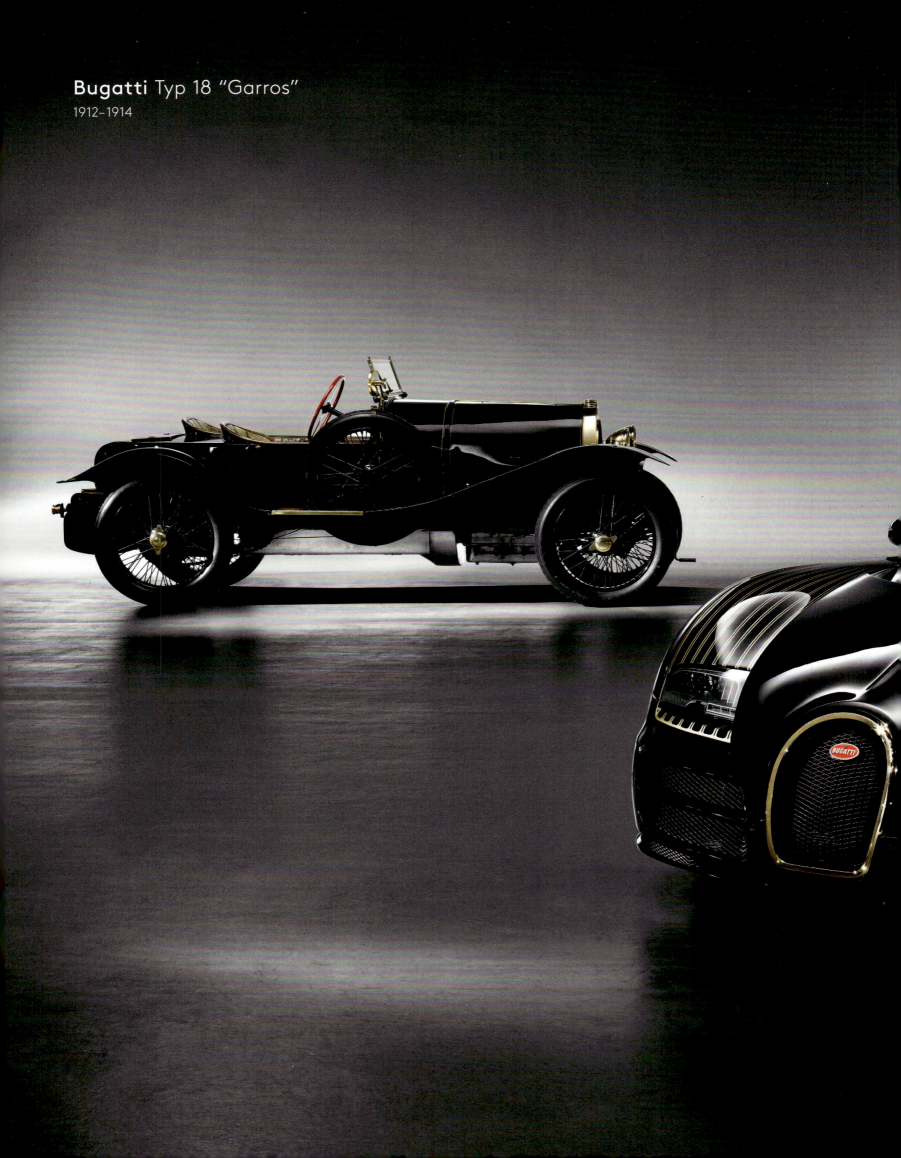

Bugatti Typ 18 "Garros"
1912–1914

Bugatti Veyron Grand Sport Vitesse
2012–2015

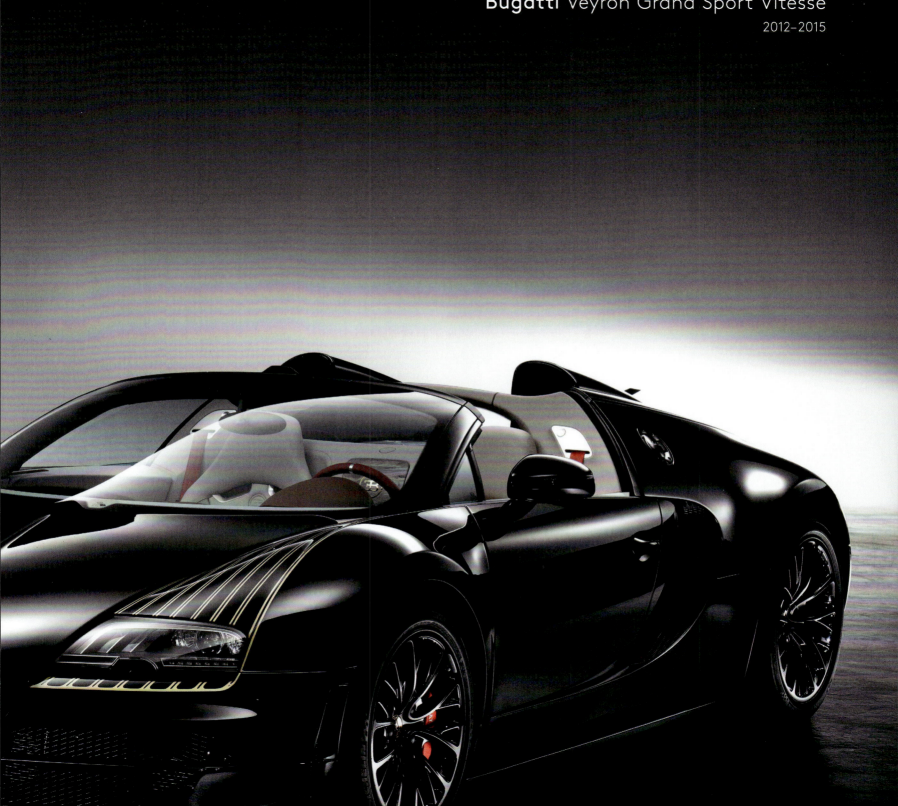

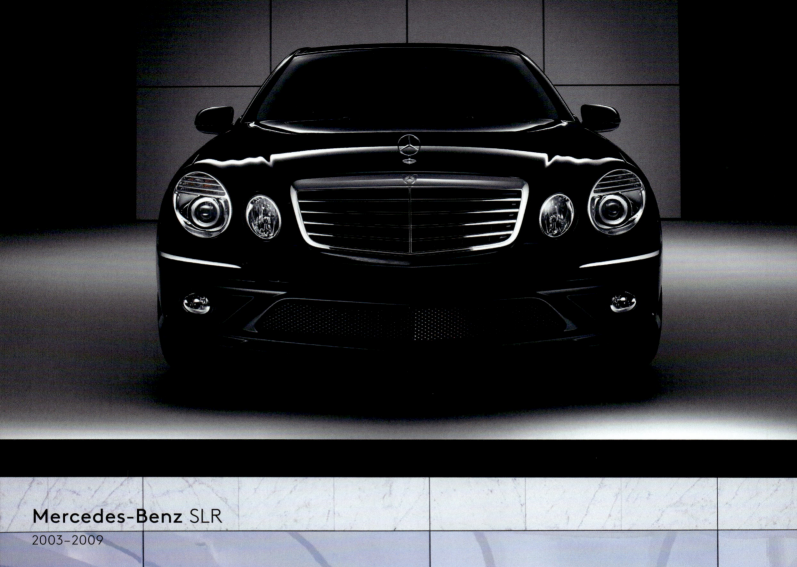

Mercedes-Benz SLR
2003–2009

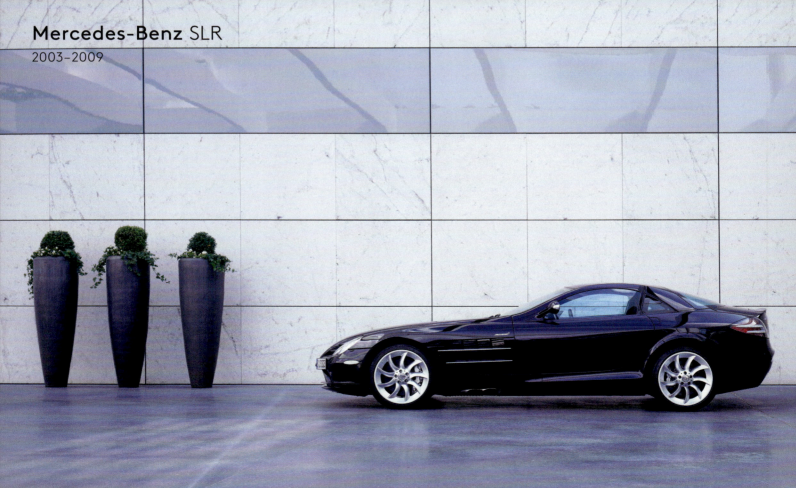

Mercedes-Benz GLK-Klasse
2008–2015

Mercedes-Benz CLK DTM AMG
2004

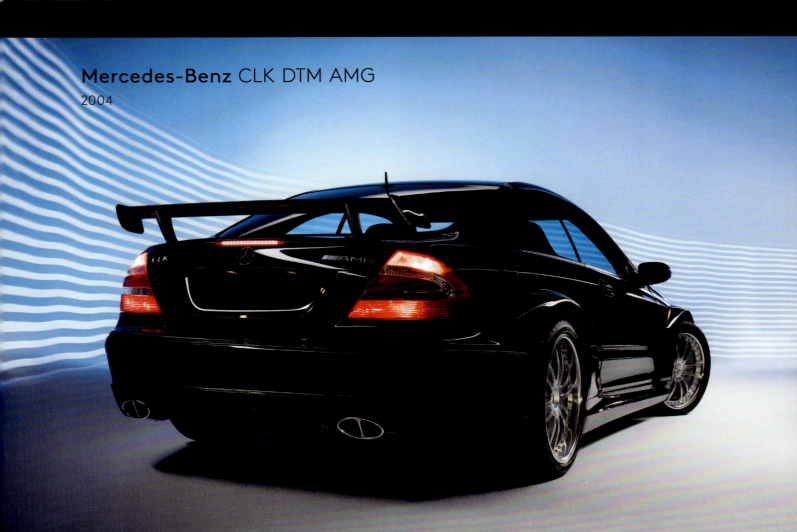

Ferrari F430

2004–2009

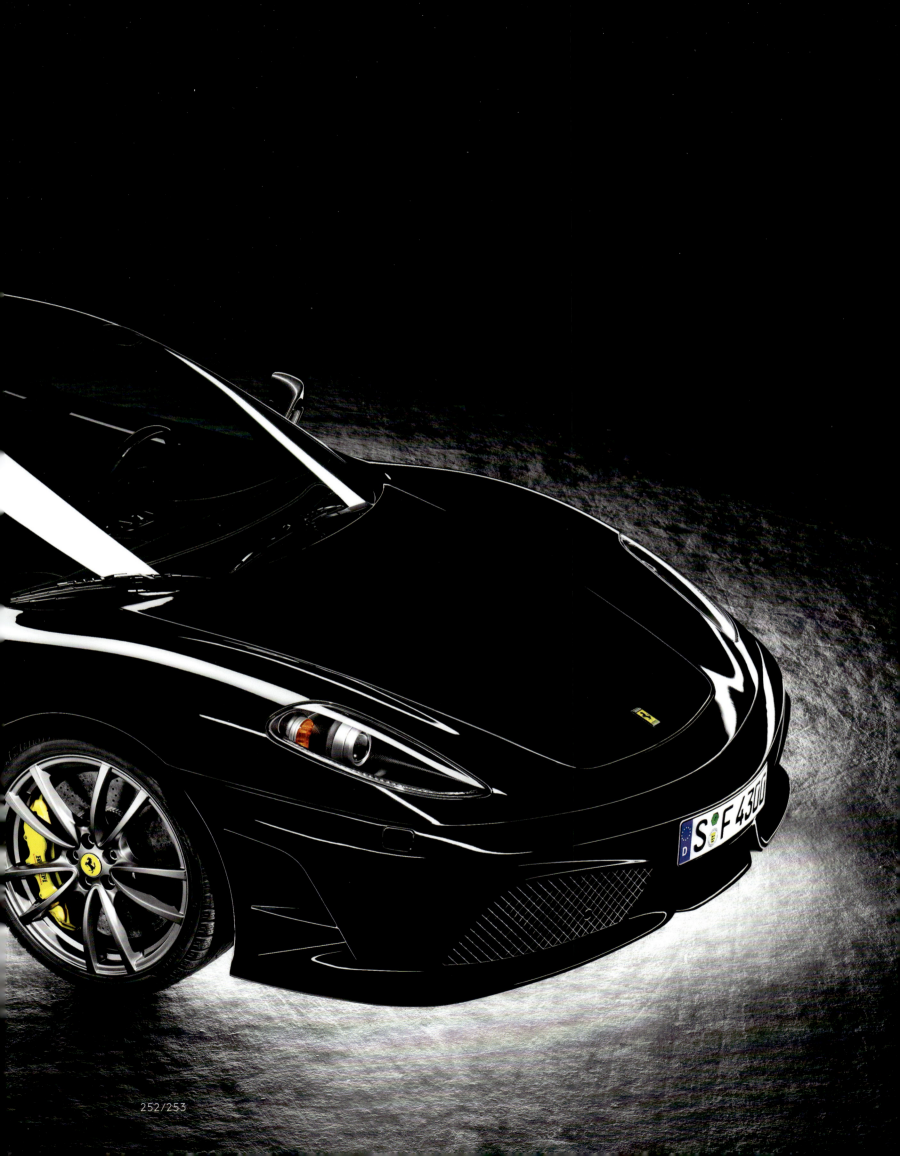

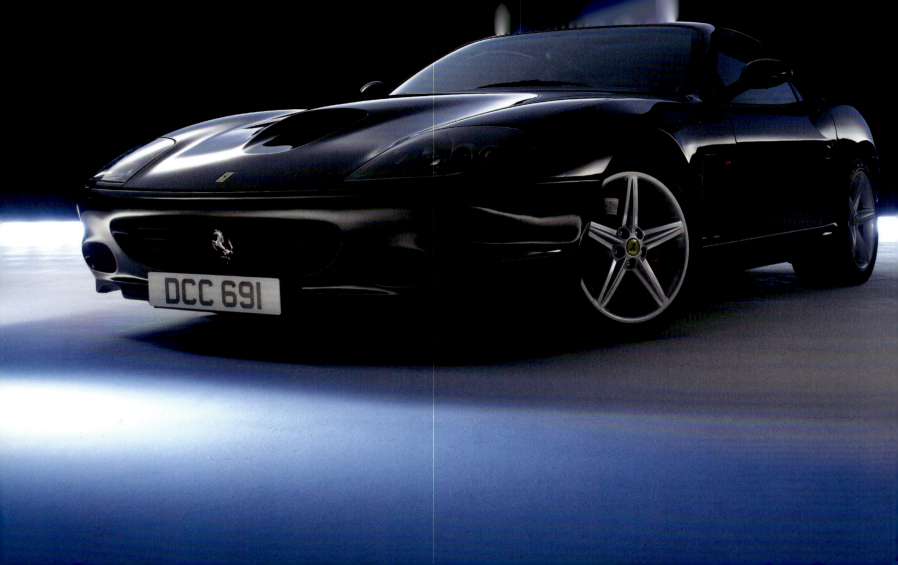

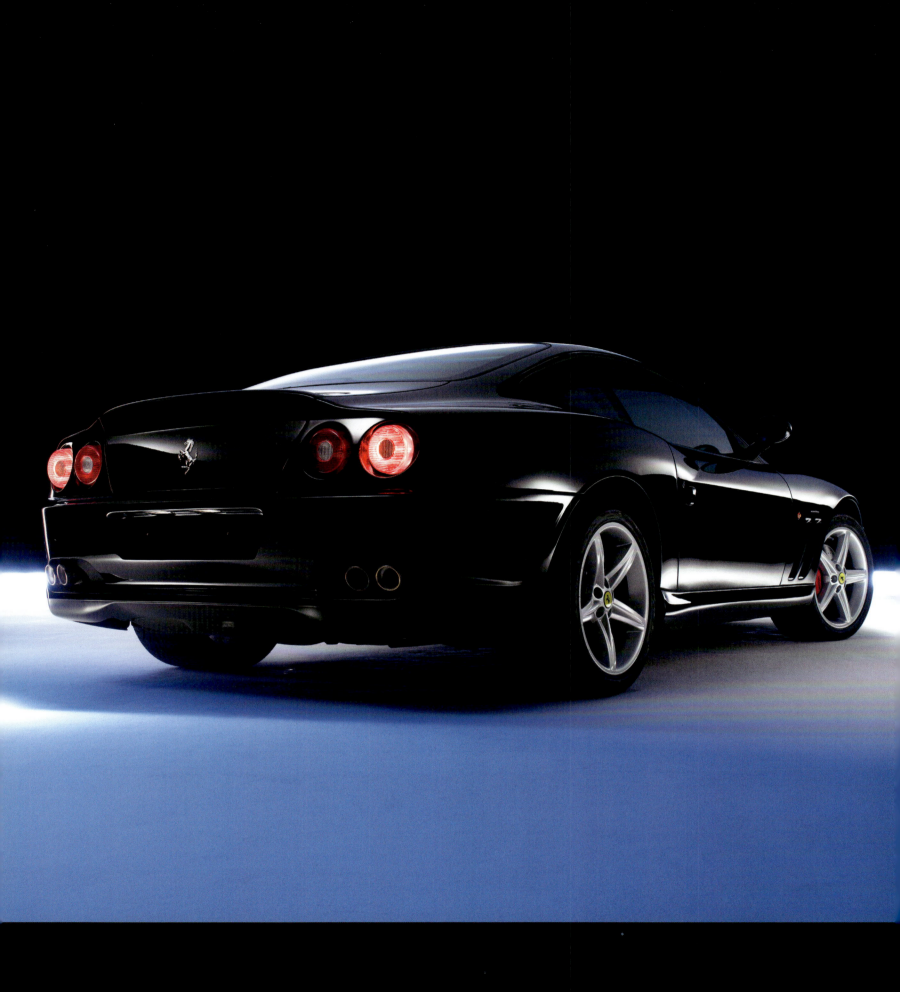

Maybach 57 S

2002–2012

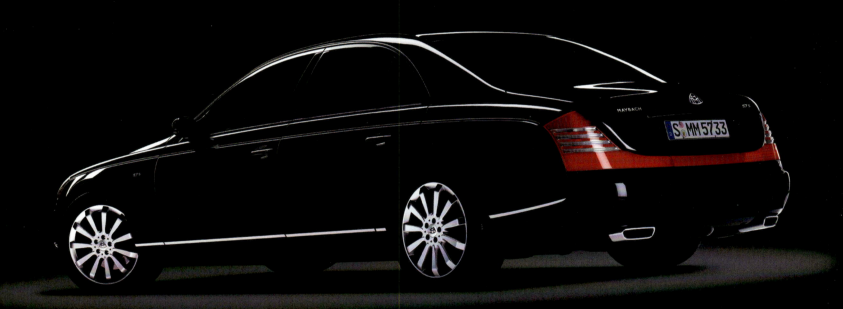

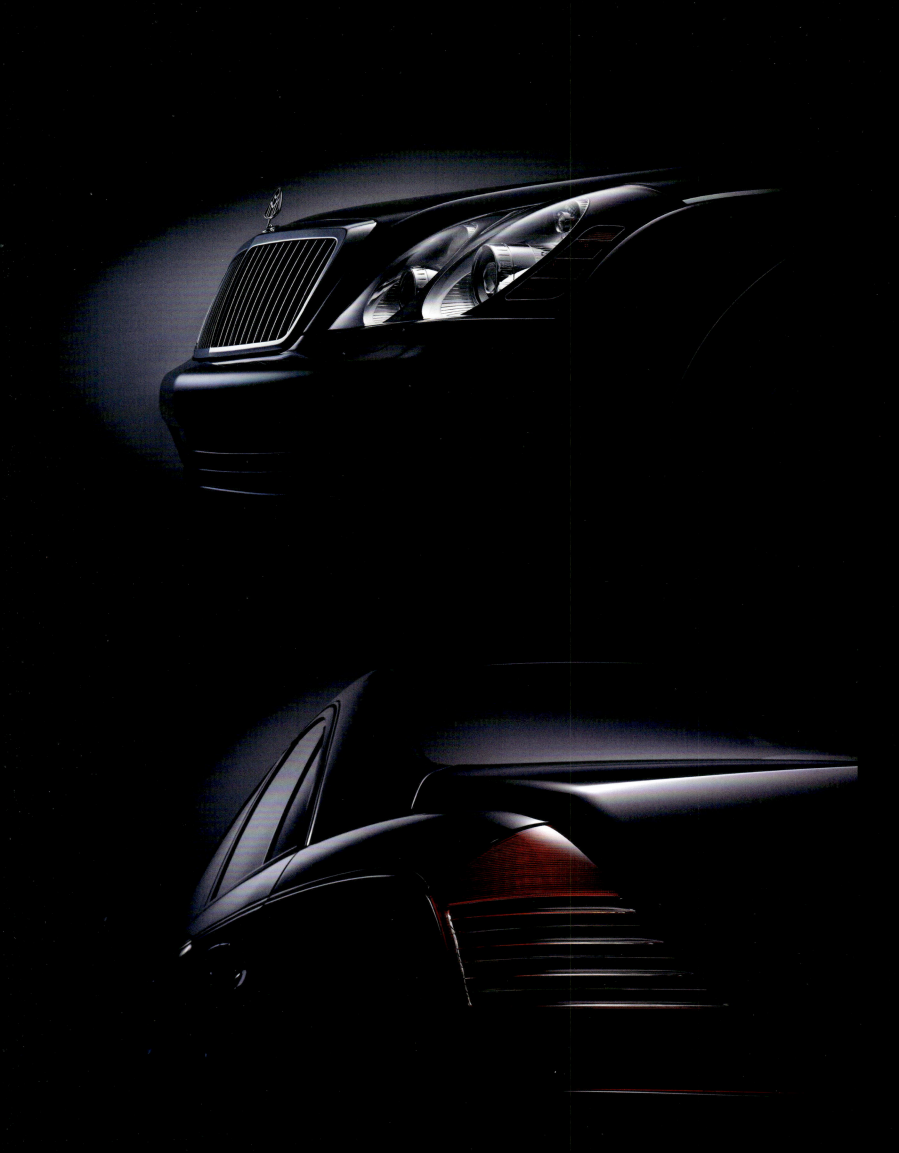

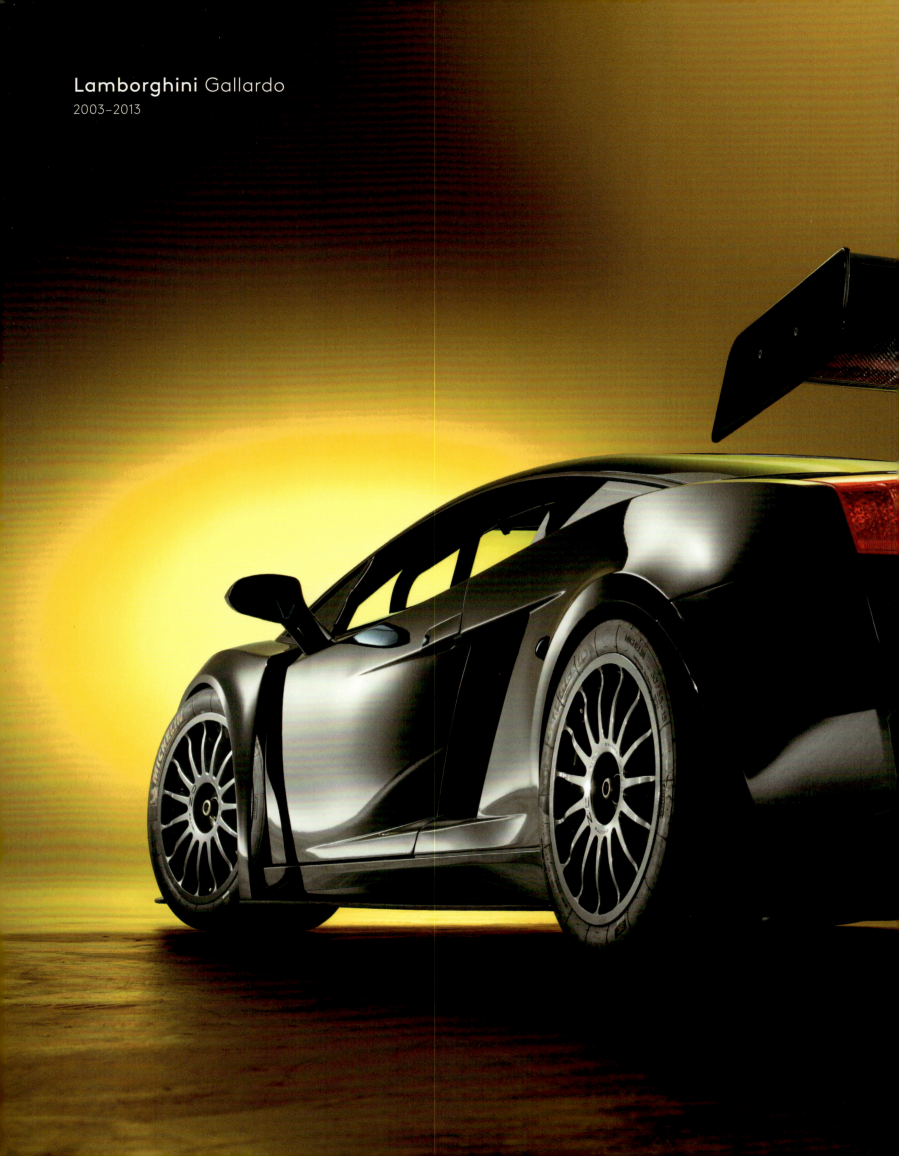

Lamborghini Gallardo
2003–2013

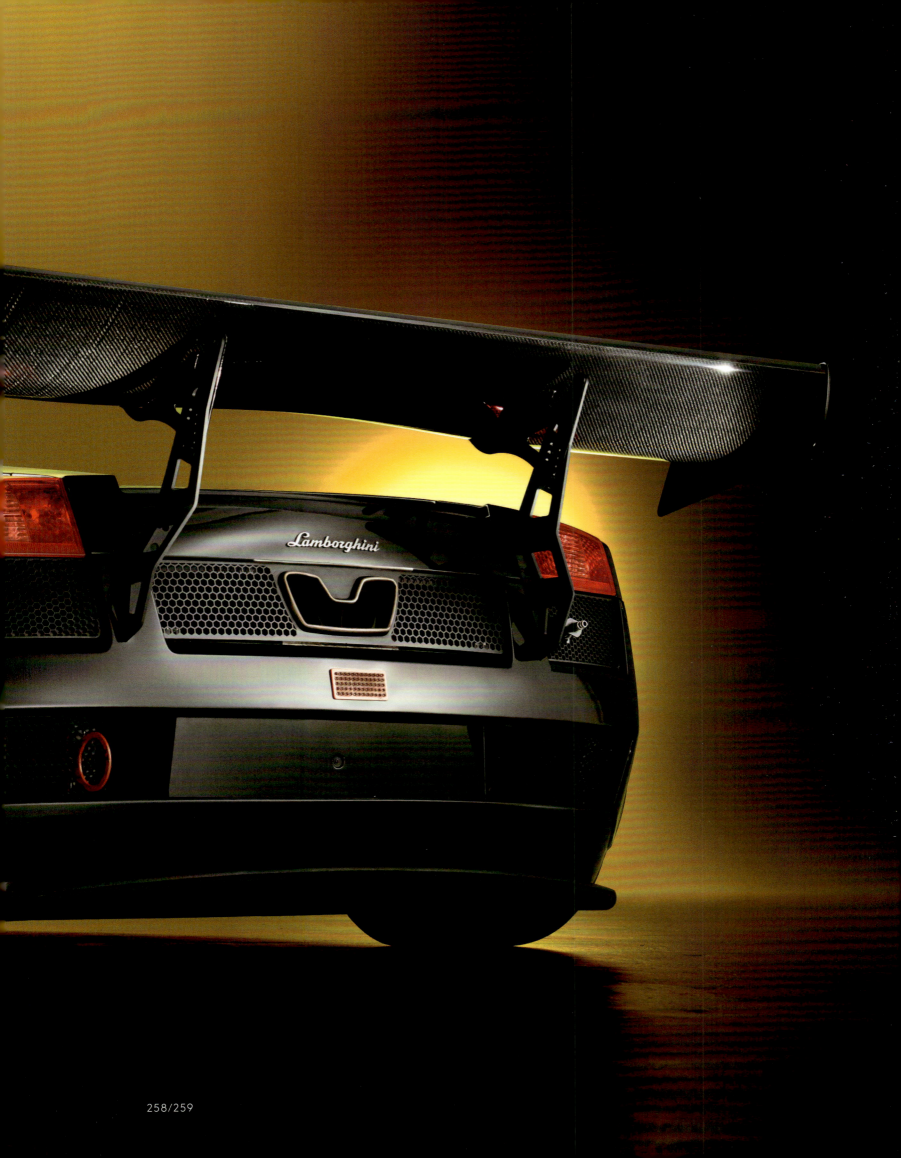

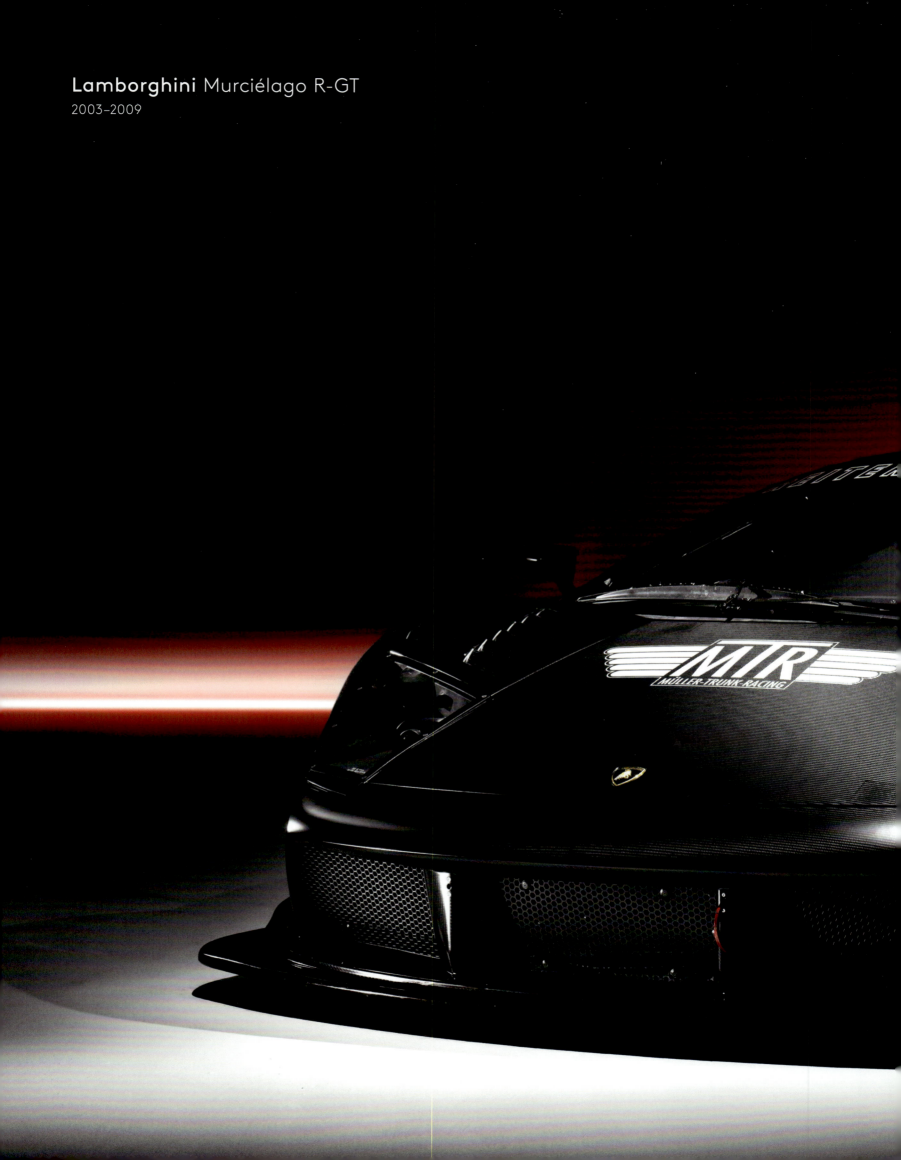

Lamborghini Murciélago R-GT
2003–2009

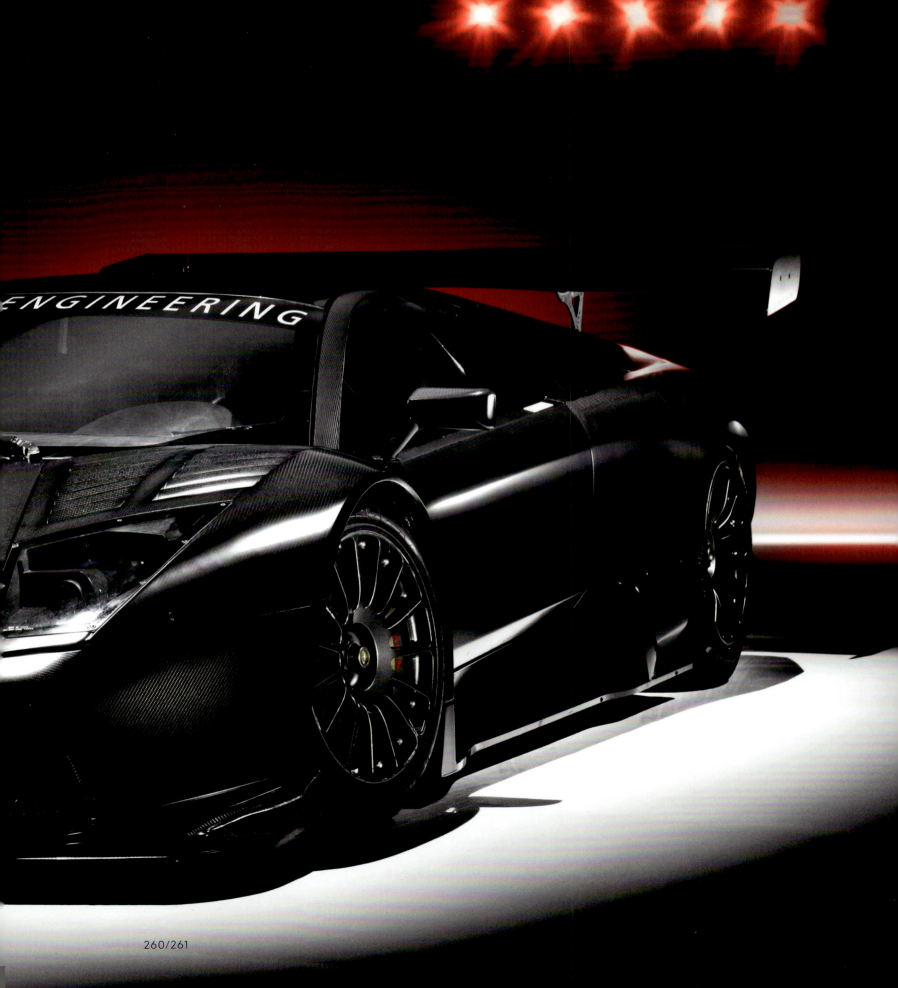

Maybach Exelero V12 Biturbo
2003

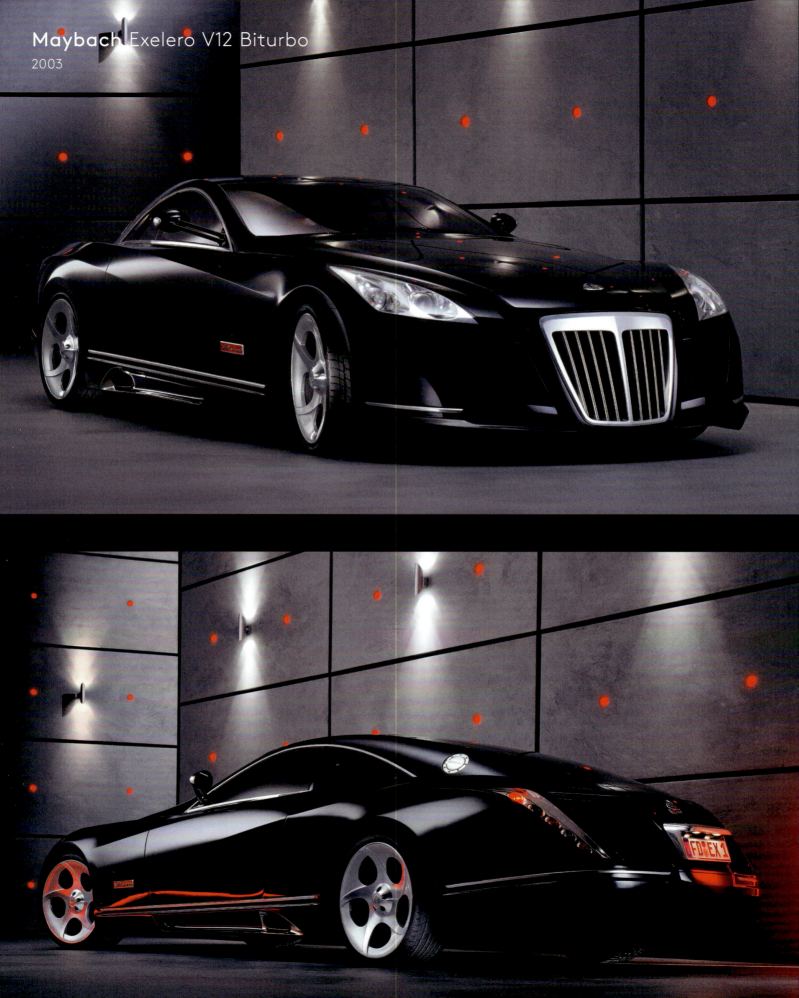

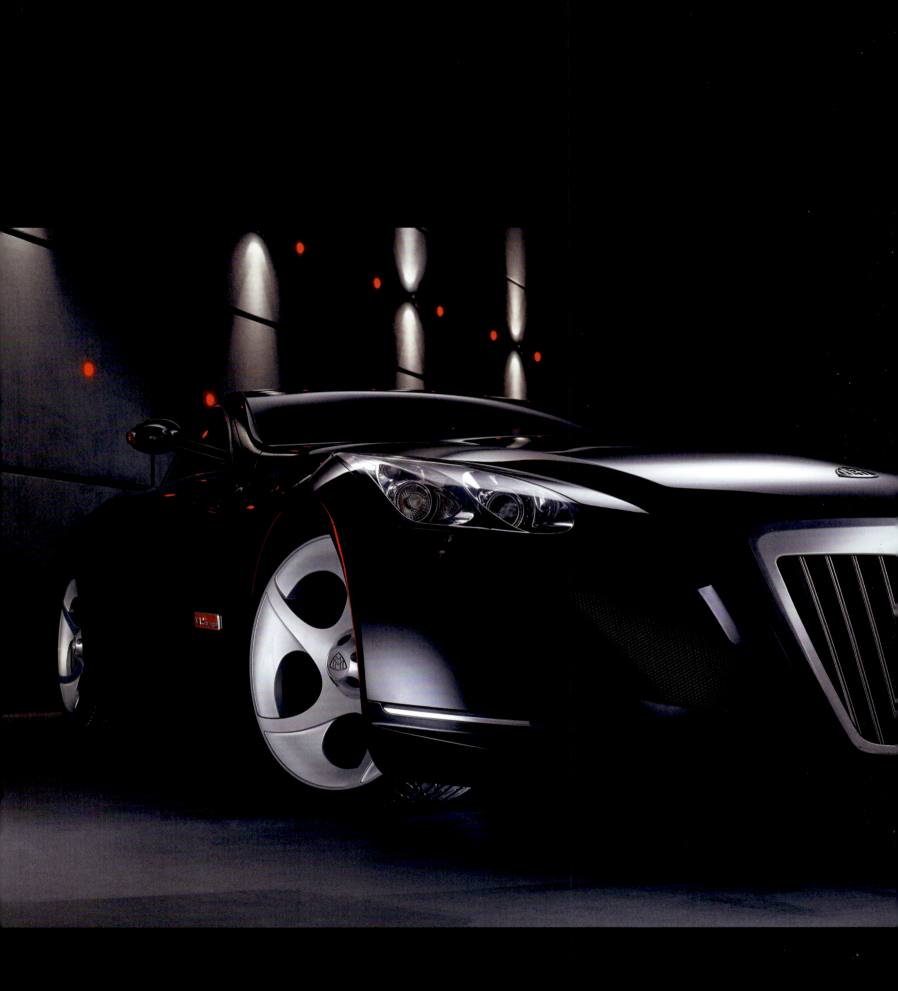

Mercedes-Benz S-Klasse C 216

2006–2013

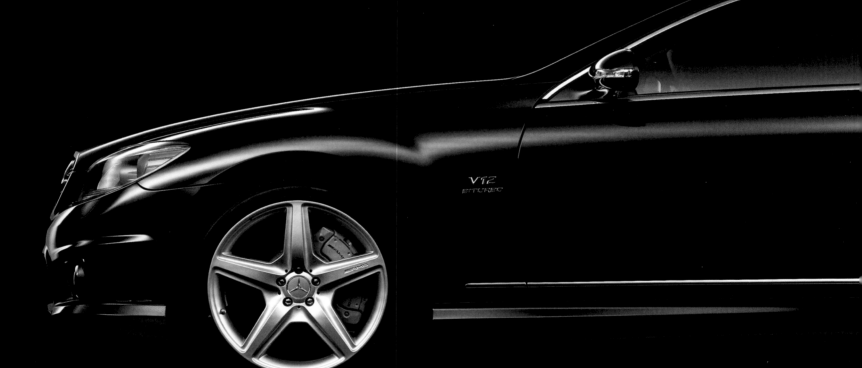

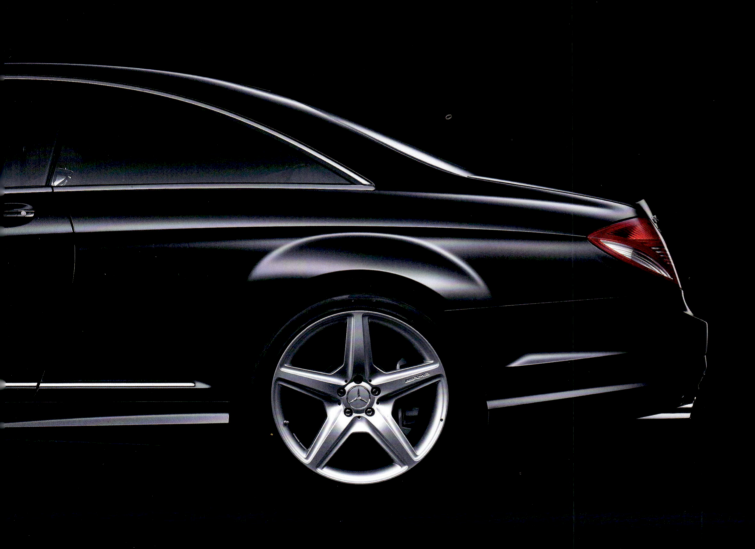

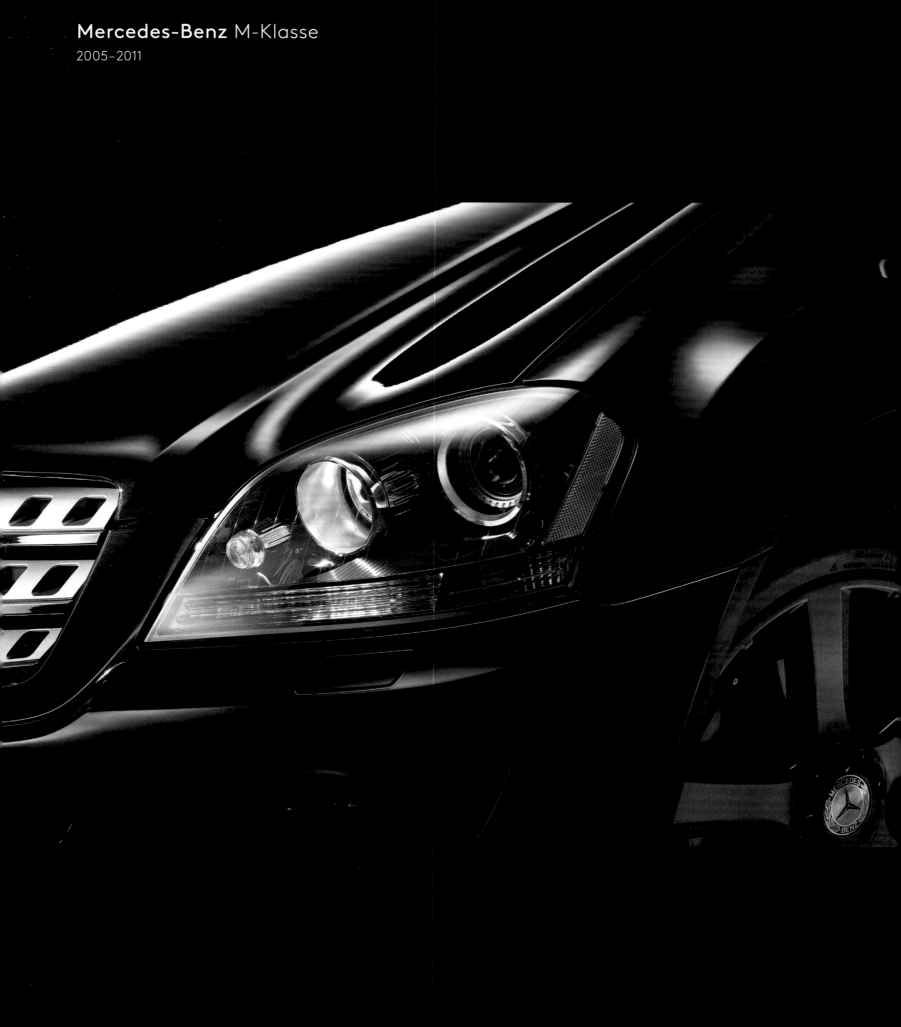

Mercedes-Benz M-Klasse
2005–2011

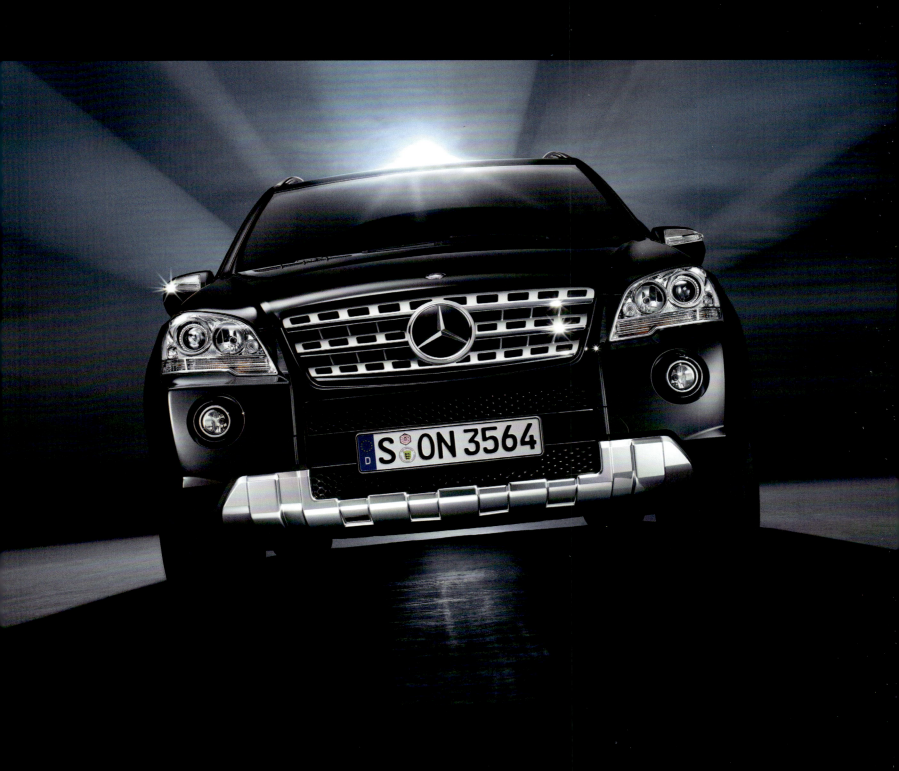

Mercedes-Benz SLR
2003–2009

Mercedes-Benz SL 350

2001–2011

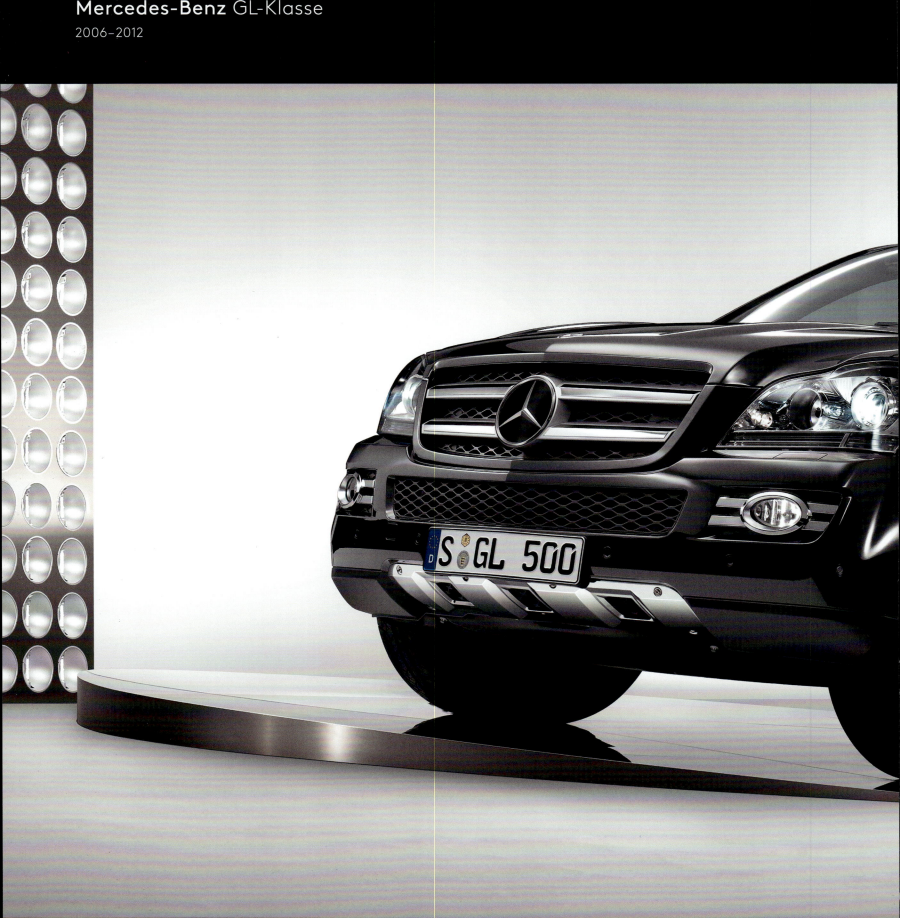

Mercedes-Benz GL-Klasse
2006–2012

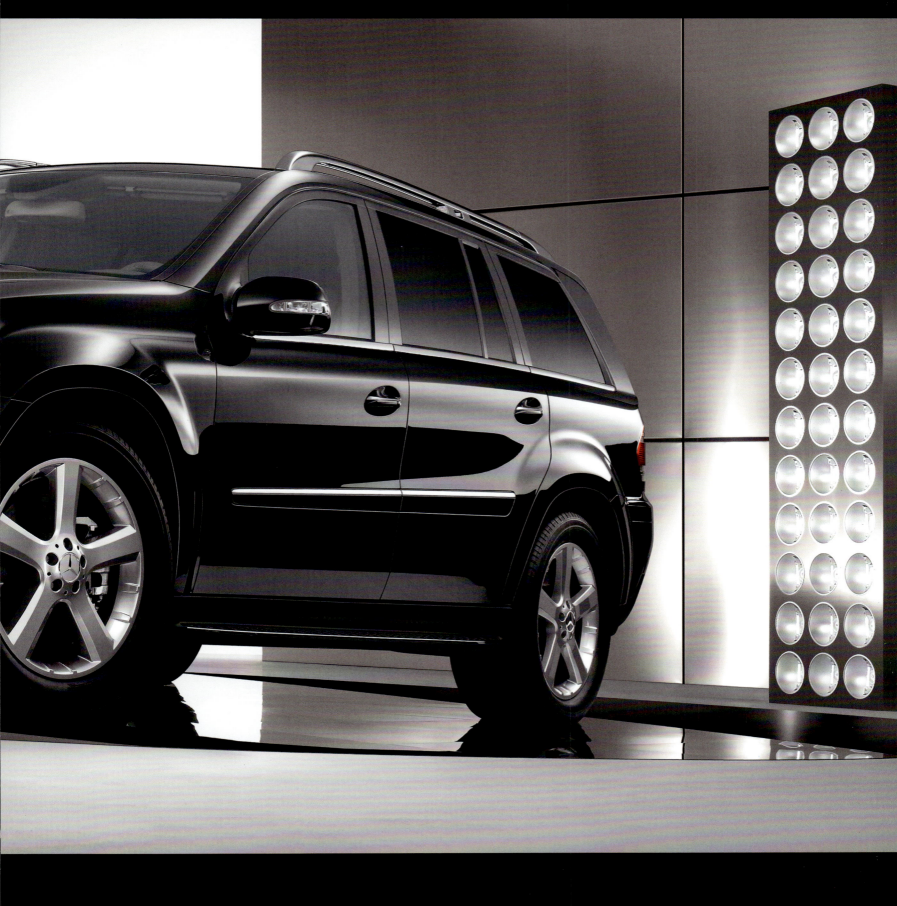

Porsche 911 Carrera 4 (991)
2011–2019

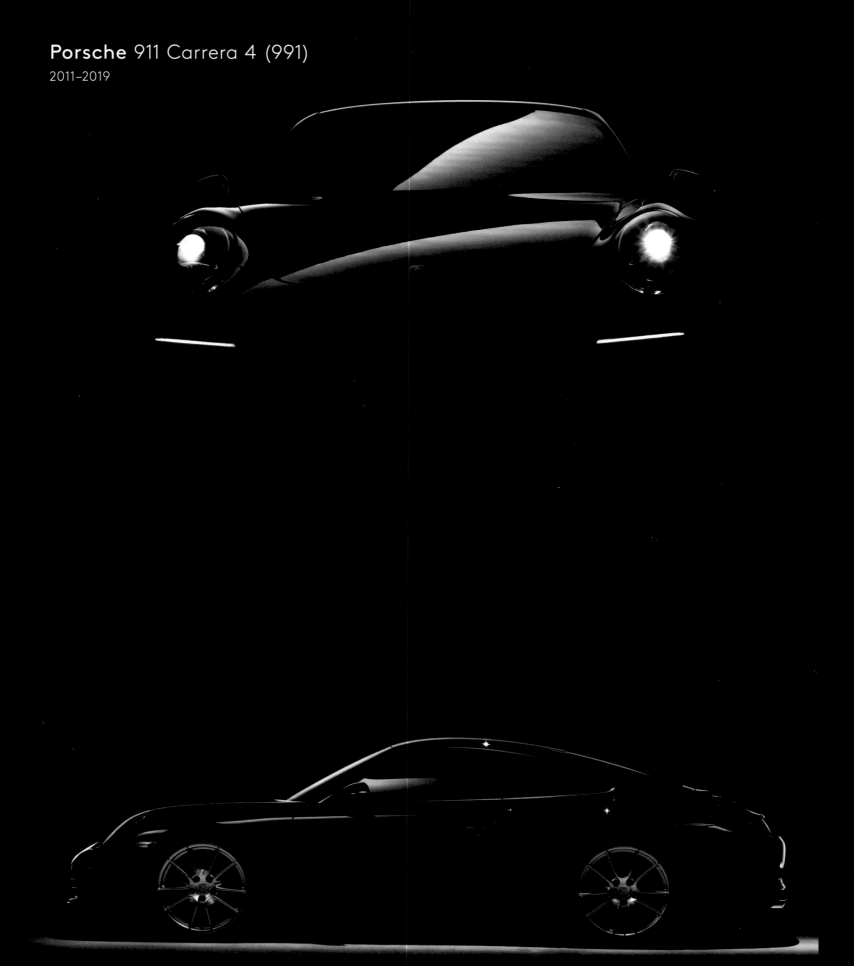

Porsche 911 Carrera GTS (997)
2004–2012

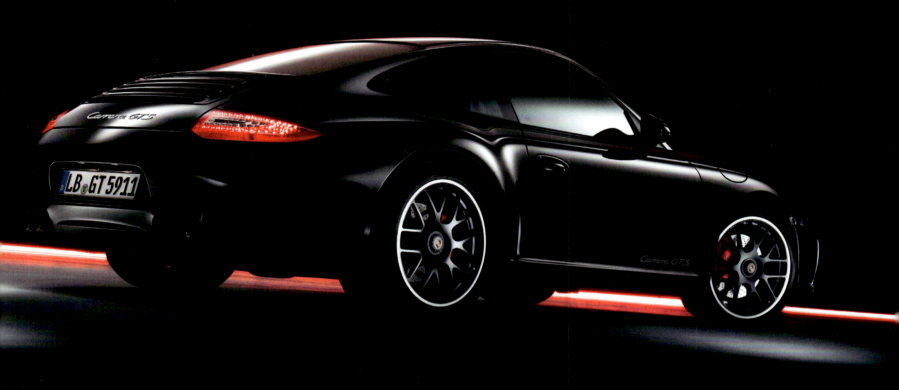

Audi R8 V10
2006–2014

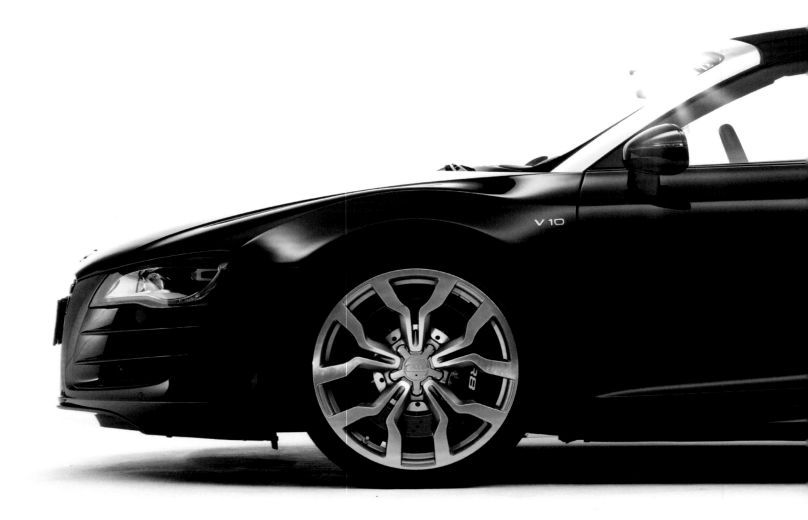

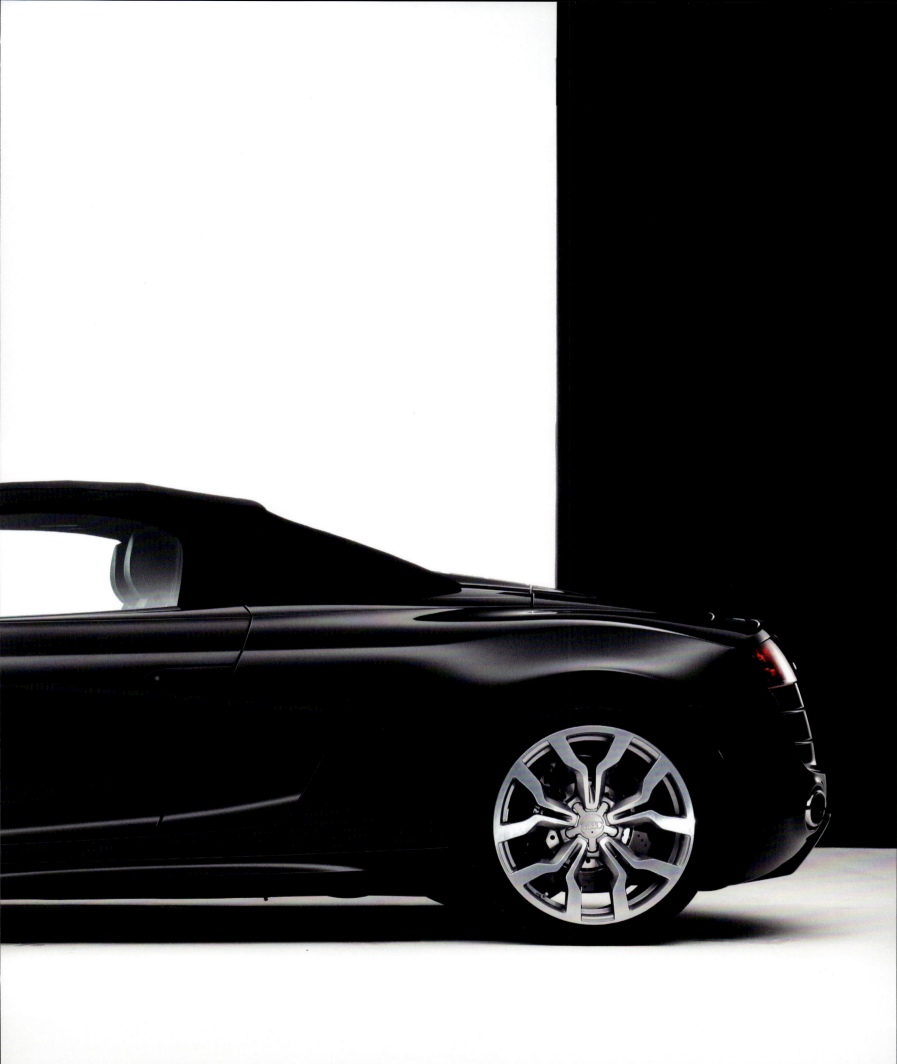

Bentley Continental GT
2003-2018

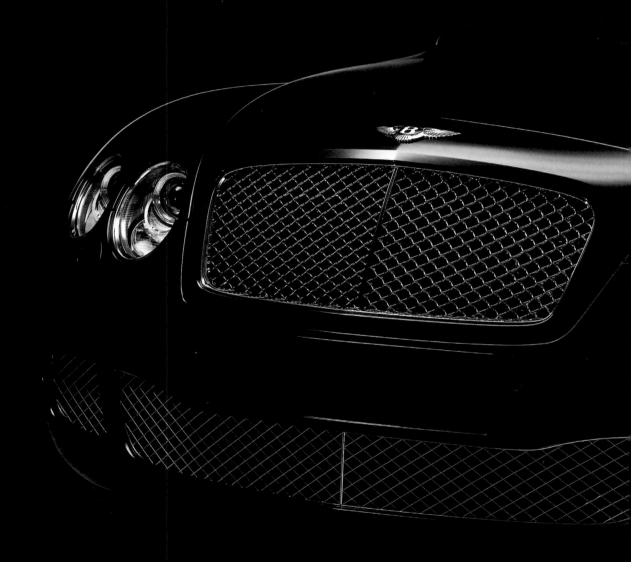

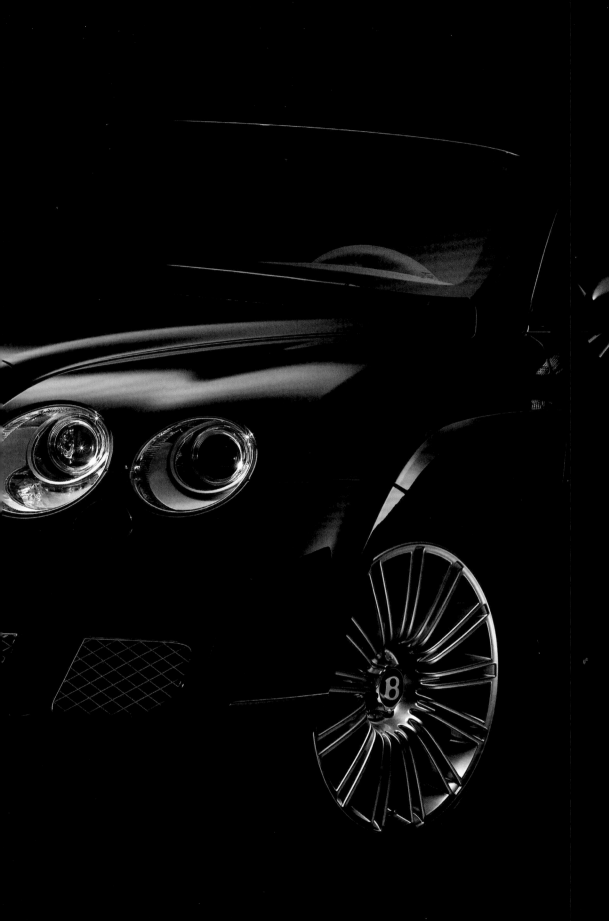

Bentley Continental GT
2003–2018

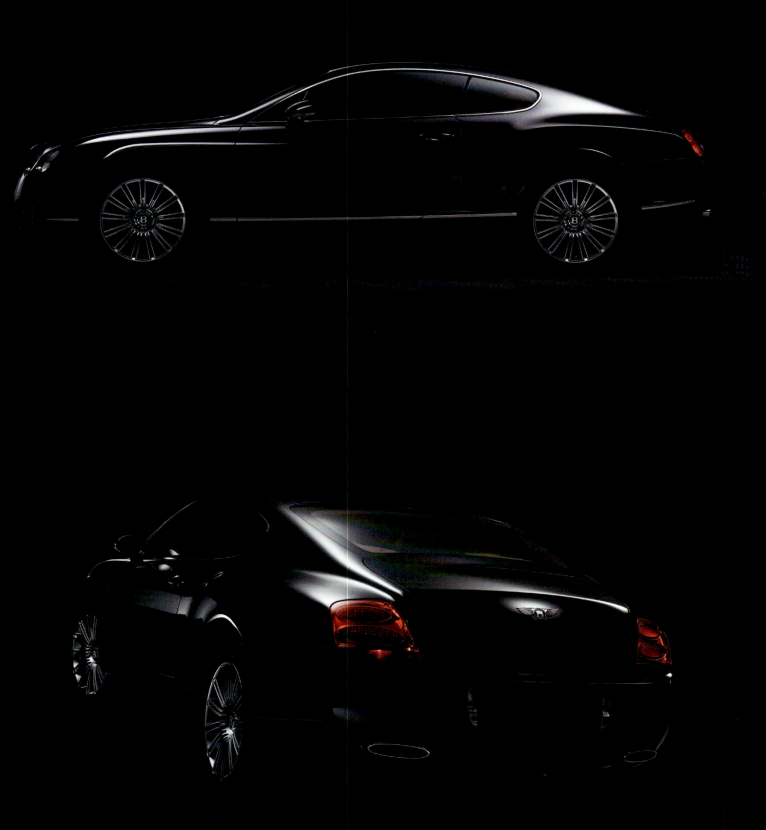

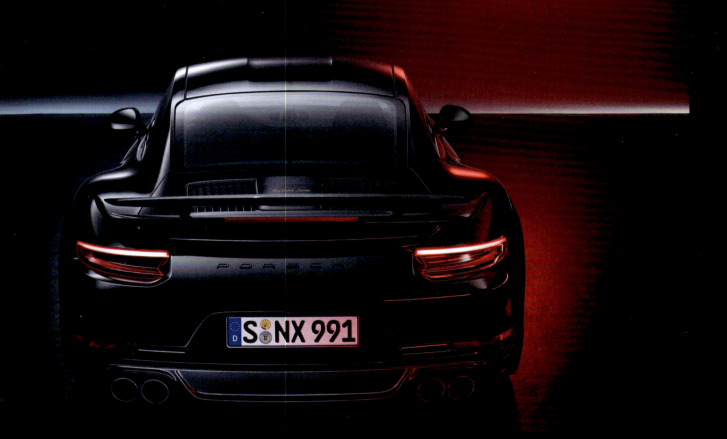

Porsche 911 Turbo S (991)
2017

Porsche 911 Carrera S (992)
2018–2022

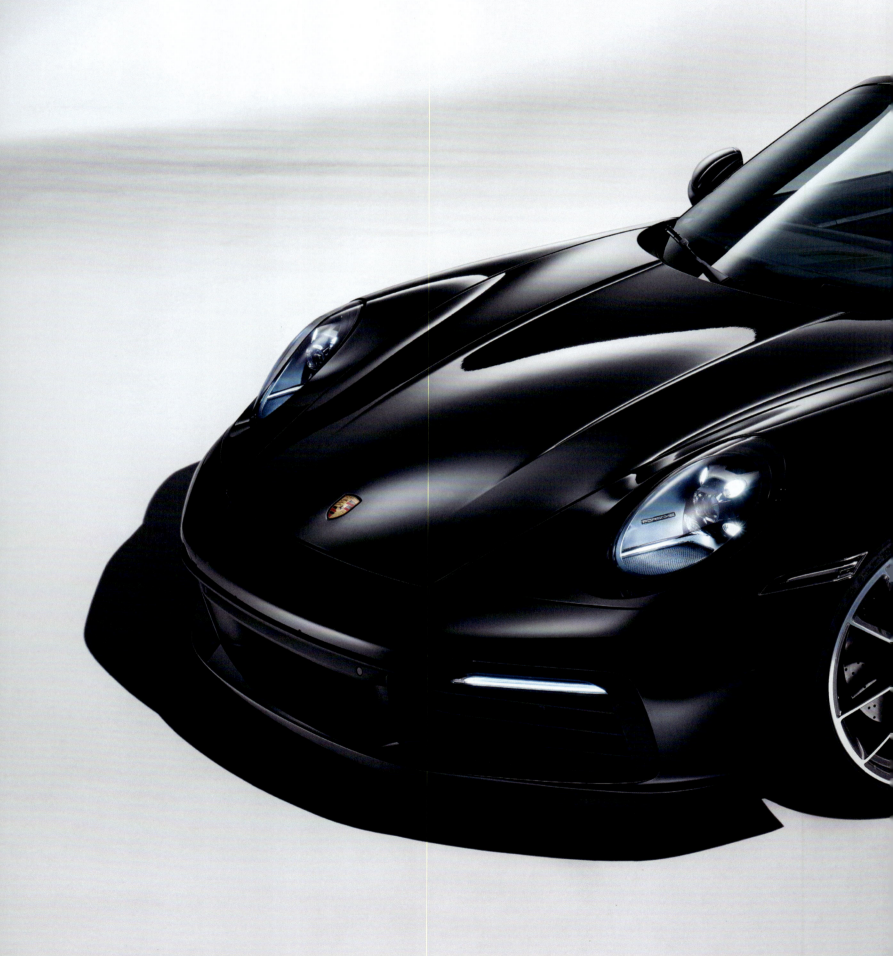

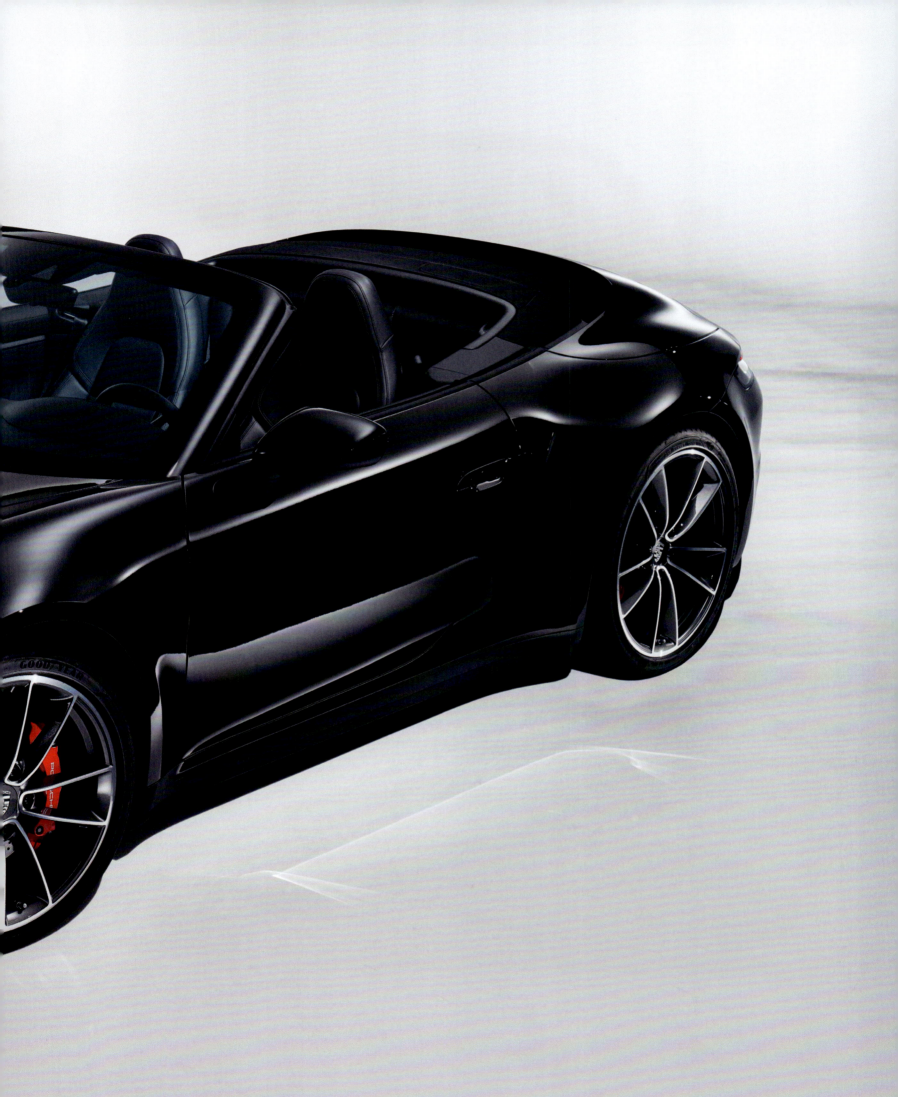

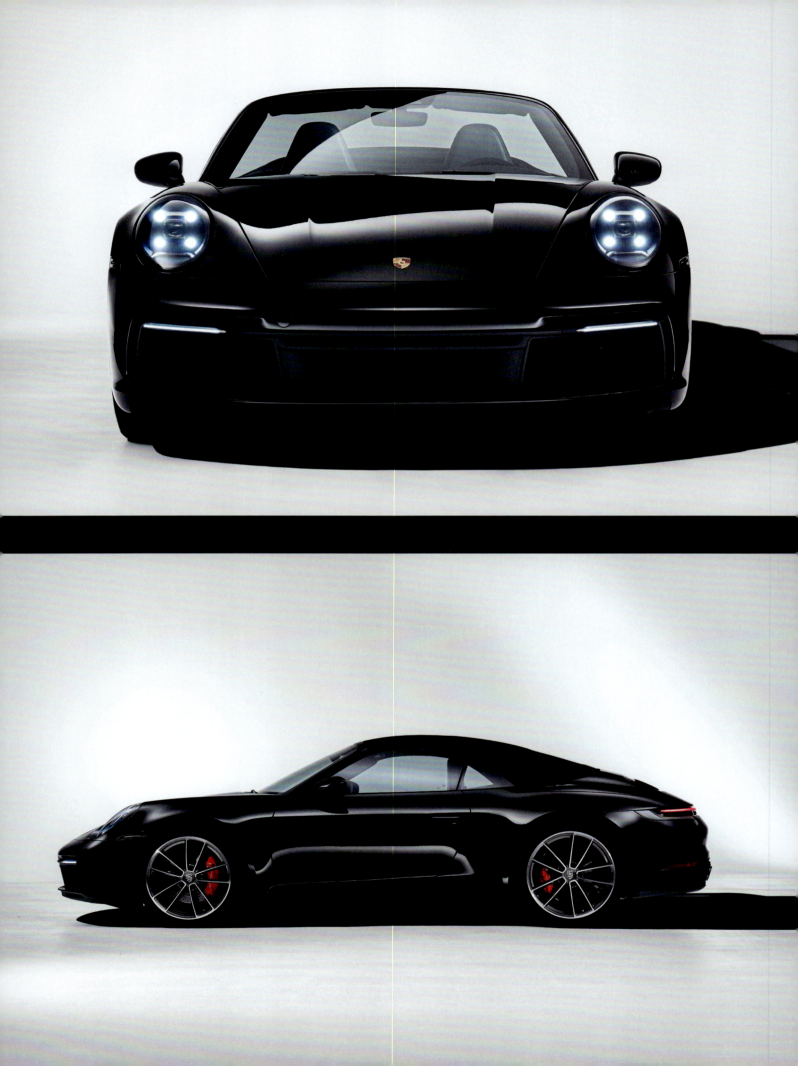

Porsche 911 Carrera S (992)
2018–2022

BLACK
UNIVERSE

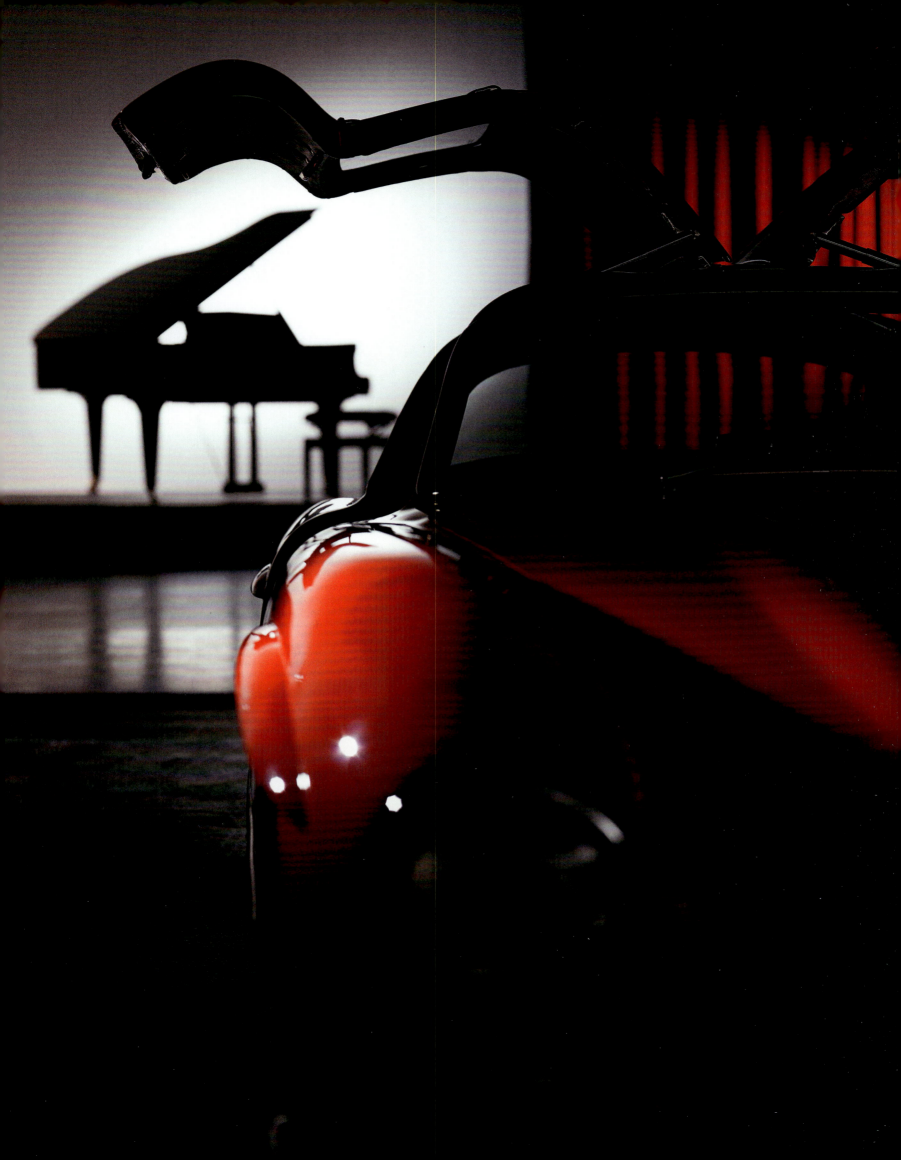

Black: The Ultimate Color

Lukas-Pierre Bessis, bestselling author and idea developer

Black is serious. Black is considered, well thought out, and successful. Black means you've made it, you've reached your goal. In martial arts, it is a black belt that proves the fighter has attained complete mastery. In the courtroom, the judge wears a black robe. And in target shooting, you are only the best if you hit the black in the very center of the target. And even death, the final destination of life, is black. Why? Because black is final, because it is perfect and absolute. While other colors usually seem undecided or playful, black means that you've arrived. German soccer legend Günter Netzer once described it this way: as a soccer player with a playboy image, he always drove sports cars, each one in the trendy color appropriate for that car. In other words, he had a red Ferrari, a Jaguar in British racing green, a silver Mercedes, etc. Finally, when he turned 60, he felt he had finally matured, and from then on, every single car he drove was black.

Black isn't a color, it's a feeling.

In the early 2000s, neurologists conducting research on the brain were able to describe the emotions that individual colors stand for. They painstakingly monitored oxygen levels in far-flung regions of the brain to categorize the colors by what feelings they inspired. According to their results, black stands for victory, power, status, battle, fame, autonomy, freedom, being an elite, persistence, pride, honor and achievement. To sum it up, black stands for dominance.

So when an instrument maker picks a color for his best guitar or finest grand piano, he chooses black. When a credit card represents boundless possibilities for its cardholders, the issuing bank makes the card black. And when an engineer builds his greatest bicycle or fastest car, then it too is always black.

Because black is not a color, it's a message!

Schwarz: die endgültige Farbe

Lukas-Pierre Bessis, Bestsellerautor und Ideenentwickler

Schwarz ist ernst. Schwarz ist überlegt, reflektiert und erfolgreich. Schwarz bedeutet anzukommen, das Ziel erreicht zu haben. Im Kampfsport ist es der schwarze Gürtel, der die Vollendung der Reife des Kämpfers beweist. In der Juristerei trägt der Richter eine schwarze Robe. Und im Schießsport ist man erst dann der Beste, wenn man ins Schwarze in der Mitte der Schießscheibe trifft. Und auch der Tod als das Endziel des Lebens ist schwarz. Warum? Weil Schwarz endgültig ist, weil es perfekt und vollkommen ist. Während andere Farben meist unentschlossen oder verspielt wirken, bedeutet Schwarz, angekommen zu sein. Die deutsche Fußballlegende Günter Netzer beschrieb es einst so: Als Fußballer mit Playboy-Image sei er immer Sportwagen gefahren. Jeden dieser Wagen natürlich in der dafür vorgesehenen (Trend-)Farbe. Sprich: Ferrari in Rot, Jaguar in British Racing Green, Mercedes in Silber etc. Erst als er seinen 60. Geburtstag feierte, hatte er den Reifegrad erreicht und fuhr fortan seine Autos alle nur noch in Schwarz.

Schwarz ist keine Farbe, sondern ein Gefühl.

Gehirnforscher haben Anfang der 2000er Jahre mit Hilfe der Neurowissenschaft die Emotionen beschrieben, für die die einzelnen Farben stehen. In aufwendigen Verfahren wurden die Sauerstoffaktivitäten in den unterschiedlichsten Regionen des Gehirns beobachtet. Jeder Farbe konnten so die passenden Gefühle zugeordnet werden. Demnach steht Schwarz für Sieg, Macht, Status, Kampf, Ruhm, Autonomie, Freiheit, Elite, Durchsetzung, Stolz, Ehre und Leistung. Kurzum, Schwarz steht für Dominanz.

Wenn also ein Instrumentenbauer die Farbe für seine beste Gitarre oder seinen besten Konzertflügel aussuchen will, dann wählt er Schwarz. Wenn eine Kreditkarte grenzenlose Möglichkeiten für ihre Besitzer ausdrücken soll, dann wählt die ausgebende Bank Schwarz, und baut ein Techniker sein bestes Fahrrad oder sein schnellstes Auto, dann ist das ebenfalls immer schwarz.

Denn Schwarz ist keine Farbe, sondern eine Botschaft!

Steinway & Sons
meets Mercedes-Benz 300 SL

BMW R 68
1952

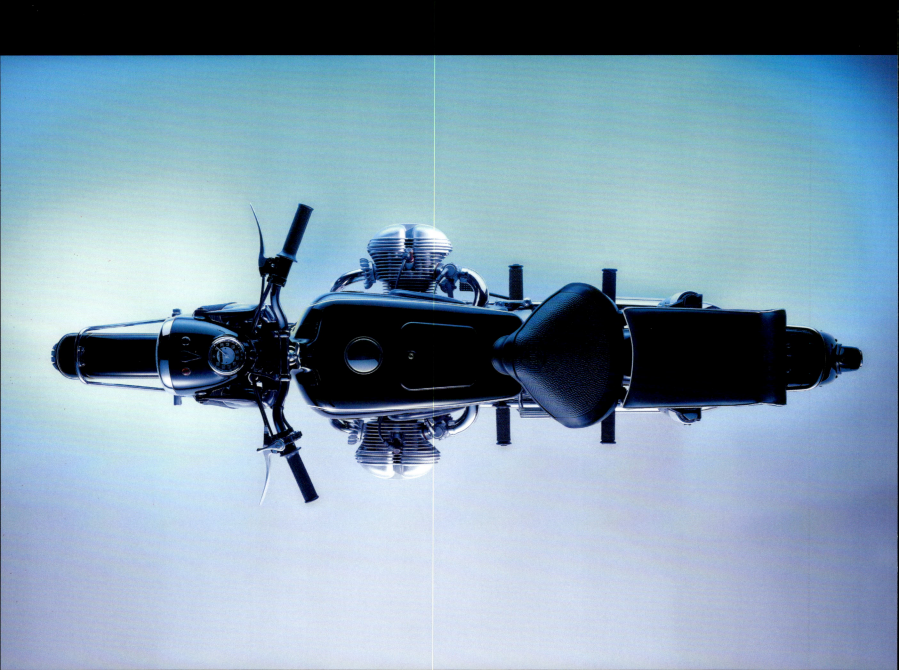

Bovet Pininfarina Tourbillon Ottanta
2011

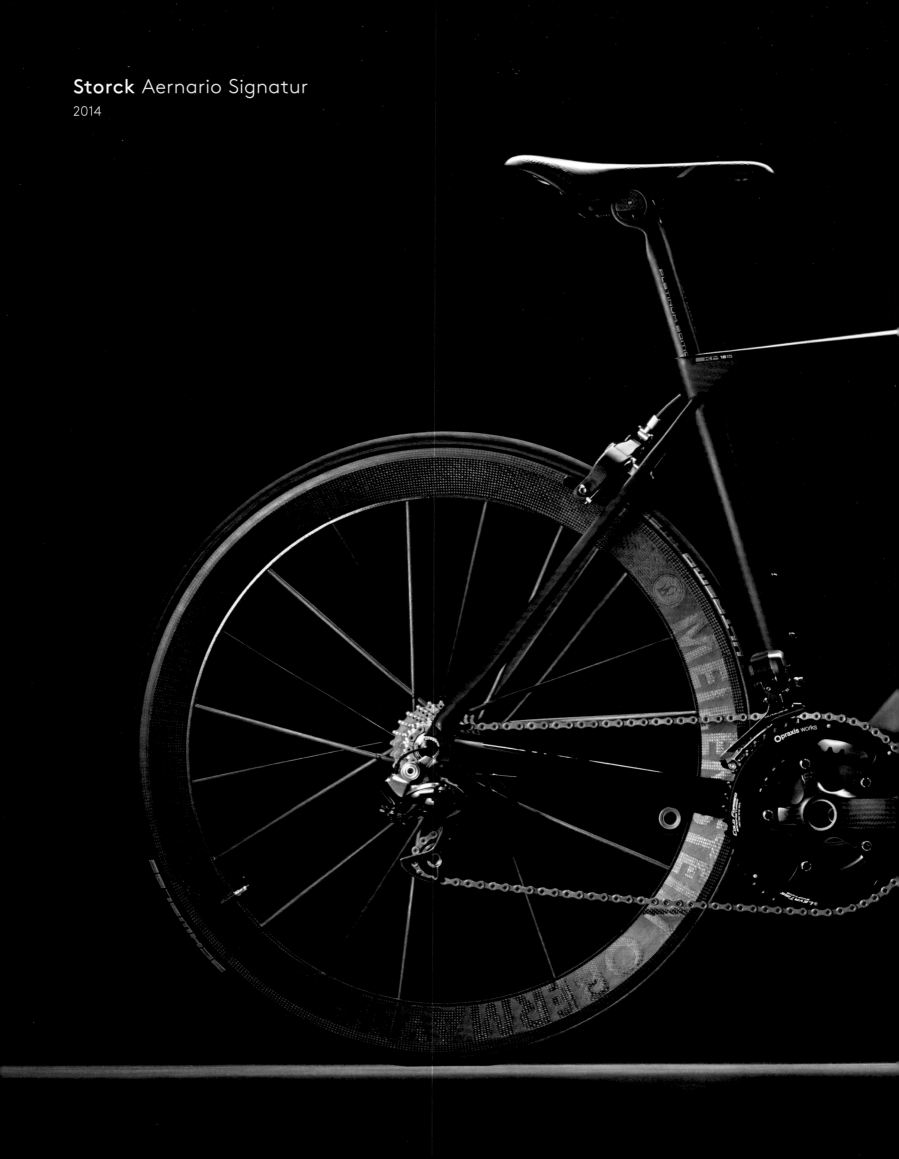

Storck Aernario Signatur
2014

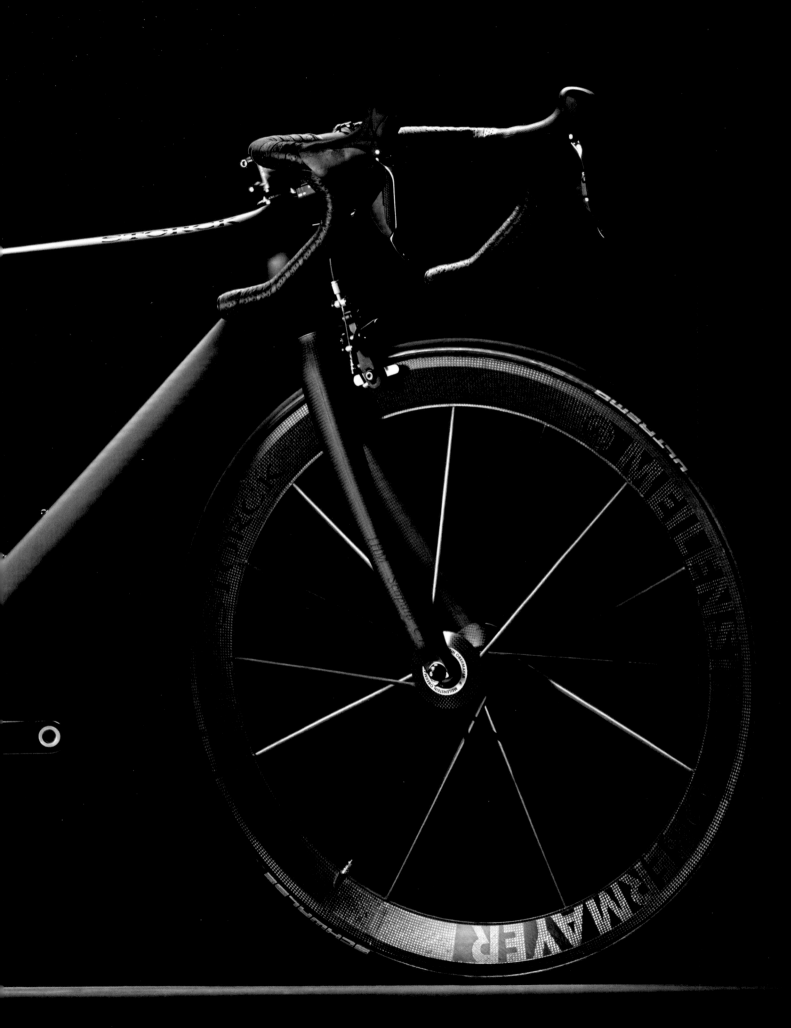

Gibson Les Paul Custom "Black Beauty"
1957

WHERE THERE IS DARKNESS, THERE MUST ALSO BE LIGHT

René Staud

In automotive photography, and particularly when photographing black vehicles, lighting is extremely important. It took a very long time for us to achieve what we considered to be "perfect" results.

In early 1982, only some of the capacity of my large studio in Wendlingen was actually being utilized by furniture industry clients. I had long wanted to delve into new industries such as the automotive industry and began taking my first experimental shots. But I soon threw in the towel because the lighting equipment I had would not allow me to take any truly exceptional photos.

At some point, I had a flash of insight while thinking back to my experiences with tabletop photography. By setting up jewelry and writing implements—extremely shiny still life items—with dazzling lighting, I was able to compile a very good client portfolio in the early years of my career. So if I were to shoot large, extremely shiny items like automobiles under similar conditions—eureka, that had to be it!

At the end of a long process with a lot of experimenting, calculating, optimizing, and dead ends along the way, Magicflash® was born. It has all the advantages of a conventional softbox—totally homogenous lighting, excellent flash yield, a clearly defined color temperature, all while being child's play to use—but it is much larger. Size, directionality, statics, suspension—all parameters are perfectly tuned to the requirements of photographing cars in the studio.

The first results were revolutionary; there were basically no other comparable shots of cars back then. There were a few bugs that had to be worked out, like the annoying activation of the universal lamp heads before every shot, but the new lighting system provided a whole new revenue stream for Staud Studios. Today, over 30 years later, we still work with the softboxes, which have undergone only slight modifications, nearly every day. Many studios, both in Germany and abroad, have purchased Magicflash® lighting systems and use them for a variety of different applications.

The photo studio began to be used in a whole new way. A furniture studio that had been underutilized for years left no room for investing and experimenting. A fully booked automotive studio, on the other hand, enabled us to make great strides in our technique and gave us the luxury of having a full team of assistants.

Magicflash® was the basis of my breakthrough as an entrepreneur and enabled Staud Studios to move to its present location in Leonberg. At the same time, this technology set a new bar for studio photography, allowing me to kill two birds with one stone: to bring the automotive industry into the studio and showcase the automobile as a design statement.

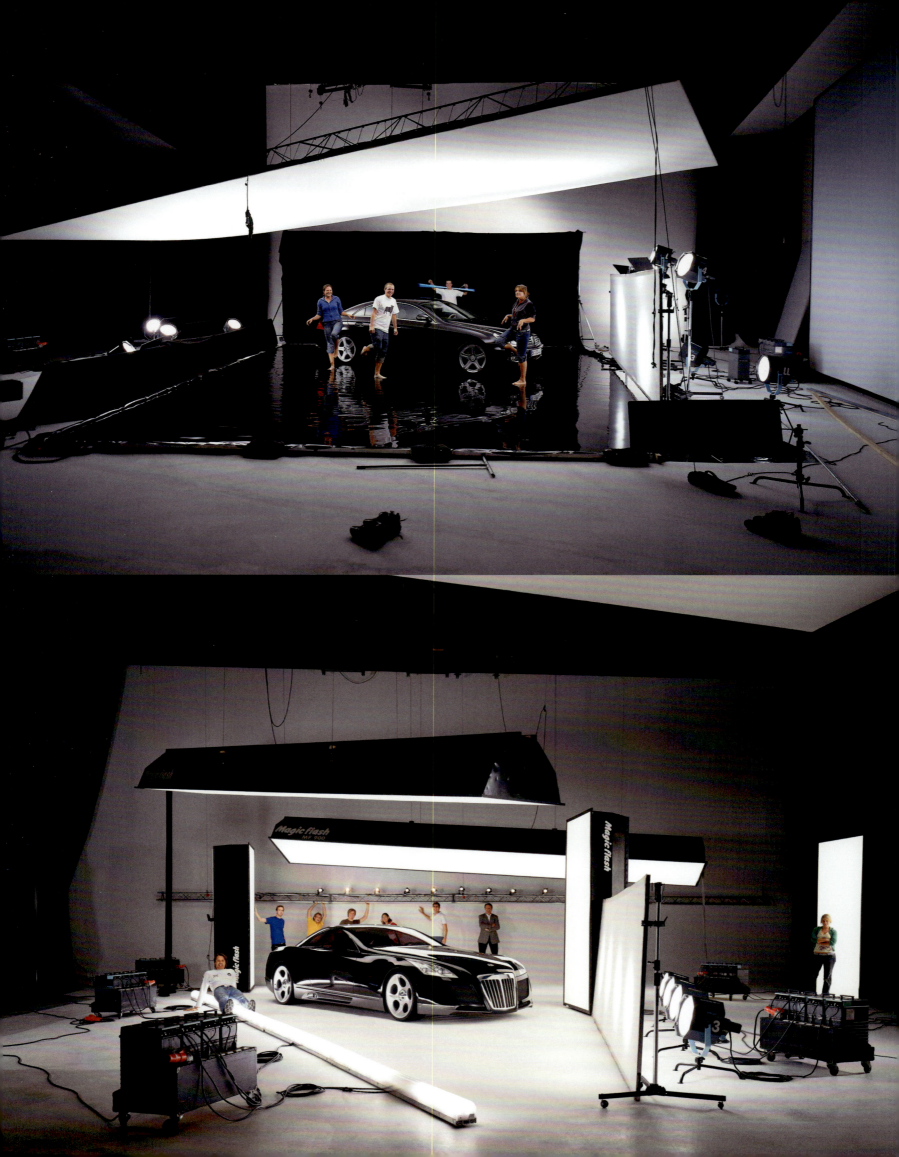

WO DUNKEL IST, MUSS AUCH LICHT SEIN

René Staud

Bei der Automobilfotografie und besonders bei der Inszenierung von schwarzen Fahrzeugen kommt der Beleuchtung eine große Bedeutung zu. Bis wir auf diesem Gebiet die aus unserer Sicht perfekten Ergebnisse erzielen konnten, war es ein weiter Weg.

Anfang 1982 waren die Kapazitäten meines Wendlinger Großraumstudios mit Kunden aus der Möbelindustrie nur zum Teil ausgelastet. Schon lange wollte ich neue Branchen erschließen, wie z. B. die Automobilindustrie, und startete die ersten fotografischen Versuche. Doch schon bald brach ich meine Testaufnahmen wieder ab, mit dem vorhandenen Lichtequipment war kein außergewöhnliches Fotokonzept zu realisieren.

Irgendwann kam dann die erlösende Einsicht, als ich mich an meine Erfahrungen mit der Tabletop-Fotografie erinnerte: Indem ich Schmuck und Schreibgeräte, also hochglänzende Still Life Objekte, mit gleißenden Lichtverläufen in Szene setzte, konnte ich mir in frühen Berufsjahren ein hochzufriedenes Kundenportfolio aufbauen. Große hochglänzende Objekte wie Automobile unter ähnlichen Bedingungen zu fotografieren, das musste es sein!

Am Ende eines langen Prozesses mit einer Vielzahl von Experimenten, Berechnungen, Optimierungen, aber auch Rückschlägen stand die Geburt von Magicflash®. Es hat die Vorteile einer herkömmlichen Lichtwanne – absolut homogene Lichtflächen, große Blitzlichtausbeute, klar definierte Farbtemperatur, spielerisches Handling –, ist aber viel größer. Größe, Lichtführung, Statik, Aufhängung – alle Parameter sind perfekt auf die Bedürfnisse der Automobilfotografie im Studio abgestimmt.

Die ersten Ergebnisse waren revolutionär, hatte es bis dato doch so gut wie keine vergleichbaren Aufnahmen mit Automobilen gegeben. Zwar mussten noch Kinderkrankheiten, wie das lästige Einsetzen der Universalblitzköpfe vor jedem Einsatz, behoben werden, aber mit dem neuen Lichtsystem wurde zugleich eine neue Unternehmensbasis für die Staud Studios geschaffen. Noch heute, nach über 30 Jahren, arbeiten wir fast täglich mit den Lichtwannen in nahezu unveränderter Form. Zahlreiche Studios im In- und Ausland haben inzwischen Lichtsysteme aus dem Magicflash® Leuchtprogramm erworben und setzen sie vielfältig ein.

Die Auslastung des Fotostudios nahm völlig neue Dimensionen an. Ein über Jahre unzureichend ausgelastetes Möbelstudio ließ kaum Spielraum für Investitionen und Experimente. Ein ausgebuchtes Automobilstudio dagegen ermöglichte fotografische Weiterentwicklung und den Luxus eines ganzen Teams.

Magicflash® war die Basis meines unternehmerischen Durchbruchs und des Umzugs der Staud Studios an den heutigen Standort in Leonberg. Gleichzeitig wurden mit dieser Technik Akzente in der Studiofotografie gesetzt, ich holte damit auch auf einen Schlag die Automobilindustrie ins Studio und profilierte das Produkt Automobil zum Designobjekt.

Biography

René Staud was born in Stuttgart in 1951. A top car photographer for five decades, he is renowned as one of the greatest innovators of automotive photography. His patented Magicflash® not only illuminated his art, but also revolutionized car photography in the studio. Still the most apt review of his work originated from Motor Presse Stuttgart:

"René Staud is a masterful photographer: his artworks are finely balanced compositions of light and color contoured with a flash. His portraits of captivating car bodywork have made a distinctive mark in the world of modern automotive photography."

René Staud's path to photography was defined early on: He was twelve years old when he won his first photography competitions. In 1966 he was a self-employed photographer and laid the foundation for René Staud Photography.

In 1975, at 24, he opened his first studio in Stuttgart and began to specialize in car photography. The studio's bookings flourished, also thanks to its neighboring site to the luxury carmakers Mercedes-Benz and Porsche. Above all, the special quality, Staud's signature style and, post-1986, his dream studio in Leonberg ensure that for Staud Studios, until today, iconic images are "made in Leonberg."

The auto industry is not alone in treasuring the collaborative work with René Staud. For over 10 years teNeues Verlag has celebrated the photographer's artwork with beautiful photo volumes such as *The Porsche 911 Book*, *The Mercedes-Benz 300 SL Book*, *The Aston Martin Book*, the *Black Beauties* First Edition and *The Classic Cars Book* as well as many other titles that became bestsellers.

René Staud is still passionate about photography and the automotive world. He devotes his time to exhibitions, events and photo shows in galleries, thus, revealing fresh enthusiasm for automotive trends—Staud's photo shoots of collectors' vehicles and classic cars mean the "fascination of the automobile" lives on.

Biografie

René Staud wurde 1951 in Stuttgart geboren. Seit über vier Jahrzehnten gehört er zu den meistgefragten Automobilfotografen und gilt als einer der innovativsten der Branche. Mit dem Lichtsystem Magicflash® hat er nicht nur seiner Kunst, sondern der Studiofotografie im Allgemeinen einen wichtigen Impuls verliehen. Die immer noch treffendste Beschreibung seines Werks lieferte einst die Motor Presse Stuttgart:

„René Staud ist ein Lichtbildner im meisterlichen Sinne des Wortes: Seine Kunstwerke sind fein gefügte Kompositionen aus Licht und Farbe, mit Blitzlicht konturiert. Seine Ansichten von hinreißendem Karosseriedesign haben in der modernen Automobilfotografie markante Zeichen gesetzt."

René Stauds Weg zur Fotografie war schon früh vorgezeichnet: Bereits mit 12 Jahren erwarb er Auszeichnungen bei Fotowettbewerben. 1966 meldete er sein Gewerbe an und legte den Grundstein für die René Staud Photography.

Im Jahr 1975 eröffnete er mit 24 Jahren in Stuttgart sein erstes Fotostudio und spezialisierte sich zunehmend auf die Automobilfotografie. Es folgte stetiges Wachstum, das auch vom Standortvorteil in Nachbarschaft der großen Player Mercedes-Benz und Porsche begünstigt wurde. Aber es waren vor allem die hohe Qualität und Stauds eigene Handschrift, die ab 1986 mit seinem Leonberger Traumstudio und aus den Staud Studios bis heute das Gütesiegel „Made in Leonberg" gemacht haben.

Doch nicht nur die Automobilbranche schätzt die Kooperation mit René Staud. Auch der teNeues Verlag würdigt seit über 10 Jahren seine Kunst mit wunderbaren Bildbänden wie *The Porsche 911 Book*, *The Mercedes-Benz 300 SL Book*, *The Aston Martin Book*, der *Black Beauties* First Edition und *The Classic Cars* Book sowie vielen weiteren, die zu Bestsellern wurden.

René Staud brennt auch heute noch für die Fotografie und für das Thema Automobil. Mit seinem Engagement für Ausstellungen, Events und Bildvorstellungen in Galerien setzt er beim Thema Mobilität immer wieder neue Akzente – Stauds Shootings von Sammler- und Klassikfahrzeugen machen die „Faszination Automobil" unsterblich.

MANY THANKS
VIELEN DANK

Tobias Aichele	René Marius Köhler
Detlef Alder	Thomas König
Alain Aziza	Denise Körner
Astrid Aziza	Dagmar Kraus-Stubenrauch
Arthur Bechtel	Alwine Krebber
Tim Bechtel	Uwe Kristandt
Paul Berger	Hermann Layher
Ulrich Berger	Prof. Harald Leschke
Paul Bering	Anika Lethen
Lukas-Pierre Bessis	Jürgen Lewandowski
Dr. Ulrich Bez	Michael Maier
Katja Bitzer	Uwe Mertin
Hans-Gerd Bode	Rainer Mörch
Christian Boucke	Bernhard Müller
Dr. Thomas Bscher	John Muirhead
Prof. Bodo Buschmann	Philipp Neuffer
Rüdiger Czakert	Wolfgang Osterloh
Raimund Dornburg	Pit Pauen
Dieter Dressel	Hans Pollack
Nicolas Eilken	Andrea Rehn
Thomas Ernst	Hermann Reil
Jürgen Faust	Christian Renze
Wolfgang Friedrichs	Frank M. Rinderknecht
Marie-Louise Fritz	Bruno Sacco
Jochen Gabriel	Klaus Schildbach
Thorsten Gohm	Oliver Schmidt
Dominik Greuel	Teresa Schmidt
Jochen Griesheimer	Alexander Schmitz
Karl Griesheimer	Jan Schneider
Mark Gutjahr	Hans-Ulrich Scholpp
Harald Hamprecht	Klaus Scholpp
Rolf Hartge	Thomas Schumacher
Jan Haux	Axel Schumann
Rolf Heck	Jakob Sendelbach
Thorsten Heckendorf	Stefan Sielaff
Dr. Frank Heinlein	Natanael Sijanta
Dr. Lutz Helmig	Prof. Werner Sobek
Christian M. Hembry	Albert Spiess
Karl Ulrich Hermann	David Staretz
Ursula Hillgruber	Pascal Staud
Manuela Höhne	Patrick Staud
Bernd J. Hoffmann	Hannes Steim
Torsten Hoffmann	Rolf-Dieter Stohrer
Dr. Helmut Hofmann	Markus Storck
Alexandra Holzwarth	Werner Strähle
Dr. Hans A. Huber	Hans-Joachim Stuck
Max Huber	Hendrik teNeues
Leon Hustinx	Dr. Jens Thiemer
Konstantin Jacoby	Prof. Johann Tomforde
Roland Jordi	Ralf Trumpp
Fritz Kaiser	Prof. Michael Ulbig
Saulius Karosas	Dirk Voigt
Dr. Andreas Kaufmann	Prof. Gorden Wagener
Birgit Kettel	Michael Walter
Klaus Kienle	Bernd Werndl
Marc Kienle	Dierk Wettengel
Rainhardt Klahr	Markus Würth
Thomas Klocke	Dr. Andrea Michele Zagato
Jan Koch	Willi Zins

IMPRINT

© 2023 teNeues Verlag GmbH
Photographs © René Staud Photography,
Leonberg, Germany. All rights reserved.
www.renestaud.com

Retouching and composing:
Staud Studios Postproduction Team
Production by Alwine Krebber, teNeues Verlag
Color separation by Robert Kuhlendahl, teNeues Verlag

Texts by Jürgen Lewandowski
Foreword by Dr. Andreas Kaufmann
Essays by Lukas-Pierre Bessis, Mark Gutjahr,
Konstantin Jacoby, Stefan Sielaff, Prof. Werner Sobek,
David Staretz, Prof. Michael Ulbig, Prof. Gorden Wagener,
and Dr. Andrea Michele Zagato
Translations by Amanda Ennis (English)
and Dr. Kurt Rehkopf (German)
Design by Anika Lethen and Jan Haux
Editorial coordination by Stephanie Rebel, teNeues Verlag

ISBN 978-3-96171-529-9

Library of Congress Control Number: 2023938779

Printed in Slovakia by Neografia a.s.

Picture and text rights reserved for all countries.
No part of this publication may be reproduced in any manner whatsoever.

While we strive for utmost precision in every detail, we cannot be held responsible for any inaccuracies, neither for any subsequent loss or damage arising.

Every effort has been made by the publisher to contact holders of copyright to obtain permission to reproduce copyrighted material. However, if any permissions have been inadvertently overlooked, teNeues Publishing Group will be pleased to make the necessary and reasonable arrangements at the first opportunity.

Bibliographic information published by the Deutsche Nationalbibliothek:
The Deutsche Nationalbibliothek lists this publication in the Deutsche Nationalbibliografie; detailed bibliographic data are available on the Internet at dnb.dnb.de.

Published by teNeues Publishing Group

teNeues Verlag GmbH
Ohmstraße 8a
86199 Augsburg, Germany

Düsseldorf Office
Waldenburger Straße 13
41564 Kaarst, Germany
e-mail: books@teneues.com

Augsburg/München Office
Ohmstraße 8a
86199 Augsburg, Germany
e-mail: books@teneues.com

Press Department
presse@teneues.com

teNeues Publishing Company
350 Seventh Avenue, Suite 301
New York, NY 10001, USA
Phone: +1-212-627-9090
Fax: +1-212-627-9511

www.teneues.com

teNeues Publishing Group
Augsburg/München
Berlin
Düsseldorf
London
New York

teNeues